THE FULLNESS OF TIME

THE FULLNESS OF TIME

Temporalities of the Fifteenth-Century
Low Countries

MATTHEW S. CHAMPION

THE UNIVERSITY OF CHICAGO PRESS
CHICAGO AND LONDON

The University of Chicago Press, Chicago 60637
The University of Chicago Press, Ltd., London
© 2017 by The University of Chicago
All rights reserved. No part of this book may be used or reproduced in any manner whatsoever without written permission, except in the case of brief quotations in critical articles and reviews. For more information, contact the University of Chicago Press, 1427 E. 60th St., Chicago, IL 60637.
Published 2017.
Printed in the United States of America

26 25 24 23 22 21 20 19 18 17 1 2 3 4 5

ISBN-13: 978-0-226-51479-6 (cloth)
ISBN-13: 978-0-226-51482-6 (e-book)
DOI: 10.7208/chicago/9780226514826.001.0001

This book was published with the generous assistance of a Book Subvention Award from the Medieval Academy of America.

Library of Congress Cataloging-in-Publication Data

Names: Champion, Matthew S., author.
Title: The fullness of time : temporalities of the fifteenth-century Low Countries / Matthew S. Champion.
Description: Chicago ; London : The University of Chicago Press, 2017. | Includes bibliographical references and index.
Identifiers: LCCN 2017012884 | ISBN 9780226514796 (cloth: alk. paper) | ISBN 9780226514826 (e-book)
Subjects: LCSH: Benelux countries—Civilization. | Time—Social aspects—Benelux countries. | Time perception—Social aspects—Benelux countries. | Time—Religious aspects—Christianity. | Civilization, Medieval. | Fifteenth century. | Benelux countries—History—To 1500.
Classification: LCC DH71 .C47 2017 DH180 | DDC 949.2/01—dc23
LC record available at https://lccn.loc.gov/2017012884

♾ This paper meets the requirements of ANSI/NISO Z39.48-1992 (Permanence of Paper).

For Miranda

CONTENTS

	List of Illustrations	ix
	List of Abbreviations	xiii
	Introduction	1
1.	The Polyphony of Civic Time in Fifteenth-Century Leuven	26
2.	The Altarpiece of the Holy Sacrament: Making Time in Leuven's St. Peter's Church	64
3.	Music, Time, and Devotion: Emotional Narratives at the Cathedral of Cambrai	90
4.	The Advent of the Lamb: Unfolding History and Liturgy in Fifteenth-Century Ghent	107
5.	Calendars and Chronology: Temporal Devotion in Fifteenth-Century Leuven	132
6.	Time for the *Fasciculus temporum*: Time, Text, and Vision in Early Print Culture	173
	Conclusion	197
	Acknowledgments	205
	Notes	209
	Bibliography	243
	Index	275

ILLUSTRATIONS

FIGURES

I.1. *Inviolata*, from an *Antiphoner (Summer)* of the Premonstratentisan Abbey of Averbode, early sixteenth century 13
I.2. Bell of Cambrai Cathedral with Annunciation and Virgin Enthroned, c. 1451 18
I.3. *Conditor alme siderum*, from an *Antiphoner for the Use of Cambrai*, c. 1508–18 19
I.4. *Sub tuum presidium*, from an *Antiphoner for the Use of Cambrai*, c. 1508–18 20
I.5. Vision of Lady Wisdom, from Heinrich de Suso, *Horologium sapientiae*, c. 1450 23
1.1. Tower of St Gertrude's Abbey, c. 1453 28
1.2. Calendar Dial, c. 1500 35
1.3. Children of Mercury, detail from *Calendar Dial*, c. 1500 36
1.4. *Dies naturalis*, from Peter de Rivo, *Opus responsivum* 43
1.5. Annunciation, from a Book of Hours, Bruges or Ghent, late fifteenth century 62
2.1. Christ Seated between the Old and the New Law, from a Book of Hours (use of Rome), c. 1400–1415 81
2.2. Dieric Bouts, *Erasmus Altar*, before 1464 87
3.1. Notre-Dame de Grâce, c. 1340 100
4.1. Lady Wisdom with Clock, from Heinrich de Suso, *Horologium sapientiae*, 1448 119
4.2. Central Opening, Jan and Hubert van Eyck, *Ghent Altarpiece*, 1432 125

ILLUSTRATIONS

4.3. *First Sunday of Advent*, from an *Antiphoner* of St. Bavo's Abbey, Ghent, c. 1481 130
5.1. *Liturgical Table*, from Peter de Rivo, Monotesseron 140
5.2. *Altar of Christ's Passion*, c. 1470–90 145
5.3. *Calendar Table and Rota*, from Peter de Rivo, *Reformatio kalendarii* 162
5.4. *Devotional Clock Face with Crown of Thorns and Five Wounds of Christ*, parchment painting in a Book of Hours, south Holland, 1465 163
5.5. *Virgin and Child with Peter de Rivo*, colored woodcut from Peter de Rivo, *Opus responsivum*, 1488 165
5.6. *Last Supper*, colored woodcut from Peter de Rivo, *Opus responsivum*, 1488 166
5.7. *Resurrection*, colored woodcut from Peter de Rivo, *Opus responsivum*, 1488 167
5.8. Master of the Strauss Madonna, *Crucifixion*, oil on canvas and panel, after 1445 170
6.1. *Creation of the World*, from Werner Rolewinck, *Fasciculus temporum*, 1475 179
6.2. *Genealogy of Christ from Adam*, from *Speculum biblie demonstrativum genealogie domini nostri Iesu Christi* 182
6.3. *Creation of the World*, from Werner Rolewinck, *Fasciculus temporum*, 1474 183
6.4. *Central Opening*, from Werner Rolewinck, *Fasciculus temporum*, 1474 186
6.5. *The Church*, from Werner Rolewinck, *Fasciculus temporum*, c. 1474 189
6.6. *Crucifixion*, from Werner Rolewinck, *Fasciculus temporum*, 1476 191
6.7. *Christ as Salvator Mundi*, from Werner Rolewinck, *Fasciculus temporum*, 1475 193
6.8. Dieric Bouts, *Ecce Agnus Dei*, c. 1462–64 195

EXAMPLES

3.1. Guillaume Du Fay, *Kyrie* (opening), from *Missa ecce ancilla Domini*, c. 1460 103
3.2. Guillaume Du Fay, *Agnus Dei* (opening), from *Missa ecce ancilla Domini*, c. 1460 104

PLATES

1. Dieric Bouts, *Altarpiece of the Holy Sacrament*, c. 1464–66
2. *Transfiguration*, from Jean Gerson, *Monotessaron*, Ghent, early sixteenth century
3. *Baptism of Jesus*, from Peter de Rivo, *Monotesseron*
4. *Crucifixion*, colored woodcut from Peter de Rivo, *Opus responsivum*, 1488
5. *Detail (Initial G)*, from Werner Rolewinck, *Fasciculus temporum*, 1475

ABBREVIATIONS

AA: Archive of the Abbey of Averbode
AAP: Archive of the Abbey of Park, Heverlee
ARAL: Algemeen Rijksarchief, Leuven
AUL: Aberdeen University Library, Aberdeen
BL: British Library, London
BMP: Bibliothèque Mazarine, Paris
BMR: Bibliothèque municipale, Rouen
BSB: Bäyerische Staatsbibliothek, Munich
CCSL: *Corpus Christianorum series Latina*. Turnhout, 1953–.
CMM: Médiathèque municipale, Cambrai
CUL: University Library, Cambridge
GUB: Universiteitsbibliotheek, Ghent
ISTC: *Incunabula Short Title Catalogue* (British Library)
JGOC: *Jean Gerson: Oeuvres complètes*. Ed. Palemon Glorieux. 10 vols. Paris, 1960–1973.
KBR: Koninklijke Bibliotheek/Bibliothèque Royale, Brussels
ONB: Österreichische Nationalbibliothek, Vienna
PG: *Patrologia cursus completus, series Graeca*. Ed. Migne. 161 vols. Paris, 1857–1866.
PL: *Patrologia cursus completus, series Latina*. Ed. Migne. 221 vols. Paris, 1844–1865.
RLM: Rijksarchief Limburg, Maastricht
SAG: Stadsarchief, Ghent
SAL: Stadsarchief, Leuven

SBB: Staatsbibliothek, Berlin

ST: Thomas Aquinas. *Summa theologiae.* Ed. Fathers of the English Dominican Province. 61 vols. London, 1964–1981.

VDG: *Catalogue des manuscrits de la Bibliothèque Royale de Belgique.* Ed. Joseph van den Gheyn. 12 vols. Brussels, 1901–1936.

Map. The Low Countries, c. 1450.

Introduction

Time is central to who we are and how we act. To spend time with time is to see how strict chronological divisions into successive instants or uncomplicated pasts, presents, and futures collapse when faced by time's fullness. Images of time's plenitude evoke the eschatological languages of fulfillment of prophecy that saturate the biblical tradition, and which were in turn taken up, transformed, and modulated into languages of time and eternity, old and new, in Pauline theology and early Christianity. Shaped by these interpretive traditions, wrestlings with time—the assertion of the new over the old, the lingering life of the old in the new, and the paradoxical implications of eternity in time—have formed prominent motifs in the history of Western cultures. This is the first sense in which this study grapples with a fullness of time. In a second sense, I appropriate the language of temporal fullness as an emblem for the rich variety and complexity of times in social life and cultural production—life full of time. *The Fullness of Time* is devoted to interweaving these two kinds of fullness, to interpreting some of the many voices that contributed to the polyphony of time in the fifteenth-century Low Countries.

Why the Low Countries and why the fifteenth century? In the stories we tell ourselves about the past, this period is often cast as either a time bathed in the autumnal haze of a waning Middle Ages, à la Johan Huizinga, or as a golden rebirth, a Renaissance, à la Jacob Burckhardt, where an expanding historical horizon now allowed Europe to reach back to drink from the revivifying wells of classical antiquity.[1] The fifteenth century here inhabits an uneasy space between the medieval and the modern, more precisely between the late medieval and the early modern (like an impolite dinner guest, the fifteenth century rarely arrives on time). In the schematizations of historians of time, the modern is generally characterized by precise secular time

measurement and its clear sense of history happening in the foreign past. By contrast, the troublingly religious fifteenth-century Low Countries are often seen as embodying a disturbingly naive sense of time, where a kind of static or cyclical liturgical time colonizes the past, making it inhabit an eternal present. A weak sense of anachronism marks visual culture; the rulers of the Low Countries, the Dukes of Burgundy, with their lavish courts, magically wield power over time, making Caesar, Alexander the Great, and Jesus inhabit the same time frame; the polyphony of the region's composers floats in an ethereal timelessness. Conversely, the rich cities of Northern Italy and the Low Countries have been seen as the site of new dynamics of time where precise mercantile practices effaced the older, vague ecclesiastical rhythms of time. This book attempts to imagine a different kind of historical space.

The Fullness of Time hopes to give some time back to the fifteenth-century Low Countries, uncovering, in precisely those places seen as most troublingly timeless in earlier scholarship, complex narrative unfoldings of affective time, subtle temporalizations of eternity, and dynamic cultures of historical and liturgical reflection. It seeks answers to two questions central to understanding time in the period. First, how was time experienced, perceived, measured, and produced in the fifteenth-century Low Countries? Second, in what ways did its prolific cultures of ritual, sound and music, text, and image structure and reflect these forms of temporality? Many of these temporal forms were shared across the centuries loosely categorized as medieval; others were new, or given new force by their use in new contexts. Nevertheless, the task of the book is not to give prizes for temporal novelty, but to uncover diverse textures of temporality in particular settings. Throughout, my desire is to assist broader reflections on how human cultures perceive and organize time.

Imagining spaces no longer defined by Burckhardtian or Huizingian readings of the period has become easier following the waning of Johan Huizinga's *Herfsttij der Middeleeuwen* (*The Autumn of the Middle Ages*, 1919).[2] Attracted to Huizinga's pioneering interdisciplinary and anthropological method, historians, musicologists, and art historians have also substantially revised his vision of the splendid decay and empty ritual of the Burgundian state.[3] Peter Arnade's illuminating *Realms of Ritual*, for example, reframed Huizinga's reading of Burgundian "symbolic action as emptied of primary meaning," instead insisting on the centrality and meaningfulness of symbol and ritual in constructing the Burgundian city and state.[4] A similar revision of Burgundy's importance in a pan-European context has been undertaken by historians of art and material culture like Marina Belozerskaya and Paula Nuttall.[5] Belozerskaya, for example, has challenged "the prevalent

perception of the fifteenth century [which] emphasizes humanistic antiquarianism and Italy," arguing that "the pan-European appeal of the arts hailing from the Burgundian milieu" is "one of many alternative lenses through which the period can be viewed."[6] More generally, recent scholars of the fifteenth century have stressed the period's "multiple options," a plethora of possibilities unleashed by reforming religious movements and new devotional styles, social changes associated with urban environments, and new political configurations.[7]

What were these new configurations? Across the period, successive Dukes of Burgundy amassed vast territories across modern-day France, Belgium, and the Netherlands, making the duchy one of the most important and influential powers of fifteenth-century Europe.[8] Roughly coterminous with the Dukes' northern holdings, the "cultural unit" of the fifteenth-century Low Countries extended from the northern Rhineland, including Cologne, to Holland and Guelders to the north, and in the south to flourishing urban centers of modern Northern France and Belgium—towns like Arras, Douai, the imperial cathedral city of Cambrai, the rebellious mercantile city of Ghent, Bruges, Leuven with its new university, Antwerp, and Brussels.[9] Across the region, common cultural vocabularies emerged in religious houses, guilds, and confraternities, rich seed-beds for the growth of localized devotional cultures and a multiplicity of ritual and artistic practices. The fifteenth-century Burgundian Low Countries were the site of important changes in visual culture, led by artists such as Jan van Eyck (c. 1395–1441), Rogier van der Weyden (c. 1399–1464), and Dieric Bouts (c. 1415–1475), famous then, as now, for their technical and iconographical innovations. In music, composers like Guillaume Du Fay (1397–1474), Gilles Binchois (c. 1400–1460), and Johannes Ockeghem (c. 1410–1497) transformed methods of composition across Europe. The history of the period was recorded by innovative chroniclers including Georges Chastelain (c. 1415–1474) and Olivier de la Marche (c. 1425–1502). In the late fourteenth and fifteenth centuries, the religious life of the Low Countries witnessed the startling reform movement of the *devotio moderna* and the rapidly expanding Windesheim Congregation of religious houses, with their scriptoria and schools.[10] Within the houses of the *devotio moderna*, new and subtle forms of devout scrutiny of time were developed. Members of the flourishing Burgundian court fostered these changes, supporting powerful religious cults and houses, mingling with urban elites in guilds and confraternities, and acting as patrons of art, music, and literature.

Beyond the Burgundian lands, the splendors of the courts of Philip the Good (1396–1467) and Charles the Bold (1433–1477) traveled with artists,

musicians, bankers, and tradesmen across Europe, giving rise to emulation in England, the courts of Northern Italy, and as far as Portuguese Madeira, where an image of St. James the Greater, possibly by Dieric Bouts, became venerated as a protection against plague.[11] Closer to home, the reforms of the sixteenth century are inconceivable without Desiderius Erasmus, trained at the University of Leuven and steeped in the culture of the *devotio moderna*. The influence of the *devotio moderna* stretched eastward too, shaping religious reform and transformation in central and eastern Europe.[12] Europe, in turn, came to the Low Countries. The Italian banker Giovanni Arnolfini and his wife, immortalized in Jan van Eyck's famous 1434 portrait, were only two of many fifteenth-century Europeans who made their homes in the northern trading centers of Bruges, Ghent, and Antwerp. Just as the sophisticated cities of Italy transformed Europe in the fifteenth century, so too did their northern counterparts. In the aftermath of Charles the Bold's defeat and death at the Battle of Nancy in 1477, the Burgundian territories were fused with the Hapsburg Empire. Partly as a result, complex receptions of the cultures of the Low Countries continued across Europe and the world, especially in sixteenth-century Hapsburg Germany and Spain.

Seen in this light, a history of temporalities in the fifteenth-century Low Countries can offer new approaches to an important and transformative period and region, while providing scholars across disciplines with material for further thought about how time changed in the fifteenth and sixteenth centuries.

WRITING THE HISTORY OF TEMPORALITIES

But, to re-voice Augustine of Hippo's (354–430) famous formulation:

> what is time? Who can comprehend this even in thought so as to articulate the answer in words? Yet what do we speak of, in our familiar everyday conversation, more than of time? We surely know what we mean when we speak of it. We also know what is meant when we hear someone else talking about it. What then is time? Provided that no one asks me, I know. If I want to explain to an inquirer, I do not know. But I confidently affirm myself to know that if nothing passes away, there is no past time, and if nothing arrives, there is no future time, and if nothing existed there would be no present time.[13]

Like Augustine, I do not know what time is. But Augustine's reflections can open up ways of thinking about time through our perception of its effects—

the passing of events into the past, the sense of a future to come, an experience of the present—and through an often implicitly shared language. We may not know what time is, but we know that we speak about it, and that this speaking seems both a response to, and a way of making, our worlds.

I hope to respond to this sense of time's doubleness—as given, as made—by allowing for the analysis of what Paul Ricoeur has called universal or cosmological and lived or human time.[14] As in all cultures, in the fifteenth-century Low Countries, cosmological time was marked by the passing of day into night, the cycles of the seasons, and the movements of heavenly bodies. Lived time is impossible to disentangle from cosmological time, and can be described as the formation of temporalities through the habits and practices of human action. The ways that humans form their temporal experiences include every symbolic structure and act that shapes their worlds. Texts, music, art, architecture, ritual, and history: all structure time; and their arrangements of time are in turn structured by the understandings of time held, lived with, and used by their creators, performers, and audiences.

My initial desire to write a history of time in the fifteenth-century Low Countries developed from my reading of Augustine's *Confessions* and *De musica*. I was struck by the insistent use of the Ambrosian hymn *Deus creator omnium* as an exemplum for human temporal experience, and more broadly for the temporal harmony of the universe.[15] For Augustine, human perception and experience of time is made in the unfolding of language, and involves the stretching out of the soul (*distentio animi*) to encompass the past as memory, attention to the present, and expectation of the future.[16] But time's formation in language and text, for Augustine, is also musical, founded in the harmony, ratio, and numbers of the hymn, or the chanting of a psalm. These are, of course, liturgical texts, which create and measure time in the social act of the church's liturgy. Drawing on Augustine's method of understanding time, I wanted to take seriously the arrangement of time through text, music, and ritual.

In part, then, *The Fullness of Time* advocates for a kind of historical practice that takes transdisciplinarity seriously. For if we are born into the midst of time, and situated even before our birth within folds of narrative, those folds are also the clothing of our senses and our bodies, the pages of the books we read, the folding of sound waves into each other, the vibrations of our vocal folds as we talk and sing, the worlds we shape and inhabit.

Historians often think they belong to the discipline most devoted to the study of time, and there is, of course, a substantial literature on time and history including considerable work on medieval and early modern time.[17]

These histories are in their own ways diverse and complex—yet to my mind we do not yet have a sense of the possibilities of the history of temporalities to generate the kinds of explorations that have made the history of gender, the body, space, memory, emotions, or materiality open so many more windows onto past worlds over recent decades. In the tradition of integrative historical practice that engages across disciplinary boundaries, we are now ready to write histories of time that are full—that think carefully about the ways in which different cultural forms produce, reflect, and inhabit time.

I am making no claim to an absolute fullness of analysis here: no product of the human imagination could claim to achieve a synoptic vision of every temporality. Much of this book focuses on the temporalities experienced and generated within religious institutions, universities, court and urban elites. I have not been able to pursue in sufficient detail the textures of time for merchants, artisans, farmers, and laborers, or for the laity, literate and illiterate, although these often intersected with, and were shaped by, the kinds of time I interpret throughout the book. Gender, life stage, and intergenerational change all warrant further investigation, as do questions of social acceleration and rhythm.[18] These and other large gaps and failures of analysis will, I hope, be taken by others as places for further reflection on the history of time.

My own reflections have drawn particularly on the rich literature on time that has developed in and around anthropology, sociology, and cultural history.[19] Early engagements with time within this tradition stressed the relationship between the rhythms of action and the development of categories and measurement systems of time.[20] Such approaches tended to instantiate oppositions between imprecise, natural, and organic traditional time and a mechanized modern time that aspires to exact quantification.[21] This schema forms part of historical genealogies of a disenchanted and secular modernity. Classic examples are Max Weber's *The Protestant Ethic and the Spirit of Capitalism* (1904–1905) and Ricardo J. Quinones's *The Renaissance Discovery of Time* (1972). In such genealogies, the Reformation or the Renaissance is often seen as emancipating the West from a medieval Christian temporal regime, and witnessing "the discovery of the world [and] the discovery of man."[22] In Quinones's argument, the Renaissance sees time becoming profoundly valuable, precisely measured, and an enemy to be battled by human ingenuity, marking a radical change from earlier, indifferent medieval attitudes to time.[23] An emphasis on precise measurement similarly emerged in Gustav Bilfinger's pioneering history of the measurement of the hour, *Die mittelalterlichen Horen und die modernen Stunden* (1892). Bilfinger charts a move from an imprecise and wandering religious

designation of the liturgical hours to a modern and precise secular reckoning of the hours, the fixed and mechanically measured hours of late medieval and Renaissance urban life.[24] More recent accounts, similarly interested in the genealogy of modern temporality and time measurement, are David S. Landes's *Revolution in Time: Clocks and the Making of the Modern World* (1983) and Gehard Dohrn-van Rossum's magisterial *History of the Hour: Clocks and Modern Temporal Orders* (1996), the best current survey of the history of time measurement.

A further influential example of this narrative is Reinhart Koselleck's *Vergangene Zukunft—Zur Semantik geschichtlicher Zeiten* (1979). Koselleck proposed that a change in the conceptualization of time had taken place in the sixteenth century, when a "medieval" horizon of expectation, which collapsed temporal distance into "presence," gave way to a modern temporalization of history: the Renaissance becomes the site of the "discovery of history."[25] *Vergangene Zukunft* draws heavily on an interpretation of Albrecht Altdorfer's famous painting, the *Alexanderschlacht* (1528–1529). But by viewing the *Alexanderschlacht* as an emblem of a near-timeless medieval temporal episteme, Koselleck constructs a modern fantasy of a changeless medieval past.[26] This fantasy is unsustainable. Crucial for Altdorfer's visual language, for example, were changes in representation of space and time instituted by the painters of the fifteenth-century Low Countries. As I show in *The Fullness of Time*, artworks by painters like Jan van Eyck and Dieric Bouts developed radically new and paradoxical deployments of spatial and temporal depth, constructing spaces for reflection on time and its effacement that reveal the thinness of Koselleck's account.

Oppositions between an unmeasured medieval time and modern measured time often tacitly rely on a separation between traditional, mythic, and cyclical societies, often associated with static Greek or Eastern temporalities, and modern Western Judeo-Christian societies where time is seen as an arrow, "historical," progressive, and precise.[27] Within anthropology, a powerful critique of these approaches was mounted by Johannes Fabian, who saw them enforcing the supremacy of a secular West over supposedly more "primitive" societies.[28] Simple schematizations of time have likewise been destabilized within phenomenology and philology. Paul Ricoeur's monumental investigation *Time and Narrative* drew out the complex emplotments of time within Western literary and historical traditions, stressing the constantly narrativized experience of human time. Moves toward a less schematic history of time were, of course, well underway before Ricoeur: Eric Auerbach's classic essay on *figura*, for example, had shown that temporal organization in the medieval world could not be reduced to simple

cycles or straight lines.²⁹ Auerbach's "*figura* is something real and historical which announces something else that is also real and historical."³⁰ It turns out to be "an attempt to accede to an extratemporal perspective on time and eternity: God's perspective."³¹ These insights, that the form of temporal structures may relate to attempts to approximate divine knowledge, and that temporality may escape linearity and circularity, are crucial to understanding time in the fifteenth-century Low Countries. For linear time can be arranged vertically and horizontally, and can be imagined through spirals, vortices, serpentine or fragmented lines, to name only some common forms.³² And it is not only in the *figura* that one can trace attempts to see time from eternity. Both circular and straight lines of time can come to approximate divine vision. And what kind of eternity is involved in the divine gaze is a question that cannot be answered with a simple equation of eternity with timelessness. As this book traces various figurations of time, it will be necessary to remain alert to the potential reductiveness of schematic taxonomies and the possibilities of other metaphors of time, both as heuristic tools for the twenty-first-century historian and as hermeneutics of time in the fifteenth century.

Simplistic schematizations of time were undermined from another direction by research in the 1960s and 1970s stressing a "multiplicity of social times." These studies broke down monolithic social categories of time into plural varieties of time within social groups.³³ Arguably the most influential studies of late medieval time, two essays by Jacques Le Goff collected and translated in *Time, Work and Culture in the Middle Ages*, proposed a gradual division between the church's time and the time of the merchant linked to social and economic changes over the course of the thirteenth and fourteenth centuries.³⁴ In many ways echoing Bilfinger, Le Goff saw the church's hegemony over time, epitomized by church bells, gradually giving way to more precise measures of time in the mercantile world, signaled by the introduction of independent work bells. Le Goff laid particular emphasis on Northern France and Flanders in these changes, but applied his theses to the fifteenth century briefly and, often, only implicitly. *The Fullness of Time* aims to reappraise and refine Le Goff's insights in relation to particular communities in the fifteenth-century Low Countries. In a striking passage that harmonizes with these aims, Le Goff made it clear that he saw his own work as only a starting place for more complex histories:

> It is to be hoped that an exhaustive investigation will someday be made with the intention of showing in a particular historical society the interaction between objective structures and mental frameworks, between

collective adventures and individual destinies, and between the various times within Time.[35]

The current state of research echoes Le Goff's desire in seeking to understand "multiple and competing times at the level of the individual or small group as well as a social class or a whole society."[36] The experience of time is seen as involving "multiple routines."[37] In a less well-known essay, Le Goff again provided a clear articulation of the need for, and the trend toward, histories of multiple and various attitudes to time:

> The principal conceptual and methodological innovation in recent historical thought has been the replacement of a unitary, linear and objective, mathematically divisible conception of time by a multiple, bountiful, reversible, subjective concept much more qualitative than quantitative. The notion of time itself has often given way to the more malleable one of duration.[38]

The appearance of duration (*durée*) here should give us pause for thought. It is a term most associated with the philosopher Henri Bergson (1859–1941). Bergson contrasted the inner perception of time by human consciousness—*durée*—with an external scientific, homogeneous, and divisible time—*temps*.[39] Bergson's theory of duration in some ways fits well with the critique of objectivity mounted in various guises across the twentieth century. It also bears a superficial resemblance to Augustine's radical "discovery" of subjective time as the stretching out of the soul.[40] Here, in a reliance on individual subjective experiences of time, we can find one strong strand in a genealogy of viewing time from the perspective of a fluid and changing self.

It is this kind of radically destabilized view of time that Peter Burke identifies as "occasionalism," that is, the possibility of "the same people behav[ing] differently according to the occasion or situation."[41] For Burke, "future discussions of the cultural or social history of time are likely to place increasing emphasis on occasions."[42] Examples of occasionalism include code switching in language, changes to handwriting in different situations, fluidity of religious affiliation, and, importantly, "different temporalities in an individual life, in different domains such as work and leisure."[43] The city is one place where a multitude of domains with a variety of situations and social arrangements are likely, making possible this experience of shifting temporalities.[44] Burke's method is attractive for a study of time within the prosperous, socially and economically diverse towns of the fifteenth-century Low Countries. But a slight hesitation is also necessary,

prompted by the easy allegiance of an occasionalist reading with ideologies of the fluid self. As Burke argues, greater attention to occasions is a useful corrective to understandings of culture and the self that assume consistency and coherence across domains. But the fluid self is, like all selves, a cultural phenomenon (though its genealogy should not be confined simply to the modern). We need, therefore, to combine an insistence on occasionalism with attention to the forms of time by which certain selves might create or try to create coherence and bridge situational variation. Too great an emphasis on either flux or stasis will be inadequate when analyzing the varieties of time experienced in the fifteenth century.

Central to processes of change and continuity are the objects that humans encounter and create. By objects I wish to include the plethora of cultural products which, when seen, heard, tasted, touched, smelled, or read, shaped the experience of time for historical agents, both consciously and unconsciously. Formation of time within the contingent "structures" of culture is not to be confused with a constantly conscious awareness on the part of agents of patterns of temporal formation.[45] To reframe the observation: the practice of culture by agents includes the psychic or habitual foundations of culture, that is to say, how such patterns are formed consciously and unconsciously in the mind and through action. The ways in which, for example, texts can shape how a mind structures its experience can be both conscious and unconscious, as the work of the cultural psychologist Jerome Bruner has demonstrated.[46] Bruner reports how, when a reader is asked to retell a story from Joyce's *Dubliners*, the reader's discourse changes, including mirroring certain linguistic transformations in Joyce's text that were absent from the reader's earlier language use: the reader is "resonating to . . . [the text's] discourse."[47] This kind of insight into the capacity of texts to shape readers has profound implications for the history of time. For if we accept Augustine's understanding of the intrication of textuality and time, we must think about the ways in which texts might be shaping and forming the temporal horizons of fifteenth-century readers.

These observations about text must be widened to embrace other media, including music and images. Time has been more prominent in scholarship on visual culture in the fifteenth-century Low Countries.[48] Pioneering work was undertaken by Alfred Acres in the 1990s through a case study of time in the work of Rogier van der Weyden.[49] Acres's readings can be supplemented by trends in the history of art that have stressed the changing reception of works within their contemporary settings. For example, Beth Williamson has shown how images might be perceived differently depending on particular times within the liturgy, including the liturgical day and year.[50] In a

suggestive recent study, Williamson has extended this analysis by bringing the visual more directly into dialogue with sound and music, in the process stressing the temporality of devotional practice.[51] Such re-temporalization of sacred art, ritual, and music forms a significant part of this book.

A more radical reformulation of time's relationships with "Art" has recently emerged in Alexander Nagel and Christopher S. Wood's *Anachronic Renaissance* (2010).[52] This theorization of "anachronic" art with "plural temporalities" is immensely helpful in combating narrow readings of images and their temporalities. In many ways congenial to my argument, I find the work's claims for "Art" and the artist—"only the idea of art can open up . . . the possibility of a conversation across time, a conversation more meaningful than the present's merely forensic reconstruction of the past"—overstated.[53] The work of the historical imagination cannot easily be subsumed by flourishes against "merely forensic" empiricism after the past fifty years of historical practice and theory. The accompanying positioning of the artist as the principal figure in reflections on time ("Non-artists aspired to imitate the artist's ability to conjure with time") seems unhelpful to me.[54] In other words, while the language of the anachronic is useful, it must also be handled with care so as not to efface the sophistication of other modes of temporal exploration and forms of knowing.

Anachronic Renaissance is a further witness to the resurgence of interest in time across a variety of periods.[55] Two recent works in medieval studies have helped bring an interdisciplinary history of time to the forefront of scholarly attention. Margot Fassler's *The Virgin of Chartres* (2010) draws together historical, literary, musical, and art historical sources to trace the ways in which sacred temporalities were formed in Chartres from the tenth to the mid-twelfth centuries.[56] Fassler shows how time can become a category of analysis across disciplines, and how liturgical sources can be brought into mainstream arguments about temporality and history. And in his last published work, Jacques Le Goff returned to time, "the most fundamental theme of life in the history of a human society."[57] Le Goff reads the thirteenth-century Dominican Jacobus de Voragine's monumental *Legenda Aurea* as an object designed to sacralize human time, through the fusion of a variety of temporalities—the cyclical *temporale*, a linear *sanctorale*, and an eschatological temporal horizon. Focusing on the multiple times within Christian time, Le Goff's work again signals time's importance to our understandings of particular texts and liturgies, and to the wider perceptual frames of societies.

What, then, can be distilled from this framing discussion for a history of temporalities in the fifteenth-century Low Countries? First, the institutions,

groups, and individuals that formed the complex fabric of society had explicit ways of measuring and thinking about time. Clocks, calendars, and liturgical hours, for example, ordered the passing of time textually, visually, and aurally, while a range of texts, from academic disputations to liturgical hymns, explicitly discussed time. But *The Fullness of Time* does not solely attempt a history of time as it was consciously conceptualized and measured. Grounded in the study of particular localities, and particular networks of music, image, text, ritual, and devotion, *The Fullness of Time* asks how the passage of time was ordered by the rhythms of human action, from the habits of a guildsman to the devotional practices of an Augustinian canon. It examines the multiple ways that objects, texts, and music might themselves be said to engage with, imply, and unsettle structures of time, shaping and forming the temporalities of historical agents in the fifteenth-century Low Countries.

My focus on the Low Countries is, as I have argued, partly a result of their particular importance in the fifteenth century, and partly because of the period's place in the stories we tell each other about how the West got modern and secular. But my local focus is also a form of resistance to kinds of historical practice sometimes advocated under the rubrics of big data or distant reading that can, if not carefully considered, undermine finely textured readings of particular times and places. Microhistories, case studies, and examples remain crucial ways of generating new understandings, and locating us in the kinds of communities that remain attentive to the detailed textures of our worlds. The case study is not only to be deployed to zoom out from the particular to the general, but also to let the general be submitted to specific configurations of persons, times, and places. To flesh out these observations, the remainder of this introduction takes the form of a prelude that practices an attention to one particular configuration of a fullness of time.

ENFOLDING AND INCARNATING: A MARIAN CASE AND METHOD

In 1479, Thierry van Thulden, Abbott of the Premonstratensian Abbey of Park at Heverlee outside Leuven, installed a new set of bells in a newly built tower at the Abbey church.[58] Linked by a mechanism to the Abbey's clock, every hour the bells tolled the opening notes of the Marian chant *Inviolata, intacta et casta es Maria* (You are inviolate, untouched, and chaste, Mary) (figure i.1).

Inviolata, intacta, et casta es Maria,
Quae es effecta fulgida caeli porta.

Fig. I.1. *Inviolata*, from an *Antiphoner (Summer)* of the Premonstratentisan Abbey of Averbode, early sixteenth century. Averbode ms IV 413, 130r. Reproduced by permission of the Abbey of Averbode.

O mater alma Christi charissima,
Suscipe pia laudum praeconia.

Nostra ut pura pectora sint et corpora
Te nunc flagitant devota corda et ora.

Tu da per precata dulcisona,
Nobis concedas veniam per saecula.

O benigna!
O benigna!
O benigna!
quae sola inviolata permansisti.[59]

You are inviolate, untouched, and chaste, Mary,
who are made the radiant gate of heaven.

O most dear mother of Christ,
receive our devout hymn and praise.

That our hearts and bodies be pure,
Our devoted hearts and mouths now beseech you.

You, through sweet-sounding prayers
obtain for us forgiveness forever.

O gracious one!
O gracious one!
O gracious one!
who alone remained inviolate.

We have been told repeatedly that the invention of the mechanical clock was a key moment in processes of secularization.[60] But here is a clock that sounds to a different tune—where precise measurement is tied to the public assertion of liturgical time, ringing out from the tower of the Abbey across the surrounding countryside, to the mercantile and university city of Leuven.

So how was it that this particular chant came to be used to mark time in the fifteenth-century Low Countries? *Inviolata* was undeniably popular, witness the success of the five-part setting of Josquin des Prez (c. 1452–1521).[61] Perhaps *Inviolata* also suggested a relationship to the hours through

its twelve-part division, analogous to the twelve hours of the day. Its text was clearly divided into twelve sections, and a twelve-part motet based on the chant was also attributed to Josquin.[62] But *Inviolata* had a polemical edge too: the chant had risen to prominence alongside controversies surrounding the doctrine of the Virgin's Immaculate Conception. From the twelfth to the fifteenth centuries, promoters and detractors of the doctrine engaged in sometimes vitriolic exchanges over whether Mary was conceived without original sin. At the same time Park installed its clock, the Franciscan Pope Sixtus IV (1414–1484) was engaged in a series of actions supporting the Immaculate Conception, including the decrees *Grave nimis* (1482/1483) that asserted that the doctrine could not be condemned.[63] By installing an *Inviolata* clock, the Abbey of Park placed itself firmly within the papal order of liturgical time.

Looking more closely at *Inviolata*'s text, at first sight there is only one direct reference to time: *per saecula* (through the ages). But on reflection, the whole text is shot through with arrangements of time. In its textual unfolding through time, the chant seems not to allow an immediate, abrupt, and potentially impure approach to Mary, herself the inviolate gate of heaven. The opening line offers a string of adjectives, which form both a preparation for the Virgin's name within time and an entry into it (*inviolata, intacta, casta*). The opening address to Mary (lines 1–2) is given further temporal depth through its allusion to the course of salvation history, summoning into a single present the memory of at least three past events—the immaculate conception, Christ's conception, and the virgin birth—which are the enduring proof of Mary's spotlessness. The narratives condensed into, and evoked by, Mary's attributes make this chant full of time.

In the later couplets of the chant, a prayerful desire for forgiveness *per saecula*, evoking the sequence of time, is balanced by Mary's (and God's) eternal and enduring mercy. Crucial to this double function of the prayer, as a sign of time and what exceeds it, are Mary's sweet-sounding imprecations—we might almost say sweet like bells—which mediate between temporal prayer and heavenly mercy. The tripartite address to the Virgin's benignity that concludes the text embodies this stable time of Mary's enduring kindness, while also perhaps evoking other commonly sung tripartite liturgical formulae—the *Salve Regina* with its concluding text *O clemens, O pie, O dulcis*, or the three-part repetitions in the *Agnus Dei* or *Sanctus* in the mass.[64] These kinds of liturgical chants could mark the joining of celestial and earthly choirs, fusing eternity and time.[65]

Many of these features of *Inviolata*'s textual time appear in, shaped, and were expanded by the history of the chant's use. We might say that *Inviolata*'s reception resonates with its text: the chant's time shaped how its history

unfolded. And its evocations of sequence in time, endurance beyond time, repetition and return, make it a striking instance of the way different temporal forms could interact with and become ways of aspiring to eternity.

Inviolata was, of course, normally performed within one particular arrangement of time: the liturgical year. After first appearing in manuscripts in and around Paris from the eleventh century, *Inviolata* became intertwined with the history of the Cathedral of Notre Dame in Paris, where it seems first to have been used for the Feast of the Purification in the fourteenth century.[66] It was sung during the procession into the Cathedral choir at vespers at a statue of the Virgin. The kind of careful protection of the Virgin's inviolability that *Inviolata*'s text performs is mirrored here in the time of the liturgy: as the procession penetrates the womb of the church, the place where Christ's entry into time at the incarnation was represented with each celebration of the mass, Mary's perpetual virginity is once more invoked as protection, and is itself protected against any violation. Here we see how the flow of liturgical time is inseparable from movement through space in liturgical ritual. This link between time and space centers on the careful management of change, drawing attention to beginnings as places of particular importance for the unfolding of time.

Later in the fifteenth century the chant became increasingly popular, with a flurry of endowments in Paris from around the time that Park installed its *Inviolata* clock.[67] These Parisian uses provided models for the Burgundian Low Countries.[68] Liturgy is always political, and *Inviolata*'s history situates the chant closely within the Marian piety fostered by the Dukes of Burgundy. In the mid-fifteenth century, the singing of *Inviolata* was endowed in Bruges at St. Saviour's and the Church of Our Lady. Both churches had strong links to the chivalric Order of the Golden Fleece, founded by Philip the Good.[69] New liturgies for the order stressed Mary's perpetual virginity and included the singing of *Inviolata*.[70] The purity of the social and political body of the nobility, crucial to ducal ideology and the formation of a Burgundian "state," was here asserted, communicated, and embodied in a united praise of Marian incorruption.

Elsewhere in the powerful towns of the Low Countries, *Inviolata* was inserted into liturgy and ceremonial life. Civic and ecclesiastical patrons donated funds for the singing of *Inviolata* in their memory in liturgies in Bruges, Ghent, Antwerp, and Brussels.[71] In Ghent, an *Inviolata* procession was founded in 1464 at the church of St. Nicholas.[72] In Antwerp from around 1398, *Inviolata* was used, possibly with polyphony, in a procession with an image of the Virgin from the Lady Chapel to the choir, during the celebrations of the Feast of the Assumption, and before the town's large

civic procession.⁷³ At Brussels, *Inviolata* was endowed at St. Gudule, St. Nicolas, St. Gery, and Notre-Dame de Sablon, and it was sung during the city's large Marian procession (*Maria mediatrix*).⁷⁴

Inviolata was on the rise, too, at the influential Cathedral of Cambrai—a diocese under Burgundian control through its bishop, John of Burgundy (1404–1479), the illegitimate son of Duke John the Fearless (1371–1419).⁷⁵ By the start of the sixteenth century, *Inviolata* was established in the Cathedral's repertoire by a series of donations. Jean Martini (1446) and Michael de Beringhen (1454–1455) endowed the singing of *Inviolata* at Christmas and the Feast of the Visitation, respectively.⁷⁶ In 1457, Johannes Lambertus founded the singing of the *Inviolata* on the first Sunday of Advent. Johannes's foundation again links Marian chant with time measurement: he founded a procession from the choir to a station consecrated to the Virgin, where *Inviolata* was to be sung in chant on ordinary Sundays or in polyphony on Marian feasts.⁷⁷ The location of the singing was significant: in the nave under the bell tower. Like the musical clock at Park, *Inviolata* at Cambrai was linked to bells that sounded out the church's time.⁷⁸

Bells were often named Mary in medieval Europe.⁷⁹ Cambrai had its Mary bell, and another named Glorieuse, a familiar attribute of Mary. Another bell made for the Cathedral in 1451 was decorated with an Annunciation, and an image of Mary and the infant Christ (figure i.2).⁸⁰

The image of the Virgin enthroned resembles the Cathedral's famous icon, the Notre-Dame de Grâce, donated by the canon Fursy de Bruille in 1450 (figure 3.1).⁸¹ Fursy also donated a bell to the Cathedral in 1450, perhaps this very one.⁸² But regardless of who donated what bell, *Inviolata* was sung at Cambrai beneath specifically Marian bells, allowing a potential symbolic activation of those parts of the text of *Inviolata* relating to the sweet-sounding prayers of Mary—Mary is enthroned in the heaven of the Cathedral's tower; her voice rings out in intercession to her heavenly son, filling the medieval town with the sonorous tolling of her voice, a voice that marks and measures time.

Links between Mary, chant, and time's measurement appear, too, in Cambrai's liturgical books. In one of the Cathedral's new choirbooks produced from the 1440s, liturgical time was carefully bounded by Marian chant through the placement of unique chant sequences at the beginning and end of the manuscript.⁸³ A similar effect was created in the early print antiphoner for the use of Cambrai preserved from the parish church of Avesnes-le-sec.⁸⁴ The antiphoner opens with the Advent hymn *Conditor alme siderum*, accompanied by an image of the tree of Jesse culminating in the Virgin and Child (figure i.3). It closes with the ancient antiphon *Sub*

Fig. I.2. *Bell of Cambrai Cathedral with Annunciation and Virgin Enthroned*, c. 1451. Unnumbered plate, *Mémoires de la société d'émulation de Cambrai*, 1867. Reproduced by kind permission of the Syndics of Cambridge University Library.

tuum presidium confugimus Dei Genitrix (Beneath Your Protection We Fly, O Mother of God) (figure i.4).

As in the choirbook and antiphoner, Mary enfolded beginnings and endings in liturgical practice at Cambrai. After Fursy's donation of the Notre-Dame de Grâce, Cambrai's liturgy was reordered so that each day commenced with prayers for Mary's protection: *Sub tuum presidium* was to be sung every morning after lauds in the Trinity Chapel before the icon and, from 1457, the *Salve* was to be sung after first compline on Saturdays and the vigils of Marian feasts.[85] In this way, Mary became the starting point of the day, according to the two standard reckonings current in the fifteenth century: dawn to dawn for normal days, and sunset to sunset for feast days.[86] The *Salve regina* was notated in the Trinity Chapel of the

Fig. I.3. *Conditor alme siderum*, from an *Antiphoner for the Use of Cambrai* (Paris: Simon Vostre, c. 1508–1518). CMM, CA XVI C 4, 1r. Reproduced by permission of the Médiathèque d'Agglomération de Cambrai.

Fig. I.4. *Sub tuum presidium*, from an *Antiphoner for the Use of Cambrai* (Paris: Simon Vostre, c. 1508–1518). CMM, CA XVI C 4, 248v. Reproduced by permission of the Médiathèque d'Agglomération de Cambrai.

Cathedral in 1498: "because the vicars are frequently discordant when singing the *Salve regina*, one is to be made in large notes and placed against the wall following the example of the *Alma* [*redemptoris mater*] that is before the clock."[87] Here, then, is another conjunction of Mary and time. The Cathedral's famous mechanical clock was housed in the Chapel of another important devotional image of the Virgin, the Notre-Dame de Flamenghe.[88] In this way the Cathedral placed the measurement of time under the watchful gaze of the Virgin. And, as at Park, the clock was associated with a Marian chant, the *Alma redemptoris mater*, a chant sung at Cambrai to conclude each Marian feast.[89] In this Mary-chant-clock conjunction at Cambrai, then, we repeatedly see methods of bringing time under Mary's protection, especially at beginnings and endings, ways of bringing the measurement of time's passing into Mary's enduring embrace.

The most famous account of a medieval clock is likewise bound up with musical and Marian devotions. It appears in the enormously popular *Horologium sapientiae* (The Clock of Wisdom), written in 1344 by the Dominican reformer Henry Suso (c. 1295–1366).[90] The *Horologium* can be found in at least 233 fourteenth- and fifteenth-century Latin manuscripts, excerpted in a further 150, and in nine print editions before 1500.[91] It was translated into Dutch, English, French, Italian, Danish, Old Swedish, Czech, and Hungarian.[92] Copies were owned across the Low Countries, and a version of the French translation was copied for Philip the Good (figure 4.1).[93] The devotional and liturgical conclusion to the *Horologium*, the Hours of Wisdom, was translated into Dutch by Geert Groote, a founding member of the Brethren of the Common Life and a formative figure in the *devotio moderna*. The Hours had a vast circulation in fifteenth-century books of hours.[94]

The *Horologium*'s prologue describes how Suso saw a vision of his text:

> The mercy of the Saviour deigned to reveal this present little book in a vision, when it was shown as a most beautiful clock, decorated with the loveliest roses and a variety of "well sounding cymbals" [psalm 150:5], which produce a sweet and heavenly sound, and summon the hearts of all men up above.[95]

Like Park's *Inviolata* clock, Suso's mystical and textual clock is imagined with sweet-sounding bells (as the French version has it, *les cloches doulcement sonnans*). There are gentle reminders of Mary in Suso's text: Sapientia is a figure who unifies the attributes of the Queen of Heaven with Christ; and the clock, with its surrounding roses, recalls Mary, the *rosa sine spinis* (rose without thorns), *nitens olens velut rosa* (shining, smelling as a rose).[96]

Such links became explicit in an illustration of this scene from a mid-fifteenth-century manuscript made for a prominent French noble family (figure i.5).[97]

In the image Suso is seated, contemplating the standing Lady Sapientia in a room full of all kinds of time-measurement devices: a large mechanical clock; an astrolabe; a clock with bells; a portable sundial; a sundial with compass; a table clock; a hanging shepherd's calendar; and a Profatius quadrant.[98] On the musical clock at Sapientia's left appears a short text: *ante secula qui deus et tempora homo factus est in Maria* (God, who was before ages and times, was made man in Mary). Modern scholars have failed to notice that this text comes from the liturgical sequence for Epiphany, *Epiphaniam Domino*. This chant was well known across fifteenth-century Europe, as witnessed by a polyphonic setting by Guillaume Du Fay, probably written in the 1430s.[99] Here, then, is another musical reflection on time, linked to liturgical chant, foregrounding Mary's role in the incarnation as the place where eternity enters time.

The construction of Mary's body as the throne of eternity, or, in the more familiar formulation, the *sedes sapientiae* (throne of wisdom), was familiar in the fifteenth century, and was central to the symbolic grammar of the towns of the Low Countries. Leuven, for example, placed itself under the protection of Mary through a great civic and ecclesiastical procession around the Feast of the Nativity of the Virgin (September 8).[100] The procession culminated with a statue of Mary, the *sedes sapientiae*, a cultic image from Leuven's principal church of St. Peter's, surrounded by clerics, university members, confraternities, and town councillors. In 1477, another layer was added to this September Marian celebration. A new liturgical feast, the *Recollectio festorum beate Marie virginis*, was added to St. Peter's liturgical calendar. The feast had been invented at Cambrai in 1457.[101] The *Recollectio* summed up the six standard Marian feasts to make a seventh, enfolding Mary's life in a unified liturgical embrace. This completion of a cycle of seven feasts mirrors the emphasis on seven in other forms of Marian piety. The date of its institution was particularly impressive: the seventh day of the seventh month (September), 1477.[102] In this rush of Marian sevens, we see a change at the heart of Leuven's civic and ecclesiastical time—a precise and symbolic Marianization of time. The institution of the *Recollectio* on September 7 ends the old civic year, and the town's new academic year begins with the celebration of Mary's nativity. Mary enfolds time in her protective embrace—and the town, gathered around her image in procession, enfolds Mary into the heart of their civic time.

Fig. I.5. *Vision of Lady Wisdom*, from Heinrich de Suso, *Horologium sapientiae*, c. 1450. KBR ms IV 111, 13v. Reproduced by permission of the KBR, Brussels.

Returning to listen to the bells of Park, they now seem more resonant with broader practices of making Marian time in the fifteenth-century Low Countries. These Marian temporalities involve the filling out of time with sacred narrative, the entry of eternity into time at the incarnation. They evoke a creative plenitude of time in political and social life, and cultural production; and they show why any historical account of temporality requires transdisciplinary attempts to hear and see the ways time can be imagined, experienced, and perceived. Mary's body, pregnant with time and eternity, enfolding communities in her protective embrace, there at the beginning and the end of things—in sound, in images, architecture, liturgy, music, texts, burial practices, civic processions—makes Marian time emblematic of *The Fullness of Time*.

Civic time in one fifteenth-century town, the university city of Leuven, is the starting place for this book. In Chapter One, I turn to Leuven as a case study of the polyphony of time in fifteenth-century towns of the Low Countries. I consider how time was understood over the course of the fifteenth century in relation to the town's new university, its social and economic life, and its religious institutions and practices. This outline lays the foundation for more particular studies in later chapters.

The following three chapters form a triptych devoted to the transdisciplinary history of time in three towns: Leuven, Cambrai, and Ghent. Together, they uncover common and divergent conceptions and deployments of time in towns with very different histories, institutions, and social and political structures. Chapter Two examines a collection of texts and images from Leuven's new university and St. Peter's church, connecting Dieric Bouts's altarpiece of the Holy Sacrament and its liturgical setting with contemporary debates over Aristotelian explanations of future contingency. This comparison illuminates a dominant conception of time in the fifteenth-century Low Countries: a contrast between limited human discursive time and God's intuitive glance from eternity. Chapter Three continues this focus on liturgy by interpreting a conflict over music in the liturgy at Cambrai Cathedral. The chapter revises detemporalized theories of listening in musicology, and contributes to the history of emotions by showing the importance of emotional narratives—those arcs of emotional change that unfolded within the office, mass, liturgical seasons, and year. Chapter Four turns to the use of time during Philip the Good's 1458 entry into the rebellious city of Ghent. Ghent's political relationship with the Duke of Burgundy in the 1450s was dramatized in Philip's entry into the conquered town, where liturgical organizations of time like those found in Leuven

and Cambrai spilled out onto the streets. Philip's role as Christlike lord of time was played out not just in fusing biblical and classical pasts with the fifteenth-century present, but also in histories written within the town and court.

Having established liturgical time's complex influences on social life, the final chapters investigate relationships between time, liturgy, and devotion as the advent of print and religious reform movements transformed northern Europe. Chapter Five examines debates over calendar reform at the University of Leuven. Focusing on the work of the professor of theology Peter de Rivo, I ask how one individual constructed a unique view of time, and how this may have been received within one flourishing religious community, the Priory of Bethleem at Herent. De Rivo's work and its reception are best understood alongside the construction of a reformed "liturgical self," a master and measurer of time. Chapter Six turns to the implications of the first horizontal timeline, the remarkably popular and visually innovative *Fasciculus temporum* (The Bundle of Times), for a history of reading and time. Identifying a push toward seeing time as the medium of devotion, combined with a particularly historicizing attitude to the past, these chapters revise theories that see the fifteenth century as the birth of secularizing modernity. What emerge instead are rich cultures of temporal devotion where precise measurement of time continually feeds into pious uses of images, devotional hearing and reading, and rich arrangements of time in liturgical practice. In each chapter, I hope not to exhaust time's fullness, but rather to signal a plenitude of possible interpretations of time.

CHAPTER ONE

The Polyphony of Civic Time in Fifteenth-Century Leuven

Leuven, the university city on the river Dijle, entered the territories controlled by the Dukes of Burgundy in 1430 on the death of the Duke of Brabant Philip I (1404–1430).[1] Brabant's principal ducal residence had moved from Leuven to Brussels in the thirteenth century. Despite this fall in political significance, Leuven prospered in the later thirteenth century, its new wealth generated by an expanding cloth industry famed for its quality linen.[2] Its position on trade routes connecting the prosperous merchant cities of Flanders with the Rhine, and on pilgrimage routes from Germany and the northern Netherlands to Spain, meant that Leuven was well situated for trade throughout Europe.[3] Following the waning of its cloth production, in the early fifteenth century Leuven waged a successful campaign to found a university.[4] Founded in 1425–1426 by Pope Martin V (1368–1431) and John IV, Duke of Brabant (1403–1427), the university revitalized the town's economic life and its political importance.[5] The foundation of new canonries in the city's churches to support academics, together with the arrival of beneficed academics, and the gradually increasing influx of foreign students, transformed the city's social and economic fabric.[6]

This chapter interweaves analyses of systems of time measurement with examinations of social practices that ordered and shaped the perception of time in fifteenth-century Leuven. Several common motifs emerge. First, languages of the old and new, well established in medieval European cultures, were deployed to frame the dramatic transformations in the town's physical and intellectual life in the fifteenth century. Second, Leuven's transformation into this new fifteenth-century city involved a variety of symbolic arrangements of time in its devotional life. Third, as in all periods of history, the intersections of the natural rhythms of the year, its seasons, days, and nights, with organizations of labor, devotion, and leisure, led to a multiplicity

of intersecting temporalities. Giving local form to broader European structures of time, Leuven's civic and ecclesiastical institutions addressed and formed these intersections in different ways, for example in liturgical calendars and rituals, through bell-ringing, and by regulating movement on the city's streets. Finally, I attempt to fuse measurements and organizations of time in the city with the actions and lives of some of Leuven's historical agents, to show some of the many ways in which time in Leuven was used and experienced by individuals as well as by particular groups.

THE OLD AND THE NEW

Alongside the new university, Leuven's built environment was transformed in the fifteenth century.[7] At the heart of this renewal was the ambitious rebuilding of the old Romanesque church of St. Peter, the largest and most important of the city's churches, in the late Gothic style. Founded in the eleventh century, St. Peter's was originally the court church and burial place of the Landgraves of Brabant.[8] Building continued throughout the fifteenth century, as the impressive new church became increasingly linked to the fledgling university. Yet as the old church gave way to the new, the Romanesque tower continued to stand as a sign of the church's continuity.[9] Beyond St. Peter's, a new and impressive chapel was built for the Knights Hospitaller in 1454.[10] A new Gothic transept was added to the collegiate church of St. James, and a tracery tower designed by Jan van Ruysbroeck was added to the Abbey church of St. Gertrude in the early 1450s (figure 1.1).[11] South of the city center, building continued on the church of St. John the Baptist in the Great Beguinage *Ten Hove* from 1421 to 1468.[12] The parish church of St. Quentin was rebuilt in the 1400s, with work continuing throughout the century.[13] Later in the century, a new Carthusian house was founded, funded by wealthy merchants, their wives, university members, and the families of the first monks.[14]

Renewal was evident, too, in the city's civic buildings. New administrative buildings were erected in the town's center, the most striking of which was the imposing Stadhuis, commenced around 1439.[15] Work on the Voorste huis, the ornate late Gothic wing that faces St. Peter's, was completed from 1448 to 1469 by the master stonemason Matheuw de Layens.[16] De Layens, who worked on St. Quentin's, St. James's, and St. Peter's, also undertook changes to the fourteenth-century Lakenhal, the former clothmaker's hall, which housed the university in its earliest years.[17]

The new Leuven emerged from the old over the course of the fifteenth century alongside a flurry of cultural production and intellectual dispute

Fig. 1.1. *Tower of St. Gertrude's Abbey*, Leuven, c. 1453. Photo: author.

over questions of time, particularly the relationship between the old and the new. New statues on the facade of the new Stadhuis, overlooking the Grote Markt, showed the harmony of the Old and New Law, emphasizing the role of cross-temporal, divinely sanctioned justice in civic life.[18] Inside the Stadhuis, the pictorial program commissioned from the famous Leuven painter Dieric Bouts embodied the subjection of the historical time of the old to the future judgment when Christ would make all things new.[19] Across the square, inside St. Peter's, in the chapel of the newly formed Confraternity of the Holy Sacrament, Bouts's altarpiece of the Holy Sacrament (plate 1) showed correspondences between Old Testament narratives and the institution of the new covenant at the Last Supper. The programs of the Stadhuis and the Bouts paintings were developed in consultation with

university theologians. Efforts like these were not simply cases of "typology [being] in scholarly fashion."[20] The iconographic programs gave historical authority to the new relationships between education and civic identity in the founding of Leuven's university. The structural divisions between the old and new embedded within the heart of medieval Christianity supported the political foundation of a new Leuven, grounded in the authoritative teaching of divine law.

The grounding of the new in the old required careful management of continuity and change. Jan Varenacker (d. 1475), professor of theology at the university, and one of two theologians who advised on Bouts's altarpiece, engaged with these issues in a quodlibetal question on natural, divine, and human law at the university in 1456.[21] Varenacker stressed the preservation of the immutable sovereignty of divine and natural law, while also accepting that human behavior and law requires modification depending on variations of time and place.[22] Drawing on a well-established legal hermeneutic, Varenacker's quodlibetal question thus carved out an intellectual space where the borders of change and stability, mutability and eternity, old and new, could be maintained. This attention to the management of time arises repeatedly in the work of the Leuven theologians active in the mid-fifteenth century. It perhaps shaped, and was shaped by, their specific interests in the epistles of the New Testament with their detailed elaborations of languages of the old and new.[23]

Harmonizing the old and new had particular practical importance for the clergy of St. Peter's. In 1443, as part of the new university, Eugenius IV instituted a second chapter of ten canons, in addition to the existing chapter of fifteen.[24] The new chapter comprised two professors each in theology, canon law, civil law, and medicine, and one professor each in Christian doctrine and logic.[25] In order to protect their ancient rights against this new chapter, the existing canons drafted a *Concordia inter novos et antiquos canonicos* (A Concordat between the New and Old Canons). Here, as in Varenacker's quodlibet, the new was something to be regulated with care. But unlike in the quodlibet, the *antiqui* outrank the *novi*. Acknowledging their roles in the university, the *Concordia* stipulates that members of the new chapter do not have to be in the choir except for feasts of triplex rank, when they must attend matins, mass, and vespers. In exchange for this dispensation, they had to pay 70 Rhenish florins a year to remunerate other singers. The new canons were not eligible to elect or be elected as the church's Dean. The Dean had responsibility for both chapters, mirroring the symbolic role of Christ in uniting the old and new law. So that the Dean could exercise

this oversight, the two chapters were not allowed to meet concurrently. The *Concordia* thus laid out a careful framework within which the time of the new did not overrun the time of the old.[26]

THE WHEEL OF TIME: GUILDS, LABOR, ECONOMY, AND THE SEASONS

Leuven's time was intricately connected with the life of its guilds, which, as in other medieval towns, exerted powerful influences over the rhythms of life.[27] Figures for the number of guild masters across Leuven in the fifteenth century show the large numbers of workers associated with cloth production and weaving in the city, as well as the importance of the blacksmiths', bakers', and metalworkers' guilds.[28] Guilds shaped the rhythms of time for individuals and their families involved in various trades: the length of workdays; the rhythms of markets; the educational cursus; the time before an apprentice or journeyman became a guild master.[29] Questions of membership had consequences for other social measures of time, like the age of marriage. Guild time intersected with liturgical time through statutes for the mandatory attendance of guild members at the feasts of the guild's patron saints.[30] For example, the fifteenth-century statutes from the blacksmiths' guild include a requirement to attend mass on St. Eligius's Day.[31] Guild members participated, too, in cycles of ritual time, playing a central role in the town's most important processions.[32]

Each profession had its own structures of time. A blacksmith, a member of the largest of Leuven's guilds in 1477, in the morning would light the forge fire; the time taken for the fire to reach the correct temperature before work could begin had to be calculated and managed.[33] How long did iron take to heat until it could be worked? How long could a piece of red-hot metal be worked until it grew dull and was no longer malleable? These measurements of "task-oriented" time were worked into bodily memory in the repeated patterns of work over time, and associated with particular places, objects, sounds, sights, and smells—indeed, the whole panoply of bodily habits.[34] These rhythms of work were matched by rhythms in custom linked to the time of day, calendar year, and seasons. During the day, rhythms of work and rest followed the patterns of eating and trade. At the end of the day, work had to be finished, the fire put out for the safety of the city, the forge secured.[35] Kinds of work shifted with the changing of the seasons and the cycles of the towns' markets. From the knowledge of the temporal rhythms of the smallest of tasks to predicting fluctuations in custom over the year, blacksmiths not only worked with metal, they worked with time.

A sense of the normal expectations of seasonal shifts in work hours and rest times can be gained from an outline of work times for laborers in Brussels in the early sixteenth century, the *Coustumes ordinaires d'aller en l'ouvraige, tant en yver que en estés, desquelles l'on uze à Bruxelles et ens aultres villes de Brabant*.[36] Each workday was supposed to include a standard break for eating between 11 a.m. and 12:30 p.m. At the height of winter, in the days following Epiphany, work was scheduled to commence at 7 a.m. and finish at 5 p.m.; following February 1, work lasted from 6:30 a.m. to 5:30 p.m.; following February 22, it extended from 6 a.m. to 6 p.m.; from March 18, from 5:30 a.m. to 6:30 p.m.; from April 10, from 5 a.m. to 7 p.m., with an additional pause of half an hour permitted before and after the midday pause; from May 1 to September 1, work could commence at 4:30 a.m. and finish at 7 p.m., with two hours' additional rest, one in the morning and one in the afternoon. From September, the length of the workday decreased: from September 1 to 21, from 5 a.m. to 7 p.m.; after September 21 to October 13, from 5:30 a.m. to 6:30 p.m.; after October 13, from 6 a.m. to 5:30 p.m.; then after October 29, from 7 a.m. to 5 p.m.; and finally from St. Martin's Day (November 11) to Epiphany, from 7:30 a.m. to 5 p.m. On fast days, the length of time for eating and rest from work was extended to two hours. The lengthening of the days was thus balanced in part by the addition of further periods of rest, and the longest period of stable time in the year was the lengthy spring and summer period between May 1 and September 1. We can see too how work time involved precise timetables, structured periods for food and rest, and distinctions grounded in sacred time.

The large number of guild masters for the weavers', fullers', and carpet- and linen-weavers' guilds alerts us to the continued importance of rhythms of cloth production in shaping the city's time, despite the decline of the industry.[37] Each piece of cloth had its own time, from the seasonal rhythms of agricultural production to the time of the market, and as it worked its way through myriad production processes, each with its own duration and rhythm, including wool preparation, combing or carding, spinning, weaving, fulling, tentering, napping, shearing, pressing, and dyeing.[38] After the cloth was finished, its transport and sale was organized in relation to the calendars of Leuven's markets and other trade fairs across Europe. The tasks of the cloth industry intersected with other temporal regimes in the city. Work was controlled by bells signaling the beginning and end of the workday, which for weavers could be extended in winter from 6 a.m. to 8 p.m. with artificial lighting.[39] In an important recent article, Peter Stabel has shown that across the region normal bans on work at night could also be flexible, allowing for the completion of time-sensitive tasks, or to finish work on time for

particular masters and merchants.⁴⁰ Throughout the urban networks of the Low Countries, labor markets developed where journeymen could be hired for specific lengths of time, and paid according to daily or timed wages.⁴¹ Work time intersected with liturgical time too. Stabel traces regulations from a variety of towns in the Low Countries where work was scheduled to cease at noon before Sundays and a limited number of feast days, though, again, exceptions could be made.⁴²

Task-oriented time was also marked by variation on the basis of the stage in the production process and the type and quality of product. For example, John Munro has shown that guild codes for the production of Leuven's woolens involved different times devoted to the process of napping and shearing: in one example, for "*Vier Bellen*, made from domestic wools" there were to be "fourteen nappings over 14 hours"; for "*Laken van Vijf Loyen*" made from "good" foreign wool, "eighteen nappings over 18 hours"; and for "*Raemlaken van Vijf Looden*," made from "'fine' English wools," "fifteen nappings over 22½ hours."⁴³ The fulling process, designed to shrink and bind the cloth before finishing, lasted longer for luxury woolens than for cheaper cloth: for standard sizes, Munro allows "two full-time journeymen and the supervision of a master fuller for three to five days, depending on the cloth type and the season."⁴⁴ Seasonal rhythms also affected the process of stretching the cloth on tenterhooks.⁴⁵ The time it took to undertake particular processes could also have particular implications for wages, where wages were paid not by a measure of time worked, but by piece.⁴⁶ Beyond the variations of wages, products, and seasons, the level of social control over work time differed according to different stages in the production process. Guilds increasingly asserted power over work timetables for some parts of the process, particularly weaving. Other processes, like the preparation of wool, often undertaken by women, remained without strict regulation.⁴⁷ For women like Leuven's beguines, devout women who arranged their time between work and prayer, time spent in cloth production slotted around the liturgical hours and the celebration of mass.⁴⁸ We see here how different groups of cloth workers, and different social groups more generally, could inhabit diverse, changing, and intersecting structures of time sanctioned by different authorities and formed by different practices.

The contingencies of life in fifteenth-century towns—war, plague, famine, flood, all of which troubled Leuven in the course of the fifteenth century—made projections about the future economy uncertain.⁴⁹ Nevertheless, Leuven's financial and economic life was intimately bound up with expectations about the passing of time. There were strict rules against charging interest on

loans, in part a result of the view that charging interest was the equivalent of charging for something that could not be owned, but was rather common to all creatures: time.[50] But this did not stop short-term loans, subtle ways of paying interest, or systems of providing capital based on expectations of future profit.[51] Chief among these were the system of buying and selling rents.[52] For a lump sum, a purchaser could, for example, buy a rent for the term of a life, or longer. The capital was thus immediately available to the seller, who then paid back an annuity to the rent-holder. Expectations about the normal length of a life informed decisions about buying and selling rents, but they also provided a way of dealing with risk for rent-holders, who gained a guaranteed income that was no longer subject (at least in theory) to the contingencies of time, the fluctuation of economic fortunes year by year and season by season. These kinds of longer-term projections of the future were balanced by shorter-term possibilities of gain through systems of fund-raising like lotteries, first recorded in Leuven in 1445.[53]

As was usual in the period, Leuven's economic life was also strongly shaped by the calendars of local markets and regional trade fairs, for example in Antwerp and Frankfurt.[54] The ordinances of Leuven's fishmarket survive for the fifteenth century and show the ways in which the regulation of the market involved the regulation of time.[55] Over time, of course, fish become inedible. In order to regulate "fish time," the ordinances of the Leuven fishmarket required that three-day-old catch be sold with a white flag. Four-day-old fish had to be sold under a black flag. Any seller caught mixing the two would be fined.[56] The time of the fishmarket intersected with liturgical time and the requirements of fasting.[57] For example, the thirty-third ordinance states that casting of lots for stall location during the fasting seasons of Advent and Lent must occur once a week, when at other times of the year it occurred fortnightly.[58] Times of fast meant increased demand for fish, and increased importance of stall location. The length of the natural day shaped the time for payment from sellers to the market authorities: payments were to be made on market days by sundown.[59] Further measures of time within the ordinances show how social actions spilled over into ways of recording time: fasts were called *Veschdaghe* (fishdays), and on these days, outsiders were allowed to enter the city to sell fish.[60]

The conclusion of the fishmarket ordinances records that they were written in 1453 on the seventeenth day of *Hoymaent*, the Brabantine name for July.[61] Vernacular names of the months show how human activities intersected with the seasons in time's measurement. This kind of nomenclature across Europe marked local seasonal distinctions and similarities in the

social order of time. In the Low Countries, *Hoymaent* was the time when the hay was cut. June was *Wedemaent*, probably relating to the pasturing of animals. Climate played an important role in naming winter months. December was *Hormaent*, an icy time; January was *Laumaent*, a name possibly derived from the biting cold. The slaughter of animals in the lead-up to winter gave November the name *Smeermaent*. February was *Sporkelmaent*, perhaps linked to the ancient Germanic sacrifice of pigs known as the *spurcalia*, or more mundanely, to the sparks of the fire.

These connections between action, weather, and the reckoning of time were collated for a *kalenderwijzerplaat* (calendar dial) made in the southern Low Countries at the end of the fifteenth century (figure 1.2).[62] The dial is a segmented circle that constructs correspondences between the zodiac, the months of the year, the hours of the day and night, the number of days in each month, scenes of the activities and professions influenced by particular planets, and key liturgical dates. Holes in the panel indicate that it was probably attached to a clock mechanism and possibly to a mechanical indicator of the phases of the moon. The kinds of work shown on the dial mirror the stylized depictions of the months in books of hours.[63] January shows a feast; February, a family by the fire making waffles with two jousting knights in the background; March depicts pruning; April is gardening; May is given over to love; June, to sheep shearing; July and August show scything and cutting hay; September, the sowing of the winter crop; October is wine-pressing; November depicts the slaughter of animals; and December, bringing coal for a fire and baking bread. From this list of imagined seasonal activities, we can see how representations and experiences of the year could be shaped by changes between indoor and outdoor activities, food production and consumption, and how leisure and work varied with the seasons.[64] We can also see how the perception of time was shaped by the annually changing colors of the landscape: the greens of spring and summer cluster together, followed by the golden hay of August. The winter months are characterized by a duller palette of grays and browns.

The *kalenderwijzerplaat*'s emphasis on the zodiac and planetary influence reveals an interest in astrology, which was manifested in Leuven's fifteenth-century intellectual and print culture by the repeated printing of almanacs and prognostications. These prognostications were based on the ability to predict and measure celestial time, and to apply this predictability to the unstable time of human action. For example, astronomical almanacs were prepared by the Leuven physician Joannes Vesalius for the town on at least three occasions: 1430, 1439, and 1440.[65] At least three editions

Fig. 1.2. *Calendar Dial*, c. 1500, southern Low Countries, oil on wood. M-Museum, Leuven. Reproduced by permission of M-Museum Leuven. Copyright www.lukasweb.be, Art in Flanders Vzw. Photo: Dominique Provost.

of influential *Prognostica* by the onetime Leuven professor and physician to the Duke of Urbino Paul of Middelburg (1446–1534) were published in Leuven in the last decades of the fifteenth century.[66] This astrological interest intersected with the time of action in the calendar dial through the association of particular activities with particular planetary influences. For example, at the top of the dial, a scene probably linked to Mercury shows the manufacture of a mechanical clock (figure 1.3).[67]

Fig. 1.3. *Children of Mercury*, detail from *Calendar Dial*, c. 1500, southern Low Countries, oil on wood. M-Museum, Leuven. Reproduced by permission of M-Museum Leuven. Copyright www.lukasweb.be, Art in Flanders Vzw. Photo: Dominique Provost.

This association between clock-makers and the ancient god of astronomy and astrology is a neat emblem for the intersections between the various organizations of time on the *kalenderwijzerplaat*.

Astrological measurements of time also appear in records of medical practice. A printed almanac composed for 1484 by the Leuven professor Joannes Spierinck (c. 1420–1499) exemplifies the intricate relationships between the time of heavenly bodies and the time of the human body.[68] The almanac, designed to be printed swiftly and inexpensively on a single sheet of paper, records precise times for each month's lunar conjunctions and oppositions, arranged alongside a table of dates for carrying out and avoiding bloodletting. Medical measurement of time also appeared in a controversy between Paul of Middelburg and the Leuven professor of theology Peter de Rivo over the length of time Christ had spent in the tomb, discussed further in Chapter Five. Against Paul's claim that Christ had remained in the tomb

for three whole days, de Rivo mounted an argument that used medical measurement of time against the renowned physician. If someone suffering a fever is struck down on a Sunday, and the fever recurs after an intervening day on Tuesday, the fever is called a tertian fever, and the doctor knows to predict that the patient will be afflicted again on the third day following—a Thursday.[69] The same situation exists if a doctor says that someone should be bled on the third day. This common-sense authority shows that Christ's three days in the tomb followed the inclusive method of counting time, a method that Peter defends using the Roman method of dating using kalends, nones, and ides.[70] The ease with which de Rivo used medical time to make his case for interpreting the length of three days suggests how ingrained expectations of medical time measurement were for his audience.

As the seasons revolved, the economic rhythms of the city's life shifted with the lengthening and shortening of the days. According to one calculation, workers in Leuven in 1440 earned on average seven *plekken* per day in summer, and five *plekken* per day in winter.[71] This change in earning power meant that the monetary year for the average worker moved with the natural rhythms of the seasons. Summer was a time of greater buying power, and of saving for the leaner, colder, shorter days of winter. Seasonal and yearly variations were also marked in the records of Leuven's chief charitable institution, the *Tafel van de Grote Heilige Geest* (The Table of the Great Holy Ghost).[72] In June 1460, the *Tafel* distributed only 390 loaves of bread; in March 1461 it gave 758 loaves. Although yearly variation may have been in play, these figures suggest a situation in Leuven parallel to that seen across Europe in the period: as reserves from the previous harvest diminished, the end of winter and the start of spring saw increased pressure on charitable food supply.

Variations in the seasons likewise influenced the organization of ecclesiastical time. In a *concordia* drawn up in 1454 for the transfer of the Eyncourt chapter to St. James's, Leuven, a distinction is drawn between winter and other times when specifying the hour of the Sunday sermon.[73] Here, wintertime begins with the Feast of St. Remigius (October 1), and as a concession to the darkness, the sermon should be completed around the eighth hour. At all other times, it should be completed by half past seven. These divisions of the church's life into seasons were marked in the temporal organization of liturgical books like breviaries, which were divided into summer and winter volumes.[74] Nowhere were the changes between light and darkness mapped more powerfully than in the symbolic alignment of the increase of the daylight hours with the celebration of Easter following the

spring equinox, and the movement into the great cycle of feasts following Easter.[75]

SOUNDING TIME: LEUVEN'S BELLS

Across Europe, civic and ecclesiastical time was measured and proclaimed by the ringing of bells.[76] They marked, above all, the regular passage of time by signaling church and work hours. One of the earliest known records of bells measuring work time in Leuven comes from a copy of a capitulary act of St. Peter's in 1327.[77] It records the bell of the weavers (*campana textorum*, or *Weversklok*), used by the weavers' guild to regulate work hours. The emergence of this way of measuring time matches the chronology proposed by Jacques Le Goff, who traced the emergence of work clocks associated with urban guilds in the thirteenth and fourteenth centuries.[78] As the towns of the Low Countries expanded and became more powerful, urban government was symbolized by the building of elaborate town halls incorporating imposing belfries, symbols of civic authority over work and time forming part of the mechanism for maintaining the town's economic and social order. Leuven did not, however, follow this custom: the town's bells for measuring work hours continued to be housed in St. Peter's and were maintained by the town.[79] There is a complicated local history to this variation. An impressive town hall and belfry complex was built in the fifteenth century for Brussels, Leuven's neighbor and rival.[80] Perhaps in competition, Leuven also planned to include a bell tower as part of its elaborate new Stadhuis.[81] The tower was never built, as the marshy land on which the Stadhuis was situated would not support the weight of an elaborate belfry.[82] Faced with this reality, the town's bells had to stay in St. Peter's.

But to offer a simple division between church time and work time risks losing sight of the enormous variety of bells that formed the soundscape and the timescape of fifteenth-century Leuven.[83] The 1327 record cited above mentions another role of bells in marking time: the *stormclocke* (storm bell).[84] This bell marked the onset of a dangerous time for the city, and was almost certainly believed to offer protection. As one fifteenth-century bell inscription put it: *vivos voco, mortuos plango, fulgura frango* (I call the living, I mourn the dead, I break lightning). Lightning was particularly dangerous in fifteenth-century towns, with their flammable wooden housing. The first two clauses of the inscription offer further insights into the role of the bell in shaping time in fifteenth-century Leuven. The first, *vivos voco*, signals the bell's call of the living to worship. At St. Peter's, this role was performed by the *bedeklok*, which tolled to mark the ecclesiastical hours and

to signal the celebration of the mass.⁸⁵ The second clause, *mortuos plango*, draws attention to the bell's role in recording death. This function is harder to trace in the sources for Leuven, but probably followed the pattern of use elsewhere in Europe where the length of the tolling depended on the status and gender of the person who had died.

The passing bell was just one way that bells marked out the temporal *cursus* of a human life. Bells also rang to mark baptism and marriage, showing how what might be termed social, biological, and sacramental times were fused in the daily life of the city.⁸⁶ Bells themselves were incorporated into sacramental life in baptismal rituals.⁸⁷ Bells might ring to signal times of particularly significant events in the passing of historical time, for example the bell-ringing decreed by Pope Calixtus III in 1456 to mark a midday time of prayer for protection of Christendom against the Turks.⁸⁸ Bell-ringing like this, which constructed a pan-European time consciousness, had a counterpart in Leuven in the use of bells to gather the local community. The earliest record of a bell with this function at Leuven comes from 1233.⁸⁹ The physical calling together of the community by such bells was mirrored by bells that called together a devotional community for prayers to the Virgin, which had gradually come to be said in the morning, evening, and, by the fifteenth century, midday; a midday bell, or *noenclocke*, was owned by Leuven's St. James's church.⁹⁰ And then there were the bells that signaled the closing of the city gates at the end of the day and the coming of night, the *poortklok* (gate bell), or, in one record from 1342, the *slaepcloke* (sleep bell), which announced the time for returning home, for public houses to close, for fires to be controlled to reduce the risk of a blaze damaging the city, and finally for sleep.⁹¹ Payments for the sounding of these bells made to watchmen and bell-ringers appear in the town records for the towers of St. Michael's and St. James's.⁹² From these payments we can tell that along with the bells at St. Peter's, these bells played a role in regulating the city's work times, as well as signaling day and night.⁹³

Night was a time of danger, when the boundaries of the city needed to be controlled and protected against attack.⁹⁴ The *poortklok* marked the beginning of the night watch—the time when the city guarded against enemies and movement within the town was curtailed, with exceptions for priests, surgeons, and midwives.⁹⁵ At the city's gates, lanterns were lit.⁹⁶ Anxieties over the protection of property within the city at night appear in payments in 1476 to the Company of the Rose, Leuven's chamber of rhetoric, a form of dramatic society rising to prominence in the period. The company had received funds from the town for set-building, materials, and painting, as part of the celebration of Leuven's major civic procession. The risk of damage to

the sets meant that the town paid two members to guard them at night.[97] Fears of nocturnal attacks were not unfounded: in 1451, Joris van de Putte, a priest from Roosbeek, was attacked in his rooms in Leuven, and escaped onto his roof to call for help.[98]

The bells that rang out across fifteenth-century Leuven were often produced outside Leuven, particularly in the great bell foundries of Mechelen. Yet despite Mechelen's power, Leuven continued to produce its own bells.[99] A bell-founder (*fusor campanarum*) named Albert is recorded in fourteenth-century Leuven, perhaps supplying bells to Liège's Cathedral clock and Ghent's famous belfry.[100] By the sixteenth century, the famous Leuven founder Peter vanden Ghein was producing bells and carillons for markets across Europe.[101] Bell-founding was part of the constant exchange that marked fifteenth-century towns. Bells were poured in Leuven by founders from Mechelen and 's-Hertogenbosch.[102] Clockmakers and bell-founders from Leuven were involved in producing bells and clocks for the Premonstratensian Abbey of Averbode in the 1470s and again when the Abbey was destroyed by fire in 1499.[103] For these tradesmen and their families, the measurement of time was literally their livelihood.

Leuven's bells also tell the story of the old and new city, this time surrounding an unexpected event that prompted Leuven's investment in a new set of bells. In the late fourteenth century, the city's rulers decided to build a clock for the city.[104] This clock was housed in a new tower in St. Peter's. Records survive for payments to a bell-founder named Daniel and to Jan van Lokeren for sculpting a figure who struck the hours.[105] This clock included a new *voorslag*, smaller bells that sounded before the hour bell.[106] These "prelude" bells were a specialty of the Low Countries: in the late fifteenth-century Almanus manuscript, a set of technical diagrams and descriptions of clock designs made by a German clockmaker in Rome, the only clock with a *voorslag* (given the name *melodia* in the manuscript) is a clock of Flemish design.[107] In 1458, fire damaged Leuven's old clock. The fire's destruction brought opportunities for regeneration and change. In 1459, the city's official clock master, Jan vanden Velkener, was contracted to build a new clock, and a local sculptor, Joes Beyaert, was called in to make a new figure, *Meester Janne*, for striking the hours. This clock was a combined Leuven production, and gave a new aural and visual shape to the city's measurement of time.

The inscriptions on the new bells poured for St. Peter's show how the city's bells were central to civic identity. The largest bell was named Maria, and had the following inscription:

I am called Mary. Masters Simon Magret and his son Dominic made me in the year of our Lord 1458, when Nicolas Kersmaker and Quentin Cokeroel were mayors.[108]

The bell was placed firmly within the civic time of the town, by dating according to the terms of burghermasters. The inscription does not, however, allow a strict separation between civic and ecclesiastical time: it memorializes the city's leaders and links their names to the salvific voice of the bell. Civic time and the time of St. Peter's are here connected with systems of memory, the bell as instrument of power, and the sacred name of the bell itself.

ARCHITECTURES OF ECCLESIASTICAL TIME

Ecclesiastical understandings of time in fifteenth-century Leuven, as in the rest of Europe, included complex and varying methods of organizing the hours, day, week, liturgical season, and year. The measurement of time by the canonical hours of vespers, compline, lauds, matins, prime, terce, sext, and none continued in Leuven alongside the dominant system of two cycles of twelve equal hours per day. In earlier medieval systems the twelve hours of the day lengthened and shortened in proportion to the length of daylight: an hour in summer was much longer than in winter. But in the fifteenth century, mechanical clocks like St. Peter's, Park's, or the clock present by 1468 in the tower of St. James's meant regular hours, no longer shifting with the seasons.[109]

These regular hours mingled with liturgical action to shape the measurement of ecclesiastical time. In the St. James–St. Peter's Eeyncourt *concordia*, the measured hours intersect with liturgical action to regulate the practice of masses on the solemn feasts of St. James's Church: on the Feasts of St. James the Apostle, the Assumption of the Virgin, the Circumcision, and Epiphany, the *concordia* states that no one can celebrate mass in the church between the eighth and ninth hours, unless the offertory has been completed by the curate from the first mass.[110] The order of the liturgy on these highest of feast days is thus hedged around with prohibitions: no clergyman who is not a member of the chapter or holds a benefice in the church may celebrate mass without permission. This regulation of activities based on the rhythms of the liturgical year keeps the altars of the Church of St. James free for its own clergy to celebrate mass on the highest feasts of the year.

Ecclesiastical measures of the day's length, like the hours, likewise had

a complex history. In the course of his work against Paul of Middelburg, Peter de Rivo undertook a historical examination of the day's measurement, which once more involved the negotiation of the old and new. De Rivo identifies a panoply of possible measurements of the day: the Egyptians measured from nightfall to nightfall; the Chaldeans and Persians from dawn to dawn; the Romans from midnight to midnight; and the Athenians and astronomers from midday to midday (figure 1.4).

How, then, was time measured under the old law? The ancient Jewish days of the week began at dawn and continued to the next morning. Festival days, by contrast, began at sunset and continued to the following evening. De Rivo thus distinguished two kinds of ancient Jewish day, one from sunrise to sunrise, one from sunset to sunset. Why did the Hebrew measurement from morning to morning not apply to its feasts? De Rivo's answer was typological: the first Hebrew ordering of the day shows the fall from the light of grace to the darkness of sin.[111] The second adopts the Egyptian reckoning to show how the Hebrews were freed from the yoke of servitude under the Egyptians and led to freedom. For de Rivo, this time prefigures the time of grace in which Christians are carried across from the shadows of sin to the brightness of the heavenly kingdom.[112] This figural interpretation was the foundation of the Christian order of time that still measured feast days according to this system: the measurement of the day is formed as typological, liturgical time, binding the experience of light and dark into the narrative overlays of Passover, Exodus, Crucifixion, and Resurrection.

Like the day, each night had its subdivisions. In a printed fifteenth-century hymn commentary, read in Leuven's religious houses, night was divided into six parts:

> Evening is when night falls, namely that time which follows sunset, indeed that which is called *hesperus* from that star [which shines] after the sun's rising. Dusk is that hour when men go to bed. The dead of night is when nothing is done and is the common hour of resting; it is the time of everything in between dusk and cock-crow. Cock-crow is when cocks send forth their calls. First light is when there is doubt about the difference between day and night. Early morning is when dawn appears[.][113]

In the absence of precise measures, these divisions show nighttime divided by habitual activities and natural changes. These measurements included common knowledge of animal behavior, like the cock's crow, which signaled the passing of time. Other examples of these "natural" measures of time likely included flocks of birds leaving and returning to roost, marking

Fig. 1.4. *Dies naturalis*, from Peter de Rivo, *Opus responsivum* (Leuven: Lodewijk Ravescot, 1488). CUL Inc.3.F.2.9 [3294]. Reproduced by kind permission of the Syndics of Cambridge University Library.

the early morning and evening, and the migrations of birds with the passing of the seasons.

Pan-European perceptions of night as dangerous were refashioned in the Burgundian territories in the fifteenth century by the imagined threat of a new demon-worshipping sect.[114] In a set of texts that circulated in monastic and university circles at Leuven, night was the time when this strange new heretical sect met to plan evil deeds and the overthrow of Christendom. These texts included the *Flagellum haereticorum fascinariorum* (The Scourge of the Heretical Bewitchers) by the Dominican Inquisitor Nicolas Jacquier, and a work composed in both Latin and French by the Canon of Tournai Jean Tinctor, the *Invectives contre la Secte de la Vauderie* (Invectives against the Sect of the Waldensians).[115] Copies of Jacquier's text were owned by Henri de Zomeron, a professor of theology heavily involved in debates about time at the University of Leuven in the fifteenth century, and by the monastery of St. Martin in Leuven.[116] A work by Tinctor on the sect is found in the same St. Martin's manuscript. Henri de Zomeron's copy of Jacquier's *Flagellum* later passed to the library of the Abbey of Park.[117] Written for these learned clerical audiences, texts like Tinctor's and Jacquier's transmitted a view of night as a time of diabolical deception and heretical conventicles. These views of the untrustworthy night grew out of, and were received in, communities where the daily liturgy drew attention to the dangers of night through prayers and antiphons. Perhaps the most famous of these was the compline hymn *Te lucis ante terminum* (To thee before the close of day), which Jacquier saw as a particular protection against demonic phantasms in the night.[118]

Views of the night as a time of deception and danger in texts like Jacquier's and Tinctor's were matched by apocalyptic fears that these sects heralded the end of time itself. Both Tinctor and Jacquier operate within a rhetorical landscape where the end of the world is a horizon clearly in view.[119] Views of the night as a time of pollution and beliefs that the end of the world was nigh were not new; the form of the sect these clerics imagined attacking Christendom was. Together they colored the perception of time for learned clerics in fifteenth-century Leuven.

Beyond day and night, the arrangement of the liturgical year played a crucial role in structuring time in fifteenth-century Leuven. As was the case across Christian Europe, the two cycles of the liturgical calendar, the *temporale* and the *sanctorale*, gave rise to variations in the liturgy that spilled out of the church into rhythms of work and holiday.[120] The *temporale* organized the great feasts of Christ's life, from the fixed feast of Christmas to the celebration of the moveable feasts of Easter and beyond. The arrangement

of feasts around Easter included the extended period of preparation and penitence, which commenced with Septuagesima and merged into the forty days of Lent. The feasts of the *temporale* clustered in the first six months of the year, beginning with Christmas and concluding with Corpus Christi.

As formulated by early Christian theorists of time and its measurement, the *temporale* encoded a sophisticated series of conjunctions between time and the cycles of the seasons. Christmas occurred at the point of the winter solstice (according to the Julian calendar); nine months earlier, the Feast of the Annunciation on March 25 occurred just at the point of the spring equinox. This dating system placed the Annunciation on the same date as the Crucifixion, according to the standard chronology. The dating of the great feasts of the *temporale* intersected with the dating of feasts within the *sanctorale*, the system of temporal organization that marked the celebration of particular saints on fixed calendrical dates. Through chronologies synthesizing the various Gospel accounts, John the Baptist was deemed to have been conceived on the autumn equinox, and born nine months later at the summer solstice. The remainder of the *sanctorale* was not linked to the natural cycles of sun and moon, but was instead tied to particular dates in the calendar, forming an important structure of memory, both institutional and individual. Versions of a poem known as the *Cisiojanus*, where each syllable matched the date to a saint's feast, circulated widely as a mnemonic device for this sanctified architecture of time.

Within the church itself, changes in the liturgical year were marked by modifications in the celebration of liturgies and sacraments. Perhaps the most obvious were the transformations of liturgical sound: the removal of the *Gloria* and *Alleluia* in Lent or the appearance of *pueri cantores*, taken from among the scholars of the chapter school, to sing the *Benedicamus Domino* for Advent and on Christmas Day.[121] But a whole plethora of modifications to the liturgy structured the experience of liturgical time through all the senses.[122] Access to the taste of the Eucharist was allowed at Easter for the laity, but at other times was unusual. The colors of liturgical vestments also changed over time.[123] In the *sanctorale*, for example, white was used for feasts of Confessors and Virgins, and for the nativity of John the Baptist. Red was used for the solemnities of Apostles and Martyrs, for the Feast of the Holy Cross, and for John the Baptist's decollation. White was used for Epiphany, the Purification, Holy Thursday (for the consecration of chrism), and for the Resurrection, the Ascension, and the dedication of a church. Black was used to color times of affliction and abstinence: during Advent, the weeks from Septuagesima until the Easter Vigil, and for masses for the dead. All other time was marked by liturgical green, a color deemed

to be the middle point between black, white, and red. Lent was marked by the veiling of images and of church sanctuaries.[124] Bells rang for the duration of the Tenebrae service on the Wednesday of Holy Week to mark the time's solemnity, while boys were again employed to sing the *Kyries*.[125] Silence, too, marked time on the days between Holy Thursday and Easter Saturday, when bells were replaced by wooden clappers. On Good Friday alone the cross was adored. At the celebration of the Eucharist, the Pax was kissed. Rising incense swelled and dispersed to mark the changing solemnity and significance of time. These changes formed part of wider temporal structures for shaping emotional responses to time's passage within the church.

Changes in the liturgy were accompanied by a variety of transformations of time outside the church. The calendar of popular festivals formed a counterpoint to the liturgical calendar, from the pre-Lenten carnivals, with their ludic reversals of social order and celebrations of excess, to the festivals surrounding the Feast of St. John the Baptist at Midsummer, All Saints and All Souls around the start of November, and following Christmas.[126] Beyond such celebrations, the liturgy itself moved outside the church building—for example at the ritual entry on Palm Sunday. Changes like these were marked again by significant variations in sound. On Palm Sunday, we know from one fourteenth-century source, St. Peter's employed six or more boys to sing the hymn *Gloria, laus, et honor* from the church tower during the procession.[127] In this liturgical action, the building of the church was ritually transformed into Jerusalem, with its watchmen singing from the tower announcing the arrival of the Bridegroom (Christ/Priest) for his wedding feast (the Passion and Resurrection/mass) with his spouse (Jerusalem/Church). In the entry, time was transformed by a telescoping of past, present, and future in the liturgical and sacramental time of the mass.

Church authorities sought to regulate understandings of time through various forms of education and discipline. The sacrament of confession played an important role here, particularly following the decree of the Lateran Council of 1215 that made annual confession compulsory for all the adult faithful. Confession was thus a practice where ecclesiastical understandings of time could be mediated to the laity across the social spectrum. Confession manuals designed to train priests in how to go about administering the sacrament had been popular since the thirteenth century, and were among the earliest works printed in the Low Countries. One important and popular confession manual, printed twice by the Leuven publisher Johannes de Westfalia in the 1480s, was the *Speculum de confessione* of Antonius de Butrio (c. 1338–1408).[128] Time in this manual is carefully controlled. For the priest, even the time spent administering confession is regulated: if he does

not have time, or a person confesses regularly, he may shorten the confession according to a prescribed formula.[129] Questions were to be asked of the confessant concerning their "superstitions" about times that were considered more or less auspicious: is one day better for sowing than another?; do they believe that the time of the new moon is particularly dangerous, or have superstitions about the new year or setting out on a journey?[130] If we can make the methodological jump from the confessor's manual to popular belief, it would seem that at times of newness and beginnings—new moon, new year, new journey, new crop—heterodox temporal structures might surface. If that leap seems too great (condemnations of such practices were recycled for centuries in medieval texts), we can at least sense how belief in such superstitions could continue to shape clerical assumptions about time. Indeed, superstitions about particular days—for example Egyptian days (*dies Aegyptiaci*), days in each month considered unpropitious—were also the target of polemics by prominent fifteenth-century reformers like Jean Gerson.[131] Confession could be one site where these ecclesiastical condemnations of superstition reached lay men and women.

More specific questions about the relationship of time and work are posed in the section of the *Speculum* on the commandment to honor the Sabbath. Work was, of course, forbidden on Sundays or other feast days. But treasuring time's holiness was not simply a question of avoiding work on Sundays. The confessor must ask, for example, if the confessant "uses their time badly in games or at spectacles or in pubs."[132] This also extends to celebrations held in churches and at night. It is the church's pastoral duty to observe and regulate how time is spent, and the believer's job to be aware that time is precious. Time, then, for the *Speculum*, for those who read it, and for the confessants to whom its questions might be posed, was expected to be treasured and spent with care.[133]

For the *Speculum*, the regulation of time is bound together with biological rhythms and bodily desires. Time was made sacred by strict regulation of sex and food. In its section on the sixth commandment, the *Speculum* sets out the ways in which the liturgical calendar was linked to sexual abstinence. A man sins if he has sex with his wife while she is menstruating, if she is pregnant, on feast days, or during fasts.[134] Accompanying the emphasis on sacred time's regulation through sexual discipline was a heavy emphasis on the discipline of the body through fasting. In a chapter of the *Speculum* on the sin of gluttony, Antonius lays out the standard rules that shaped the experience of the liturgical year in fifteenth-century Leuven.[135] Fasts were to be observed in Lent, the vigils of feasts, and on Wednesday, Friday, and Saturday during the Ember Days, which roughly aligned with the four seasons (the

third week of Advent, the first week of Lent, the week following Pentecost, and the week following Holy Cross). The three-day fasts for the four sets of Ember Days were understood to represent not only a fast for each season, but also the twelve months of the year, thus placing all time under a penitential shroud.[136] The relationship of fasting to other orderings of time appears in the regulations governing the age at which fasting is required. Before the age of fifteen, fasting is not to be compelled; whether the age at which fasting becomes compulsory is eighteen, twenty-one, or twenty-two, Antonius leaves to the priest's discretion.[137] Fasting during Advent should be undertaken by priests and those wishing to commune at Christmas. Marking time through fasting could also vary according to circumstance: exemptions are granted to poor laborers, the sick, pilgrims, and pregnant women.

The same flexibility is found in the *Speculum*'s discussions of work and liturgical time. It opens by stressing that no labor is to be undertaken on the feasts of the Virgin, the Saints, Sundays, and on the occasion of a church's consecration. The *Speculum* does, however, allow for one *operatio* on a Sunday—devout work: "the reason why men ought not work on feasts is that they might be able to hear the divine office and to be free for prayer."[138] Exceptions to the rule of sacred time over work quickly follow, including working for the poor or to build a church, though even this work should allow participation in worship. Rules about setting aside time for worship were, however, subject to other kinds of time: the time of war and the time of the seasons. Both of these adjustments to the church's proscriptions, though not to be undertaken lightly, occurred because of dangers to the harvest.[139]

Beyond these regulations of time common to the Latin church, the liturgical calendar of Leuven had its local inflections. Guilds celebrated the feasts of their patron saints. Local parishes had their own particular calendars of devotion. For the parish of St. James, for example, the first Sunday after Pentecost was a day of particular celebrations, following the approval in 1435 of a yearly procession with a relic of a miraculous communion wafer.[140] In the late fourteenth century, the church had received a piece of a Host that was believed to have been transformed into flesh in the mouth of a communicant in Middelburg.[141] The cult of this Host flourished, including the foundation of a Confraternity of the Sacrament (1426), and papal approval of the cult in 1431.[142] But Leuven's greatest feast was, as we have seen, the Nativity of the Virgin (September 8).[143] The importance of this feast for individuals within Leuven's ecclesiastical elite is shown by one fifteenth-century breviary from St. Peter's where the pages of the feast are particularly dirty, marking their frequent use.[144] With the foundation of the

University of Leuven on the eve of the Feast of the Nativity of the Virgin, 1426, this became the university's feast as well, marking the date as a summation of Leuven's corporate identity.

Above all, Leuven's time was placed under the protection of Mary. Her natal feast was marked by a great civic and ecclesiastical procession, the *Ommegang*.[145] In the fifteenth century, the *Ommegang* came to involve guilds, civic officials, ecclesiastics, and members of the university. A richly illustrated record of the guilds' role in the procession survives in two manuscripts, and shows how the procession embodied a unity between, and a progression from, the old to the new.[146] By the late fifteenth century, each of the guilds had become associated with a female figure from the Old Testament. The first illustration of the *Ommegang* in KBR ms II 306 shows the opening guild in the procession, the butchers, whose principal figure is Abraham's wife, Sarah.[147] The explanatory text accompanying the image states that Sarah is to be an old woman, and clothed "in the old fashion" (*op die oude maniere*).[148] The procession then moves through the women of the old law, culminating at the heart of the procession, with the statue of the Virgin Mary, Our Blessed Lady of St. Peter's. The statue was a *sedes sapientiae* (Throne of Wisdom), depicting the Virgin enthroned with the Christ-child in her lap. Designed by Nicolaas de Bruyne in 1442, the statue was, like St. Peter's itself, a redesigned fifteenth-century version of a Romanesque model. Here, the old and the new, history and the present, were worked into a mutually supporting affirmation of Leuven as a divinely protected seat of learning.

The institution of the *Recollectio festorum beate Marie virginis* at St. Peter's by Walter Henry de Thymon in 1477 rounded out this Marianization of Leuven's time.[149] More specifically, its institution in Leuven is an example of a certain form of temporal thinking, where the arrangement of liturgical time forms elaborate synchronicities and analogies, particularly through the mediation of number.

> This solemn feast of all the feasts of the blessed Virgin was first celebrated in the church of St. Peter in Leuven on the first Sunday of September in the year seventy-seven, which was then the seventh day of the month of September. And thereafter it will always be celebrated on the first Sunday of September because the procession of Leuven is held at that time.[150]

The particularly strong symbolic layering of time in this rubric from a fifteenth-century breviary of St. Peter's is expressed through the gradual accumulation of the number seven in the feast's institution. The *Recollectio*

sums up the six standard Marian feasts (conception, nativity, annunciation, visitation, purification, assumption) to make a seventh, just as Marian piety in the region was stressing the seven joys or sorrows of the Virgin.[151] It also links the feast with the growing forms of numerical piety emblematized by rosary devotions spreading throughout Europe in precisely this period.[152]

In the choice of the date of the feast, this numerical piety was specifically linked to a form of temporally specific devotion, which was being emphasized in a variety of ways in Leuven's religious communities. Walter Henry did not specify the date on which the feast was to be instituted at St. Peter's in Leuven. The evidence of KBR ms 11788 suggests that the date was chosen specifically for its seven-ness. The feast is to be celebrated on September 7, 1477. Given the common method of dating the commencement of the year from the Feast of the Annunciation, September retained its ancient place as the seventh month. By omitting reference to the century in which the feast was instituted, the author of the breviary's rubric makes the institution of the feast occur on the date that we would notate as 7/7/77.[153]

This felicitous conjunction is given wider social significance by the rubric's emphasis on the conjunction of the feast with the *Ommegang*. The feast is established as a moveable feast to coincide with the procession. This is made more explicit in the rubric that marks the approximate place of the *Recollectio* within the *sanctorale*.

> Because the procession of the blessed Virgin Mary is always celebrated on the first Sunday of September, and at that time is held the feast of the recollection of all the feasts of the blessed Virgin Mary and because that feast does not have a fixed and determined day, thus you will find it at the end of this book.[154]

The rubric implies strongly that the feast belonged to the time of the saints, but that it did not quite properly fit there because of its moveable character. It was a feast within the time of the saints, like all Marian feasts, but its relationship to the town's civic and sacred celebrations meant that it, like the procession, moved outside the traditional temporal confines of the church's internal liturgical time.

INSTITUTIONAL TIME: UNIVERSITY AND MONASTERY

Essential to Leuven's civic identity in the fifteenth century, then, was the maintenance of precise temporal structures of conjunction and recapitulation that supported the proper order of city, church, and university. This

preference for layering dates with significance, evident in the structure of the liturgical year, was further expressed in the times chosen for the foundation of the university. The initial foundation by Pope Martin V occurred on December 9, 1425 (the day after the feast of Mary's conception), nine months prior to the celebration of the university's foundation in September 1426 (the time of Mary's nativity on September 8).[155] Through this arrangement of time, the university became a symbolic re-embodiment of Mary.

The celebration of Mary's nativity on September 8 occurred in the lead-up to another important moment in Leuven's calendar: the start of the academic year, which ran from October to the end of June, with holidays around the important liturgical feasts of Christmas, Easter, and Pentecost.[156] Each year, the university constructed timetables for its subjects, shaping the lives of university students, teachers, and the wider time of the town. For example, the university statutes for 1427 (revised in 1429) decreed a mathematics course for arts students that was to be taught daily in the afternoon from the Feast of St. Dionysius (October 1) to the Purification of the Virgin (February 2).[157] Different ranks of professor taught their courses at different times of the day—the established professors taught in the morning, and the second-tier professors in the afternoon and on feast days. In accounts relating to the mid-fifteenth-century studies of the nephew of Jean VI Le Robert, Abbot of St. Aubert at Cambrai, we find that private tutors could be employed to supervise revision in the evenings following classes.[158] Beyond the daily timetable, the structure of the university *studium* shaped the temporal realities and expectations of those associated with the university, including students, staff, and family members.[159] In the first four months of studying for an arts degree, for example, each student had to pass an initial exam, an *actus determinantiae* for which the fee was around five *escus*.[160] Studying for his arts degree, a student would receive a bachelor's degree, and normally, after a year's further study, their licentiate. Following the licentiate, a further period of study and examination was to occur before gaining the rank of *magister*. The hierarchy of degrees was tied by regulations to the age of students—fourteen years old for a bachelor's student, over eighteen for a licentiate, and over nineteen for a master. The length of study varied from faculty to faculty, with a full cursus in theology, for example, supposed to take around twelve years.[161] This kind of elaborate timetable formed a time consciousness for students, teachers, and their wider social networks based on their positions within an intellectual hierarchy that was also a hierarchy of time. But we should also remember that in practice, the time taken for each stage of a university cursus varied from student to student, just as it does in modern universities.

Details of university timetables and other regulations relating to time emerge in the records of a visitation of the university made for Charles the Bold in 1477.[162] The first problem the visitation addressed was the movement of students within the town after the ringing of the curfew bell, identified here as the bells of St. Michael's.[163] Here, night was not so much a time of danger, as a time of potential public nuisance.[164] Charles ruled that no student should wander the streets after the ninth hour in winter, or the tenth hour in summer. Should students find themselves in a tavern or house of ill repute after these times, they were to remain there for the night. An exception was made for students walking in the company of a university doctor. The exception reveals that the higher the rank in the university, the greater the freedom of movement after dark. Perhaps so that groups of academics were not targeted by footpads (or mistaken for them), such groups were required to carry lanterns. The visitation goes on to stipulate the hours of lectures, signaled by the tolling of the hour bells, holidays for major feasts and the dates of the summer vacation, and the division of the academic year in the various faculties. Here, the precise measurement of time was linked to social order in the town, and to a revitalized use of the classical principle *ars longa, vita brevis*: students' time was to be devoted to learning, because *artes longe sunt, dies vero nostri breves*.[165]

Further details of the temporalities of student life emerge in sets of notes from fifteenth-century Scottish students at Leuven. One of these students, George Lichton, later Abbot of the Cistercian monastery of Kinloss in Moray, was a student in Leuven in the 1460s. His notes, famous for their hand-drawn illustrations of fifteenth-century university life, include a colophon where he recorded the exact time when he finished the manuscript: "In the year of our Lord, 1467, on the 26th day of the month of May between the sixth and seventh hours, praise and glory to God and his unblemished mother the Virgin Mary."[166] Although this colophon follows generic conventions and the specificity of date and time is not unusual, the particular emphasis on the time the manuscript was finished may still have been meaningful for George.[167] Perhaps written out of relief, or joy, scholarly precision, or habitual piety, the colophon was a measurement of time that could link precise measurement to devotion.[168]

The other notebooks, written by William Elfynston, father of the founder of Aberdeen University, record lectures at Leuven in the 1430s by John Grosbeck, Henry Rether, and Richard of Tournai.[169] One day in 1433, William took a holiday thinking mistakenly that there would be no lecture held on the occasion of John Grosbeck's election to the university rectorship. William's expectation was not unreasonable: commemorative celebrations

of significant time spans were a normal part of Leuven's temporal landscape. The significance of commemoration is suggested by an enigmatic portrait painted by Dieric Bouts, possibly of the university member Jan van Winckele.[170] In the portrait, Jan sits in simple red clothing in front of an open window. On the wall behind is the date 1462. The first three numerals are depicted as engraved; the final is raised in relief from the wall. Jan van Winckele seems to have been interested in commemorating the dates of significant events in his life. In 1499, he celebrated the fiftieth anniversary of his mastership. Lorne Campbell makes a persuasive, if circumstantial, case that this image was made to commemorate his appointment in 1462 as notary to the Conservator of the university. The significance of the different methods of portraying the numerals has not yet been explained. One possibility is that the numeral 2 marks the significant number in the date for the calculation of any form of commemoration from this point on. By mimicking a less permanent form of representation (the relief numeral could be replaced later with an engraved numeral), the image shows that the painting is no anniversary portrait for the deceased, but an active image designed to record the time of a living person's career. This example suggests how the lived time of a life might be punctuated by anniversaries and how the length of time served in a position might shape the identity of individuals within institutional environments.

These methods of organizing and punctuating time through commemoration flourished in the monastic communities that formed such an important part of Leuven's diverse institutional landscape. One of the most striking records of time in Leuven's religious houses is the chronicle of Leuven's Carthusian monastery.[171] Preserved in a large early sixteenth-century manuscript, the chronicle records the monastery's foundation and history. It is divided into two sections, the first organized according to the building of the monastic cells, the second according to a strict yearly chronology.

In the first part of the chronicle, the space of the Carthusian house becomes a monument of memory to its pious founders, and also a space through which its history can be experienced. Each cell is named by a letter of the alphabet; the text reproduces this arrangement in its own structure. The alphabet becomes a unifying device for arranging the historical time of the monastery, its physical space, and the memorial time of the chronicle's reader, both in the temporal process of reading the chronicle and in remembering the house's history when passing through its physical space. Using the alphabet to arrange and order the time of reading has parallels in devotional literature, for example Johannes Nider's *Alphabetum divini amoris* (The Alphabet of Divine Love), printed by two Leuven publishers

in the fifteenth century.[172] It finds visual expression in images like one late fifteenth-century Brabantine altar of Christ's Passion (Figure 5.2).[173] Here, moments of the Passion placed in one physical plane are allotted their particular time in the narrative sequence through tiny letters of the alphabet painted above each scene.

This nexus of devotional time and space forms part of a wider culture where monastic space was transformed into the landscape of devotional narratives. Central here were texts like Henry Suso's widely circulated *Hundert Betrachtungen* (Hundred Articles) on the Passion, which filtered into the Low Countries particularly through the *devotio moderna*.[174] For Suso, the geography of his monastery in Constance became a space for re-embodying the time of the Passion in exquisite detail, just as the Carthusian house became a way of memorializing the past through both its physical space and the space of the chronicle text.

The importance of marking beginnings and endings within the Carthusian monastery is revealed by the careful attention paid to them in ritual and text. During the laying of the first stone of the second cell, the monks sang with tears the *Veni creator Spiritus* (Come, creator Spirit), to the honor of God and the glorious Virgin. The two cells were completed in the same year around the Feast of St. Martin.[175] To understand this moment's function for a history of time, it is essential to note not just that the beginning of work is the central moment for ritual invocation, but that that beginning and ritual are textually recorded to become a part of the collective memory of the monastery. Beginnings and endings are recorded because they mark significant triggers for the construction of narrative—narrative in turn becomes a central form for organizing the landscape of time in memory. Indeed, it is possible to make a speculative extension of the text's effect to show how music in this passage acts as a trigger for memorialization in its traditionally constructive medieval form.[176] This chant connects the time of laying the cell's foundations with the time of the reader, who may hear the same song as they hear the words of the chant. In this way music could fuse the voices of faithful rememberers across time.

In the material on the eighth cell, the narrative of the monastery's foundation widens to include events beyond the monastery walls. The change begins with entries recording the birth of a son to Duke Philip the Fair (1478–1506):

> Item, in the year of grace, namely the year 1500, on the eve of St. Matthew the Apostle, the son of Duke Philip was born of his most illustrious wife. This birth was celebrated with much joy in Ghent, because he was born there, and in Leuven and in other towns of the country.[177]

The inclusion of this material shows how noble families, with their rhythms of succession, provided a framework for historical time in the period. The presence of the marker "year of grace" (*anno gratie*) alerts us to the way this birth was placed within sacred time by the chronicler. This fusing of the court's time with the church's becomes clearer in the next entry:

> Item, in the year of grace 1500, because there was a great concourse of all pilgrims towards Rome on account of the indulgences, on the seventh day of March, on the day of St. Thomas, the son of Duke Philip, Duke of Austria, Burgundy, and Brabant, was baptized, and called Charles. And many nobles lifted him into the font in Ghent.[178]

In the chronicle, the *annus gratiae* system is used to signal the particularly special time of the Jubilee year, a year when the Pope granted a plenary indulgence to pilgrims who traveled to Rome.[179] These jubilees occurred every twenty-five years over the course of the fifteenth century and caused massive, and sometimes dangerous, crowding in Rome. The great crowds of pilgrims who travel to Rome find their parallel in the assembled nobility in Ghent, honoring their new prince.

In this extract, two further ways of marking time appear that we have not yet fully encountered. The first is the ordering of the time of individual lives through the sacramental cycles of the church. Charles was born on February 24 and was swiftly baptized. This sacramental beginning was followed by a series of other rituals and sacraments that formed the temporal arc of each Christian's life: confirmation, to mark the transition from childhood; for many, marriage; for others, ordination; and to mark the end of life, extreme unction, funerals, and masses for the dead. For receiving many of the sacraments, a normative age was codified in law, and formed in social practice. These moments provided horizons of expectation, and sites of memory, shaping the experience of time for individuals and communities across the social hierarchy.

The second form of time that emerges from the episode of Charles's birth is revealed by the system of indulgences that operated far beyond the temporal superstructure of the Jubilee. Indulgences, like confession, were a way in which the church's ordering of time was communicated and constantly re-instantiated in social life. They connected the lives of individuals, families, and communities to church doctrine regarding the time after death, when those sinners who escaped eternal damnation would endure punishment for their sins in purgatory. Time's measurement became crucial here to maintaining an economy of punishment and remission.

Indulgences were granted both at the diocesan level and by the papacy. In synodal statutes promulgated at Cambrai in the thirteenth century, a model for other northern dioceses including Leuven's own diocese Liège, indulgences were calculated for a wide variety of activities, including ten days for carrying a corpse and being present at a mass for the dead and funeral; ten days for those reciting the *pater noster* (Our Father), kneeling at the name of Jesus and Mary, or at the words *verbum caro factum est* (and the Word became flesh); twenty days for praying for the bishop; ten days for those who accompany the *corpus Christi* on its journeys to and from the sick (twenty days at night); twenty days for attending the funeral and burial of a priest; ten days for rising respectfully for a priest.[180] Indulgences ratified by various popes were attached to praying particular prayers, for example saying the prayer *Adoro te in cruce pendentem* (I adore you, hanging on the cross), which was said to carry an indulgence of 20,014 years and twenty-four days.[181] Kathryn Rudy's work on patterns of use of books of hours from the fifteenth century has shown that both lay and monastic readers often favored indulgenced prayers.[182]

Such indulgences were remembered using mnemonics like that recorded on the opening pages of a copy of the Leuven edition of Werner Rolewinck's timeline, the *Fasciculus temporum*, probably by a Cistercian scribe, somewhere in the Low Countries.[183] In this short poem, indulgences were enumerated for saying *Ave Maria* three times while a bell is ringing, for bowing when the *Gloria* is sung after the psalms, and at hearing the name of Jesus. Examples like this show not only how devotional and liturgical times were shot through with temporal structures relating the present to future judgment, but how indulgences were designed to bring meditation on Christian futures to the forefront of daily experience. If a seated tradesman rises as a priest passes on the street, if the Host is reverenced as it passes on its way to the house of a dying woman, if the prayers of the *Angelus* are recited, an uncertain future can, in some small way, be controlled. Time here plays two roles: it is both the fearful time of future punishment, and the present where merits and indulgences can be accumulated. In this second time, there is no time to be wasted.

The idea of time wasted, or spent incorrectly, was, of course, part of the confessional tradition that we have encountered in de Butrio's *Speculum*.[184] Proper use of time also featured heavily in the reforming traditions of Leuven's monastic houses, like the Priory of Bethleem at Herent, the Abbey of Park, and the Windesheim monastery of St. Martin's. Here, texts like Suso's *Horologium* dealt specifically with the proper use of time in the process of the pilgrimage of earthly life.[185] One example of how this attitude to time's

preciousness played out in a reforming milieu comes from a letter by the renowned reformer and theologian Jean Gerson (1363–1429), whose works circulated widely in fifteenth-century Leuven:[186]

> I would add that nothing is more harmful to mental peace and contemplation, nothing more wasteful of that most precious thing, time, and nothing more of a hindrance to the perfection of those who study, as conversations . . . in which, from morning until night, the day is slowly eaten up and even much of the deepest night.[187]

Gerson was most likely aware of the Augustan poetic tradition that fostered the image of time as a devourer, the *edax rerum* (devourer of things), through its explorations of textual survival and poetic fame.[188] In this passage, he transfers anxiety about time as eater into time as eaten, using the traditional Christian frame of what occurs in time having positive or negative value. Time itself is not the enemy, but rather the framework within which a life can be led subject to future judgment.

The ancient conception of time as *edax rerum* made explicit appearances in later fifteenth-century Leuven. A monument for a professor of theology at Leuven, Joannes Godthebsdeel (d. 1490), transcribed in the seventeenth century, preserves a Latin epitaph that fuses the topos of time's appetite with the eternal victory of the virtuous Christian:

> After the funeral rites, virtue shall endure into eternity,
> Nor, though the flesh may be destroyed, can it perish.
> But, after the corpse is buried in the icy sepulchre,
> Even yet the soul seeks the stars of the golden heavens;
>
> . . .
>
> Time shall neither devour it, nor tardy old age,
> But in all things it grows strong even as it endures[.] [189]

This epitaph shows how varieties of time in the classical tradition were being adapted and reformulated in late fifteenth-century Leuven. In the emerging discourses of Christian humanism, time might devour, but the soul, preserved through its virtue, could be lauded into eternity.[190]

Stable languages of time could, however, be put to the test by unexpected and disastrous events. Around the year 1500, the Carthusian Chronicle records a fearful crescendo of disturbing wonders and disasters in Leuven.

According to the chronicler, the town's suffering began on December 19 with the greatest flood "in human memory."[191] Then,

> in the year of our Lord, 1501, around Lent, a certain girl in Leuven was possessed, who was staying not far from the Chapel of St. Margaret; who, adjured by a certain priest in the house of Herent near Leuven, said many things.[192]

The possession of this unnamed girl forms part of a catalogue of miseries. In contrast to the "year of grace" (*annus gratie*) of 1500, the year 1501 was a "wretched year (*annus miserie*), for it contained many pitiable things."[193] In Leuven, around the Feast of the Purification, a man fell into a boiling vat and broke his neck, a young butcher killed his uncle, and was in turn gruesomely punished. There follows a catalogue of further strange and horrible events drawn from the years around 1501, including an account of the suicide of a young cleric known to the chronicler, and a lynching of a woman by her neighbors. This catalogue reminds us that time is marked by events, events that could be structured into systems of understanding according to their perceived quality. In this case, a fascinating temporal transformation occurs textually in the process: the chronicle's spatial arrangement of time according to monastic cells gives way to a quasi-annalistic record of events, which by the very power of their singular eventfulness seem to resist narrative flows of time.[194] The wonder, the disturbing sign, the disaster were at the forefront of these rearrangements of time.

Indeed, in contrast to the repeated social rhythms analyzed earlier in this chapter, the singular, the odd, and the unrepeated often shape the organization of time within the chronicle. Such events seem to call for a greater precision in the measurement of time. For example, in 1502, when the first woman was buried in the monastery's church, the dating system in the chronicle becomes far more precise, noting the dominical letter along with the day, month, and year. According to the venerable calendrical system still used by Leuven's churches and monasteries, the first Sunday of the year was assigned a letter from A to G (the first seven letters of the alphabet), depending on its date. If Sunday fell on January 1, the dominical letter for the year was A; if it fell on January 2, B, and so on. By a complex system of calculations, this letter could be used to determine the dates of the other feasts of the *temporale*. In the Carthusian house at Leuven, tables for calculating these feasts appear in the same volume as the Carthusian Chronicle.[195]

Leuven's Carthusians, then, were deeply involved in marking time; every page of the chronicle seems to involve a new facet of time. The chronicle

records the alignment of the dates of the laying of the foundation stone and the monastery's completion, another sign of the significance of dates and recapitulation in time.[196] The feast of the monastery's dedication is recorded with a dominical letter, so that it can be celebrated with precision each year on the Sunday before the Feast of Mary Magdalene.[197] The dedication of a new set of bells brought from Mechelen is timed for the lead-up to the great celebrations of Leuven's foundation in September.[198] The first vespers sung in the choir occurs five years from the date of the laying of the foundation stone.[199] A personal jubilee celebrated for a brother Johannes shows how such rhythms intersected with the culture of personal memory surrounding anniversaries within the monastery.[200] On this occasion a great brunch was had by all, with various friends of the house contributing all that was necessary.

Food, indeed, was essential to the order of Leuven's time.[201] While the eating patterns of monks and nuns can be traced in detail, the sources do not allow us to see those of lay townsmen and -women so easily. Eating and food preparation had their own temporal shapes, profoundly forming patterns of experience depending on factors like gender, social position, and economic status. For Leuven's urban poor, we can reconstruct some simple ways in which time intersected with food. Bread was distributed by various charitable foundations, including one linked to Leuven's Carthusian house, where the distribution was arranged to occur at the eleventh hour of the day.[202] Other foundations, like that of Jan Varenacker's brother Guillaume, specified that bread was to be distributed after masses in honor of the soul of the founder.[203]

The time taken to prepare individual dishes could perhaps unite precise measurement of time with devotional time. In an early sixteenth-century manuscript from Ghent, probably owned by a member of the city's urban elite, recipes record the length of time necessary for preparing certain dishes with precision to the half hour.[204] Evidently the kitchen needed its own clock or hourglass.[205] Other recipes show the intersection of prayer texts and cooking time. In a recipe for a gargling mixture, the book advises mixing rose petals, fennel, the peel of a pomegranate, and elderflower, then boiling them "together in water for the length of time of a *Miserere*."[206] In a recipe for a quark cake, the mixture is to cook for the length of a *Pater noster*, probably the time taken to pray the rosary.[207] These kinds of time measurement occurred across Europe.[208] Whether or not the prayer was prayed in earnest while the cake baked, these recipes show how the repeated performance of text could measure time, and accords with evidence from liturgical sources regulating the performance of liturgical chant, where the pauses between half verses of psalms were measured by saying *Ave Maria*.[209]

TIME, GENDER, AND THE BODY

These day-to-day measurements of time were experienced in the embodied practices of habitual action, practices that are always gendered. In what follows, I offer only some brief reflections on this important area, where further studies will be needed to expand our understanding.[210]

Men were deeply involved in the maintenance of public time in the city: there are no records that I know of for payments to female clock-makers or bell-ringers in Leuven, and the time of town, guilds, and markets was largely in the hands of male town councillors and guildsmen. But the women of fifteenth-century Leuven were not passive recipients of male time. Women played important roles in the economic life of the fifteenth-century Low Countries. Alongside the economic importance of many women's domestic roles and their position within marriage structures, they participated in commercial activity and money lending, as studies of other towns in the Low Countries have shown.[211] Women's time could thus be connected with the time of the town's work hours and clocks, and also with the legal times of courts adjudicating on disputes over, for example, property ownership and debts.[212] Communities of women who could play important parts in connecting commercial and liturgical time were Leuven's two communities of beguines.[213] Women appear as guild associates and as itinerant carp-sellers in the ordinances of the Leuven fishmarket, showing their participation in, and subjection to, the time of guilds.[214] Women were employed each year in seasonal labor, for example at the harvest, or to mow hay (figure 1.3, August).[215]

Biological rhythms marked the embodied passage of time for fifteenth-century women, men, and children. For example, oaths could be rendered invalid if sworn before the age of twelve for girls or fourteen for boys.[216] These ages roughly marked out the boundaries for marriage and for entering a convent or monastery. The time before was the time of childhood, which was hedged around with exemptions from adult time, and constituted by activities that only children could undertake (like singing from St. Peter's tower on Palm Sunday).[217] Beyond childhood lay the other ages of life, organized according to various schemata and symbolically aligned with the influences of the planets, the humors, and the numbers of seasons, months, or days of the week, or with the ages of the world.[218]

The passage of time was inscribed on the bodies of those living in fifteenth-century Leuven in different pains and pleasures, in physical changes like scarring, posture, eyesight, hair growth and loss, and changing humoral

makeups, according to the influence of the stars or the processes of aging. For women, menstruation's onset and its cessation were markers in the changing of life-cycle time. Pregnancy was marked by its own rhythms, including the time marked off around childbirth by the lying-in. The time of pregnancy was important too for the female profession of midwives, who, as we have seen, joined priests and doctors in being allowed to attend their charges during the night. Menstruation and pregnancy were linked to confessional and liturgical regulations about sex and church attendance, tied both to concepts of impurity and to times of fast and feast. This regulation of women's time extended to ceremonies like churching, which provided a ritual form to the time of childbirth, signifying the reintegration of a woman into her normal social roles following her time of lying-in.[219]

Rhythms of liturgical and devotional time were shaped in particular ways by and for women. Leuven was home to several female religious houses where women participated in the cycles of liturgical time.[220] But over the course of the fifteenth century, a wider social range of women outside religious orders could also adopt regular scripted devotional practices, including private prayer using one of medieval Europe's most unmistakably time-ordering texts, the book of hours.[221] These books, most often owned by women, brought the possibility of praying the liturgical hours into domestic interiors, into relationships with individual and familial temporal rhythms. The effects of this change in devotional practices could result in the uncoupling of the hours from their temporally specific liturgical times, or their omission.[222] But this translation of liturgical time into the home was also accompanied by the development of domestic clocks that, hand in hand with books of hours, could extend the reach of precisely measured liturgical time into the heart of more wealthy households (figure 1.5).[223]

These two possibilities, time's radical subjectivization and time's increasing objectification through clock measurement, are not mutually exclusive, and participate in the long history both of the sacralization of the domestic sphere and the family, and of the creation of individualized experiences of time that nevertheless exist in cultures with highly developed systems of temporal measurement and control.

Whatever form they took, each temporal schema for the human subject in fifteenth-century Leuven drew to a close in old age and death. What kind of eternity awaited the departed souls of the townspeople of fifteenth-century Leuven? This unanswered question is a fitting way to close this incomplete account of time's polyphony in fifteenth-century Leuven. For while I have tried to listen to and see a wide variety of times, still others

Fig. 1.5. *Annunciation*, from a Book of Hours, Bruges or Ghent, late fifteenth century. CUL MS Additional 4100, 43v. Reproduced by kind permission of the Syndics of Cambridge University Library.

remain unheard, unseen. The variety of times encountered in this chapter shows the possibilities unleashed by using time as a major category of historical analysis, while revealing the need to look more closely at particular contexts and agents to deepen understandings of time's history. I will now attempt to see and hear more minutely one such network of time, and eternity, clustered around the church of St. Peter in Leuven.

CHAPTER TWO

The Altarpiece of the Holy Sacrament: Making Time in Leuven's St. Peter's Church

Over the course of the fifteenth century, the collegiate church of St. Peter in Leuven, the center of the town's devotional life, was expanded by a series of building works, including a new choir and radial chapels in late Gothic style. The fifteenth century also saw the foundation of an influential Confraternity of the Holy Sacrament in Leuven, a devotional community drawn from leading members of the urban elite and members of the university. The confraternity commissioned artworks for their new chapels in St. Peter's, including Dieric Bouts's altarpiece of the Holy Sacrament. The contract between Bouts and the confraternity for this altarpiece survives, allowing us access to arrangements of time made between clients and artisans in the period. Central to the commission was the involvement of two professors from the faculty of theology at the University of Leuven. Both participated in one of the most spectacular theological debates concerning time in the fifteenth century. The debate hinged on how to interpret Aristotle on the truth of statements about the future. By situating Bouts's altarpiece alongside the temporal structures embedded in the contract, the debate over future contingents, and within the liturgical time of St. Peter's, this chapter continues the task of constructing a history of time in the fifteenth century by delving into the detail of a particular network of visual culture, legal practice, philosophy, theology, and liturgy.

TIME AND THE CONTRACT

The altarpiece of the Holy Sacrament (plate 1) was commissioned by the Confraternity of the Holy Sacrament for its chapels in St. Peter's in 1464.[1] Today the altar stands in its original position, in one of two radial chapels granted to the confraternity in 1432.[2] It would have been opened at least

on feast days, and during the octave of Corpus Christi, and was most likely closed for the seasons of Advent and Lent.[3] The contract for the painting was destroyed in the First World War but survives in a nineteenth-century transcription.[4] It is one of the earliest surviving commission contracts from the Low Countries.[5] The rarity of the contract has led to its repeated use by art historians, but the variety of ways of organizing time embedded in the text have not been considered. Although a rare historical document, the contract was not designed to be unusual or striking: it is telling precisely because it reflects normative fifteenth-century arrangements of time.

The contract opens with a formula that directly asserts a relationship between the presence of the document itself, the past, present, and future. It constructs and maintains social and economic relationships by organizing time:

> All who will see the present document or will hear it read are hereby informed and notified that on the fifteenth of March 1464 (according to the custom of writing in the venerable court of Liège) a firm agreement was set up and concluded between the four administrators of the Confraternity of the Holy Sacrament at the Church of St. Peter in Leuven ... and the painter, Master Dieric Bouts[.][6]

The document encompasses an act in the past: "a firm agreement was set up and concluded." But in the fact of its documentation, this past act becomes a continual present: "[t]his present [*tegenwoirdige*] document." Wherever the document is present, the particular past of the contractual arrangement is made present—it is re-presented—as an act that codifies and orders the past, present, and future. The ability of legal documents such as this to speak to the future in the present tense ("All who *will* see ... *are* hereby informed"), and to make present a particular past ("a firm agreement *was* set up"), shows how the maintenance of textual authority involves particular arrangements of time. Past, present, and future become arranged in the present document that endures both textually and physically through time, maintaining its presence from the past act of concluding the contract, to its present and projected futures in the act of reading.

Embedded within the opening sentence of the contract is the date, March 15, 1464, fixing the document's legal veracity and forming another mechanism for establishing the document's past for future readers. But a date like this is not simply marking a point in the past. It organizes a future relationship to the past, what we might term, in homage to Koselleck, a "past's future."[7] An important and standard inclusion is the reference to the method by which

the date of the year is reckoned: "according to the custom of writing in the venerable court of Liège." By identifying a specific use, the diversity of starting dates for a year could be addressed; and the date March 15 was a difficult one to place within the array of possible fifteenth-century years.

Medieval years could be many and various.[8] In Leuven and its surrounds, there were different days for beginning the year, for liturgical years (Advent), years of political office (Midsummer), and financial and administrative years, which depending on the institution could begin in January, Easter, August, the Feast of St. Thomas, the Feast of All Saints, or Christmas.[9] When it came to the strict calendar year, however, as recorded in documents like the Bouts contract, the most popular commencement dates were Christmas, January 1, the Feast of the Annunciation (March 25), or Easter Sunday. In Leuven, the Easter year and the Christmas year cohabited, making definition of the year a practical necessity, as well as a marker of the institutions under whose authority documents were written or of the particular trainings of the notaries responsible for their formulation.[10] The Easter-to-Easter year, a year of variable length, was a favored system for city authorities.[11] Ecclesiastical documents, including those of Leuven's new university, took their cue from the dating system of Leuven's diocese, the prince-bishopric of Liège, where, from the fourteenth century, the new year commenced at Christmas.[12] March 15 falls early in the new year in this system of reckoning, but late in the year according to the Easter reckoning favored by Leuven's civic authorities. The reference to Liège situates this transaction, then, firmly within ecclesiastical time, while allowing legally binding computation of the number of months Bouts was to devote to the altarpiece, and when he would be paid.

Bouts was to be paid the sum of two hundred Rhenish guilders for the work. The money was to be paid in installments:

> twenty-five Rhenish guilders as soon as [Bouts] has begun the aforesaid altar, and further, twenty-five Rhenish guilders during the next half year, fifty Rhenish guilders after completing the work, and the remaining one hundred Rhenish guilders during the following year, not including the three months of the year after that.

Like the contract itself, this precise regime of payment stretches across time. The oddity is in the payment after the altarpiece has been completed: "one hundred guilders during the following year, not including the three months of the year after that." It is not quite clear what this exclusion of the three months means, but it seems most plausible that the contract

is again distinguishing its measurement of time from a year commencing sometime in March. The payment in the year following the completion of the Altarpiece will not stretch beyond December 25 into the first three months of the following year, as, for example, might be the case were an Easter year being used as the temporal framework for organizing payment.

The contract goes on to make it clear that this method of payment by installment after the date of the work's completion is not the perfect arrangement:

> But if, by the grace of God, the good people should so amply demonstrate their charity and liberality toward the said work that the above named sum can be paid in full to the said master Dieric for his completed work, and if that sum of money would otherwise lie unused in awaiting the aforementioned time limit, it has been contracted that the said Master Dieric shall be paid in full as soon as he has fulfilled his obligation.

This coda to the contract reveals an ideal conception of the relationship between time, work, and money. If sufficient funds are available, final payment should come at the end of the contractor's work, preserving a synchronic temporal relationship between completed product and payment. In the practical world of fund-raising, however, the direct relationship between time spent, product produced, and time paid for must extend in time beyond the point of the product's completion.

A synchronic understanding of exchange—the ideal present moment when product and money maintain a symbolic equilibrium despite change in ownership—exists in the contract alongside a sense that money also purchases time. Bouts is commissioned "to make this altar to the best of his ability, to spare neither labour nor time." Similarly, he "shall not contract any other work of this kind until this one has been completed." This is both a requirement that the work be completed as quickly as possible (a requirement that balances the need for Bouts to be paid as soon as possible), and shows the power of symbolic exchange to move beyond the simultaneous to include the purchase of processes—in effect, exchange in a diachronic sense. The long history of these structural relations between money, work, and time does not reduce their significance for understanding the specific experiences of time in relation to this particular contract: Bouts's time as constructed by the contract should now be devoted to the altar, and will return to him only after its completion.

After determining the dates and the parties involved, the contract turns to the details of the commission. The contract records the request for

a costly altar . . . with scenes pertaining to the material of the holy sacrament. On the inside of this altarpiece, the Last Supper of our dear Lord will be depicted with his twelve apostles. Item, on each door within two figures from the Old Testament, the first of the heavenly bread, the second of Melchizedek, the third of Elijah and the fourth of the eating of the paschal lamb as described in the old law. Item, on the outside of each of these doors will be an image: on the first, the image of the twelve loaves which only the priests were allowed to eat; on the second . . . [lacuna]

One element of the iconographical program was most likely never painted: the outer wings of the altarpiece.[13] The damage to the manuscript of the contract before its destruction means that we have information about only the first of these panels, the "twelve loaves which only the priests were allowed to eat." This reference to the bread of the presence, the showbread, codifies a temporal arrangement between old and new, preparation and presence, prophecy and fulfillment, which was to be embodied in the temporal experience of the altarpiece in the liturgical calendar of the church.

The role of the bread of the presence in ancient Israel is most fully explained in Leviticus 24:5–9. Twelve loaves are to be baked and placed in two rows of six upon a table within the tent of meeting, outside the curtain veiling the Ark of the Covenant. The bread is to be renewed each Sabbath, and eaten only by the priest Aaron and his descendants. The showbread on the outer doors of the altarpiece is a typological prefiguration of the Eucharist. But because of its role in the temporal unfolding of the altarpiece, it is more than that. First, the narrative of the showbread places it outside the holy of holies, the ark, the presence of God with his people. In the arrangements of space and time made by the altarpiece, this aligns the central inner panel, where Christ celebrates the Last Supper with his twelve disciples, with the Ark of the Covenant. In the architectural structure of the planned altarpiece, where, when the altarpiece is closed, the Last Supper is overlaid with the image of the showbread, the movement in time from showbread to Eucharist signals both unity and difference between the old law and the new. By opening the altarpiece on days of particular liturgical importance, the time of the liturgical year comes to embody the movement from veiled presence in the old law to real presence in the new. At the same time, the structure of the panels symbolically synchronizes the old and new laws by drawing on a spatial and spiritual movement from veiling to presence, a movement found *within* the old law.[14]

Liturgical time intersects with the physical structure of the altarpiece to construct multiple possible arrangements of images across time.[15] Far from

being a static object, the altarpiece's meanings change and are changed by its liturgical setting. Closed during the season of Lent, the altarpiece signals the veiled presence of God, and human distance from the divine presence. The veil of the temple is rent almost literally in two by the opening of the altar at Easter.[16] The old law passes away and the new is instituted. At Corpus Christi, new meanings might emerge. The showbread stands as a sign of the exterior accidents of the Eucharist, opening to reveal the substance of Christ's physical body. In this way, the flow of time in the liturgy can form a counterpoint to the movement in time and space from veil to inner sanctum.

The contract for the altarpiece reveals that this complex theological program was to be developed in consultation with two professors of theology from Leuven's university, Jan Varenacker and Giles Bailluwel (d. 1482):[17]

> And the aforementioned Master Dieric has contracted to make this altarpiece . . . in such order and truth as the Reverend Masters Jan Varenacker and Giles Bailluwel, Professors of Theology, shall prescribe to him with regard to the aforementioned subjects.

In this case, we are in a near-unique position: we can situate the views of these professors on time with greater precision, and so imagine possible responses to the temporal structures embedded in the altarpiece.

FUTURE CONTINGENTS AT THE UNIVERSITY OF LEUVEN

Over the course of the fifteenth century, interpretation of time became a hotly disputed topic at Leuven. The controversy, which arose in 1465, centered on how to interpret Aristotle's claim that propositions relating to future events without predetermined causes could not be categorized as true or false.[18] This debate over future contingents included not only the University of Leuven, but the universities of Paris and Cologne, the Burgundian Court and, eventually, the Pope.[19] Histories of this debate have thus far traced the intellectual moves of its leading protagonists and the philosophical traditions on which they drew. The following analysis situates the debate within learned discourse on time and begins the important task of reconnecting the debate with its specific social setting and wider cultural patterns in fifteenth-century Leuven.

In 1447, the first hint of controversy appears in the records. A statute, drafted by the faculty of theology and adopted by the arts faculty, forbade discussion of future contingents.[20] One of the four members of the theology

faculty who drafted the statute was Jan Varenacker, one of the two professors from the Bouts contract. The statute specifically banned teaching "that determinately one part of a contradiction in future contingents is true and the other false."[21] According to Aristotle, all statements about the future can be proved true only by future events (that is, contingencies) and therefore cannot be said to be definitively true or false at the time of their utterance. Varenacker, and the faculty of arts, were here siding with the Aristotelian interpretation. Why? To reconstruct some of the possible parameters of Varenacker's understandings of time, we can turn first to the statute itself, and then to the views of Varenacker's student, Peter de Rivo, the major proponent of the Aristotelian view in the faculty of arts, and finally to Varenacker's opinion on de Rivo's work, published as part of a conclusion of the theologians of Leuven in 1471.[22]

The statute was, in part, written to combat deterministic understandings of the future that had come to be associated with the Oxford theologian John Wyclif (c. 1331–1384).[23] By claiming that a statement made about the future was true or false in the sense that a past event could be described as true or false, a door could be opened to denying future contingency, thereby substituting human free will with fate. The condemnation of Wyclif promulgated by the Council of Constance in 1415 dealt particularly harshly with his supposed determinism. Wyclif's name appears repeatedly in the Leuven debate, always signaling a move against deterministic understandings of the future.[24] The 1447 statute and Jan Varenacker were specifically linked to this move against determinism by Varenacker's student Peter de Rivo, who saw the intent of the statute as "to escape the heresy of John Wyclif, with all its concomitant absurdities."[25] Fear of heresy also motivated the theology faculty at Cologne to support the statute in their conclusion of 1470, labeling contrary views as "suspect and dangerous to the . . . catholic faith."[26]

Criticisms of the Aristotelian position were, however, understandable: core Christian doctrine was difficult to reconcile with the view that statements about the future had neutral or indeterminate truth value. According to its foremost opponent, the Leuven theologian Henri de Zomeron, it was heretical to argue that statements like those made in the creeds about the future ("he will come again to judge the living and the dead") were not true in the same way as statements made about the past ("on the third day he rose again"). The same problems applied to biblical prophecy. In order to meet these criticisms, Peter had to tread a careful line, managing his argument in relation to venerable philosophical and theological authorities. To make his case, de Rivo grounded his argument in what was uncontentious doctrine

about time and eternity articulated by "Augustine, Anselm, Boethius [and] St. Thomas Aquinas."[27]

Aquinas provides a particularly influential account of the conceptions of time and eternity shared by Leuven's theologians. For Aquinas, God is not subject to time, but rather relates to time from eternity. Since eternity has no duration, "the divine intellect . . . sees in the whole of its eternity, as being present to it, whatever takes place through the whole course of time."[28] This means that the future is just as present to God as the past, since the divine glance from eternity is always able to see each point in the progress of time equally.[29] Aquinas imagines this relation of eternity to time through the image of a watchtower:

> [God's] eternity is in present contact with the whole course of time, and even passes beyond time. We may fancy that God knows the flight of time in his eternity, in the way that a person standing on top of a watchtower embraces in a single glance a whole caravan of passing travelers.[30]

God's vision of time can also be formulated as the relationship between a circle's central point and its circumference.[31]

For Aquinas, human knowledge of time, unlike God's, is always temporally situated. So, while the future and past are equally present to God's divine vision, humans can see only from where they stand in time. "We see what is future because it is future with respect to our seeing, since our seeing is itself measured by time; but to the divine vision, which is outside of time, there is no future."[32] All human thinking is thus discursive: "for the act of reason is like a certain movement from one thing coming to another."[33] Motion between propositions, and the inability to conceptualize knowledge as a whole, is matched by the inability of human "abstractive apprehension" to grasp the unity of substance and accidents. For Aquinas, then, imperfect human thought always involves "partial views," which must be articulated diachronically and resolved into some form of "intelligible unity."

Between divine and human knowledge is the knowledge of angels. Angels have "intuitive" knowledge, "behold[ing] all things which can be known" in those things that they can know naturally.[34] The formulation is again essentially visual. The glance of the angel apprehends the object synchronically and comprehensively. In this act, angels approximate the "simple intuition" of divine knowledge. Where angelic knowledge requires divine assistance is with those things that cannot be known naturally. One central mystery that delineates this distinction is Christ's real presence in the Eucharist.

Christ's presence cannot be comprehended by bodily or natural eyes, but only through God's glorified intellective vision, and by those to whom he grants that vision.[35]

Using metaphors of vision resonant with Aquinas, and drawing on arguments advanced by the Franciscan theologian Peter Auriol (c. 1280–1322), in his *Questio quodlibetica disputata anno LXV° Lovanii* (Quodlibetal Question Disputed at Leuven in the Year 1465), Peter de Rivo takes it as axiomatic "that all things, present, past, and future, are immediately present in the divine sight."[36] What humans perceive as temporal distance is irrelevant for God: "all things [are] immediately present to him, however much they are temporally distant from each other."[37] De Rivo elaborates this distinction between human experience of time as distance, and divine experience of presence, by analyzing the different kinds of foreknowledge experienced by humans and God. Since God does not experience past, present, and future as humans do, God's way of thinking cannot be classified according to the temporal language appropriate to humans. To use de Rivo's language, as filtered through Zomeron, human thought is "expectative" (*expectativa*) and "memorative" (*memorativa*), awaiting an unknown future and remembering a distant past, whereas God's cognition is neither "expectative" nor "memorative," since the past and future are always present to him.[38] De Rivo elaborates this view through the example of knowledge about an eclipse. Human knowledge of a future eclipse is separated from the event of the eclipse by "an intervening line of succession which makes the eclipse distant from our cognition."[39] Divine "foreknowledge" of such an event, however, is in no way to be understood as occurring before the event through a "line of succession," since "all future things are, in respect of divine cognition, immediately present."

This view of time allows de Rivo to address the question of the truth of future statements in prophecy and in the creeds.[40] This is a real pastoral problem, since the argument that statements about the future do not have "determinate truth" might disturb faith by undermining the truth of statements like "the Antichrist will be born" or "the dead will rise again."[41] To address this pastoral difficulty, Peter de Rivo explicitly moves beyond the philosophical context of the faculty of arts and into the domain of theology, drawing a distinction between propositional truth, under the rules of Aristotelian logic, and eternal Truth, as described by the doctrine of the church.

De Rivo begins his distinction by stressing the distance between human knowledge and divine knowledge, this time by underlining the inability of human logic and language to capture the nature of God's temporal knowledge. The heart of the problem is the tense structure of language. "Since . . .

there is no expectative cognition in God . . . it seems to follow that his cognition is not properly expressible by a future tense proposition."[42] According to de Rivo, the prophets were aware of this difficulty and so used not only "future-tense propositions, but sometimes . . . the past, as in Isaiah 9: 'Unto us a child has been born.'"[43] God's eternity introduces complex tense confusions into human discourse, signifying that the prophets could find "no proposition by which they could properly express God's cognition of future things." If, however, such statements are "not true by virtue of their own truth and by logical rigour," they do have truth by another standard, that is, by the intent of the prophets and authors who were not intending propositional truth, which is "created truth," but "uncreated Truth." Uncreated truth, the truth of God's unique eternal existence, is the goal of all prophetic and credal statements, and to that end, such statements must continue to be held true.

Although we cannot say with absolute certainty that Varenacker shared Peter de Rivo's views, they certainly correspond with the intent of the 1447 university statute, which Varenacker drafted. On the basis of his role in drafting the statute and his support for de Rivo's views, Varenacker was called to appear in person at the papal curia in 1472.[44] Varenacker's continued support for de Rivo and his beliefs can be found in a 1471 opinion, preserved at the head of a set of opinions on future contingents from other professors in the faculty of theology at Leuven.[45] In it, Varenacker responds to the controversy over future contingents in three ways. First, he argues that Aristotle's view of future contingents is consistent with the catholic faith, dwelling initially on the question of determinism. For Varenacker, Aristotle demonstrates that if statements about the future can be determinately true, "all things would come about of necessity." This must be avoided, not only for its philosophical difficulties, but also for its theological and pastoral implications: if future events are determined, "men would easily persuade themselves there was no need to be concerned about their salvation and other things they should do." For Varenacker, then, how the future is imagined has profound implications not only for the present, but for the future of the soul. Varenacker mirrors de Rivo's account by drawing the distinction between the indeterminacy of future contingents, except where they rest upon the "uncreated Truth, which is utterly certain." This distinction is based on an implicit theory of the certainty of "divine foreknowledge" and the contingency of human natural existence. Second, Varenacker stands by the 1447 statute. It "seemed to [him] consistent and useful for the college to the end that solid doctrine be preserved at the University of Leuven." Third, Varenacker shows that he was present at Peter de

Rivo's quodlibetal discussion in 1465 and was aware of the written treatise drafted afterward, which contains Peter de Rivo's explicit theorization of time. According to Varenacker, that treatise was not contrary to the catholic faith and "contained ... many things ... which after careful consideration seem[ed] to [him] useful."

We cannot at present chart the views of Giles Bailluwel, Varenacker's co-advisor on the altarpiece of the Holy Sacrament, in anything like the same detail. Although he appears on the sidelines of the debate, there are no descriptions of his views on future contingents. The three references that I have been able to trace suggest an association with the opposite side of the debate. Giles first appears in November 1446, charged, alongside de Rivo's rival Henri de Zomeron, with "teaching for some time now propositions offensive to the ears and contrary to the common opinion of doctors and philosophers, and prejudicial to the honour of the faculty and even of the university."[46] Which one of the numerous debates or propositions censured in the 1447 statute Giles may have been associated with is, however, difficult to determine. Giles's only other appearance in the records once more links him to Henri de Zomeron. When Henri traveled to Rome in late 1470, Bailluwel taught his courses. Again, what this implies about the relationship between the two is unclear. Given the strength of the debate, it is odd that Bailluwel's views on future contingents are not recorded, and it is possible that he remained neutral. But since there are at least some links between Bailluwel and the opposite side in the debate, it is worth attempting to reconstruct de Zomeron's views on time. This is not simply useful because of the direct connections between Bailluwel and the Bouts altar. By considering both sides of the debate, common assumptions about the temporal structure of human existence emerge. These, in turn, suggest some possible creative responses to, or readings of, Bouts's altarpiece. What might a viewer like Henri de Zomeron see in this image? How might we recreate the experience of a viewer like Peter de Rivo in front of the altar?

De Zomeron's understandings of time are not as explicitly formulated as de Rivo's. What can be discerned is articulated in his 1470 treatise *Against the Opinion of Peter de Rivo on Future Contingents*.[47] For de Zomeron, de Rivo's application of Aristotelian language ultimately undermines the "absolute truth" of statements of faith made about the future. In rather more heated language than de Rivo's, de Zomeron takes de Rivo's distinction between propositional truth and uncreated Truth to be an attempt of "this most pestilent snake ... to hide and conceal his venom."[48] The venom is that, by strongly suggesting that God in his eternity is unable to have "expectative" knowledge of the future, de Rivo is not only diminishing the

breadth of divine freedom and knowledge, but also undermining the normative understanding of God's foreknowledge. The key difference between the two positions is over the meaning of eternity, and how it relates to human language about time. For de Zomeron, God's mode of cognition in his eternity includes awareness of the temporal situation of events, and is able to be described as expectative, since eternity always precedes time. It is therefore acceptable to describe the statement "the Antichrist will be damned" as true in relation to human time, since God has foreordained it in his eternity, and in relation to the flow of human time.[49]

VISIONS OF TIME: THE BOUTS ALTARPIECE

Equipped with some of the nuances of temporal understandings among Leuven's theologians in the second half of the fifteenth century, we can now return to contemplate Bouts's altarpiece. The central panel shows Christ celebrating the Last Supper with his disciples. Christ blesses a wafer, while an empty pewter dish for the Passover lamb sits in front of him on the table. Two members of the Confraternity of the Holy Sacrament stand in the room, one behind Christ to his right, the other by the door in the right-hand corner of the image. Two further members of the confraternity are seen through a small window into servants' quarters.[50] Each side panel depicts typological prefigurations of the Last Supper. On the upper left, Melchizedek brings blessed bread and wine to Abraham.[51] A cavalcade stretches out on the road behind Abraham leading beyond hills to a distant city, whose buildings recall fifteenth-century Leuven. Behind Melchizedek's assistant are two figures in fifteenth-century dress, possibly Varenacker and Bailluwel.[52] The lower left-hand panel shows six Jews celebrating the Passover feast around a small square table.[53] They are dressed, as specified by the law, ready for a journey, wearing shoes and carrying staves. The leading Jew is cutting open the Passover lamb in the middle of a large pewter dish. On the panel to the upper right, the Israelites gather manna in the desert.[54] High above, at the rear of this panel, God looks out over the scene below through a bright rent in the clouds. Below, Elijah receives food from an angel as he sleeps under a broom tree in the desert.[55] In the upper right of the scene, fortified for his journey, he ascends a path into the wilderness.

There is a striking contrast between the central panel's stillness and the constant movement of the outer panels. In the Melchizedek scene, movement is signaled by the winding path, which draws the viewer's eye back toward the distant city. In the upper right-hand panel, a similar path leads the eye further into the wilderness. In the bottom right-hand panel, the eye

is drawn into the wilderness by a curving path that links the sleeping Elijah with the later scene. In the Passover panel, the dynamic form of the presiding Jew mirrors the serpentine path that leads out from the house where the Passover is celebrated. In each of these scenes, a sense of the passage of time is created by movement and through relations of distance. This visual vocabulary of distance and time recalls de Rivo's and Aquinas's insistence that human experience of time is marked by intervening lines of succession, which make future and past events "distant" from our cognition. According to Aquinas, this distance can be comprehended in human thought only through processes of movement: discursive processes. It is precisely a discursive mode of seeing that is modeled in the relationship between distance and movement on the outer panels of the altarpiece.

This movement is not mirrored in Christ's still, hieratic pose. Unlike the Jews celebrating Passover, the apostles have laid aside their staves, which rest beneath the windows to Christ's right.[56] Christ is paused at the moment of consecrating the Host. He is here both priest and victim in his own Eucharistic sacrifice. Christ performs the rite that embodies his later sacrifice on the Cross (signaled here by the prominent cross on the wood paneling behind him) within a fifteenth-century household setting, with his apostles, and with four donors from a fifteenth-century confraternity. This complex temporal overlay is further heightened by the iconographic form chosen by Bouts for his Christ. Christ is a *salvator mundi*, a type traditionally associated with the risen and ascended Christ. The figure of Christ here embodies a transhistorical temporality, one that resonates with both Aquinas's and de Rivo's description of all time being equally present to the divine cognition.

The relationship of God's present to the discursive world of the Old Testament scenes is a relationship between the old and the new. Bouts's contract specifies that the lower left-hand panel should depict the celebration of the Passover "according to the old law" (*in die oude wet*). Such distinctions were highlighted in the liturgy for the celebration of Corpus Christi, instituted at Leuven sometime in the fourteenth century, and recorded as one of St. Peter's capital feasts in 1474.[57] One clear example comes from the well-known hymn *Pange lingua gloriosi corporis mysterium*, attributed to Thomas Aquinas, which can be found in the surviving fifteenth-century breviaries of St. Peter's.[58] *Pange lingua* resonates strongly with the Bouts altarpiece, particularly in its third verse, which emphasizes the fulfillment of the law:

> On the night of his last supper,
> Reclining with his brothers,
> The law being fully observed

With permitted foods,
To the group of twelve
He gave himself as food
with his own hands.

One verse of *Pange lingua*, the *Tantum ergo*, became strongly associated with Eucharistic devotion and was used independently in a variety of liturgical and extra-liturgical settings. Here, as in the Bouts altarpiece, the old gives way to the new:

Therefore so great a sacrament
Let us venerate with bowed head:
And let the old document
Yield to the new rite:
May faith provide a supplement
For what is lacking to the senses.

The question debated at Leuven, here reformulated in relation to the Bouts altarpiece, was whether the old document gave way to the new only from a human perspective of time (de Rivo), or whether God's mode of cognition, too, included expectative and memorative dimensions (de Zomeron). How, then, are we to interpret the appearance of the Passover in the lower left-hand panel and the Eucharist in this altarpiece? For someone like de Rivo or Varenacker, Christ contemplates the old and the new as continually present. To de Zomeron, in addition to God's presence, the Passover might also show God's foreknowledge of the truth of the Eucharist through his actions in instituting the Passover, and his memory of the Passover in the institution of the Eucharist.

The latter interpretation can give rise to readings of the divine figure in the upper right-hand scene of the Israelites gathering manna in the desert. Here, like Aquinas's God who views "in a single glance a whole caravan of passing travelers," God is situated above the temporal scene. Given his privileged vantage point at the upper right of the whole altarpiece, we might even see God as looking beyond the frame of his own panel to gaze out over the whole painting, comprehending the complex patterns of time that run through and between images, and looking forward to the time when the typological truth embodied in each scene will be fulfilled. The former interpretation sees Christ as the eternal center, comprehending typological relationships as complex reflections—present images reflecting themselves, as in a mirror.

Indeed, the image of a mirror appears in de Rivo's explanation of the act of divine cognition. "God is to be understood as a sort of mirror in which all things succeeding one another in the whole course of time have images shining back, a mirror indeed directly beholding itself and all the images existing in it."[59] The Passover dish in the center of the table in the central panel, rounded and filled with the blood of the Passover lamb, is one such mirror embedded in the Bouts altarpiece. This dish resembles the form of fifteenth-century convex mirrors, and symbolically mirrors Christ's "future" shedding of blood on the cross, which is present at the moment of consecration. At least two further mirroring processes are constructed by the liturgical and architectural situation of the altarpiece. First, in the rite of the mass, the elevated Host would appear in front of the image of Christ consecrating the Host. In a liturgical performance of divine continual presence, physical Host and painted Host could come to mirror each other, under the gaze of the divine Son. Second, the altarpiece stands facing a sacrament house that was commissioned by the Confraternity of the Holy Sacrament and completed in 1450.[60] This architectural mirroring of Host by sacrament house forms the space between the altar and sacrament house as a world "inside" the mirror.

We can see from the example of the altar's interaction with the sacrament house and the *Pange lingua* that interpreting the altarpiece in relation to time involves situating it within the context of its liturgical use. Can we push these interpretations further by considering the Bouts altarpiece in relation to more complex fifteenth-century liturgical music? Despite the thin evidence for polyphonic practice at St. Peter's, viewing the Bouts altarpiece alongside polyphonic music opens up further possible interpretations of time within the mass and the altarpiece. At least one canon of St. Peter's was a composer of polyphony, and records from the fourteenth century show that St. Peter's hired boys to augment its liturgical music for important feasts, often a sign that some forms of polyphony were being performed.[61] Beyond the walls of St. Peter's, both Bouts and other potential viewers of the altarpiece were exposed to performances of polyphony, within ecclesiastical settings and in urban rituals or court entertainments. Might listening to polyphony have informed ways of seeing the temporalities of the Bouts altarpiece?

Christ in the Bouts altarpiece has a similar temporal function to the *cantus firmus* in a polyphonic mass. The *cantus firmus*, a voice usually based on a passage of chant, was used in the fifteenth century to provide the architectural foundation for the composition of other voices in polyphony. It was usually sung by the tenor, sitting within the polyphonic texture surrounded

by altus and bassus. Like the *cantus firmus*, Christ is placed not as the bass of the image but as its tenor, at the center of a polyphonic texture of images. The four images on the side panels create and imply structures of viewing that can evoke structures of hearing in the mass. Just as the eye is drawn to particular details in the texture of the painting—for example, the detail of staves across four of the panels—so too, the ear hears imitative or allusive rhythmic, intervallic, and harmonic patterns across the voices of a polyphonic mass, and through time. Just as each of the outer parts of the mass follow discursive contrapuntal lines, so too the outer panels, with their unifying winding paths, signal the human temporal experience of movement and distance. The *cantus prius factus* has the same kind of cross-temporal range as the figure of Christ, the *salvator mundi*. Present in the fifteenth-century liturgy, a *cantus firmus* also has historical depth, often reaching back to origins in authoritative Gregorian chant. Together, under the unifying gaze of Christ, the various time frames of the images combine to form a complex variety of temporal experiences. In the same way, the harmonic implications of the *cantus firmus* unify and give meaning to the surrounding voices.

This view of the altarpiece as functioning in a way similar to a polyphonic mass challenges the assertion that such art is "timeless" in any simple sense.[62] The Christ of the altarpiece sits within the discursive patterns created by the movement of the disciples at table with him, the movement between time frames created by the presence of the donors, and the movement of the viewer's gaze between the central panel and the times of the outer panels. In Christ's eternal gesture of blessing, in the institution of the Eucharist, eternity comes paradoxically into contact with time. Fullness of time, the relationship between the prophetic typological world of the Old Testament and its fulfillment in Christ and in the Sacrament, is, of course, the most significant "point" of the image. Music helps as an interpretive aid to liberate the altarpiece from the view of the dead "work of art," "frozen" and "still," and to resituate it within the temporal worlds in which it was created and within which it acts.[63]

Considering the altarpiece alongside liturgical music suggests further possibilities for interpreting the altarpiece within the liturgical time of St. Peter's. Charles Caspers has recently drawn attention to ways that the Bouts altarpiece, and Eucharistic piety more generally, related strongly to the Feast of the Transfiguration.[64] This feast became increasingly popular from the 1450s, and its importance in Leuven is signaled by the particular signs of the feast's use in an extant liturgical book from St. Peter's.[65] Its popularity was partly due to its institution as a universal feast in 1457

by Pope Calixtus III, in commemoration of the victory over the Turks on July 22, 1456.[66] In the Bouts altarpiece, on a ledge above the fireplace, to Christ's left, stands a cup evoking that brought by the angel to Elijah. To Christ's right in the same register stands Moses, graven in stone, like the tablets of the law that he holds. Only three disciples focus intently on the events of the institution: John, James, and Peter.[67] In this way, Christ is watched by the three disciples and framed by the two Old Testament figures present on the mountain of the Transfiguration.[68]

Or almost framed: Elijah is, as it were, figured by a figure—a cup. This figuration allows another reading of the image within the temporal framework of the old and the new law. Iconographies of Christ as a mediator between the old and the new, even as the new surpasses the old, depict Christ seated between the tablets of the law and the Eucharistic chalice and Host (figure 2.1). Christ is, in such images, often shown with the traditional attributes of the Judge, showing his position at both the center and the end of time.

A passage specifically addressing the Transfiguration in Jan Varenacker's *Commentary on Wisdom* offers us another standpoint from which to view the altarpiece's resonances with the Transfiguration.[69] Addressing the sticky question of how Moses and Elijah were actually present at the Transfiguration, Varenacker had to negotiate the temporal difficulties of these wondrous appearances. Since the Old Testament recorded Elijah's assumption into heaven, his bodily presence on the mountain was not too problematic. Moses posed a greater challenge: he had died before entering the promised land.[70] Was he somehow resuscitated to make his appearance on the Mount of Transfiguration? Varenacker's conclusion is that Moses' spirit was present in an assumed body.[71] This somewhat arcane problem reveals a crucial "historical" attitude to time: Moses, the Old Testament Jew, is just dead. Any living appearance at the time of the Transfiguration would constitute illusion or anachronism.[72] Neither he nor Elijah was actually present at the historical moment of the Last Supper. The possibility of this kind of reading of the altarpiece within a historicizing temporality will appear again in Chapter Five.[73] But even as the image might confirm a historicizing temporality, the figural presence of the living Elijah and the dead Moses again suggests Christ as a figure spanning time, who is present at the institution of the Eucharist, in the elements themselves and as the one who, in the credal formulation, "will come to judge the living and the dead."[74]

An essential part of the Transfiguration liturgy was the hymn *O nata lux*, sung at both vespers and lauds.

Fig. 2.1. *Christ Seated between the Old and the New Law*, from a Book of Hours (use of Rome), c. 1400–1415, northern France. Free Library of Philadelphia mca 1101031, 103r. Reproduced by permission of the Free Library of Philadelphia, Rare Books Department.

> O light born of light,
> Jesus, redeemer of the age,
> in your mercy receive
> the prayers and praises of your suppliants.
> You who once chose to be clothed in flesh
> for the sake of the lost,
> let us be made members
> of your blessed body.

The opening couplet of the hymn immediately emphasizes Christ's complicated intertwining of time and eternity, by evoking comparison with the Nicene Creed. The creed's confession of Christ as *lumen de lumine* (light of light) forms part of its strong assertion of Christ's coeternity with the Father. But the hymn's emphasis on pre-existence is also coupled with a change in emphasis in relation to Christ's temporality: the one who in the Nicene Creed is *ex Patre natum ante omnia saecula* (born of the Father before all ages) is here transformed into the *redemptor saeculi*, the redeemer of time, the person of Christ who has historically redeemed the world. Yet, even as the historicity of Christ's redemptive act is implied, it is once more transformed by the form of address: a prayer that is addressed to Christ's eternal presence. The hymn, then, like Christ's shining face at the Transfiguration, is shot through with eternity.

The final couplet of the hymn further strengthens the similarity that we have been elaborating and expanding between the Transfiguration and the Eucharist. Listening to the *O nata lux* alongside the Dieric Bouts altarpiece, the imprecation of the final couplet can be transformed into a Eucharistic prayer—in what other way are the members (*membra*) of the confraternity to become limbs (*membra*) of that body they see instituting the Sacrament of the blessed body, than by eating the radiant white Host at the altarpiece's center? This radiant Host, dazzling white, is the source of light that eliminates the need for a candle in the room's central chandelier; it is the promise of transformation into the eternal body born of light.

This kind of desire for incorporation into Christ's eternity through the time of the liturgy is the devotional crux of the Confraternity of the Holy Sacrament. It was continually restated in the prayers for the office of the Transfiguration:

> We await Our Lord and Saviour Jesus Christ who has reformed the body of our humility, reshaped into the body of his radiance.[75]

The verb *expectamus* (we await) is the same used in the Nicene Creed for awaiting the arrival of the last day (*et expecto resurrectionem mortuorum*), yet it is firmly grounded in the past and completed reality (*reformavit*—reformed) of Christ's transfiguration of the human body. Here, in miniature, is the temporal shape of expectation and fulfilment, which we have seen as a key to the visual temporalities of the altarpiece. And in the temporal form of the feast day itself, this text plays an important role in moving from the expectation of participation in the transfigured body of Christ to the fulfillment of that participation, as made possible in the Eucharist.

The language of the Office of the Transfiguration is essentially visual, and it is here that we can return to the understandings of time elaborated through my analysis of the Leuven debate over future contingents. What is offered to humans in the Transfiguration is the glimpse of an eternal intuitive vision of time. It is this transformed vision that is the sign of incorporation into the transfigured body. So, taking the words of Paul, the office affirms: "we all, indeed, with unveiled face, gazing on the glory of the Lord, are being transformed into that same image."[76]

This kind of vision was associated with both the culmination and the end of time in the third lection for matins, taken from a homily of Bede for the second Sunday of Lent:

> But that "after six days," after which he promised his disciples that he would extend to them the brightness of his vision, signifies that the saints will take possession of the kingdom on the day of judgment, as he had promised them, he who does not lie, God before the times of the world [Titus 1:2]. [Indeed the times of the world] correspond to the six ages. When they are completed, they shall hear his voice saying: come, blessed ones of my father, inherit the kingdom which I have prepared for you from the foundation of the world [Matthew 25:34].[77]

Here, the six days that commence Matthew's Transfiguration narrative allegorically represent the six ages of the world. The Transfiguration, in this reading, is taken to be a *figura* of the end of time, of the kind of vision granted in eternity. Such vision will allow human comprehension of the full course of history in its six ages. Understood according to this schema, the Bouts altarpiece could similarly offer a proleptic glimpse of eternity, comprehending history in a single glance.

The later lections for matins endorse the interpretation of Moses and Elijah that I earlier derived from Varenacker's own *Commentary on Wisdom*.

In the sixth lection, again taken from Bede's homily, "Moses and Elijah . . . signify the oracles of the law and the prophets, which in Christ are completed, and which are now revealed to the learned, and in the future will be made manifest to all the elect."[78] This offers another possible way of seeing the Bouts altarpiece: to those who interpret correctly, the learned viewers of the altarpiece, the correct relationship between completion and fulfilment, old and new, is now revealed. The learned viewer participates to some extent in the kind of insight and clarity of vision granted in the Transfiguration. To some extent: that this caveat is necessary is revealed by the final lection for matins in the office, in a passage from a sermon of Pope Leo I.[79] According to the lection, humans cannot have the divine vision. The Transfiguration is about the destiny of the glorified human body in eternity, not about vision in the present. To approach this eternal vision through the time of the liturgy is, however, the desire articulated throughout the office of the Transfiguration, and incarnated in the Bouts altarpiece.

This desire is tied to the language of the old and the new in the *capitulum* for Sext, in a characteristic Pauline move that applies the language of the old and the new to the life of the individual believer:

> You, taking off the old man with his arts, put on the new, who was created to follow God in justice and in the holiness of truth.[80]

This temporal language of the old and the new, combined with clothing metaphors resonant with the Transfiguration, had profound social implications in a fascinating episode that can be reconstructed from two short entries from Leuven's town accounts.

In 1437, money was given by the town for linen to clothe a Jewish convert, Peter van Sinte Peters, who had been baptized in St. Peter's.[81] Jews were not normally present in Leuven in the fifteenth century. Expelled from Brabant in 1370 after accusations of Host desecration involving the Jewish communities of Brussels and Leuven, Jews did not officially return to Leuven until the sixteenth century.[82] In this world, Peter van Sinte Peters was literally clothed by Leuven in a new identity, an identity that neatly involved the town's major domestic product. By clothing the Jewish body in Christian garments, the symbolic transformation enacted in Peter's baptism was complete: absorbed into the body of Christ in baptism and clothed in its linen, Peter van Sinte Peters could become a living embodiment of the movement from the old to the new in fifteenth-century Leuven.

Later in the fifteenth century, the Bouts altarpiece was itself reclothed. The outer panels with the commissioned scene of the showbread were

apparently never completed. Instead, in 1486, a payment is recorded to Dieric Bouts's son, to paint the outer panels gold.[83] The use of gold was, of course, a way of showing the work's preciousness. But it could have more specific meanings in this context as a figure of the transfiguring glory of eternity in late medieval depictions of the Transfiguration, like this image from a copy of Jean Gerson's *Monotessaron* (plate 2).[84]

This image, which appears in a lavish manuscript commissioned by Raphael Marcatellis, Abbot of St. Bavo's in Ghent and an illegitimate son of Philip the Good, shows Christ's earthly face shining with gold.[85] What is astonishing about the image is that the heavenly face above Christ is not depicted in gold, or even surrounded by gold, as is usual elsewhere in the manuscript. Instead, the clouds open to reveal God in an iconic form similar to Christ's face as portrayed in the Bouts altarpiece.

When viewed in relation to the Feast of the Transfiguration, the post-1486 golden panels of the Bouts altarpiece might be understood as showing the glory that shines out from Christ's human form within. But when read in conjunction with the image from the *Monotessaron*, another interpretation perhaps emerges. The *Monotessaron*'s Christ in his human person dazzles his disciples on earth with the radiance of eternal light, while offering a vision of his Father in heaven through the face of his human Son. What is offered, then, in this transfigured reading of the altarpiece, is an approachable human face behind the glory, and the possibility of a human translation to the eternal perspective of the divine and human Son.

The desire to reach this eternal home was, of course, a central motivation for the chapels of the Confraternity of the Holy Sacrament at St. Peter's. These were confraternity chapels, communities of memory designed to reduce the time that the souls of the departed members spent in purgatory. A central way of helping release souls from purgatory in late medieval piety was the performance of masses for the souls of the dead. Here we can develop an interpretation of the altarpiece that makes its fusion of eternity and time a way of addressing the needs of the confraternity. Although the altarpiece must be read as a temporal object, its subject matter did not change from day to day: every day, in the confraternity's chapel, an icon of Christ is present performing the mass. This recalls strongly the biblical imagery of the Epistle to the Hebrews, where the language of Christ as the great high priest is most explicitly formulated. Jan Varenacker wrote an extensive commentary on the letter, and Maurits Smeyers has elaborated its wider significance for the Bouts Sacrament altarpiece.[86] In Hebrews, emphasis is placed upon Christ's once-and-for-all sacrifice, which eliminated the repeated sacrifices of the old law. Christ's eternal role as high priest

is developed in Hebrews by reference to the priesthood of Melchizedek, portrayed in the altar's upper-left panel, and with reference to the passing away of the accoutrements of the temple, which we have seen were to be portrayed on the outer panels of the altar.[87] When placed in the chapel confraternity in St. Peter's, we can read this image of Christ as the high priest continually offering the sacrifice of himself not only as a theological principle making eternal the temporal events of Easter, but also as playing an important social function in recalling and embodying the confraternity's role of making constant intercession for its dead members.

The confraternity did not exist solely for the benefit of the dead. Situating the Sacrament altarpiece in the context of the confraternity's chapels shows how the architectural space of the chapels implied a temporal structure in the confraternity's devotional practice. Entering the church from the south, confraternity members walked around the ambulatory until they came to the first of their chapels. The first chapel was not, however, the home of the Bouts altarpiece of the Holy Sacrament. Instead, it housed another of Bouts's works, the Erasmus altarpiece (figure 2.2).[88]

Commissioned before the Sacrament altarpiece, this altarpiece depicts the martyrdom of St. Erasmus by windlass. Modern interpreters have linked this altarpiece to a confraternity member, Erasme van Brussele.[89] But there is a convincing case that the altar was commissioned by Ghert van Smet, the schoolmaster of St. Peter's and a confraternity member, and later given to the confraternity.[90] Ghert donated masses to be sung on the feasts of the saints represented in the image: Jerome, Erasmus, and Bernard.[91] Ghert's commission shows how personal devotion to particular saints could shape the liturgical time of the believer's year, and how this time was shaped by the presence of devotional objects like the altarpiece. But the meanings of the Erasmus altar cannot be completely circumscribed by its possible donors, particularly given St. Erasmus's explicit links to Eucharistic piety.

The confraternity's first chapel had been dedicated to St. Erasmus from 1433, significantly earlier than the commission for the Erasmus altar. This reveals the close link between St. Erasmus and the Eucharist that existed in fifteenth-century devotional practice. Suffrages to St. Erasmus were linked to receiving the Sacrament in the final hours of life and to indulgences. According to a rubric in one fifteenth-century book of hours:

> Anyone who reads this prayer [to St. Erasmus] every Sunday with devotion and contrition in his heart, God shall provide him with everything that is necessary, and he will not die a bad or sudden death, and he will

Fig. 2.2. Dieric Bouts, *Erasmus Altar*, before 1464, oil on wood. Treasury of St. Peter's, Leuven. Reproduced by permission of M-Museum Leuven, copyright www.lukasweb.be, Art in Flanders Vzw. Photo: Dominique Provost.

receive the Holy Sacrament and extreme unction, and he will be released from all of his enemies, and he will receive an indulgence of 140 days.[92]

The Erasmus altar, placed before the chapel of the Sacrament altarpiece, formed a temporal space wherein such prayers to Erasmus could be fulfilled in the subsequent reception of the Sacrament.[93] It also filled an important role in the confraternity's function as a community of memory for the dead. By accumulating indulgences through prayers to St. Erasmus, channeled through the altarpiece, confraternity members were shaping a future with a shortened stay in purgatory, as well as gaining the intercession of a saint particularly linked to appropriate death and the Eucharist. This particular prayer was not simply a personal one, but a prayer for one's fellow confraternity members: "and I also dedicate to you, holy martyr St. Erasmus, my soul and my body and all my friends and their works that they might live in prosperity, in peace and in happiness eternally and evermore."[94]

The prayer to St. Erasmus brings into focus another aspect of devotional time associated with the chapels of the confraternity. The rubric makes it clear that the prayer is effective only if offered on a Sunday. The reason for this specification is revealed at the opening of the prayer: "O, holy and glorious martyr of Christ, St. Erasmus, who on a Sunday was offered to death."[95] The specific day of the martyrdom, Sunday, was also the day of the most important mass of the week, and becomes the time when the Saint's intercession will be effective. Here is another example of how sacred time was arranged in analogical structures that presumed the power of the martyrdom endured through time, but with a once-for-all quality linked to a particular historical situation. The Erasmus altar, then, far from being a static image, can be read as forming and being shaped by a fullness of time in fifteenth-century Leuven.

For, like the Sacrament altarpiece, the Erasmus altarpiece persists in and through time. This has been an analytical *cantus firmus* of this chapter: the altarpiece is full of time. So, in the liturgies for Corpus Christi or the Transfiguration, the Sacrament altarpiece could be seen within the unfolding of liturgical time, in conjunction with chants like the *Pange lingua, O nata lux*, and perhaps with sacred polyphony. Like the sinuous melody of chant which, by music's complex relationship with memory, forms curving lines that pass through time, uniting past with present and implying the future, the two altarpieces persist in time, constructing sinuous paths and complex structures of temporal overlay. Like the spatial and liturgical structures that join chapels, sacrament house, altarpieces, priests, and confraternity members, the Bouts altars embed structures of mirroring that

shape the passing of time. How we interpret these structures will depend on how we situate them. They certainly functioned as ways of granting privileged access to the Eucharist for members of Leuven's civic elite, and as a way of guaranteeing future access to corporate structures of remembrance. And they may have functioned, too, for learned viewers from the university like Jan Varenacker or Giles Bailluwel as one of many ways of visualizing complex relationships between God and the world, time and eternity.

CHAPTER THREE

Music, Time, and Devotion: Emotional Narratives at the Cathedral of Cambrai

Sometime around 1470, Gilles Carlier (c. 1390–1472), Dean of Cambrai Cathedral, penned a tract on music entitled *Tractatus de duplici ritu cantus ecclesiastici in divinis officiis* (A Treatise on the Twofold Practice of Church Music in the Divine Offices).[1] The active role accorded to time in the *Tractatus* allows Carlier to propose specific answers to contested questions about music's role in the emotional fabric of the liturgy. Essential to Carlier's discussion of music's emotional meanings is an interpretation of liturgy and history that relies on established Christian emotional narratives. In this chapter, I interpret Carlier's *Tractatus* alongside some of the liturgical practices of the Cathedral of Cambrai in the fifteenth century in order to trace how temporal perceptions were shaped by emotional expectations, and how emotional expectations shaped time.

Fusions of emotion and narrative at Cambrai Cathedral provide a way of integrating the history of time in the fifteenth century with the recent flourishing of research on the history of emotions.[2] Although emotions history has generated a wide range of theoretical reflections, the implications of the ways time structures emotions and emotions structure time require further investigation. On the micro level, the theory of emotional scripts has helped in understanding how emotions change over short durations of time.[3] On the macro level, the temporal regimes of particular eras have been seen as related to the emotional orders of particular societies.[4] But the middle range—the temporal structures of particular emotional narratives that are supposed to evolve, for example, over the course of a year, or a week, or a day—deserve further thought.[5] In this chapter, I attempt the task of connecting emotion and time specifically in relation to the narrative arcs of Cambrai's liturgical time.

The approach of this chapter also speaks to scholarly interest in hearing

or listening to music. The late 1990s and early 2000s saw a flurry of new musicological research into listening and hearing.[6] In these studies, the listener was to be resituated within their social and spatial settings. Yet the analysis of these settings largely did not include sustained reflection on either time or emotions.[7] This has now changed: Emma Dillon's recent intervention, *The Sense of Sound* (2012), holds open the door for medievalists to participate in creative reconstructions of emotional listeners and "listening communities."[8] Following Dillon's lead, this chapter imagines emotional fifteenth-century listeners who can be situated more precisely within narrative structures of time. The emotional narratives of the liturgy and their interpretation and deployment by writers like Carlier were, of course, invitations and directives to feel in certain ways; to understand them is not to circumscribe the multiplicity of affective experience for past listeners.

A prolific author, Gilles Carlier had a distinguished ecclesiastical career.[9] From his engagement with the Hussites at the Council of Basel in the 1430s to his professorship in theology at the College of Navarre at the University of Paris from around 1456, Carlier was a significant theological authority in the fifteenth-century Low Countries. Carlier was a canon of Cambrai Cathedral from 1411, and despite his position at the University of Paris, he was the Cathedral's Dean from sometime in the 1430s until his death in 1472. His continued engagement with the life of the Cathedral can be charted through records of his liturgical foundations, innovations, and in objects donated or bequeathed by him and recorded in the Cathedral's inventories. An inventory of the Cathedral's possessions made in 1541 records a statue of St. Christopher between two angels made from silver, gold, and crystal given by Master Gilles Carlier, Dean of Cambrai.[10] It also refers to Carlier's donation of a cope of white velvet brocaded with gold and images of the apostles and prophets with the caption *Deus in templo inter doctores* (God in the temple among the doctors).[11] In 1446, 1450, and 1464, Carlier made endowments for the Feasts of Corpus Christi and St. Egidius. He wrote texts for a new feast celebrating the various feasts of the Virgin, the *Recollectio festorum beatae Mariae Virginis*, instituted at the Cathedral in 1457.[12] This feast formed part of the Cathedral's complex arrangement of time around the Virgin Mary, which was at the center of its fifteenth-century liturgical reform.[13]

Carlier's treatise on music is found in the early printed collection of his theological writings, the *Sportula fragmentorum* (Brussels: [Brothers of the Common Life], 1479), and in three manuscript copies.[14] The text has had almost no impact on scholarship outside musicology, where it has remained in the shadow of much longer and more widely disseminated texts like those of Carlier's near contemporary, Johannes Tinctoris (c. 1435–1511).[15]

The *Tractatus* begins by setting out a potential conflict between churches whose worship includes choral music beyond simple Gregorian chant, and those whose worship does not. A certain devout man asks:

> Why is it that many churches, as often cathedrals as collegiate churches of secular canons, neglect Gregorian chant, that is, simple chant [*cantus simplex*], while the sweet jubilation and harmonious concord of voices [*dulcis iubilatio armonaque vocum concordia*] sounds forth in the office, when the well-founded religious orders do not observe this rite, but with tearful and submissive voice [*voce flebili et submissa*] they serve God appropriately—even though both are good?[16]

The questioner wants to understand the reasons for differences in musical practice in the liturgy of the church, specifically the distinction between jubilant and tearful voices.[17] As the tract unfolds, concerns about time and emotion become explicit: why might music with different emotional meaning be appropriate in different places at different times?

The *Tractatus*, in fact, addresses a conflict over the relative value of different varieties of music in the church's liturgy with much wider implications for emotional interpretation of liturgical time. After sketching the context of this conflict, I turn to a closer examination of the *Tractatus*, arguing that the emotional variety of music is used to carve out a space where music of both kinds—both the jubilant music of cathedrals and collegiate churches and the tearful music of the "well-founded religious orders"—is appropriate at different times within the church's liturgical life. The chapter concludes by exploring how the emotional language of the *Tractatus* might provide an affective vocabulary and hermeneutic for understanding the complex liturgical music associated with the Cathedral of Cambrai in the fifteenth century. Here, I focus on the flourishing devotion to the Virgin Mary at the Cathedral, prompted by the acquisition of an icon of the Virgin and Christ, the Notre-Dame de Grâce. The aim of exploring such a hermeneutic is to reconnect experiences of music with the temporal structures embedded in the emotional narratives of the liturgy. Emotion and devotion were linked at Cambrai by a variety of highly developed ways of organizing time.

TIME TO REFORM?

Cambrai Cathedral in the fifteenth century was a powerhouse for new liturgical music.[18] In addition to the famous composer Guillaume Du Fay (c. 1397–1474), it also played a role in the careers of well-known composers,

singers, and theorists like Johannes Ockeghem (c. 1410–1497), Johannes Tinctoris, and perhaps in the musical education of the most famous composer of early Renaissance polyphony, Josquin des Prez (c. 1452–1521).[19] The musical life of the Cathedral was fostered by the donation of several feasts with specifications for polyphonic music. Gilles Carlier himself was deeply involved in this process. In addition to endowing a mass for the Virgin Mary, his 1446 endowment for the octave of Corpus Christi specified the singing of a polyphonic mass and a procession in the nave after compline with the responsory *Homo quidam* performed by three choirboys in counterpoint (*in contrapuncto*) before the altar.[20] Carlier's two later foundations for the feast of his patron St. Giles similarly included the donation of motets and hymnody. In 1450, raising the feast of St. Giles to duplex rank, Carlier specified that motets were to be sung at both vespers. The *petits vicaires* were to sing the hymn *Iste confessor cum iubilo* alternating with both sides of the choir.[21] In 1464, Carlier raised the feast to the rank of greater duplex, specifying that the same polyphony be performed.

The inclusion of polyphony in the church's liturgy was not, however, without its difficulties.[22] Reservations about musical "modernization" can be seen, for example, in comments made by the former Bishop of Cambrai, the famous reformer and Cardinal, Pierre d'Ailly (1351–1420). In a treatise written at the Council of Constance, the *Canones reformandi ecclesiam in concilio Constantiensi* (1416), d'Ailly criticized the use of modern hymns (*hymni novi*) in worship, and argued that "generally all newness and variety [*novitas et varietas*] [in the liturgy] should be avoided."[23] D'Ailly's position on church music must not, however, be oversimplified. He was, for some time, the *chantre* at Rouen Cathedral, a role whose responsibilities included the organization and correct performance of the Cathedral's chant repertoire.[24] He was also involved in revising the liturgy during his time at Cambrai. D'Ailly's hand has been seen in the reform of the Cambrai breviary, particularly in changes to the office of the Assumption of the Virgin.[25] This copy of the revised liturgy was later owned by Carlier. D'Ailly also endowed a mass for the Virgin to be sung at Cambrai *alta voce* (with loud voice).[26] Finally, it is possible that the young Du Fay was a member of d'Ailly's retinue at the Council of Constance.[27] It seems clear, therefore, that d'Ailly was not against all music, just music that might be a distraction from the proper order of the church's liturgy.

More thoroughgoing criticism of certain forms of elaborate music can be linked to those "well-founded religious orders" which, as we have seen, were used to frame the opening of the *Tractatus*.[28] Musicologists have drawn attention to uneasy relationships between musical elaboration and the

liturgy in and around the reform movement of the *devotio moderna*.[29] For example, the theologian Denys Rijkel (also known as Dionysius the Carthusian, 1402–1471) was troubled by the practices of *discantus* or *fractio vocis*—the elaboration of a monophonic melody by additional, sometimes improvised, vocal parts.[30] Directly quoting criticisms of *fractio vocis* from the thirteenth-century *Summa de vitiis et virtutibus* of William Peraldus (c. 1200–1271), for Denys, "the breaking of the voice seems to be a sign of the broken soul."[31] This attitude did not, however, mean abandoning all counterpoint. Denys contrasted problematic broken voices with some *discantus*, which "may provoke some people to devotion and to the contemplation of heavenly things."[32]

Denys's largely critical assessment of *discantus* was probably further shaped by musical practices of the type advocated by one of his teachers, Johan Cele (1343–1417), the rector of the city school in Zwolle, a center of the *devotio moderna*. Cele particularly objected to the singing of measured *discantus*:

> One wishes that no *discantus* in precise measures be sung as ecclesiastical song, an exception being made for the lections of the night office of Christmas, and the *Benedicamus* for the same feast, because [*discantus*] brings the joy [*leticiam*] of Christmas into the church.[33]

Examples of this simple multiple-part vocal music made for *devotio moderna* houses suggest a sparse aesthetic even for music performed at Christmas.[34]

Alongside moves like these within the *devotio moderna*, currents of reform were strengthened by the decrees of the Council of Basel (1431–1437/49) concerning the regulation of the church's liturgy. An official copy of these decrees was given to Cambrai Cathedral in the fifteenth century by one of its canons, Robert au Clau.[35] The donation was recorded in an inscription on the inside back cover by Carlier in his own hand. In its twentieth session, held on June 9, 1435, the Council had paid particular attention to the performance of the divine office:[36]

> Therefore, this holy synod ordains that in all cathedrals and collegiate churches at the hour agreed upon in advance with proper signs and suitable ringing, the divine praises for each hour be reverently performed by all those about to recite the canonical hours, not hastily or quickly, but slowly and with seemly pauses, especially in the middle of any psalm verse, making a proper differentiation between a solemn and a ferial office.[37]

The Council's decree thus attempted to regulate the flow of time in liturgical music. It linked tempo and rhythm, the speed of music and its relationship to silence, with a proper sense of devotion in the church's time. Irreverence was characterized by haste and hectic tempi. According to the Council, time within the devotional life of the properly governed church flowed with a slow and reverent regularity, punctuated by times of silence free from distraction.

Beyond the specific requirements of liturgical practice, the Council's decree emphasizes the proper preparation for, and measurement of, liturgical time. The hours are to be announced in advance with appropriate signs and with ringing. Bells play a crucial part in the demarcation of the church's time. The decree includes, like the text of Johan Cele, a sense of seasonal variety in the church's liturgical practice. Christmas, for Cele, was a time marked by joy. Therefore, the singing of *discantus* was appropriate. This sense of variety in the emotional experience of liturgical time is crucial for an understanding of the ways in which time and emotion are interwoven with the shape of the liturgy in Carlier's *Tractatus*.

It must be noted, however, that the Council's decree does not clearly mark emotional difference within liturgical time. But the text does draw attention to the variety of times and places (*diversitatem temporum ac regionum*) where it will be appropriate to wear certain liturgical vestments.[38] Synthesizing Johan Cele and the Basel decree, we can say that the variety of liturgical time is to be marked by changes in music and vestment, judged by their appropriateness to the liturgical season.

In the Cathedrals of Rouen and Paris, musical reforms like those advocated at the Council of Basel had been instituted early in the fifteenth century. Rouen banned some forms of polyphony.[39] In Paris, the Cathedral chapter moved to assert control of polyphonic practice, and delimited when in the liturgy it could be performed.[40] Polyphony was to be performed strictly by leave of the chapter and with the permission of the cantor and the succentor. Gilles Carlier's uncle, Jean Gerson (1363–1429), the famous French theologian and Chancellor of the University of Paris, strongly linked to Pierre d'Ailly and the College of Navarre, was particularly involved in this process of regulation at Notre Dame.[41] In Paris, as in Zwolle, the desire to control music centered on the use of *discantus*.

NARRATIVE NEGOTIATIONS OF TIME AND AFFECT IN CARLIER'S *TRACTATUS*

How then does Carlier's *Tractatus* navigate its way through the complexity and difficulty of music within these discourses? The *Tractatus* begins

its response by arguing for music's importance in "stirring human affects towards God."[42] Carlier positions himself directly and strongly within standard medieval discourses on music and its value, drawing on Aristotle, Augustine, Boethius, and Aquinas. Because different music affects the soul in different ways, it was a healthy decision when music was "introduced into the praises of God, as a means of encouraging the weak-minded to devotion."[43] From the outset, music has a role that we could term "emotional," but which might be more properly spoken of as "affective"—that is, these "emotions" relate specifically to the soul and its direction toward God.[44]

But the tract is not simply a praise of music in general. Carlier is swift to spell out that he is referring specifically to the two kinds of music mentioned by the pious questioner of the *Tractatus*'s opening:

> Both types of music, namely the plain and the jubilant, draw the soul to godly meditation, allowing for the diversity of rank, person, time, and place.[45]

To argue his case, Carlier makes a polemical division between the two types of music, based on their affective qualities.

The text begins with plainchant, associating this form of music directly with lamentation and grief. According to St. Jerome, "a monk's duty is, in fact . . . to lament [*lugere*]."[46] And there are others "who, when God touches their hearts, aspire to spiritual rather than physical monasticism."[47] These people, "both priests and laymen," are suited to lamentation (*luctus*) "and to plain chant [*cantus simplex*]" "rather than joyful music with jubilation [*iocundus cum iubilatione*]."[48] Those who are suited to grieving music also include

> prelates and outstanding teachers, suited to guiding the people by their life and teaching, whose dignity is not suited to putting on a show of lightheartedness for the simple-minded and who, perhaps wrongly, regard musicians as rather lightheartedly directing their jubilation towards the praise of men, not God. Simple chant certainly agrees with them; and this chant, when sung with due humility, the merciful Lord considers most pleasing[.][49]

But, Carlier hastens to stress, the lamentation of plainchant is not the only option: jubilant music is also appropriate. "To enable the human mind to rise above its heavy burden of sighs, God, in his mercy, fills it with inner joy."[50]

To demonstrate his point, Carlier draws on a variety of biblical exempla to chart an emotional narrative pattern in God's action in the world and the corresponding normative human emotional responses. Take, for example, the story of Abraham and Isaac: "though willing to obey, did not [Abraham] suffer the smart of sadness at God's command to sacrifice his son? But did not his joy soon surpass it when God gave his son back to him unharmed?"[51] Likewise, Moses is afraid and sad "when he sees the Egyptians pursuing him and his people, who as they flee are hemmed in near the Red Sea, but his joy was beyond human estimation when the Red Sea gave them a safe passage by parting its waters."[52]

The emotional "journey," a narrative structure that Carlier shows operating throughout scripture, is from grief to joy: "after grief . . . God vouchsafes joys."[53] This movement prompts an interpretive principle for liturgical music. Depending on the time and place, either plainchant (lamentation) or more complex music (joy) may be appropriate. Carlier spells this out in a passage on how place will influence which kind of music should be sung: "the location should also be taken into account. If the land sings, musical [art] is appropriate; for a wrongfully crushed one, the sighing of simple chant is fitting."[54]

We can compare this emotional narrative with the conditions of Carlier's own musical experience. As I have suggested, Cambrai Cathedral was deeply involved with the performance of "complex music." Carlier himself was committed to these musical practices, as his endowments of polyphony demonstrate. All this implies that Carlier might view his current time as one where polyphonic jubilation should flourish—that he sees his land as "singing." This is supported by the vocabulary used in the specifications of Carlier's foundations. The music for the Feast of St. Giles is to be sung *cum iubilo*, just as in the singing land of the *Tractatus* it will be appropriate to hear singing with sweet jubilation.

If Cambrai is in a "singing" land, what of the "wrongfully crushed" land? Here, we need to look to those situations where plainchant is performed. The *Tractatus* specifies one such time at the opening of its argument on the value of plainchant, the exemplum of the Babylonian exile:

> As is witnessed in many passages of scripture, [simple chant is appropriate] if it be prompted by postponement of the heavenly glory for which they long, but, being constricted by bodily fetters as they sit and weep beside the waters of Babylon, they cannot sing a hymn of the songs of Sion in a strange land.[55]

This exemplum may appear not just because of its relevance to the singing of chant, but because it makes sense of parts of the ecclesiastical tradition that had problems with complex multiple-part liturgical music. This image of the Babylonian captivity connects plainchant and critique of jubilation to the tradition of reform generated by conciliarists like Pierre d'Ailly and with links to the *devotio moderna*. These movements for reform grew out of attempts to solve crises like the "Babylonian captivity" of the papacy in Avignon and the papal schism in the fourteenth and early fifteenth centuries, those events conceptualized as a period of exile from proper ecclesiastical order. By linking plainchant and Babylonian captivity, Carlier's treatise carves out a space for negative attitudes toward complex music. They are completely legitimate as responses to the schism and other historical epochs of lament, for example the recent lamentable treatment of France at the hands of the English.[56] But by writing these attitudes into a narrative of emotional change linked to differences in time and place, Carlier also creates a space in his singing land for the practice of elaborate polyphonic music of the kind that was so central to the liturgical life of Cambrai.

AFFECTIVE NARRATIVES AND LITURGICAL TIME

The question then arises: can this kind of affective narrative structure help in interpreting the affective variety of music at Cambrai Cathedral? This included both polyphony and monophony, which does not fit the strict division between plainchant (lamentation) and multi-voice music (joy) suggested by Carlier's *Tractatus*. To take a famous emblematic example: following the disastrous events of 1453, Du Fay composed a polyphonic lament over the fall of Constantinople, which is anything but jubilant. Rather than adopt a reductive typology of the kind chant = sad or polyphony = happy, I argue that it is Carlier's attention to emotional narratives—narratives that provide mechanisms for ordering emotional change within the temporal structures of the liturgy—which might allow more historicized appreciations of the affective power of sacred music.

Such affective narratives and transformations were central to medieval commentators on the church's liturgy and the liturgical year. According to one widely circulated commentary on the mass, the *Summa super missam* (also known as the *Tractatus super missam* or *Speculum ecclesiae*), attributed to the thirteenth-century Dominican theologian and biblical exegete Hugh of Saint Cher (c. 1190/1200–1263), the introit to the mass (sung in plainchant) signifies the longing of the prophets and the desire of the saints

for the Incarnation of the Son of God.[57] Similarly, the omission of the *Gloria* in the mass in Lent signifies the Jewish exile in Babylon, that time when the captives hung up their musical instruments and said, "How can we sing a song to the Lord in a strange land?"[58] In this way, Hugh associated both the opening of the mass and Lent with expectation and exile, with the Jewish time of the Old Testament, which gives way to the New Testament and the post-Resurrection time of Christianity. This kind of fundamental temporal structure, which is also an affective structure, is formed, therefore, in the progression of liturgical time, in the musical time of the mass.

This structure should alert us to problems with the interpretation I advanced earlier in this chapter, which tended to situate difference in time and place in Carlier's *Tractatus* solidly in a modern historical temporality: if the period of the schism was one of lament and the present one of jubilation, then fifteenth-century organizations of emotion, music, and time would (conveniently for the modern historian) reflect broader trends in the historicization of the period. Although Carlier's *Tractatus* does plausibly allude to these historical distinctions between the church's musical practice before and after the schism, it is equally important to see these emotional and temporal divisions within Carlier's *Tractatus* playing out within the time of each individual liturgy and the liturgical year.

When analyzed alongside commentaries like Hugh's, Carlier's treatise gives us a language with which to begin interpreting the complex liturgical music of Cambrai Cathedral within the affective structures of liturgical time. This encourages us to speak about fifteenth-century liturgical music as part of the affective structures of wider narratives, be they historical movements from schism to unity, or narratives of individual masses and the liturgical year—movements from longing to fulfillment, from lament to joy.

How might this language be applied to the experience of liturgical time at Cambrai Cathedral? I will explore possible answers to this question through two short musical examples. The first is drawn from the Cathedral's chant repertory, the use of the Marian antiphon, *Sub tuum presidium*, in conjunction with the Cathedral's most famous image, the Notre-Dame de Grâce. The second is Guillaume Du Fay's well-known *Missa ecce ancilla Domini*, a complex example of the interweaving of established chant with newly composed polyphonic material.

In 1450, Cambrai Cathedral received a donation from Fursy de Bruille, a canon of the Cathedral, of an icon of the Virgin and Christ (figure 3.1). This icon, the Notre-Dame de Grâce, was believed to have been painted by St. Luke himself and was hence considered a *vera icon*.[59] The gift contributed to the

Fig. 3.1. *Notre-Dame de Grâce*, c. 1340, tempera on panel. Cathedral of Cambrai. Reproduced by permission of the Archdiocese of Cambrai. Photo: Vincent Bertin.

increasingly Marian orientation of Cambrai's liturgy. One striking example of this orientation was a liturgical innovation instituted by the chapter shortly after receiving the *vera icon*. The Marian antiphon *Sub tuum presidium* was to be sung every morning after lauds in the Trinity Chapel before the icon (see figure i.4).[60]

Beneath your protection we flee for refuge, holy Mother of God. Do not despise our petitions in our time of need, but free us always from all perils, glorious and blessed Virgin.

The performance of this liturgical action placed each day under the Virgin's protection, and more specifically under her protection as present in the Cathedral in the *vera icon*. How can we think more specifically about the emotional meaning of this chant in conjunction with this icon? Adopting the principles outlined above, we can read the chant as forming part of emotional narratives both in terms of the particular time of the chant, and in terms of its place within wider liturgical time.

The chant melody gives rise to one possible affective structure. It begins by invoking the Virgin's protection, even as the music flees upward from the earthbound singer toward the protective embrace of the golden icon. The opening of the second sentence, setting the text *nostras deprecationes* (our petitions), mirrors the structure of the chant's opening, once more giving the sense of rising prayer. The shift in modal emphasis marked in the phrase *sed a periculis cunctis* (but from all dangers) darkens the affect of the chant. Danger enters with the phrase's departure from the strong sense of the mode's final. But once more, with the return to the glorious and blessed Virgin, the chant reaffirms its modal center to rest again in her protection. One reading of the chant's emotional narrative is thus a movement toward Mary marked by traumatic distance caused by the dangers of earthly life, which achieves partial resolution in the final hope of rest beneath the Virgin's protection. Caution is needed with this kind of approach: the ascending opening phrase of the antiphon is characteristic of other chants in this mode (mode 7). Yet, as with all grammars of expression, simple conventionality does not render each instantiation of the convention meaningless. Conventions do not efface the possibility of affective responses.

When it comes to analyzing the antiphon's affective roles in larger structures of liturgical time, greater interpretive challenges are faced. Are we to hear this antiphon on a Marian feast day, perhaps the Assumption, when the golden icon might depict the *Regina caeli*, the Queen of Heaven? Here, the possible affective inflections of the chant may be modulated into rising triumphant confidence. Or shall we attempt to listen to the antiphon as it sounds at the heart of a penitential season, where singing may be framed by Hugh of St. Cher's Lenten Babylonian exile? Here, the chant might become the impossible song, sung by the church in its penitential exile, each voice pleading with desire and longing for the Virgin's protection. Or, given the constant overlay of emotional and temporal structures within the Christian

tradition, is separation between exile and return, grief and joy, old and new permitted, beyond the very slightest of seasonal inflections? The intensely varied possibilities of the emotional narratives embedded at the heart of liturgical time, combined with the variety of individual emotional responses to music and image, make this a highly productive, if rarely concrete, method of analysis.

Forming another part of the Cathedral's organization of liturgical, devotional, and emotional life around the Virgin, Guillaume Du Fay's *Missa ecce ancilla Domini* was first copied at Cambrai in 1463.[61] One of the first masses by Du Fay to enter musicological discourse in the nineteenth century, *Ecce ancilla* is a *cantus firmus* mass, where a chant (here, *Ecce ancilla*) appears in each mass part surrounded by polyphonic material.[62] As Andrew Kirkman has shown, the reception of such masses has been shaped by a problematic emphasis on their "cyclicity": early commentators on "cyclic masses" like *Ecce ancilla* stressed the unity of form across the mass as an early stage in the development of an aesthetically absolutized music freed from ecclesiastical shackles.[63] Nevertheless, at Cambrai in the mid-fifteenth century, some sense of mass settings as "integrated unit[s]" appears to have emerged.[64] Certainly, *Ecce ancilla* begins each of the parts of the mass with the same polyphonic material, a duet between the *superius* and *contratenor*, before widening into a fuller polyphonic texture around the chant that gives the mass its name, found in the tenor. Might the apparent repetitiveness and integration of this kind of mass pose a problem for interpretations of emotion in music? After all, how could the same duet have been thought to fit both the plaintive *Kyrie* and the joyful *Gloria*? What are we to make of the affective possibilities of this style of liturgical polyphony?

Placed within the affective narrative of the mass, the "same" polyphonic duet of the opening might be interpreted as operating very differently depending on its situation. At the beginning of the mass, in the *Kyrie*, this material is heard for the first time, involving worshippers in processes of expectation and longing (example 3.2). At the close of the mass, in the *Agnus Dei*, the same opening, now perhaps heard four times, might be perceived as full of the whole narrative of the mass, signaling the movement from sin and repentance to the presence of Christ in the Eucharist (example 3.3). The music has also become familiar: no longer experienced as expectation, it can be experienced as the presence of memory, a figure of the Eucharist, fulfillment and joy.

This is not, of course, to say that this is the only kind of interpretation that can be offered for the emotional experience of these movements. Other possibilities are opened up by seeing the music's repetition as part of an approximation to, or embodiment of, God's eternity, where each movement

Example 3.1. Guillaume Du Fay, *Kyrie* (opening), from *Missa ecce ancilla Domini*, c. 1460.

shows the essential temporal continuities within the mass. In this way, the music of the mass might be seen as a kind of divine thread running through the liturgy. The polyphony of the mass might be read as mirroring this interpretation in one of its own compositional devices, the use of a chant *cantus firmus* in the tenor. Here, the chant *Ecce ancilla Domini* provides a repetitive ground that unites each movement in its unfolding polyphony. One question for temporal interpretation at this point is how different temporalities, particularly divine intervention into worldly time, might evoke different affective responses. And once more this opens up the possibility of a spectrum of emotional responses, from lament to joy, dependent on the soul's particular situation in the temporal world. Another direction for affective interpretation is to suggest the possibility of multiple affective responses occurring almost at once in the musical time of the mass. For just as, in some late medieval contexts, divine temporality encompasses the

Example 3.2. Guillaume Du Fay, *Agnus Dei* (opening), from *Missa ecce ancilla Domini*, c. 1460.

Father's grief and the Son's Crucifixion together with the joy of the Resurrection, so too, *Missa ecce ancilla* might be seen as participating in a new kind of emotional fusion that approximates a contemplative vision which, soaring over a purely discursive vision of the emotions' embeddedness in temporal moments, approaches a paradoxical holding in tension of a variety of emotional experiences—joy in grief, grief in joy.[65]

These reflections on the possibility of contextualizing the emotional experience of fifteenth-century music in conjunction with historicized accounts of temporality are first attempts. If it is useful to interpret liturgical music within affective narratives, and alongside wider understandings of time and eternity, undertaking the task in practice will always remain a highly unsettled and creative response, which takes into account the hermeneutics of variety of person, rank, time, and place embedded at the heart of Carlier's *Tractatus*.

This hermeneutic of variety was not, of course, restricted to Carlier's text. The most important articulations of *diversitas temporum* for medieval Europe appear in the writings of Augustine.[66] Just as in Carlier's *Tractatus*, in Augustine's *De doctrina christiana* the meaning of a text or an action must be interpreted in relation to different times, places, and persons.[67] The same hermeneutic appears in Book III of Augustine's *Confessions*, and is alluded to in Book VI of *De musica*.[68] This language of *diversitas temporum* was further developed in relation to music by Carlier's famous uncle Jean Gerson.[69] Gerson's writings on music strongly emphasized the inaudible music of the heart—an instrument for reforming the individual—in contrast to the sensual music of the mouth.[70] According to Gerson, drawing on Pauline languages of the old and the new, the song of the heart is the music of the believer newly transformed by the grace of God; the song of the mouth is that of the old, sinful man. This cannot, however, be linked simplistically to Gerson's attitude toward music in the liturgy. When Gerson does mention contemporary musical practice, he, like Carlier, argues for maintaining its variety, since the diversity of possible Christian vocations also applies to the diversity of songs: "variety of such a kind descends even to the diversity of songs."[71] In Gerson's schema, then, as in Carlier's, music does not have an essentialized value, but a value as part of the relationship of the soul to God. So, for Gerson, the same music may be "new in the mouth of one and old in another."[72] The same is true for a song sung by the same person at different times. Change in time may mean a change of heart, affecting whether or not the song is a sign of the old or the new believer.[73]

Gerson's language of the old and the new believer has strong parallels with Carlier's *Tractatus*. For both Carlier and Gerson, old and new, grief and joy, are aligned as a unifying theological, temporal, and affective structure. This structure also resonates with the views on polyphony of one of its most famous later listeners, Martin Luther (1483–1546). Luther gives us a rare example of how these temporal and affective oppositions between grief and joy, Old and New Testament, were reformulated and transformed into the sixteenth century. Interestingly for a reading alongside Carlier's *Tractatus*, the distinctions between emotions are once more made along the lines of old plainchant and newly composed polyphony. According to Luther, a *contrafactum* of a song by Josquin des Prez, to the text *Haec dicit dominus*, "beautifully comprehends the difference between law and gospel, death and life. Two voices make the plaintive lament *Circumdederunt me gemitus mortis* (the groans of death surrounded me), against which four voices sing *haec dicit dominus, de manu mortis liberabo populum meum* (thus says the Lord, I will redeem my people from the hand of death). It is composed

very well and comfortingly [*trostlich*]."[74] Here, the emotional language has a different inflection—joy is modulated into *Trost* (comfort/consolation)—a move with its own history.[75] But the hermeneutic principle—that music should be read within the oppositions and conjunctions between the old and the new, law and gospel—is the same. So too is the mapping of these oppositions onto affective relationships in music, relationships between lament and comfort, grief and joy.[76] That these kinds of emotional experience are embedded in the musical arrangement of time—that a grieving chant is heard at the same time as comforting polyphony—reminds us that analysis of music, time, and emotion cannot be disentangled.

CHAPTER FOUR

The Advent of the Lamb: Unfolding History and Liturgy in Fifteenth-Century Ghent

In the middle of the fifteenth century, no city in the Low Countries was in need of more comfort than Ghent. Attempting to assert its position against the Dukes of Burgundy, the city had engaged in a devastating war that culminated in the comprehensive defeat of its forces at the Battle of Gavere on July 23, 1453.[1] Following the Ghent war, Philip the Good imposed strict penalties on the town, including massive fines and levies, placing it under an extreme financial burden.[2] Probably in an attempt to regain the rights and privileges held before the rebellion, Ghent campaigned for the Duke to visit the town in the years following its defeat.[3] When he eventually agreed, Ghent constructed an elaborate ritual entry that dramatized the city's penitence, and its desire for reconciliation with the Duke. On St. George's Day, Sunday, April 23, 1458, the Duke was met outside Ghent's walls and led through the city past a sequence of figures and scenes staged by the city and its powerful guilds. The entry, with its complex arrangement of allegorical tableaux along the Duke's processional route through the city, is recorded in a variety of contemporary sources, including two particularly detailed accounts, one in French by the court chronicler George Chastelain, the other, the *Chronyk van Vlaenderen*, by an anonymous author writing in Flemish. As at Cambrai, emotional transformations marked the unfolding temporalities of the entry, this time in the context of fragile and eventful political negotiations. In this chapter, I chart how time was used and formed by this entry celebration as a social reality, and the ways in which the event was temporally mediated in the texts of fifteenth-century historians. In so doing, I trace common languages of time within urban and courtly cultures, and their intersections with liturgy, art, ritual, and text.

Civic entries are a staple of scholars interested in the complicated and conflicted symbolic communication and power struggles between the Dukes

of Burgundy and their urban subjects in the period.[4] And communication and power are always entwined with forging structures of time. The most explicit reflections on time and ritual in Ghent appear in Peter Arnade's study, *Realms of Ritual*. Early in the book Arnade includes a short, suggestive section, "Court Ritual and the Eternal Past," that considers how the Dukes of Burgundy manipulated time.[5] For Arnade, "reality, history, and time were all at the prince's magical command."[6] The cornerstone of Arnade's argument is the insight that "court festivals were constantly shifting the boundaries of historical time and context, using the past as an infinite resource for recrafting the present."[7] But for Arnade, this leads to an "unsettling variety" of ritual temporalities.[8] Here I part company with Arnade. The court's temporalities are only unsettling for a modern historicist temporal sensibility. Nothing suggests that these temporal structures were particularly unsettling in the fifteenth-century Low Countries, for the temporal structures of courtly and civic ritual repeatedly draw on the kinds of liturgical temporalities I have traced in earlier chapters.

Thinking about civic ritual in relation to time and liturgy fits with a broader scholarly reappraisal of liturgy's role in forming ways of "seeing and ... knowing," and constructing historical time.[9] The 1458 Ghent entry itself has been the subject of important studies by Elisabeth Dhanens, Jesse Hurlbut, Jeffrey Chipps-Smith, and Gordon Kipling, yet it is only in Kipling's interpretation that liturgy plays a central role.[10] Kipling's analysis sits within the interpretative tradition inaugurated by Ernst Kantorowicz's wonderful 1944 article on ritual entries.[11] Kantorowicz outlined two structures that he saw as providing the material for medieval Christian entries: a "historical" entry, an *Adventus*, based on Jesus' entry into Jerusalem on the first Palm Sunday, and an "eschatological" entry, modeled on the coming of Christ's reign at the end of time.[12] Kantorowicz treated these two types of *Adventus* separately, although he did allow for possible blurrings of their boundaries.[13] Kipling supplements Kantorowicz's taxonomy with two further categories: epiphanic entries like Christ's revelation to the Magi, and the advent of grace in the world. Kipling predominantly sees the Ghent entry as an example of the apocalyptic entry of the second coming. Clear taxonomies like Kipling's risk creating interpretative blinkers, so rather than discussing particular kinds of advent, this chapter shows how broader temporalities of sacred history and liturgy, with their particular and varied affective structures, help in interpreting representations of the entry. My interest in affect and time also resonates with the nuanced work of Élodie Lecuppre-Desjardin on the affective rhetoric of fifteenth-century entry ceremonial.[14] Lecuppre-Desjardin's

emphasis on emotions harmonizes with Jeffrey Chipps Smith's more schematic reading of the entry as (to adopt Geertz's terminology) a "model of" and a "model for" the transition from Ghent's fear and the Duke's anger to the Duke's forgiveness and Ghent's joy.[15]

In what follows, then, I supplement existing accounts of the entry in three ways. First, by including the liturgy as a model for constructing the time frames of urban ritual, I hope to allow a fuller texture of time to emerge. Second, I show how the complex arrangements of time in the entry are not "magical," but rather part of a considered program where the time of the ruler is symbolically aligned with an intuitive synchronic vision of time from eternity of the kind we have encountered in earlier chapters. Finally, I approach the sources for the entry from a different direction. Whereas previous accounts have focused on the social facts of the entries, I wish to emphasize their textual mediation, the important place of the rich historiography of the period in constructing temporal frames for the interpretation and experience of events like the Ghent entry. Rather than eliminating the social, I ask how these texts might encode structures of time that might both obscure and illuminate other social realities.

It is difficult to determine exactly where an interpretation of the Ghent entry should commence. Scholars tend to begin, following the anonymous author of the *Chronyk van Vlaenderen*, with Philip the Good's arrival outside Ghent on St. George's Day 1458. From this point, the *Chronyck* provides the most detailed account. Several different versions of the *Chronyck* survive. In this chapter, I use the versions written in Ghent in the fifteenth century (GUB mss 433 and 590).[16] The *Chronyck* is a regional chronicle, whose earliest sections were originally written in Latin. It commences with a genealogical and mythical account of the founding of Flanders. By the fifteenth century, the *Chronyck* had been translated into the vernacular, and had become, in the Ghent manuscripts, a history of the relationship between the Dukes of Burgundy and their troublesome Flemish urban subjects. A conveniently clear beginning for the entry is not preserved in the other major source, the *Chronique* of the Burgundian court historian Georges Chastelain.[17] Chastelain's *Chronique* is a history of the Dukes of Burgundy in the high tradition of French royal historiography pioneered by the monks of St. Denis.[18] In keeping with his focus on the Burgundian Dukes, Chastelain spends far more time narrating the negotiations over the entry than describing the unfolding of the ritual itself. In what follows, I examine the temporal structures embedded within and constructed by Chastelain's account of the entry negotiations, before analyzing the entry ritual as

recounted in the *Chronyck*. Complex webs of time founded in the unfolding of desire and fulfillment are the *cantus firmus* for each of these discussions of time and the Ghent entry.

HISTORY AND SACRED NARRATIVE IN CHASTELAIN'S *CHRONIQUE*

Chastelain's narrative organization of the entry reflects his larger vision of history as subject to God's providential and recapitulative intervention. Such a vision of time is clearly articulated in his *Prologue*, which commences at the creation of the world.[19] Thereafter, the *Prologue* charts its course through sacred history as governed by divine providence. The chief narrative structure for this sacred history entails human offenses to divine justice and power, and subsequent returns toward God. This pattern commences with the disobedience of Adam and Eve, which leads to misery for the "long and old days afterwards" (*longs et vieux jours après*) until the time of grace, when grief is turned again to joy.[20] For Chastelain, this is the pattern of the whole history of God's relationship with the Jews:

> So it would not be enough to give an example, not one, not many, whereas over the duration of two thousand years God has thus treated the Jews between hot and cold, now fallen, now raised up, now forgotten, now remembered, ever in lofty and singular mystery, beyond the power of nature and any faculty of human comprehension.[21]

This structure of time also applies to the very recent present. England's aggression and the Hundred Years' War are seen as God's divine scourge for the French (particularly the sinful towns of Bordeaux and Calais), who turn again to implore God's mercy.[22] God frees the French in an action that Chastelain explicitly likens to the Israelites' escape from Egypt and their release from the Babylonian captivity. God's agents in this action are the Duke of Burgundy, Philip the Good, and Charles VII, King of France.

Chastelain writes the Ghent entry into this narrative form. The people of Ghent, like the Jews, languish in their hearts (*languissoit au coeur*), and have labored *par longues et diverses instances*.[23] The Duke's apparent favoring of other towns is for them a new grief (*une nouvelle douleur*). They humbly seek mercy and forgiveness for their past faults (*par misericorde et en oubliance des fautes passées*). When the Duke is unmoved, their sadness gives rise to quasi-liturgical imprecations:

> O would to God that his mercy could be opened toward us and that his highness would deign to know the strong and good love with which we love him![24]

Once more, Philip the Good is cast in the role of divine agent. As God toward the Jews, so Philip has been cold to the people of Ghent. All this changes, however, when Philip relents and enters the city.

Philip's characterization as divinely comprehending time is neatly embodied in a short episode early in the city's campaign to win his approval for the entry. The citizens of Ghent are portrayed as laying siege to the Duke, battering and ramming him with their requests (*hurter et buquier*), recapitulating their military rebellion during the Ghent war. In response, the Duke finally intervenes, stressing that he will show clemency at a time of his choosing.[25] Just as with the recalcitrant Jews, the Lord will relent when the time is fitting. This coloring of time as "right," "proper," or "opportune" forms part of a long-lived cultural plot that sets a qualitative time of the event (*kairos*) in relation to time's normal quantitative flow (*chronos*).[26] A kairotic sense of the time of divine intervention or noble action is heavily emphasized at the conclusion of Chastelain's account of the Duke's motives: Philip senses that by 1458 the hour has arrived for his entry into the city.[27] This sense of timing is not arbitrary—it is modeled on the eternal consistent, patient, and just love of God. Philip's entry is tied to his unceasing love for his subjects, despite their war against him.[28] There is a resonance between this sequence in Chastelain's *Chronique* and the passage from John's Gospel that announces Jesus' determination to enter Jerusalem:

> It was just before the Passover Festival. Jesus knew that the hour had come for him to leave this world and go to the Father. Having loved his own who were in the world, he loved them to the end.[29]

The language of *kairos*—the knowledge of the coming of the fitting hour—is combined with the language of love, in this account of Christ's entry into his rebellious city. Christ comes to suffer, but also to rise, offering redemption to his sinful subjects. It is, then, a neat and most likely orchestrated synchrony that the events of the Ghent entry were originally timed to coincide with Easter.

To underscore this synchronizing of events, the *Chronique* follows this passage with a new chapter, dating the planned time of the entry to the Thursday immediately following Easter:

It was in the month of March in Lent that this meeting took place between the Duke and his great city of Ghent and the day settled for him to make his entry into the said city was the Thursday next after Easter, April 6.[30]

This is to be an entry within the octave of Easter, designed to show Ghent as Jerusalem redeemed by her risen Lord. Ghent's long Lenten exile, with its resonances with the Old Testament history of exodus, is to be ended with the Duke's advent. The sinful city of Ghent, which has tried to kill her Lord, becomes the site of his glorious resurgence. This paschal *Adventus* is not so typical, according to the analyses of Gordon Kipling, who downplays the resonance of Passion and Easter imagery in the *Adventus* tradition, and almost completely ignores the structural similarities between the liturgical seasons of Advent and Lent.[31] But this kind of *Adventus* belongs to a firm tradition of constructing correspondences between the historical time of Easter, as reembodied each year in liturgical celebrations and contemporary politics. So, for example, in the *Chronyck van Vlaenderen*, we read that in 1452, embassies went to the Duke on Good Friday to beg for his grace.[32] By bringing their embassy at this time, the citizens of Ghent were hoping to write their history into the time of Jesus' redemptive act, giving Philip the chance to recapitulate the gift of Jesus' redemption granted to sinners upon the cross.

The Ghent entry did not, however, take place as planned in the week following Easter. On March 27, the start of Holy Week, Chastelain relates that an earthquake in Ghent and all around the city (though, significantly, not elsewhere) cast the timing of the entry into question.[33] Disturbingly, the earthquake was accompanied by St. Bertoul thumping within his reliquary in Ghent's St. Peter's Abbey.[34] There is another resonance here with accounts of Jesus' Passion. In Matthew's Gospel, Jesus' death is immediately followed by an earthquake, accompanied by the opening of tombs and resurrection of the bodies of the saints.[35] The loud banging of St. Bertoul has further significance because of its situation within the liturgical time of Holy Week. As part of the Tenebrae office of the final days of Holy Week, a loud noise (*strepitus*) was made that signaled, for some commentators, the earthquake at the moment of Christ's death. That Holy Week was a time of odd, loud, and tuneless noises is further signaled by the replacement of bell-ringing with wooden clappers from Holy Thursday. Such analogies made Bertoul's noisy display liturgically appropriate, marking a complex interweaving of the temporality of Ghent's history with the times of the Gospel and the liturgy.

But there was an instability: these unexpected miracles disrupt the temporal overlay with the events of Easter that had been so neatly arranged

between Ghent and Philip, and by Chastelain within the fabric of his narrative. The neat chronological progression of time is rent in two by the earthquake and the Saint's unquiet sleep. There is a complicated interweaving of generic convention and social reality here. According to theories of narrative time current in the fifteenth century, the natural order of narration could be disrupted by miraculous events.[36] We have already seen how this could be the case in the chronicle of Leuven's Carthusian house.[37] Other examples can be found in Chastelain's text, where the chronological flow of the *Chronique* is broken by achronological accumulations of strange and wondrous portents.[38] Just as in these texts, the normal flow of time in the organization of the Ghent entry is unsettled by miraculous events. For while such wonders occur to signal the proximity of the time of great events (St. Bertoul is pointing toward "a great future event"), the meaning of that future is unclear. What is in one respect the perfect overlay of liturgical, historical, and biblical time becomes a cause of fear among the people of Ghent. The entry's symbolic strength—the overlay of time—becomes its weakness. The correspondence becomes read as a bad sign (*un mauvais signe*), with repeated emphasis laid on the contemporaneity of the events that "correspond to one another and at the time of [the] entry" (*correspondent l'une à l'autre et sur le temps de ceste entrée*).[39]

Worries over the correct timing of the Ghent entry were not limited to the citizens of Ghent. Early in the negotiations over the entry, the Bishop of Toul worried about the shortness of time between the defeat at Gavere and the possible entry: four years is not long enough; the events are still fresh, and antagonisms might be reignited.[40] Time in this vision could see the fading of motivations for revenge, and the correct time of the entry become a matter of life and death for the Duke. The Bishop fears that the people of Ghent will rise up in vengeance and make an attempt on the Duke's life in the night.[41] Similar suspicions reappear in the days before the entry. Members of the entourage of the Dauphin (later Louis XI), then in exile in the Burgundian territories, visited Ghent to observe the preparations for the entry, and became alarmed by the barriers erected across some city streets. Perhaps this was a plot to trap the Duke. The Duke determined to delay his entry, eventually approaching the city on the afternoon of St. George's Day, April 23, 1458.[42]

The danger of the Burgundian court being trapped by barriers within a town at night can be found in other interactions between urban communities and Philip the Good in the 1450s. As we have seen, fifteenth-century towns sealed their boundaries and restricted movement at night.[43] This was effected by closing the city gates and often by hanging chains across streets.[44] Chains were used, for example, in Mons, as is revealed in the town council

minutes surrounding the visit of Philip the Good for a meeting of the Order of the Golden Fleece in 1451:

> those responsible for hanging the town's chains will be instructed to do so in the event of any commotion, but they will not hang the town's chains by night as is the custom because numerous lords lodged in different places in the town will need to come and go to court often at night and outside normal hours.[45]

Night was a time of potential "commotion," whether internal riot or external attack. But the presence of the Duke made right of passage more important than any threat to order. Here is a distinct difference in the order of time between urban and courtly cultures. Members of the court "come and go . . . outside normal hours." The higher up the social scale, the more time opened out for activity: nighttime becomes less closed, more able to be used. In fact, one feature of time's relationship to power at the Burgundian court is the court's capacity to command every form of time, and to break divisions between classifications like day and night. Much like the courtiers' free passage through the streets of Mons, the time of the Burgundian court was free from some of the chains imposed on time in the urban communities of the Low Countries.

Control over the night was partly a result of the Duke's wealth: he could afford expensive lighting.[46] Both accounts of the Ghent entry place particular emphasis on the lighting of the town and the Duke's movements at night—the *Chronyck* even enumerates the number of torches, a massive 22,517.[47] The emphasis on lights draws attention to splendor and expense, but something is also happening in relation to time.[48] This is particularly clear from Chastelain's *Chronique*:

> The butchers' hall, which is large and spacious, was so full of torches that no one had ever seen such a sight, the whole fish market so decorated and so full of rich ornamentation and figures and torches that it would be difficult to tell you about it except roughly . . . the belfry so full of illuminated torches that it could be seen clearly at night from places from five or six leagues distant, and it seemed to be on fire all around across its whole length and width, for it is a great old edifice, and a fire remained lit on top throughout the night and for the following three days . . . That night the greatest bonfires the city had witnessed to that time were lit all around, and the torch illuminations continued everywhere until daybreak, and on into the next day, sustained by mutual

competition; and each guild seeking to outdo the other, these feasts and
illuminations continued on the third and fourth day up until Friday ...
and men and women sang and danced and turned night into day ... The
Duke was so much at his ease that first night that he went out to visit
the bonfires and the feasts throughout the city accompanied by just two
or three people, for which the people cast themselves down before him
in joy ...[49]

This use of light suggests a further reading of the Ghent entry. By making the night as bright as the day, all time is made visible, brought under the synchronic gaze of the Duke, made a perpetual day, the last, the everlasting day of Revelation.[50] This is the view of divine perception and knowledge of time found in liturgical texts like Psalm 139: the "darkness is not dark to [Philip], and the night is as clear as the day. The darkness and the light to [Philip] are both alike." In the symbolic manipulation of time and the vast array of lights, the town of Ghent opens itself to the gaze of both God and God's representative, where all time is subject to view.

This excursus into the bright night of Ghent has made us leap forward in the entry narrative. I now return to Philip as he approaches Ghent on the afternoon of St. George's Day. As numerous scholars have noted, the Feast of St. George had a rich set of resonances for Philip and the city of Ghent.[51] In 1440, not long before the uprising, Ghent had hosted the Duke in a spectacular shooting tournament in which the city's shooters' guild of St. George had played a major role. The guild embodied the intimate and fractured relations between Ghent's urban elites and the Burgundian court.[52] Rescheduling the entry to the Feast of St. George thus offered a chance at activating a past where relations between the Duke and the city had been warm.

Yet the choice of date for the entry can also be interpreted as a humiliation for the city. For St. George was not simply a symbol for Ghent's shooters' guild, he was also a figure for ducal power.[53] Philip, re-embodying St. George, now tramples down the sin of the city, recapitulating St. George's triumph over the dragon. From the fourteenth century, Ghent's belfry, home to the town's archives, bells, and clock, was topped by a large golden dragon.[54] The importance of this dragon as a symbol of Ghent is demonstrated by its appearance as a distinctive marker of the city's identity in a famous manuscript of the Ghent privileges perhaps given to the Duke of Burgundy as part of the 1458 entry negotiations or celebration.[55] By conquering the dragon of Ghent, Philip becomes overlord of one of the city's major monuments of civic identity, its belfry.[56] The belfry, in its role as archive, was simultaneously Ghent's storehouse of collective memory and the continual guarantor of its

civic freedoms through time. Its bells and clock were the measurers of the city's time, symbols of its economic life and social order. This role of the Ghent belfry as the unified marker of the town's time was reinforced in the fifteenth century with the placement of the city's work, day, and night bells in the tower in 1441–1442.[57] The entry of Philip on St. George's Day can thus be read as integral to his assertion of lordship over the city's economy, its history, its time.[58]

PHILIP THE GOOD AS LITURGICAL LORD OF TIME

Philip's entry into Ghent as the lord of time is signaled from the very beginning of the *Chronyck van Vlaenderen*. The *Chronyck* begins by recording that the Ghentenaars took down the gates as a guarantee of the city's love for their lord and that there would be no threatening rumblings (*murmuracie*) against the Duke.[59] This recalls the language of Revelation applied to the city of Jerusalem that we have already heard in counterpoint with the Ghent entry: "on no day will its gates ever be shut, for there will be no night there."[60] The eschatological timing of the entry was perhaps further underlined by the new decorations of the clock face on the town's belfry, repainted in 1456 with images of the four evangelists in the guise of the four beasts surrounding the throne of the apocalypse.[61] What exactly does this kind of eschatological arrival mean for a history of time? Perhaps the arrival of the eschaton means entry into a timeless frozen eternity? Our readings of fifteenth-century understandings of time have prepared us for something different—a fullness of time, framed by liturgical narratives of desire and fulfillment, which gives way to a contemplative vision of time's plenitude converging to a central point in the apocalyptic figure of the Lamb upon the throne.

The entry proper begins with an address made to the Duke by the town's spokesman, Mathijs de Grootheere, in French. The keynote is the town's desire for the Duke's arrival. They have "long desired [the Duke's] most joyous coming into this [his] great city of Ghent."[62] Now they see "the hour which [they have] so desired."[63] Unlike Chastelain's account, the *Chronyck* swiftly passes over this long period of waiting. There is a leap straight from the disturbing aftermath of the Battle of Gavere—the bodies of those drowned at the battle float down the Schelde to Ghent and are fished out of the river, some too bloated for identification—to the Duke's entry.[64] We might read this absence of time as a sign of the city's trauma following their defeat, as if history had stopped. Or we could see this gap as formed by the expectations of the chronicle genre: although the *Chronyck* emerged in an

urban milieu, it is shaped by the expectation that the time of history is the time of the Prince.[65] In Philip's absence from Ghent, the chronicling of time seems impossible—without the Duke's presence guaranteeing the course of narratable history, the flow of time falters.

The language of desire in Mathijs de Grootheere's speech shifts rapidly into a liturgical register:

> We thank [*nous remerchions*] our blessed creator for the grace which he has granted us this day, for certainly this most joyous and happy entry takes away from our hearts all the doubt and fear which we had that your anger had not yet ceased towards us, but since it pleases you in your most generous grace to visit us, we consider ourselves wholly comforted and reassured that all past time is forgotten and wiped out by your most noble character, for which we thank you [*nous remerchions*] as humbly as we possibly can, offering to you everything which we can and which is possible for us, in other words our bodies, our goods, our wills, and everything that you may be pleased to command of us for life and for death[.][66]

The Duke's mercy is mingled with God's grace, as the *nous remerchions* first applied to the creator is transferred to the town's supplication to the Duke. The aim of the speech is to replace the city's unstable future with the stable pattern of God's mercy. Just as in the narrative structure of Chastelain's history, the desired change is framed in emotional language of a transformation from doubt, fear, and indignation, to blessed grace, assurance, and the certainty of a joyous and happy entry. This, then, is an entry that is not only about eschatological *Advent* in Kipling's terms, but about the advent of grace into the souls of the people of Ghent.

The language of desire is, of course, a keynote of the liturgical season of Advent, and most commentators have taken Advent as the model of a liturgical hermeneutics of *Adventus* ceremonial. But it is equally a language of the season of Lent, where penitence, mingled with a desire for forgiveness, shapes the passage of time up to Holy Week and Easter. So, in the compline liturgy for the octave of Easter, the time originally designated for the Ghent entry, we find the following:

> Jesus, our redemption,
> Love and desire,
> God, creator of all things,
> Man, in the limit of time.[67]

Indeed, the whole language of the liturgy is so saturated with expectation and longing that a strict demarcation of seasonal resonance breaks down. Desire, in the hymn, is the emotional coloring of human time when properly directed to God. It is both the sign of human temporality, and its limit—for when all is transformed into the desire for God, that is eternity.

According to standard contemporary theological understandings, humans should make a temporal pilgrimage through this time-bound life, constantly desiring the pure vision of eternity. The centrality of desire to an ideal Christian life found heightened expression in the times of the church's liturgical year particularly dedicated to desire and hope, Advent and Lent. This kind of fundamental temporal structure, a temporal pilgrimage suffused with desire, was constructed in the progression of liturgical time and theological commentary. Such a narrative of time is found depicted in the manuscript, made for Philip the Good, of Heinrich de Suso's *Horologium* (figure 4.1).[68] In an illustration depicting Suso's vision of his book as a clock, Lady Wisdom stands beside a clock, surmounted by an hour bell and a two-bell *voorslag*. One side of the clock is open to reveal its mechanical system of foliot, wheels, and weights. To attain knowledge of divine—or eternal—wisdom, the weary figure of the pilgrim who signals to the clock's weights with his left hand must regulate his life according to the passing hours, and comprehend the mechanics of time. Time is the medium by which he can attain his desire—the constant presence of Lady Wisdom—and cease being weighed down by the constant circling of the hours.

It is within this kind of world, where attention to the particularities of time is placed in the service of an ascent to an eternal comprehension of time, that we must place the unfolding sequence of tableaux that met Philip the Good as he entered through the first gate of the city, into streets lined with black, gray, and red cloth emblazoned with the text *Veni nobis pacificus Dominus, utere servitio nostro, sicut placuerit tibi* ("Come to us, peaceful Lord, use us to your service, as it shall please you").[69] Divided into three clauses, its appearance throughout the entry fills the procession with a consistent unchanging message. But the text is also in the business of constructing a very particular new future, where the arrival of the Duke inaugurates the city's renewed service. The phrase is thus about a present and a future. When understood within its original narrative setting, in the book of Judith, the text also encompasses the biblical past, and the past of the Ghent war. Judith tells the story of the violent campaign of Nebuchadnezzar's general Holofernes against the Jews. In the opening chapters, Nebuchadnezzar orders Holofernes to threaten with his wrath those nations who had disobeyed his commands.

Fig. 4.1. *Lady Wisdom with Clock*, from Heinrich de Suso, *Horologium sapientiae*, 1448. KBR ms 10981, 4r. Reproduced by permission of the KBR, Brussels.

The people submit, and escape the worst of Holofernes' anger, offering an entry celebration in his honor.[70]

By translating the events of the Ghent war into the biblical past, the organizers of the entry write them into the same kinds of emotional narratives we have seen used in Chastelain's *Chronique*. But there is a further level of nuance here. The church's liturgies commemorate and make present past events. In the mass, as we saw in Chapter Two, Christ's sacrifice on the cross, the sacrifice of the Passover lamb of the Jews, is both commemorated and made present, in a foretaste of the fullness of time in God's eternity. By transposing the events of the Ghent war onto the biblical past, the entry unleashes the transformative potentials of liturgical temporality for the present and future—absolution granted to sinners, a foretaste given of eternal glory.

There is a further complexity here: it can be argued that the Ghent entry was already a commemoration of a past event—the submission of the city to the Duke immediately following the Battle of Gavere. Ghent's survival following the protracted and bitter warfare of the early 1450s was by no means guaranteed. The arrival of the Duke's forces outside the city in 1453 could have meant the city's destruction. Instead, according to the *Chronyck*, the Duke met them "very lovingly" (*zeere minentlijc*), and promised to be a good and true lord, should they be true subjects.[71] The Ghent entry thus involves a double evocation of the past, in exactly the same way that the liturgical celebration of the mass involved a typological past of the Old Testament, and the institutional past of the New. As I have already noted, this multiplication of pasts serves a communicative and political function. The past was, according to contemporary understandings of time, unchangeable. By making the present a mirror of that unchangeable past, the Ghent entry was a means of making the Duke's goodwill toward the city an unassailable past reality, out of which a harmonious future could emerge.

The liturgical framing of the entry is further heightened by the assembly of the city's clerics immediately within the first gate of the city, singing the *Te deum*. The author of the *Chronyck* emphasizes the similarity with the liturgy by remarking that the clerics were dressed in their most precious copes in the manner of a beautiful procession.[72] The clerics are followed by two prophets who point into the city holding banderoles with the texts *Ecce nomen Domini venit de longique* (Behold, the name of the Lord comes from afar, Isaiah 30) and *Canite tuba, praeparentur omnes* (Blow the trumpet, let all be made ready, Ezekiel 7).[73] As others have observed, these prophetic statements invoke the context of the Lord's wrath and apocalyptic entry.[74] But both passages also have more specific liturgical resonances. The Isaiah

passage is an antiphon from the first Sunday of Advent, the very start of the liturgical year. The passage from Ezekiel recalls the antiphon *Canite tuba* for the fourth Sunday of Advent. The blurring of time frames characteristic of both the liturgy and the Ghent entry is evident here; for the first Sunday of Advent is the time of preparation for the entry of Christ into the world in the Incarnation, the entry of Christ into Jerusalem before his Passion, and his final apocalyptic entry into the New Jerusalem at the end of time. Likewise, the text *Canite tuba* recalls both the language of Old Testament prophecy ("Blow the trumpet in Zion, sanctify a fast" [Joel 2]), the sanctification of the fasts of Lent in preparation for the events of Easter, and the apocalyptic last trumpet. Hence it is not possible to isolate a single temporality in the Ghent entry. Rather, it inhabits a time of expectation and fulfillment, of absence and coming presence, which both uses and vaults beyond temporal specificity.

The appearance of the prophets was immediately followed by the first in the elaborate sequence of tableaux within the city's walls. In a scene showing the fulfillment of desire, a beautiful young girl dressed in white comes toward the Duke from a green bower with the text *Inveni quem deligit anima mea* (I have found the one in whom my soul delights).[75] The presence of this figure of fulfilled desire so close to the beginning of the entry disrupts modern readings that see its unfolding as strictly linear. Here is a foretaste of a future culmination, which is in itself the future culmination. The scene also activated, once more, the narrative of St. George, as the Duke meets the innocent maid of Ghent (yet another symbol of the city), freed from her subjection to the dragon of sin.[76]

The Duke, moving now beyond the Waelport and further into the heart of the city, meets a depiction of the prodigal son, kneeling and begging forgiveness with the words *Pater peccavi in coelum, et coram te* (Father, I have sinned against heaven, and against you).[77] Recalling that the entry ritual was originally designed to occur just following Easter, we should not be surprised that this scene has strong connections with the movement between Lent and Easter. This text from Luke was also a matins responsory used on the first Sunday of Lent. It points toward the Father's (the Duke's) forgiveness, and his delight at the resurrection of his Son (Ghent): for the Father in Luke's parable will announce a few verses later, "this son of mine was dead and is alive again."[78] Concluding the first set of scenes with this promise of resurrection, the opening sequence of tableaux charts a movement from Advent to Resurrection.

A similar narrative can be traced in the following two scenes, both of which are announced by the appearance of a prophet. Outside St. John's

hospital, the Duke saw a prophet in green robes with the text *Lex clementiae in lingua ejus* (The law of clemency is in his speech).[79] This clemency is given a historical exemplum in the following scene, showing Cicero praising Caesar for his clemency toward Marcus Claudius Marcellus, a senator who had joined Pompey's rebellion and later abandoned his party.[80] The eloquence of Cicero, kneeling and bareheaded, recalls the oration delivered outside the city walls at the Duke's arrival, and the subsequent lining of the Duke's road with guildsmen kneeling and bareheaded.[81] It is a scene of forgiveness whose biblical overtones are heightened by twelve senators, like the twelve apostles, surrounding the figure of Caesar. Once more, the past is used as a tool for making a particular present. As other commentators have noted, a further nuance appears: Cicero praises Caesar for *diverschen libertheiten* (various liberties) shown to the conquered.[82] Ghent, in the person of Cicero, is here alluding to the possibility that the city's liberties be restored by its ruler, appropriately represented by Caesar, mythical founder of Ghent. Cicero's text, *Diuturni silentii*, is taken from the very start of his oration *Pro Marcello*: "this day, O conscript fathers, has brought with it an end to the long silence in which I have of late indulged." This sentiment finds a fascinating parallel with the textual time of the *Chronyck* itself, which begins to speak following its long silence after the defeat at Gavere. The long silence of this history is, as I have noted already, a sign of the Duke's absence, his silence–

–now broken with the roaring of the lion of the counts of Flanders clasping the standard of the Duke, the lion of Judah, depicted in a tableau that stood across the Holstraat.[83] From the brief foray into secular classical history, the tableau vivant across the Holstraat returns us once more to the language of Easter and resurrection, which we have seen as a crucial "seasoning" of the entry. At the foot of a black lion (the Duke), a white lioness (Ghent, again feminized) lies stretched out, with her three white cubs half-dead (*halfdoot*). Kipling rightly identifies this image as a Resurrection scene: the roaring lion bringing its children to life is a figure for Christ with a strong medieval pedigree.[84] So here again, we meet a structure of organizing time that cannot be reduced to a single temporal frame. It is eschatological—the roaring of the lion mirrors the sounding of the last trumpet—but it also recalls the Easter advent of Christ to his disciples, half-dead with fear.

And so the Duke comes to the third appearance of a prophet, this time beyond the walls of the convent of Our Lady of Galilee.[85] If the keynote of desire had been missed before, it becomes unmistakable with the prophet's text, *Ecce venit desideratus cunctis gentibus et replebitur gloria ejus domus domini* (Behold, the desired of all nations comes, and the house of the

Lord will be filled with his glory).[86] The text from Haggai is an antiphon for the fourth Sunday of Advent, and we seem to be circling in here on another arrival—another consummation—another resurrection. In this scene, the temporal frames of expectation and fulfillment are given a further overlay, the symbolic opposition between the old and the new, which we have already seen used as a mechanism for absorbing cultural change in the fifteenth century. The role of the Jews is again central. The first scene following the prophet is of Abigail pleading with King David for the life of her husband Nabal, who had insulted the King. In the story, after Nabal's sudden death, Abigail marries David. The description makes explicit that this is a *figura*, of the kind we saw in the Leuven *Ommegang*, and it involves Jews: David is armed with Jewish weapons (*ghewapent naer de Joedssche maniere*), while Abigail and her attendants wear necklaces in the Jewish manner (*naer de joedsche maniere*).[87] There is a marked parallel here with the marriage imagery earlier in the entry, the language of desire for the beautiful bride—Abigail—a point made abundantly clear in the *Chronyck*. Thus, the scene of pleading for forgiveness becomes part of a desire-rich prelude to a royal marriage.

This desire is once more signaled as the Duke passes on under the little Torrenpoort. Hanging above the gate is a scroll with the text *Advenisti desiderabilis quem expectamus in tenebris* (You have come, desired one, whom we have awaited in the shadows) inscribed in golden letters.[88] The *Chronyck* attributes this to the Gospel of Nicodemus with the words *In historia resurrectionis. Nicodemus*. This citation has puzzled interpreters of the entry, who have noted that it is similar to passages relating to the harrowing of hell from the apocryphal Gospel, but not a direct citation, unlike the other texts in the entry.[89] But now, armed with an appreciation of the prevalence of antiphon texts and the Resurrection coloring of the entry's organization of time, we can go further. The text in fact comes not from the Gospel of Nicodemus, but from the Easter antiphon *Cum rex gloriae*, the so-called *Canticum triumphale*, sung during the Easter procession and used in other entry rituals across early modern Europe.[90] The chant possibly became associated with the Gospel of Nicodemus through the German tradition of vernacular translations and adaptations of the Gospel that sometimes include the *Cum rex gloriae*.[91] What is certain is that Ghent's chronicler associates the chant with the *Historia resurrectionis*, the history of the Resurrection, thereby emphasizing once more the entry's Easter temporality.

But, as usual, there is more going on here. The harrowing of hell is the leading of the Old Testament Just out of the old and into the new creation, a movement from old to new cast into relief by the historicizing dress of the

David and Abigail tableau. To make the apocalyptic resonances of this resurrection patent, trumpeters play from the top of the gate.[92] Inside, the Torrenpoort is decorated with a blue cloth on which are suns, moons, and stars "in the appearance of a heaven."[93] In a temporal unfolding drawn from the vision of the apocalypse, this new heaven is immediately followed by the vision of a new earth, a massive three-tier tableau vivant taken from the central opening of the famous van Eyck Ghent altarpiece, also known as the Adoration of the Mystic Lamb (figure 4.2). The text of the *Chronyck*, however, gives the altarpiece the name *Chorus beatorum in sacrificium agni paschalis* (The Chorus of the Blessed at the Sacrifice of the Paschal Lamb).[94] We should not be surprised by now to see an emphasis on the Easter sacrifice in the *Chronyck*'s labeling of the picture, nor to see a combination of the language of the apocalyptic advent with the Resurrection, and with the celebration of the mass. This is the temporal landscape in which the Ghent entry unfolds, and its unfolding is motivated by a desire for the fullness of time.

DESIRE AND THE GHENT ALTAR

Because it is the central moment of the 1458 entry, I wish to step back for a moment and reflect on the way in which the Ghent altar might be seen as an architecture of time. This exploration will allow a return to the 1458 entry to consider the ways in which the temporalities of the altarpiece may have shaped the entry, and how its organization of time may have changed, as it moved from its liturgical function in St. John's church into the civic drama of the Duke's entry. I offer this reading not to efface or foreclose other readings, but simply as one way of "thinking with" this altarpiece as an architecture of time. As I see it, the Ghent altar is formed around desire for the liturgical culmination and consummation of reality in a Eucharistic revelation.[95] This desire involves a temporality defined by constant movement—the movement of worshippers, saints, prophets, martyrs, confessors, royalty, pilgrims; the movement of angels; and the sacramental movement of the waters of the river of life. This principle also lies at the heart of the entry's processional logic.

And yet, as Reinhard Strohm has observed, works of art like the Ghent altar also involve a "stillness": "motion and sound are contained in them, but in a frozen form: reduced to an infinitely small fraction of time. Given time, the pictures would start to move, and the music would be heard."[96] Strohm supports his case through the use of music in the altarpiece. The angelic choir and orchestra that form the upper side panels are performing some kind of polyphony. The angelic choir is mid-song; the organist is

Fig. 4.2. *Central Opening*, Jan and Hubert van Eyck, *Ghent Altarpiece*, 1432. Cathedral of St. Bavo, Ghent. Reproduced by permission of Saint Bavo's Cathedral, copyright www.lukasweb.be, Art in Flanders Vzw. Photo: Hugo Maertens.

poised to play a chord comprising the notes F, A, and C. For Strohm, this means that "musical measure determines the precise moment in time in which the whole picture is set." How can we understand this seemingly irreducible tension between the moment—stressed by Strohm—and the sense that the image contains and creates continuous varieties of motion? One way of addressing this problem is to think about how this momentary stillness might activate the desire of the viewer. Movement and time can be reinstated by a desire for the eschatological future embodied in the image. This desire is, more specifically, a desire not simply for the angelic music to envelop the listener, but to move with the congregation toward the center of the altarpiece—the body of Christ, which is the Lamb of God upon his altarthrone. That is, the image can become full of time, movement in space and movement in music, when it is activated by desire.

From another perspective, descriptions of time in the altar as "frozen" collapse when the altarpiece is resituated in a liturgical frame. Placed within these ritual frames, the feast celebrated within the picture is not only a representation of a paradisiacal future time, but is continuous with a "present" contemporary time. Fullness of time in this reading of the image means participating in a dynamic enfolding in the future, which is figured by a desired movement toward the center (Christ), angelic music, and the liturgical present of the paschal mass. Such processes of movement and desire are embedded in the structure of the altarpiece and its relation to liturgical time. The outer panels of the altarpiece depict prophets of the Advent of Christ, together with an annunciation scene. Closed for the majority of the year, and for the whole of the liturgical seasons of Lent and Advent, these panels can be seen as shaping a desire for advent, for the fulfillment of the story inaugurated in the Old Testament. When opened, the object of desire, Revelation's mystic Lamb, is fully present, yet still to be desired. This almost-fulfillment, or presence of fulfillment that is yet to be fulfilled, is figured in the central panel by the constant movement of worshippers, saints, prophets, martyrs, confessors, royalty, and pilgrims toward the Lamb at the image's center.

The language of Hugh of Saint Cher's *Speculum ecclesie* provides words for this form of desire, and links it once more with liturgical time, now not simply at the level of the liturgical time of the year, but in the temporal structures of desire embedded in every celebration of the mass. As we saw in Chapter Three, Hugh reads the drama of the mass as embodying the transformation of the prophets' expectation and desire for the incarnation of the Son of God into the advent of God at the moment of the consecration of the Eucharistic elements. It is just this moment that is imagined in the altar as the angels cense the Eucharistic Lamb-cum-Host of the apocalypse.

The implications of this redemptive end time seem to spill out of the central panel into the side panels of Adam and Eve, and the outer panels of the altarpiece. The expectation that Adam and Eve will be redeemed at the last is shown not only in their presence on the side panels of the altarpiece's central opening, but also in the effect created by Adam's foot, which moves beyond the frame as if he might walk from his enclosure into the future of the central panel. Moving to the outside panels, the Annunciation signals the ways in which the divine Word enters the world through a time of expectation and waiting. This panel, closed over the Eucharistic lamb, and seen during Advent, acts like the body of Mary, enclosing Christ. The time of desire and waiting instituted at the Annunciation is a "full," pregnant time, participating in the future revelation rather than simply concealing it. This is communicated through the images of Old Testament and classical prophets in the ceiling of Mary's room, who demonstrate that the Annunciation is a fulfillment of prophecy as well as the reception of Gabriel's new prophecy, and also through the Marian symbols of glass and water in the room, which model the way in which an outside or present can be transparent to what lies in the future, inside and beyond.

The desire embodied in this outer panel is fulfilled in the incarnated lamb on the altar, which is the sign of the future, and which is discovered in the movement of time from annunciation to revelation, from veiled incarnation to the open altarpiece of the high feast day. That is, the altarpiece embodies physically the liturgical motions of time that mirror the seasons of expectation, waiting and (near) consummation.

This desire for advent is signaled as a contemporary desire by the prospect of fifteenth-century Ghent through the windows of the annunciation panels, in its everyday objects, and by the placement of the central adoration panel in the real physical world of a fifteenth-century countryside. This is the construction of a fifteenth-century present for the biblical drama. The presence of this "real" fifteenth-century time frame shows how desire is figured not as an escape from the body, but as completely bodily, as the extreme realism of Adam and Eve's bodies also suggests. Such bodily realism has a particular function in relation to the varieties of time constructed by the altarpiece. It creates the biblical past as a present, and the biblical future as a future for the present.

How, then, are we to read the *Chronyck*'s description of a massed performance of the Ghent altar, involving ninety actors, at the heart of the 1458 entry? What does it contribute to a history of time? I will draw out three areas of difference and similarity between altarpiece and tableau. Perhaps the most obvious difference is the disappearance of the outer panels, replaced

by the unfolding of the time of desire upon the streets of Ghent: Haggai's prophecy of the advent of the desired one, the Old Testament scene of David and Abigail, and the new heaven of the Torrenpoort. Here, some of the temporal structures of the altar's liturgical form are preserved—prophets still announce the lamb's advent. Yet the presence of the Old Testament scene perhaps places a greater weight on historical change from old to new, and the heaven of the Torrenpoort perhaps provides a more insistent eschatological framing of the image.

Second, the author of the *Chronyck* draws attention to the music of the angelic choir, which this time is heard:

> And ever when the curtains were drawn, these same angels in both choirs next to these figures were singing and playing very melodiously and exactly.[97]

We see here a very old cultural plot in relation to time and music. In harmonious ratios, music offers a bridge between the heavens and the earth, cosmos and human, eternity and time. So, even as the vision of eternity is shut from view, the angels are ever (*emmer*) singing, their music breaking the barriers between the eternal and the earthly liturgy.

Third, the *Chronyck* includes a particularly interesting description of the angels who kneel to cense the altar:

> before each corner of the altar knelt an angel, each of whom had a thurible standing stiff just as if they had swung it in the direction of the aforesaid altar[.] [98]

Even in this physical re-enactment of the altarpiece, it is only music that provides the bridge between eternity and the present. The angel thurifers provide no rising incense; there is no movement here. Perhaps we might say that the desire for movement that is embodied in the altar is also a desire for a smell—for the sweet incense of the altar, of the "real" liturgy of the mass, which is here granted only to vision and hearing, not in a total immersion of the senses.

What emerges in this brief comparison is a complex interplay of fulfillment and expectation, even within the performance of the altarpiece as one of the entry's moments of culmination. As the Duke moves on, he has caught a vision of all time, and yet remains in the middle of the procession's unfolding discursive time.

After the Ghent altar, the Duke passed through a series of further tab-

leaux. Though each is interesting, they do not significantly alter the temporal structures I have already traced. But, at the very conclusion of the entry, a moment in the *Chronyck* provides a kind of closure to this examination of the temporalities of the Ghent entry. At the end of the day, Philip comes to the gate of his residence. Here, he meets a final prophet holding the text *Haec requies mea* (This is my rest), a final liturgical text used in the requiem mass.[99] This text is, of course, about Philip staying in the town overnight, the subject of such anxieties early in the planning of the entry. Here, this potentially difficult time is written into the narrative of God's time, the eternal Sabbath that is the conclusion of the discursive time of the entry—after his labors, having traversed both the space of the town and the flow of time itself, Philip can rest in peace.

CODA AND BRIDGE: AN ANTIPHONAL FROM ST. BAVO'S ABBEY

A similar temporal overlay to that of the 1458 entry can be found in the iconography of an antiphonal made for Ghent's Abbey of St. Bavo around 1481 (figure 4.3).

The antiphonal's first chant, the responsory *Aspiciens a longe* (I look from afar, and behold, I see the power of God coming), is a sign of the apocalyptic coming of Christ and is illustrated by a miniature of Christ's entry into Jerusalem on Palm Sunday. In the margins, a prophet is depicted with a banderole with a text from Isaiah, just like the figures who punctuated the unfolding drama of the Ghent entry. Below him, two monstrous knights are engaged in hand-to-hand battle—evoking, perhaps, the conflicts of the end time. At the base of the page, two monks kneel, presented by their patrons to Christ, who takes an iconographic form closely associated with the Resurrection. Here, then, on one page, the liturgy of Advent unites prophecy, Christ's advent into Jerusalem preceding his Passion, the language of his final eschatological return, and the Resurrected Christ's appearance to the monks of St. Bavo's. Advent, then, is a time when multiple temporalities meet in the performance of the liturgy, opening up to a comprehensive vision of time that unites text, music, and image.

Lest this seem like the loss of time in an "unsettling" ahistorical mélange, it is important to emphasize that this unification of times does not mean the effacement of historical specificity. This opening folio from GUB ms 15 is headed by a banner that announces the date 1481. Thus, the synoptic vision of time evoked by the manuscript includes the historical present of the book's manufacture. It is one of the marginal emblems of time's

Fig. 4.3. *First Sunday of Advent*, from an *Antiphoner* of St. Bavo's Abbey, Ghent, c. 1481. GUB hs 15, 1r. Reproduced courtesy of the Ghent University Library.

extension from prophets to present to apocalyptic future, emblems that gain meaning only through their relation to the central events of Christ's Passion commemorated in the liturgy and the events of Holy Week, commencing here with Christ's triumphal entry into Jerusalem. The language of frame and margin seems useful here: the flow of historical time signaled on the margins of the liturgy gives the structure within which the central events of Christ's life unfold; Christ's history, as unfolded in the liturgy, provides the center that illuminates the meaning of its historical frame.

This historical framing of the liturgy is, of course, subject to the passage of time. So, the dating of the book's present and its construction swiftly passes into memory, commemorating the book's owners and its makers within the life of the monastic community. In this way, the liturgical book becomes a repository of memory, a holder of a communal understanding of time that is repeatedly performed in singing, hearing, reading, and seeing the liturgy. Books play a crucial role in shaping these memories of pasts, presents, and futures, and it is to bookish cultures of time that I now turn.

CHAPTER FIVE

Calendars and Chronology: Temporal Devotion in Fifteenth-Century Leuven

Among the earliest books printed in Leuven was a group of texts specifically about time. In his *Epistola apologetica* (1488), the theologian and astronomer Paul of Middelburg (1446–1534) proposed a radical realignment of the calendar, calling into question whether Christ's Passion and Resurrection had occurred on a Friday and Sunday.[1] Paul proposed that Christ had died on a Monday and risen on a Thursday, creating a full three days in the tomb, just as Jonah had spent three days in the belly of the whale. Paul's texts prompted fierce opposition from the now-eminent Leuven professor Peter de Rivo.[2] De Rivo entered the lists with a detailed computistical work defending the church's teachings on Easter, the *Opus responsivum ad epistolam apologeticam M. Pauli de Middelburgo de anno, die et feria dominice passionis* (A Work in Response to the Apologetic Letter of Master Paul of Middelburg Concerning the Year, Date, and Day of the Lord's Passion) (Leuven: Ludovicus Ravescot, 1488). Around the same time, de Rivo also set out a program for calendar reform, the *Reformatio kalendarii* (Reform of the Calendar). De Rivo's final calendrical salvo, the *Tercius tractatus de anno, die et feria passionis atque resurrectionis* (A Third Tract Concerning the Year, Date, and Day of the Lord's Passion and Resurrection), appeared in 1492. De Rivo's works failed to convince, and with his death in 1500, the controversy died down. Paul's influence, however, continued to grow: his 1513 magnum opus, the *Paulina de recta Paschae celebratione* (Fossombrone: Ottaviano Petrucci, 1513), contributed to calendar reform efforts at the Fifth Lateran Council (1512–1517) and became one of the most important works on the calendar before the 1582 Gregorian reform.

In early histories of calendar reform, Peter de Rivo remained offstage or was cast as a small-town medieval professor.[3] Paul, by contrast, a cosmopolitan Renaissance intellectual who made the journey from the Netherlands

to Italy, a humanist interested in textual criticism of the Bible, and a keen astronomer and astrologer with links to Copernicus, was the man of the moment.[4] Such histories of calendar reform—heavily shaped by the 1582 Gregorian realignment, focused on Italy, and often tied to narratives of scientific secularization—are now being rewritten.[5] This new approach marks Philipp Nothaft's recent study of Christian chronology, *Dating the Passion* (2012). Nothaft's account, which places de Rivo's works in the context of the long history of dating Christ's Passion and calculating the date of Easter, is a lively intervention into a difficult and technical field. But I am after a different kind of analysis: one that integrates calendrical works into a wider devotional world. In this chapter, I therefore place de Rivo's work on calendar reform alongside his extensive engagements with the life of Christ as presented in the Gospels. I neither recast de Rivo as a hero of pre-Gregorian calendar reform, nor debate the merits of his computistical work. Instead, I write de Rivo's work into a cultural history of fifteenth-century engagements with time. I am interested in understanding how de Rivo's texts, produced and read in the reforming milieux of Leuven's university and monastic communities, implied and constructed certain temporalities and forms of temporal devotion.

The chapter begins by showing that two codices on time by de Rivo, now in the Bibliothèque Royale in Brussels and Cambridge University Library, once formed part of a single volume in the fifteenth-century library of the Augustinian Priory of Bethleem at Herent near Leuven. The Cambridge codex contains a manuscript of de Rivo's *Reformatio kalendarii*, a work considered lost until I stumbled across this copy. The discovery that the Brussels and Cambridge volumes were once a single codex allows me to place de Rivo's texts within the context of fifteenth-century reform movements, and more particularly within the devotional milieu of the Windesheim Congregation. Following the structure of this Bethleem "dossier on time," I argue that an intense interest in time and textuality pervades the form and content of de Rivo's monumental biblical synthesis, the *Monotesseron evangelicum de verbo dei temporaliter incarnato* (A Harmony of the Gospels Concerning the Word of God Made Flesh in Time).[6] I then turn to the calendrical contents of the collection, interpreting de Rivo's intertwining of pastoral care, devotional practice, and the correct measurement of time, as they appear in the opening sections of the *Opus responsivum*. This leads to an exploration of de Rivo's program for reform as articulated in his *Reformatio kalendarii*. Here, practical questions of how to institute changes to time's measurement come to the fore. I close by discussing a series of woodcuts from the opening folios of the *Opus responsivum* that

unite scrupulous scriptural examination and calendrical exactitude with intense visual piety. These images, like the texts they introduce, illustrate how the ordering and measurement of time was intimately bound up with devotion and care for the soul in the fifteenth-century Low Countries.

PETER DE RIVO AND THE BETHLEEM PRIORY

Each work analyzed in this chapter once formed part of a collection of texts copied at, and owned by, the Priory of Bethleem at Herent near Leuven. The original contents of this Bethleem dossier on time are known from a list in a fifteenth-century hand on folio 1v of Brussels, KBR ms 11750–51: Augustine's *Super Genesim ad litteram*, Peter de Rivo's *Monotesseron*, his works against Paul of Middelburg, and his *De reformatione kalendarii*.[7] The volume entered the KBR in 1833 from the collection of the Leuven bibliophile Jan Frans van de Velde (1743–1823).[8] But, in fact, the Brussels volume is incomplete. In its current form, it contains only Augustine's commentary and de Rivo's *Monotesseron*; the final texts on the list, de Rivo's *Opera contra magistrum paulum de middelburgho* and *De reformatione kalendarii*, are missing.[9] What happened to the missing half of the manuscript? A copy of de Rivo's *Opus responsivum*, bound with a short manuscript *Reformatio kalendarii* (hereafter *Reformatio*), does in fact exist as Inc.3.F.2.9 [3294] in the University Library, Cambridge.[10] Could this be the missing section of the Brussels manuscript?

Further evidence shows that it is. First, the contents list in ms 11750–51 suggests that the *Opus responsivum* and *Tercius tractatus* were printed: they are the only works described as "given" (*data sunt*) rather than written. The *Reformatio*, in contrast, is clearly identified by the list as a manuscript written by Peter Maes, one of the monastery's numerous scribes. These are the formats found in the Cambridge volume. Second, both volumes were once in the collection of Jan Frans van de Velde, whose catalogue records the printed works of Peter de Rivo on the calendar and the *Reformatio* appearing as a separate volume.[11] This suggests a division of the original volume by van de Velde or a previous owner.[12] Third, the ownership marks of the Bethleem Priory on the Cambridge volume suggest that it formed the final part of a manuscript. The usual fifteenth-century ownership mark, the inclusion of the phrase *pertinet monasterio beatae Mariae in Bethleem prope Lovanium* (This belongs to the monastery of blessed Mary in Bethleem near Leuven), occurs at the base of folio 2r of the Brussels manuscript. At its conclusion there is no ownership mark. The situation is reversed in the Cambridge volume. Lacking any sign on its opening leaf, the text *pertinet*

monasterio . . . appears on the final page of the volume. Placed together, then, the Cambridge and Brussels volumes preserve Bethleem's method of marking ownership on the first and last pages of a volume. Fourth, the sizes of the manuscripts are compatible.[13] Finally, two other surviving Bethleem manuscripts were labeled in the fifteenth century as being copied by Peter Maes: KBR ms 1382–91 and Manchester, John Rylands University Library, ms Latin 476.[14] KBR ms 1382–91 records that Peter Maes was a copyist for part of the manuscript's final section. The hand used there is the same as for the Cambridge *Reformatio*, and traces of the same script can be found in the Rylands manuscript.[15]

Since we can confidently place de Rivo's texts at the Bethleem Priory, what were the characteristics of the community that read and produced them? Bethleem was founded as an Augustinian Priory in 1407, and was incorporated into the Windesheim Congregation in 1412.[16] In 1414, it became the first male Windesheim house to adopt strict enclosure, and thereafter it played an active role in promoting monastic enclosure.[17] The chronicle of the house, now held in Vienna, positions the house's foundation and its support for enclosure and reform in the context of the evil times of the late fourteenth and fifteenth century: the traumas of the Hundred Years' War, the rise of the Hussites, and the papal schism, as well as local troubles in Brabant and the diocese of Liège.[18] Over and against the adversity and evils of the times (*adversitas, malicia temporum*), the chronicle sets up the well-ordered time of its liturgical celebrations, and situates the Windesheim Congregation within a dynamic temporality of constant reforming zeal and the hope for a transformed future.[19]

The priory's reform credentials are shown by its leading role in the controversy over the enclosure of the monastery of Groenendaal near Brussels.[20] Documents relating to the controversy were collected by Wouter Rumelans van Diest, a brother who had professed at Bethleem in 1414.[21] The major protagonists for Bethleem were the eminent Leuven professor of theology Eymeric de Campo and Bethleem's prior, Egidius Boucheroul. The Groenendaal side was represented by its sub-prior, Willem Berwouts van Waalwijk, and a supporting text by Gilles Carlier, Dean of Cambrai.[22] Carlier's reservations were not sufficient to overcome the endorsements amassed by Bethleem: in addition to its own texts on enclosure, Bethleem enlisted the Universities of Cologne and Paris.[23] Crucial political backing came from the Duke of Burgundy, who had actively supported Dominican and Augustinian reform, and had strong ties to the enclosed Carthusian order.[24] In 1447, Groenendaal was finally enclosed. Beyond Groenendaal, Bethleem actively promoted the reform of other religious houses in Brabant.

The house's prior, Henri van der Heyden, was involved in the 1462 election of a pro-reform abbot at the Abbey of Park.[25] Henri also helped reform Leuven's *dames blanches,* and the convents of Oignies and Rolduc.[26] Later in the century, Bethleem's prior, Guillaume Guennes, collaborated with St. Martin's in Leuven to reform St. Gertrude's convent at 's-Hertogenbosch.[27]

Bethleem and its brothers promoted an active academic culture, partly through strong links with Leuven's university. A large number of Bethleem's brothers had been university students.[28] Peter de Rivo's teacher Jan Varenacker bequeathed books to the priory.[29] In addition to his support of Bethleem's enclosure movement, Eymeric de Campo gave lessons there.[30] Bethleem's academic culture was founded in devotion to book learning and manufacture. Reading and writing practices at Bethleem were strongly shaped by attitudes to the written word within the *devotio moderna.*[31] Within this tradition, devotion to books was figured as devotion to the incarnate word, Christ. So, for Thomas à Kempis, reading was an *opus pium*: taking a book in his hands, the reader was like Simeon taking Christ in his arms to embrace and kiss.[32] The monastery produced multiple volumes of devotional texts quickly and without ornamentation in the style of other Windesheim houses. Its brothers also produced and decorated liturgical books for the Priory and for other religious houses, as well as writing liturgical commentaries.[33] A licensed reading program survives for novices at the monastery of St. Martin in Leuven, with which Bethleem had close ties.[34] This program included books of the Bible, the Fathers, and a limited number of devotional works, among them Suso's *Horologium,* which, as we have seen, played an influential role in reformed monastic piety.[35] Precisely these kinds of texts, including a number of copies of Suso's *Horologium,* are listed as copied by Bethleem's brothers in the Priory's chronicle.[36] Indeed, the chronicle itself is a witness to a memorial and devotional understanding of recording the passage of time at Bethleem.[37]

In fact, the priory of St. Martin's provides yet another link between reformed monastic culture in and around Leuven and Peter de Rivo. Among the works in St. Martin's library was de Rivo's earlier exploration of the chronology of Christ's life, the *Dialogus de temporibus Christi* (A Dialogue on the Times of Christ) (1471), written before his print war with Paul of Middelburg.[38] This text, a dialogue in three parts between Paul, a Christian, and Gamaliel, a Jew, investigated controversies over the correct dating of Christ's birth, the year of his death, and the hour and day of Christ's Passion. The *Dialogus* is witness to a wider interest in the correct timing of Christ's life in fifteenth-century Leuven, and was the groundwork for de

Rivo's later explorations of calendars and chronology that are the subject of this chapter.

TEXTUAL TEMPORALITIES IN PETER DE RIVO'S *MONOTESSERON*

The reconstruction of the Bethleem collection situates de Rivo's works within the reforming monastic milieu of the *devotio moderna*, within a community familiar with discourses on time's crucial place in devotional life. It places de Rivo's works on calendar reform back where they belong: in the context of the intense scrutiny of scripture found in de Rivo's *Monotesseron* and in Augustine's *De Genesi ad litteram*. If time has been unkind to de Rivo's texts on calendar reform, their association with debates about calendrical evolution has at least meant they were not forgotten. Time has been less kind to his *Monotesseron*. Split from the calendar controversy by modern disciplinary divisions and by its literal division from its binding-fellows, it has never to my knowledge been studied.

De Rivo's *Monotesseron* introduces a theoretical problem seen in a slightly different mode in earlier chapters. There, we encountered questions of how explicit reflections on time and its measurement intersected with the social rhythms and habitual actions that form perceptions of time. Similar problematics emerge in relation to the *Monotesseron*. De Rivo's text is quite explicitly about time, about reframing the temporal discrepancies across the Gospels into a single *cursus*. This leads de Rivo to focus on the mechanics of temporality within texts at multiple levels, from the meaning of adverbs to the variety of discourses within the Gospel narratives. But the text also implies structures of time through the various processes of reading enabled through its tables, its prologue, its rubrics, and its referencing apparatus. These materials often depend upon and construct forms of time consonant with the social role of the text within communities like Bethleem, communities formed by liturgical and devotional reading practices. The following interpretation of the *Monotesseron* attempts to understand temporality at all these levels: the interpretation of textual time that dominates the content of the text; the processes of reading in time that are implied by the text's form and content; and the ways in which the text connects with temporal structures sustained in social practice.

Only two copies of De Rivo's *Monotesseron* appear to have survived.[39] Bethleem's manuscript, KBR ms 11750–51, seems to derive from an earlier version in two parts possibly associated with one of Leuven's college

libraries, KBR mss 129–30 and 5570.[40] This version, perhaps an autograph, includes substantially more material than 11750–51, including a lengthy collection of introductory tables with concordances between the Gospels, a liturgical table, and an incomplete introductory dialogue on the work between two characters, Simon (*discipulus*) and Peter (*magister*).[41] Ms 5570 includes additional commentary on the text of the last of the *Monotesseron*'s three sections.[42] In my analysis of the *Monotesseron*, I particularly draw on KBR mss 129–30 and 5570 to deepen an understanding of the *Monotesseron*'s temporal structures.

What was the *Monotesseron*? Peter de Rivo tells us in the introductory paragraph:

> The present volume, which encloses in one the four Gospels, is not inappropriately called a *Monotesseron*, since *monos* means one and *tesseron*, four.[43]

The *Monotesseron* was an attempt to unite the four Gospels in one work. It is divided into three groups of one hundred sections (*centenae*), "the first of which finishes at the death of John the Baptist, the second at the resuscitation of Lazarus, and the third in the Lord's glorious Ascension."[44] Each *centena* is "individually comprised of one hundred smaller sections (*particulae*)," making the work three hundred *particulae* long.[45] Each *particula* deals with an episode in the biblical narrative, and is placed in a chronological sequence from the Gospel prologues to Christ's Ascension. Within each *particula*, the concordant texts from the Gospels are placed alongside each other (plate 3).

Such attempts to harmonize the Gospels were not new, as de Rivo acknowledged.[46] In addition to early Christian harmonizations like Tatian's *Diatessaron*, de Rivo was following in the footsteps of the famous fifteenth-century reformer Jean Gerson.[47] Gerson's *Monotessaron* (1420) was printed twice in Cologne in the 1470s and continued to be copied into the sixteenth century.[48] Closer to home, de Rivo's teacher Varenacker had apparently also compiled a Gospel harmony, *Ex quatuor unum*, now lost, and a variety of further Dutch and Latin Gospel harmonies were produced across the Low Countries in the period.[49]

But de Rivo's *Monotesseron* offered something new: it had a new hermeneutic and a new system of organization. Leaving aside hermeneutics for a moment, and focusing on structural change, de Rivo trumpets the virtue of his new system's unification of the temporal flow of the Gospels while preserving the integrity of each Gospel's account. A comparison of Gerson's

and de Rivo's Gospel harmonies shows how this occurs. Gerson orders the Gospel passages in a strict diachronic flow, in a single linear text. He notes which texts are used with letters for each of the Gospel writers' names. In this way, Gerson's text preserves chronology through the spatial figure of the straight line: the reader should read continuously (*debet continue legere*) and thereby experience a single Gospel made from all the Gospels.[50] De Rivo's organization, by contrast, presents multiple lines that flow concurrently down the page.

Another important feature of de Rivo's new *Monotesseron* was the introduction of a lengthy table linking each of the *particulae* to the set lectionary readings for the mass across the liturgical year.[51] As a result, the *Monotesseron* could act as a liturgical book, a complex, interactive temporal object, opened and closed according to weekly shifts in liturgical time. The text introduces the table by explaining that it allows the reader to read the Gospel lection for the mass "for the whole year, following the order of the church of Liège both in the *temporale* and the *sanctorale*."[52] De Rivo evidently spent some time thinking about what to include in the table, as an earlier version can be found at the end of the introductory dialogue to the *Monotesseron* proper.[53] What was eventually included is an exhaustive table that synchronizes Gospel, liturgical date, Gospel chapter, incipit of the lection, *centena* and *particula* of the incipit, and the Gospel explicit (figure 5.1). Despite this comprehensive treatment, the time of the Gospel and the liturgical lectionary did not always successfully map onto one of de Rivo's *particulae*. Such discrepancies involved further management to coordinate the chronology of Christ's life, the narratives of the Gospels, and the time of the liturgy with the temporal processes of reading.

The gymnastics required to move between liturgy and Gospel are illustrated by an anomaly that arises in the entry for Friday's lection in the week following the first Sunday after Epiphany.[54] The Gospel explicit, which in earlier examples was written in black, is underlined in red (figure 5.1, right-hand column). The lection begins with Jesus' baptism (Matthew 3:13) and continues to Matthew 4:13, including the temptation in the wilderness and Jesus' departure from Galilee following John the Baptist's arrest. According to the flow of time that governs the *Monotesseron*, the different sections had to be transplanted into different *particulae*, provoking a potential difficulty with liturgical time. How was this to be resolved?

The process of reading the lection begins with the liturgical table, from which the reader is referred to the first *centena*, *particula* 24 (plate 3). A marginal note with a reference symbol above Matthew's text has been inserted on this folio, designating the date for the reading. At the end of the

Fig. 5.1. *Liturgical Table*, from Peter de Rivo, *Monotesseron*. KBR ms 129–30, 6v. Reproduced by permission of the KBR, Brussels.

particula, the continuation of the Gospel is marked in red. This text, "then Jesus was led into the desert," is followed by a reference to *particula* 27, which contains Jesus' temptation in the wilderness. This *particula* is visible on the same opening on folio 23r, and concludes with the text "and, behold, angels came and ministered to him. But he." This *particula* in turn refers the reader to *particula* 38, which records the arrest of John the Baptist.[55] The single verse from Matthew 4:12, "but when Jesus heard that John had been arrested, he withdrew into Galilee," is again accompanied by a marginal note and a hash indicating the text's place within the liturgy. This *particula* concludes by referring the reader to *particula* 45, on Jesus' relocation to Capernaum, which is marked again with two hashes that link the passage to the preceding *particula* and to the text's liturgical time.[56]

In this example, de Rivo was making the text legible within two time frames: the historical and the liturgical. This entailed a temporal experience in the physical process of reading the book, where the single time of the liturgy was marked by entering and correlating multiple episodic time frames. This experience resonates with the cross-referencing and correlation of time frames required in liturgical practice more generally. In managing the practicalities of liturgical time, clerical readers of de Rivo's *Monotesseron*, like an Augustinian monk at Bethleem or a university lecturer, also managed the time of the book. And juggling their psalters, antiphonals, lectionaries, missals, and breviaries, readers continually made the flow of liturgical time.

These books, too, implied the formation of certain kinds of subjects, selves formed in the daily practice and maintenance of a complex temporal order.[57] These liturgical selves were constantly re-instantiated by, and experienced through, intricate and detailed organizations of time in turning pages, reading marginalia, following incipits and explicits, and calculating liturgical dates. In this labor of temporal minutiae—what followed what, when a particular antiphon came in the order of time, when in the year a tract was to be sung, when a gradual—the liturgical self was trained to be a master of time. Liturgical subjects formed time through writing, reading, and ritual practices, creating and using texts that themselves ordered time, yet which required the constant oversight of a self who could see beyond each single moment, ascending to comprehend the whole of salvation history as it was reperformed in individual liturgies like the mass, or in temporal arcs of liturgy like the hours of each day, the liturgical week, season, and year. To imagine how this kind of self was formed in a specific community, we need look no further than the network of devotional and liturgical texts that circulated within the Priory at Bethleem near Leuven. Here, the project of de Rivo's *Monotesseron* intersected with devotional reading practices

associated with works like Suso's *Horologium sapientiae*, works peppered with liturgical references, which often blended meditation and liturgy.[58] These texts were read alongside detailed commentaries on liturgical time, within a community formed by liturgical practice and the production of liturgical books.[59]

Beyond the liturgical table, De Rivo introduced two further structural innovations to his *Monotesseron*, both of which involved complicated arrangements of textual time. The first was an indexing system formed by a three-hundred-line abecedarian hexameter poem on the Gospel. This system was likely inspired by Gerson's 150 rubrics on his *Monotessaron* and his twenty-six-line mnemonic system, the *Carmina super totum Monotessaron*. Gerson's *Carmina* was, however, not tied to his particular *Monotessaron*, but rather, like earlier mnemonic summaries of the Bible, used key words designed to prompt the reader to remember the Gospel narrative generally.[60] By contrast, de Rivo's poem encodes within itself his *Monotesseron*'s structure of *centenae* and *particulae*, while also providing an orientation in the narrative of Christ's life. Take for example the dactylic line for the baptism of Jesus: *descendens in eo residet patre teste columba* (Descending on him, the dove rests with the Father as witness) (plate 3). Three letters are rubricated: the opening *d* of *descendens*, the *e* of the first syllable of *residet*, and the final *a* of *columba*. According to the key provided in ms 129–30, the final vowel reveals the placement within the *centenae*: *a* or *e* represents the first hundred; *i* or *o*, the second; *u*, the third. The vowel that sits in the second syllable of the third foot, the usual place for a strong caesura, shows to which *vigena* (a grouping of twenty *particulae*) the episode belongs: *a* for the first twenty, *e* for the second, and so on. Finally, the first letter of each line always signals where the *particula* is within the *vigena*. The line, in its entirety, means that the *particula* is the fourth of the second *vigena* in the first *centena*.

The poem is a complex mnemonic device. The alphabetical index relied on activating the familiar narrative episodes of the Gospels, embedding a numerical structure that correlated narrative time with the arrangement of the *Monotesseron*. De Rivo adds that the mnemonic's key could be written on the hand if one's memory was not developed enough to remember both verses and key. In this way, de Rivo imagines the time of the text being inscribed on the body, activating methods of memorization established by monastic education, in liturgy, devotion, and music.[61] One field where mnemonic texts played a crucial role was calculating the Easter date. An extraordinarily popular example of calendrical mnemonic techniques involving verses and the use of the hand was Ananius's *Compotus*, which appeared in

around thirty-five print editions prior to 1500, and which similarly unites the hand with poetry in a memory system surrounding the calendar.[62] Multiple memories could be inscribed on the same hands—the body becomes the site of layering and (perhaps) erasure of experience. The same hands could perform the devout exercises of Jan Mombaer (c. 1460–1501), whose *Chiropsalterium* mapped affective responses onto the liturgical cursus, and detailed numerical calculations of the correct date for celebrating Easter.[63]

The discussion of time in Augustine's *Confessions* in my introduction drew attention to the way that text organizes time, and the crucial mediation of memory in that process.[64] For Augustine, the "music" of poetic texts, the rhythmic properties that order time through ratio and number, were essential. De Rivo's index poem operates with this same Augustinian grammar. It foregrounds poetic numbers that in turn provide the framework within which the time of the *Monotesseron* unfolds. In this way, the index implies and embodies the kind of hermeneutic employed in this chapter: it brings to the surface the structures of time that order texts. It does this while re-instantiating the narrative of Christ's life—the direct semantic content of the *Monotesseron*—and within the cultural structures of communities where such mnemonic textual and numerical forms were repeatedly used.

The *Monotesseron*'s further organizational innovation was using the alphabet to express the relationship between the Gospel narrative and a supertextual historical time. De Rivo divided each *particula* into *clausulae* that organized the time of the text on a more minute level. These *clausulae* were each marked by a series of rubricated letters, commencing with the letter *a*. To understand the system, we can return to the example of Jesus' baptism (plate 3). A rubricated letter *a* occurs at the start of Matthew and Mark, indicating that if the reader wishes to preserve the flow of historical time they should commence here. *b* is found in Matthew alone, followed by *c* and *d* across Luke, Matthew, and Mark. John, the right-hand column, has independent material, not reconcilable with the narrative time of the synoptics, and is given the letter *e*.

According to de Rivo, this system allows the reader to survey the Gospels and see passages of concordance or apparent dissonance.[65] But it also allows a reading of the Gospels within a single irreversible flow of time, supplied by the alphabet. Yet another kind of reader might comprehend these arrangements of time in a single, almost instantaneous glance: the reader might be drawn above the page to contemplate the arrangement of textual time as a human approximation of the divine intellective vision of time.

There is a strong analogy between the kinds of reading made possible by the *Monotesseron* and the kinds of devotional seeing that were being

fostered by narrative altarpieces like the Brabantine altarpiece of the Passion and Resurrection, which we encountered in Chapter One (figure 5.2).[66] In the altarpiece, the Passion narrative is arranged episodically, and, like the *Monotesseron*, is ordered in time by small letters of the alphabet painted above each scene. The viewer can comprehend the whole Passion narrative, from the entry into Jerusalem to the Resurrection, in a single glance from a stable "place" beyond the historical time of the Passion. But this glance is in some ways deceptive: the devotional path through each of the episodes winds through time and space, drawing the viewer into meditation on particular moments and particular narrative arcs through time. Like the *Monotesseron*, then, the altarpiece is amenable to devotion to the particular in time, and to contemplative vision where time's expanse is subject to an intuitive devotional gaze.[67] This double-seeing is consonant with the full title of De Rivo's text: *Monotesseron evangelicum de verbo dei temporaliter incarnato*. *Temporaliter* in this phrase can mean both temporarily and temporally. The title thus suggests the distinction that has been emerging throughout this book as generative of cultural exploration: the paradoxical temporalization of the eternal word of God.

The paradox of the incarnation is embodied in one final aspect of the text's arrangement: the system of dots that surrounds the rubricated letters. In the opening dialogue to the *Monotesseron*, the interlocutor Simon asks Peter for an explanation of these dots.[68] Peter responds by asking Simon to recall Ezekiel's vision of the four creatures surrounding God's throne.[69] These creatures represent the four evangelists: the lion, Mark, to the right of the throne; Luke, the ox, to the left; Matthew, the man, below; John, the eagle, above. The *Monotesseron*'s dots are placed in the same positions around each letter, showing which evangelist records the material. Peter's description of the dots arranges the evangelists around the throne of God not from the perspective of the viewer, but from the position of the letter itself: the dot for Mark is to the right (.*a*), and for Luke it is to the left (*b*.). The letters thus take the symbolic position of God's throne in Ezekiel, as if the text looks out on the reader. In this way, the *Monotesseron*'s alphabetical ordering of time becomes a symbol of the incarnated word. The letters are the lords of the text's time, while also participating in its construction and its diachronic flow. They create time, yet exist within it.

These transformations in the layout of the *Monotesseron* were explained in its opening: a short introduction to the work, and the dialogue between Simon and Peter. In his introduction, de Rivo argues that nothing is more worthy or valuable than the desire to know about eternal wisdom, which is

Fig. 5.2. *Altar of Christ's Passion*, c. 1470–1490, Brabant, oil on wood. M-Museum Leuven. Reproduced by permission of M-Museum Leuven, copyright www.lukasweb.be, Art in Flanders Vzw. Photo: Dominique Provost.

revealed in the words and example of Jesus. For this reason, each of the four Gospels, the sources for this wisdom, is to be retained in the *Monotesseron*. Nevertheless, Peter states that

> because it might perhaps be pleasant to many if they should see the whole Gospel story in one volume and each occurrence in that order in which it was probably said and done, I have endeavoured, desiring to aid their prayers, to fuse a single text from the four Gospels.[70]

To see the whole Gospel story (*totam evangelicam historiam*): this is the possibility of a devotional vision that situates the Gospels in time, and, in comprehending their detailed arrangements of time, connects with eternal wisdom, as figured in a trans-temporal gaze. In undertaking this visual labor, de Rivo highlights the crucial issue for any attempt to synthesize the four Gospels: chronology, the subject that comes to dominate the opening dialogue. The dialogue is divided into four parts: the first is an introduction to using the *Monotesseron*, which we have already encountered; the second shows why Peter adopts Luke's Gospel as his chronological guide; the third and fourth parts, not present in the manuscript, were to deal with the geography of the Holy Land, and with the *cronographia temporum* of Christ's words and deeds.[71]

These missing parts of the dialogue show de Rivo's intense concern with chronology. Indeed, it is possible that his work on chronology became too detailed to fit an introductory dialogue, since extensive chronological and topographical material appears in the companion volume to ms 129–30, ms 5570, which contains the final *centena* of the *Monotesseron*. It is here that the *Monotesseron* has its first direct intersection with calendar reform. Ms 5570 begins with Christ's anointing by Mary at Bethany. This episode contains important evidence for dating Christ's Passover celebration, the Crucifixion and Resurrection, and, consequently, determining the date of Easter. The introductory verse for the *particula* shows its link to the Passover date: *ante dies ferios pasche fuerat jhesus unctus* (before the days of Passover, Jesus was anointed).[72] The *particula* is followed by commentary on its implications for dating the events of Holy Week.[73] The discussion is amplified in the commentary for *particula* 37, the Last Supper, which is dominated by discussions about dating Passover.[74] Later, the *particula* on the Crucifixion includes a discussion on finding the correct year for Christ's Passion.[75] These commentaries on dating Passover and Passion form one important strand in de Rivo's works on calendar reform.

Nonetheless, the chronological focus of ms 5570 cannot be reduced to calendrical problems. As the commentary on Jesus' Crucifixion reveals, the task of this sacred time reckoning is to map as closely as possible—to the nearest hour—the exact time of the Passion. The Gospel text for the Crucifixion *particula* begins with a reference to time: "and it was about the sixth hour, and there was darkness over all the earth until the ninth hour."[76] Peter explains that these measurements must be understood as historically contingent. The ancient Jews counted the hours of the day from sunrise until sunset, dividing day and night each into twelve hours. During the day, six hours were observed before the sun crossed the meridian, and six afterward. The proof text for this historicization of time's measurement is John 11.9: "are there not twelve hours of daylight?" On this basis, Peter proclaims the historical moment of Christ's death: the ninth hour from the rising of the sun and the third from its crossing the celestial meridian according to the ancient Jewish reckoning.

This attitude to precise timing motivates de Rivo's adoption of Luke's chronology as the framework for his *Monotesseron*. In following Luke, de Rivo departed from the most influential authority for harmonizing the Gospels, St. Augustine. Augustine's *De consensu evangelistarum* used a fluid method, loosely following Matthew, so de Rivo had to carefully justify his change.[77] Simon asks why Luke has been chosen, even though his Gospel was written after Matthew and Mark.[78] Peter explains that, as befits a historian, Luke narrates events in the order in which they occur, and had articulated this principle in his prologue to Acts.[79] Beyond that, Peter sees Luke's divergences from the other evangelists as signaling a distinctive historical attitude to time.[80] Luke's historical attitude to time and narrative, where events are chiefly ordered chronologically, makes him Peter's preferred source for the *Monotesseron*.

Using Luke as the standard of historical narrative had its difficulties. Peter did not need Ricoeur to remind him of narrative's capacity to structure time—he had his interlocutor. Simon pounces on Peter's apparently naive acceptance that historical narration follows the flow of time. Frequently, he observes, historians change the order of events by anticipation or postponement.[81] There are indeed, says Simon, three kinds of narration. The first is that of things done, the second of anticipation, the third of remembrance.[82] Peter agrees. Time's strict diachronic flow can be altered by the organization of narrative. But, he argues, these reorganizations of time already rely on a reconstructable sequence of events—time's natural flow (*cursus*). In this way Peter introduces a distinction, well known in the rhetorical tradition,

between "natural" (*naturalis*) and "artificial" (*artificialis*) narration.[83] According to Peter, the natural corresponds to the narration of deeds in the order in which they occurred, whereas the artificial alters the natural order of time. Natural order is usually used by historians.[84]

What of the artificial organization of time? Simon, convinced by Peter's distinctions, wants to know why anyone uses artificial narration.[85] Peter identifies three reasons for manipulating time's natural order.[86] First, artificial time is used to link causes and effects. Time's natural flow is bridged by these relationships, which lead narrators to recall an event's cause, or anticipate its implications. For instance, in Matthew and Mark, Mary's anointing of Jesus is presented as a cause of Judas' betrayal.[87] In contrast, John's Gospel preserves the natural order of time, where the plot to betray Christ occurs well after the anointing.[88] Second, artificial time can be used to alter the kind of narration being undertaken. Narrating doctrine or miracles, for example, alters the arrangement of narrative time.[89] Thus, Matthew's account of the Sermon on the Mount collates a variety of Jesus' teachings from across time because of their doctrinal similarities.[90] We have already encountered the potential of the miraculous to alter narrative time in Chastelain's *Chronique* and Leuven's Carthusian Chronicle.[91] Peter's third example of rearranging natural time is drawn from book two of Virgil's *Aeneid*—the account of the Trojan War inserted during Aeneas' sojourn in Carthage. Here, a narrative about the past forms part of the action.

These hermeneutic principles provide the framework for de Rivo's reconciliations of Gospel chronology. His framework was not completely new: it derived from Augustine's *De consensu evangelistarum* and other Gospel harmonizations. Yet a lack of complete originality does not diminish the importance of de Rivo's hermeneutics. Instead, it draws attention to the particular constitution of fifteenth-century hermeneutics of time and their negotiations with authority. Augustine's attention to textual time did not form part of the distant past in the fifteenth-century Low Countries. It was rather part of a living tradition of interpretation consistently attentive to narrative time.

The remainder of the dialogue discusses these mechanics at the level of individual Gospel passages. Two brief examples show how the principle of "natural time" could provide a flexible hermeneutic for bringing chronological discrepancies back into the fold of a unified temporal flow. First, applying the second rule of artificial time, Peter deals with differences between Matthew's and Luke's accounts of Jesus' death.[92] Matthew has the curtain of the temple rent in two immediately following Jesus' death, whereas Luke has it preceding.[93] In a rare departure from Luke's chronology, Peter follows Augustine in preferring Matthew.[94] Matthew's insertion of *Et ecce* (and

behold) following Jesus' death signals that he is following the natural order of time. By contrast, Luke has departed from natural time by joining the miracle of the temple curtain with the miracle of the darkened sun.

The smallest of textual signals is similarly used to interpret time's flow in my second example, a protracted discussion of the adverb *tunc* (then) in a difficult corner of Matthew's Gospel. After teaching on John the Baptist during his Galilean ministry, "then [tunc] Jesus began to denounce the towns in which most of his miracles had been performed, because they did not repent."[95] In Luke, four chapters (7–11) intervene in the space of this "then" in Matthew: Simon suggests that Luke's Gospel has altered the order of events. He sees Matthew's *tunc* as signaling a movement to a particular point of time, a *punctum temporis*, close to that which preceded it. By contrast, Peter argues that through the *tunc*, Matthew introduces a significant break in time, a *longum temporis*, marking a shift to the narration of miracles. Peter concludes that Matthew narrates the beginning and end of a period of time, while Luke's narrative fills out the space signaled by the *tunc*. Simon replies that he will be convinced if he can be persuaded that *tunc* is able to denote a great extent of time.[96] Peter responds by using John Chrysostom's reading of Matthew 24, to show how Matthew uses *tunc* elsewhere without referring to an immediately antecedent time.[97] In this passage, *tunc* encompasses the vast time from the captivity of Jerusalem to the consummation of the world. It does not simply yoke together continuous events, but can span many cycles of years (*multa annorum curricula*).

De Rivo's *Monotesseron* has several significant implications for this history of time. De Rivo is interested in creating a temporal framework within which the diversity of times in the Gospels and the liturgy can be integrated into a single, natural, and historical temporal flow. This is not, however, to deny that multiple forms of textual temporality are in play: artificial narrative arrangements of time continue to be useful; liturgical time continues to require attention. A similar kind of unity with difference to that found among the Gospels can be extracted from the book's complex design. Rather than collapsing the various temporalities of individual narratives, the *Monotesseron* preserves each narrative's distinct arrangements of time, while providing tools for resituating them in an overarching historical time.

MEASURING TIME IN PETER DE RIVO'S *OPUS RESPONSIVUM*

A belief in recovering natural and historical time was central to de Rivo's subsequent work on calendar reform, a vexed question in fifteenth-century

Europe. Making calendars involves coordinating and reconciling the varying times and rhythms of cosmic and social orders.[98] There is no one correct solution. For example, an insistence that months should always coincide with particular seasons was not present in the oldest forms of the Egyptian calendar, where the seasons wandered through the months. Similar "wandering" festivals are found in Islamic lunar calendars. But for many, the urge to maintain continuity between months and seasons formed a crucial motivation for regularizing the calendar.

This was true of calendar makers in the Latin West who sought to reconcile the calendar's basic unit, a day, with the system of months (the moon) and seasons (the sun). The foundation for the medieval calendar was the reformed solar method of the Roman Empire, the Julian calendar. In its final form, the Julian calendar determined that each tropical year was 365.25 days long. Every four years, an extra day was inserted between February 23 and 24, making the year an *annus bisextilis*, a year with two sixth days before the kalends of March. There was, however, a critical difficulty: the length of the solar year was not a neat 365.25 days, but a more unwieldy c. 365.2422 days. The tiny difference of around eleven minutes would cause trouble: over long periods, the seasons would begin to wander through the months. By the sixteenth century the observable equinoxes had moved around ten days earlier in the calendar.

But the medieval Christian calendar was not simply the child of Rome: it was also a child of Jerusalem. Jerusalem's calendars were devised by students of the moon. The lunar Jewish calendar in the ancient world was regulated by priests, who announced the visibility of the new moon to inaugurate each month. Yet the Jewish calendar also tried to stop the months from wandering through the seasons. Complex methods were devised to synchronize the lunar month with the solar year. The method needed to be complex because there was no neat fit between synodic and tropical cycles. There are c. 12.3683 synodic months each tropical year. The Jewish solution was to allow a normal lunar year of 12 months, totaling 354 days, supplemented every 3 years by an extra embolismic month. Crucially for the history of the Christian calendar, this allowed Passover to be commemorated in the same month, Nisan, and the same season, spring.

Calendrical questions were pressing for early Christians, who sought to relate Gospel events to commemorations of Jesus' life, death, and Resurrection. The Jewish calendar was the central resource for dating the events of Jesus' life. According to both the synoptics and John, the last days of Jesus' life occurred in the lead-up to Passover. But while John gave the Crucifixion date as the day of preparation for the Passover (14 Nisan), the synoptics

give Passover itself (15 Nisan). Christians hoped to reconcile the ostensibly different dates of the Passion in the Gospels, and place their commemoration of an event tied to a Jewish lunar festival within a Roman solar calendar. These problems created a mind-bending array of possible calendars and methods of calculation. But the authoritative solution of the church, attributed to the Council of Nicaea in 325, was that Easter was to be celebrated on the first Sunday after the first full moon on or after the vernal equinox.[99] This meant that Easter always fell on the same weekday as the (agreed day of the) Resurrection, and that Easter should always follow the Jewish Passover. From the outset, then, Christians attempted to correlate their commemoration with the time of Christ's Passion in as many ways as possible: lunar month, season, day of week, and situation in relation to the ritual calendar. This process eventually developed into a particular form of coordinating lunar months with solar years that allowed the prediction of Easter over long periods: 19 years of 228 solar months was the equivalent of 19 lunar years of 235 synodic months (19 lunar years of 12 synodic months with 7 embolismatic months), giving rise to a regular 19-year cycle for calculating the date of Easter. The most influential calculation method of this type was associated with the sixth-century cleric Dionysius Exiguus.[100]

The number 19 was used to calculate a year's *numerus aureus* (golden number), found by counting the remainder after dividing the number of a year AD + 1 by 19. The golden number for 2017 is achieved thus: (2017 +1)/19 = 106 with the remainder 4 as the *numerus aureus*. The golden number provided a way of finding the beginning of each calendrical lunar month—the new moon—within the Julian year. By using calendrical tables which aligned dates and golden numbers, the new moon could be found throughout the year, and, by adding 14 days to the date of the golden number, so too could each full moon.

Two further details fill out this brief survey of medieval Easter computus. The first is that medieval Christians believed that Nicaea set March 21 as the unchanging date of the vernal equinox. The second is that a system of letters was instituted to show how the days of the week were coordinated with the numerical dates of the year. This system commenced at A on January 1, and moved through the letters to G on January 7. The letter that fell on the first Sunday of the year was known as the dominical letter.[101] By determining the dominical letter for a year, and finding its first appearance after the fourteenth day after the appearance of the golden number after March 21, the date of Easter was discovered.

Despite the calculation system's attempt at comprehensiveness, it had its problems. The gap between the essentially integral system of the calendar

and the unruly non-integral lunar month and solar year meant that, despite leap years, the observable spring equinox gradually moved earlier in the year. Likewise, the non-integral lunar month's observable new and full moons moved out of alignment with the golden numbers. Well aware of these problems, computists proposed a variety of reforms. The most prominent calls for change in the fifteenth century originated in conciliarist milieux. In 1411, Pierre d'Ailly, the Cardinal and Bishop of Cambrai, who had a profound influence on the Council of Constance (1414–1418), had called for reform in his *Exhortatio super correctione calendarii*.[102] The *Exhortatio* was available in Leuven, having been published around 1483 by Johannes de Westfalia, together with a text on lunar cycles, *De vero ciclo lunari*, in a collection of d'Ailly's works on astronomy, astrology, and history.[103] A more concerted effort toward reform was made at the Council of Basel (1431–1437/49).[104] The Basel recommendation was to remove a week from the calendar for one year. Although this would not completely correct the discrepancies between observable equinoxes and computus, it had the advantage of preserving the existing tables of dominical letters.

From this survey, we can see that when Paul of Middelburg launched his attack, what was at issue was not simply the correct Easter date but diverse structures of time that drew together custom, numerical piety, historical method, and textual hermeneutics. Paul's solution was radical. He proposed that Christ had been crucified not on a Friday but on a Monday, specifically Monday, March 22, and had risen a full three days later on Thursday, March 25. The *Opus responsivum* was de Rivo's reply. The text is divided into two *Tractatus*. Following Paul's response, a third was published in 1492. Each *Tractatus* is composed of three *capitula* subdivided into smaller *particulae*, much like the *Monotesseron*. The first *capitulum* of the first treatise investigates Christ's age at the Crucifixion and Resurrection. The second deals with the date of the Passion and Resurrection, and the third with the weekdays of the Easter events. Because of its length, I will examine here only the prologue and first two *capitula* of the *Opus responsivum* before turning to de Rivo's program of reform.

In the prologue to the *Opus responsivum*, de Rivo outlines three reasons for his response. First, in the *Epistola apologetica*, Paul had asked the University of Leuven to assess his calculations and, if necessary, defend the proposition that Christ's Passion occurred on a Friday. De Rivo offers such a defense. Second, de Rivo cannot remain silent because of the love he has for the lowliest believers.[105] According to de Rivo, many were confused by Paul's redating of the Crucifixion and Resurrection. Paul had argued that his

opinion was supported by the original practice of the church, the opinions of church fathers, including Theophilus of Caesarea and Lactantius, two of Christ's disciples, and even Christ himself. Who then was to come to the assistance of those "little ones" who had believed "from their cradles . . . that the Lord suffered on the sixth day [Friday] and rose on the Lord's day"? None other than de Rivo himself. He thus proposes a pastoral impulse for the *Opus responsivum*: a desire to care for those who until now had been untroubled in their acceptance of the church's temporal order. De Rivo realized that questioning the Easter date had more wide-ranging implications than disputes over lunar cycles, equinoxes, or dominical letters. If Easter Sunday was not a Sunday, why was it celebrated then? Why was Friday a fast, if Christ died on a Monday? In fact, why did each marker of sacred time attach itself to a particular day of the week? The foundations of lived time's order would be shaken, its weekly rhythms unsettled, its web of analogies between history, liturgical year, week, and day broken. Unhinged from a foundation in historical time, the church's temporal order would not hold. De Rivo's task, as he saw it, was not simply to address the fears of individual troubled believers, but to defend the church's comprehensive analogical ordering of time.

De Rivo's third reason for writing is personal:

> Moreover it is agreeable to me that now the best of occasions is given (according to the standard of the most glorious doctor Augustine who both confessed the faults of his youth and retracted his earlier opinions) to confess a certain frivolity which I fell into when I was younger.[106]

De Rivo confesses that when he was younger and tempted by empty glory, in a quodlibet at the Faculty of Arts, he presumed to assert this novelty: Christ was not crucified on the same date as the Annunciation. His reckoning was founded on four assumptions: Christ suffered between the age of 33 and 43; Christ was crucified on a Friday; the Passiontide moon was 15 days old; and the calendrical system (*cursus annorum*) before and after Christ did not change. Even as he gloried in these novelties, he was checked by the familiar voice of Jan Varenacker. Varenacker, whom de Rivo styles as a "most famous professor of sacred theology, both my preceptor and predecessor," warned de Rivo that he was "perverting the order of reasoning."[107] New discoveries had to be weighed against established doctrine:

> we should not believe easily in ambiguous things which militate against the view of the greater number, excepting that they first be discussed for

a long time most acutely, lest afterwards they should be discovered to be invalid, and it be necessary with penitence to take back the opinion expressed.[108]

Guided by this "prudent and holy counsellor," de Rivo now retracts his former opinions. His reference to Augustine's *Retractationes* here reveals the ways in which Augustine's biography could be used to license changes over time.[109] Contrary to his fourth hypothesis, that the calendrical system remained constant before and after Christ, de Rivo has come to be convinced that the *cursus annorum* of the Romans changed just before Christ's birth. Similarly, he considers his assumption concerning the moon's age to be complicated by historical variations in the calculation of lunar cycles. As a result, de Rivo now declares that he follows church doctrine on Easter. He "openly declares with common doctrine that Christ was crucified on the day on which he was conceived," defending once more the church's conception of the analogical ordering of time in salvation history.[110]

De Rivo concludes the prologue by offering the same chance for confession and repentance to Paul. De Rivo, who once labored in sickness, is motivated by Christian love to offer the antidote of correct Easter calculation to Paul and others who err. He hopes this will scotch the scandal threatening the church, defend her current rite, and silence those who dissent from orthodox belief. His work is therefore a kind of pastoral chronology: he will seek to find "what should be faithfully believed concerning the time of the Lord's Passion."[111]

The first *particula*, concerning Christ's age at his baptism, makes clear that the *Opus responsivum* is not simply a discussion of astronomical phenomena and methods of computus.[112] De Rivo's starting point is essential to understanding his perception of time. Time flows, punctuated by events recorded in narratives, which themselves order time through systems of measurement. The events subject to these measurements are the events of Christ's life. So, de Rivo begins not with astronomy or mathematical formula, but with interpretation of the events of Christ's life as recorded in the Gospels. Sitting behind this interpretation is the liturgy, where the time of Christ's life is played out in repeated ritual action. De Rivo begins with the hypothesis: "Christ was baptized in the course of his 31st year."[113] The hypothesis is followed by interpretation based on his historical textual hermeneutic and church authority. Both Gregory of Nazianzus (c. 329–390) and Thomas Aquinas stated that Christ was baptized when he was 30. According to a third authority, John Chrysostom (c. 349–407), when Christ reached his 30th year, he attained full adulthood according to Jewish law.[114]

By showing that Christ fully upheld the law in his baptism, while as an adult being fully able to sin, Chrysostom and de Rivo use the measurement of time to support the narrative of fulfillment that was central to the discourse of Christ's transformation of the old covenant into the new.

From here, de Rivo swiftly moves to harmonize the calculation of Christ's baptismal age across the Gospels. Unsurprisingly, he turns first to Luke. De Rivo had to reconcile the age of Luke's Jesus, "around 30 years old" (*quasi annorum triginta*), with his hypothesis that Jesus' baptism occurred in his 31st year. Drawing on the same passage of Chrysostom used in the *Monotesseron*'s discussion of *tunc*, the discussion revolves around the imprecise meanings of the adverbs *quasi* and *fere*, which can mean a little more or less than the number specified.[115] The difficulty is, however, resolved decisively by another form of authority: the time of the liturgy. The liturgical calendar specifies that Christ was born on December 25 and baptized on January 6. If this is true (and it must be—it is the liturgy), the only possible reading of the adverbs is that they mean "a little more than 30," otherwise too much time would have "flowed between" (*interfluxit*) for the adverbs to make sense.

After the baptism, de Rivo outlines a chronology of Christ's life. His second *particula* argues that the wedding at Cana occurred the year after Christ's baptism. De Rivo is drawn to the symbolic layering of time: the miracle at Cana, Christ's baptism, and Epiphany all occurred on the same day of the year, becoming for de Rivo a figure for the Trinity.[116] If God is equally present to all time, his eternity shines through in the historical conjunction of sacred events in the cycles of the year.

These reflections are the prelude to determining Jesus' age at his Passion, the subject of the *capitulum*'s remaining six *particulae*. De Rivo first demonstrates that the Crucifixion occurred 3 years after the wedding at Cana.[117] This involves correlating the number of Passovers celebrated during Jesus' ministry with the names of high priests recorded by the early Jewish historian Josephus, resulting in this "truth" (*veritas*): "Christ was crucified in his 34th year."[118] The truth is first adduced from the previous *particula* and on the authority of Bede's *De temporibus*, which, with its liturgical proof of Christ's age, provides the *capitulum*'s conclusive final argument. According to de Rivo, Bede records that the Roman Church inscribed its paschal candles with the number of years from the Lord's birth minus 33 (Christ's age at death), thereby annually recalling both the number of years since the Lord's Passion and Christ's age.[119] For de Rivo, then, time's measurement within the liturgy becomes the final arbiter of Christ's time.

This numerical piety linked with liturgical memory had a long history. The candle inscribed with Christ's age was yet another way in which Christ's

time was re-presented in the liturgy. This re-presentation was made clear in the rite for the baptism of the Paschal candle at the Easter Vigil that specified that the candle be baptized and then raised, mirroring Christ's death and Resurrection, and pierced with incense to recall Christ's wounds. In this ceremony, the candle became a sacramental figure of Christ's body, a symbolic body full of time.

The *Opus responsivum*'s first *capitulum* closes with *particulae* addressing competing opinions on Christ's age, and culminates with a refutation of Paul of Middelburg. Although Paul asserted that Christ's age at death was 33, de Rivo disputes that his method of computation allows this conclusion. If the traditional dominical letters and 19-year cycle are used in conjunction with the historically situated dates of Christ's birth and the Passover, Paul's method would give Christ's age at his death as 32 years and 3 months.

The *Opus responsivum*'s second *capitulum* moves to examine the dating of the Passion, and commences with problems in the church's computus. The Nicene method of Easter computus rested on calculations of the moon's phases at odds with astronomical observation. So, according to Pierre d'Ailly and Nicolas of Cusa, every 304 years the new moon will move a day earlier than calculated. Add to this the precession of the equinoxes, and the Easter calculation separates further from observation, even moving outside the observable first lunar month. This presented a problem, given Nicaea's clear affirmation of Easter's date in relation to cycles of the moon. De Rivo responds by reaffirming Nicaea's authority: the decree concerning Easter and the 14th moon of the first month must not be understood as referring to the true (observed) 14th moon but to the "legal" 14th moon.[120] This law for celebrating Easter, however divergent from observation, was given to the faithful along with the 19-year cycle until some other law could be determined by the church.[121]

De Rivo's argument deploys the language of the old and new, the classic language that we have seen deployed to license change in a variety of ways in the fifteenth-century Low Countries.[122] Ecclesiastical law's enduring power meant that time's measurement could not change without ecclesiastical imprimatur; legal time is stable time, even when it departs from what the eyes can see. But de Rivo's language of fulfillment of the law also employs the old Pauline logic that allowed a shift in the law's authority. Paul maintained that Christ's advent did not abolish the old law, but relativized it through the new law of grace. De Rivo's appropriation of Paul's dynamic opposition allows for the possibility that a new law might reconfigure time and bring observation back in line with calculation—the possibility of calendar reform.

De Rivo's investigation of the history of computus continues with an examination of ancient Jewish lunar cycles.[123] Those who think that the Jews do not have a cycle are incorrect. This Jewish cycle begins at a different time to the Christian: the Jewish year 1 begins in the Christian year 4. This meant the golden numbers, and hence the new and full moons, also differed. Following Eusebius (c. 260–339), de Rivo argues that these Jewish golden numbers were historically significant, since they formed the foundation of the Roman calendar's lunar cycles adopted under Augustus. Yet, for de Rivo (following Josephus), the Jewish origins of lunar calculation extended further: Abraham's calculation of the lunar cycle was the origin of the Egyptian lunar calendar. Abraham's cycle showed the gradual slippage between calculation and observation and gave way after time to a new cycle, the cycle of the Hebrews (*ciclum hebreorum*), attributed to King David and his son Solomon.

Determining the precise years in which Abraham's and the new Hebrew cycles were instituted was important for calculating the dates of Christ's life and death. Fixing these dates made it possible to measure how far their lunar calculations had departed from observable moons. And, given that the Hebrew cycle was used during Christ's life, and that the early church subsequently realigned its cycles, these two cycles had to be calibrated to generate an accurate date for the Passion. De Rivo thus rebuffs calculations based purely on astronomy. Time's order in the past is artificial, not founded on precision of observation but on estimation. It does not last in perpetuity but is specific to particular times.[124] This view of time is consonant with the understanding of narration that I traced in de Rivo's *Monotesseron*: human constructions of time in their historical variety and specificity are bound together with the flow of natural time.

De Rivo's dedication to this understanding of time leads him to a "truth" concerning Christ's Passion: "Christ was crucified on the 8th day before the kalends of April" (March 25).[125] This truth is derived partly from Gospel chronology and partly from non-astronomical calculation. According to the Gospels, Christ celebrated the Passover on 14 Nisan. But this, as de Rivo had shown, related not to the "true" age of the moon, but to the legal moon of the Hebrew cycle. The new and full moons of the Hebrew cycle relied on golden numbers that commenced under Solomon. The number of years between the Hebrew cycle's institution and Christ's birth is counted using data from Eusebius. Mathematical calculations then show that the Incarnation took place in year 18 of the Hebrew lunar cycle, and that 33 years later, the cycle was in year 13. In this year, 14 Nisan fell on March 24, meaning the Crucifixion occurred on March 25.

De Rivo's hard-won historical conclusion was supported by Jerome, Augustine, and Cyril of Alexandria. Cyril's dating of the Crucifixion to March 25 supported a complex structure of temporal layering that de Rivo cites with approval. Sacred dates cluster in typological relations, which approximate an intellective perception of time:

> Cyril . . . says that [Christ] was conceived in the womb and died on the cross on the same day while on the 6th day Adam died in his soul on account of the sin in paradise and on the same day Christ died on the cross. But none of the faithful should doubt that Christ was conceived, with the angel's message, on the 8th day before the said kalends because on the same day the church celebrates the feast of the Annunciation.[126]

Again, the culmination and proof of the Christian edifice of time is the liturgical date. March 25 joins the moment of Adam's fall with Christ's incarnation and Crucifixion. Fall and Redemption occur, as it were, at the same time, just as in the celebration of the mass, Crucifixion and Resurrection, fall and redemption, are conjoined in the reception of the Host by humankind.

This way of seeing time had important consequences for Leuven's symbolic arrangement of time, as we have seen. I wish to expand here the interpretation of particular liturgies like the mass or Corpus Christi processions, which have been productively analyzed as social institutions, to show how the temporal structures of the whole liturgy were available for social and intellectual use.[127] De Rivo's work on the calendar forms part of a layering of time around the central moments of the liturgical and institutional years. In Leuven, alignments of time united in the university's foundation, the town's foundation, and the life and liturgies of the Virgin. It was in the context of such expectations of time that Paul of Middelburg's arguments could become so disruptive, potentially breaking analogies that were not only doctrinal, but also embedded in liturgical and civic occasions, and the liturgical year, with its rhythms of feast and fast, rest and work.

REFORMATIO KALENDARII: TIME'S REFORM

De Rivo's positive program for calendar reform was not developed in his *Opus responsivum*, but rather in the short manuscript treatise, the *Reformatio kalendarii*, or "The Reform of the Roman Calendar and Its Return to Its Former State at the Time of the Fathers, Who Promulgated Decrees and

Ordinances That the Paschal Festival Was to Be Celebrated on No Other Day Than Sunday."[128] Despite not explicitly mentioning Paul of Middelburg, the work is directed strongly at defending the Nicene law, especially the celebration of Easter on a Sunday, and realigning its measurement of time with the observable moon. For de Rivo, the time of the fathers is a time of authority, which shapes and frames the present. Calendar reform, then, is best conceptualized as return, a *reductio* and *reformatio*. Newness for de Rivo has been established in the giving of the new law, but that law, once given, remains the standard against which present and future are recalibrated. Newness becomes not so much a chronological concept, but rather a relationship to the authoritative newness of the past. Newness takes on an eternal reference to which a world grown deformed must return. In framing his argument in this way, de Rivo was drawing on a long tradition of medieval reforming discourse.[129]

The *Reformatio* begins with a history of patristic decrees and ordinances concerning Easter and lunar cycles.[130] De Rivo's sources are chiefly Eusebius, Isidore of Seville (c. 560–636), and Bede. He starts with the decision of Pope Victor I (d. 198–199) to celebrate Easter on a Sunday. This decision was made against the Quartodeciman churches, which celebrated Easter on 14 Nisan whatever the weekday, and in accordance with the decisions of Victor's predecessors, Pius and Eleutherius.[131] But the crucial moment was the 19-year cycle's adoption at Nicaea. Each of these decisions needed to be dated precisely, in order to understand the commencement of cycles of Easter calculation. De Rivo calculates these dates using Eusebius' *Historia ecclesiastica*. Accordingly, Nicaea's Easter cycle commenced in 324.

The *Reformatio*'s second chapter tackles the vernal equinox and the paschal 14th moon.[132] The Nicene vernal equinox falls on March 21. This is the date when daylight equals night's shadow: it cannot occur unless the sun enters Aries. In this one date, systems of zodiacal, lunar, solar, and seasonal time interact with the calendrical year. The equinoxes are, then, moments of time's synchronization. But there is a problem: the natural equinox does not always align with the calendrical date. The most obvious example is the leap year, where the astronomical equinox precedes the calendrical. Further complications arise in calculating the new moon. This calculation requires knowledge of the lunar conjunction, calculated astronomically. The following evening then marks the first day of the moon, which continues until the next evening. The same logic applies to the full moon. Every 19 solar years, the lunar movements return to the same set of calendrical days . . . almost. This "almost," not accounted for in the 19-year cycle and golden

numbers, led to the calendar's deformation. For de Rivo, the popes who made the decrees concerning Easter did not use measurements as precise as those in astronomical calculation.[133] Their chief aim was to avoid any conspicuous errors in the calendar. Any such problems could not, without serious scandal, be understood by the general populace. The popes' purpose was pragmatic: to make sure all Christians celebrated Easter together.

Having alerted readers to problems with earlier Easter computus, while managing to endorse the early popes, de Rivo continues his historicizing project by considering the history of observable moons, equinoxes, and the church's Easter calculations. According to de Rivo, under Pope Hilarius (c. 455) it was noticed that the vernal equinox had moved back in the calendar. Dissent arose over this change between Latins and Greeks, with Victorius (for the Latins) proposing a new cycle.[134] But the Greek opinion prevailed, and the original system remained. Later, Bede observed a difference of 2 days between the calculated Easter moon and the observable moon.[135] Again, the church did not revise its cycle. De Rivo sees this as unsurprising: the purpose of stability was to avoid incensing the general populus.[136] The current situation was, however, different. As Pierre d'Ailly and Nicolas of Cusa had outlined, accurate calculations of calendar shifts were now possible because of astronomical observation that the vernal equinox and lunar cycle regressed one day in every 134 and 304 years, respectively. For de Rivo, these calculations made long-lasting calendar reform possible.

It was not simply astronomical accuracy that motivated de Rivo's reform. The inaccuracy of the calendar was clear to the faithful and infidels alike, bringing ignominy on the church.[137] Nothing could now remove this dishonor except reform. The *Reformatio*'s fourth *capitulum* is devoted to the practicalities of such a reform. De Rivo was adamant: the best time to institute calendar reform was 1501, the year after the next papal Jubilee. This provided a chance to publicize reform with the Jubilee's announcement. Mindful of the difficulties (perhaps particularly in light of his strained relationship with the papacy over future contingents), de Rivo attempted to forestall criticism by stating that if doubts arose about his reform, changes could be declared to people who came to Rome for the Jubilee, and be disseminated across Europe on their return home. Beyond these practical advantages, the Jubilee might also offer a symbolic frame for reform, linking the elimination of calendrical distortions to the remission of accumulated debt and sin.

As for the precise details, de Rivo first uses astronomical data to show that by 1501 the equinox will have shifted 10 days back from the church's original decree. He offers a simple solution: jumping 10 days from the end of March 10 to March 21.[138] This would realign the equinox with Nicaea. It

would also necessitate shifts in the lunar cycle and dominical letters, which de Rivo outlined in the remainder of the fifth *capitulum*. De Rivo, now the great preserver of all things ecclesiastical in relation to time, showed that the existing sequences of 19-year lunar cycles (for golden numbers) and 28-year solar cycles (for dominical letters) for calculating the date of Easter could continue in use after his reform, although the formulae used for determining any one year's position in the cycles would have to change.[139] Astronomers, too, would have to add 10 days to their calculations of future events.

As we would expect, de Rivo details the need for adjustments to the liturgical year in the year of the reform's institution. The proposed omission of 10 days encompassed several feasts of the *sanctorale*. St. Gregory's feast day usually fell on March 12. It was to be translated to March 21. Yet any tweaking of the calendar had consequences: the Feast of St. Benedict on March 21 was bumped to March 22. Special attention is paid to St. Gertrude because of her importance to Leuven's ecclesiastical life and sacred calendar.[140] Her feast on March 17 was transferred to March 23. These moves were not especially problematic. Since the *sanctorale* in this part of the year was always dependent on moveable feasts like Easter, de Rivo simply took this mechanism and applied it to his reform.

The seventh and final chapter of the *Reformatio* makes provisions to ensure that his calendar will endure.[141] So that the moon ceases to wander by a day each 304 years, an intercalary day should be removed in 1804, 2108, 2412, and so on. To correct wandering equinoxes, the added day in a leap year every 134 years could be omitted. This correction could lead to an inconvenience in relation to the shift in lunations. De Rivo offers a pragmatic solution: the omission of a leap day once every 304 years means that the equinoxes will wander more slowly—resolving the problem until sometime after 2716. These long-term calculations reveal the temporal horizons that the study of the calendar opened for de Rivo, spanning time from the creation of the world into a thousand-year future: here is yet more evidence that the temporal horizons of the fifteenth century should not be reduced to a static apocalypticism.[142]

To communicate the practicalities of his reform, the *Reformatio*'s final folios are devoted to explanatory diagrams. Folio 3v is a calendar like those found at the opening of liturgical books, showing from left to right the golden number, dominical letter, date according to the Roman system of kalends, nones and ides, calendar day, and liturgical feast (figure 5.3).

The table runs from Septuagesima Sunday to the octave of Easter. Smaller notes in black show the old and new equinoxes and the conjunctions of the moon. The table clearly signals the date of the paschal moon with a rubric.

Fig. 5.3. *Calendar Table and Rota*, from Peter de Rivo, *Reformatio kalendarii*. CUL Inc.3.F.2.9 [3294], 3v–4r. Reproduced by kind permission of the Syndics of Cambridge University Library.

Fig. 5.4. *Devotional Clock Face with Crown of Thorns and Five Wounds of Christ*, parchment painting in a Book of Hours, south Holland, 1465. KBR ms 21371, 15v. Reproduced by permission of the KBR, Brussels.

The omitted days are bracketed in red from the bottom of the first column. Changes in liturgical feasts are also marked, showing the transferred feasts leading up to the Annunciation. On the next folio, both recto and verso, changes in 19-year lunar and 28-year solar cycles, including dominical letters, are shown on two conversion dials.

These diagrams draw on a long tradition of using "wheels" (*rotae*) in Easter calculation for determining the relationships between different parts of the computus system. Like miniature clock faces, these wheels make time's cyclical movement and measurement visible. Kathryn Rudy has recently shown how this visual form—the rota, or clock face—could be marshalled in devotional parchment paintings and books for use by both lay and religious readers across the Low Countries, particularly women.[143] In these images, the clock, and thereby time itself, could be imagined as filled with the wounded heart of Christ, even as the devout viewer is exhorted like the wise virgins of the parable to watch for the coming of the Lord (figure 5.4).

SEEING TIME: TEMPORAL DEVOTION AND THE CALENDAR

The *Reformatio* concludes with a dedication to the Virgin: the work was written "at the University of Leuven in *anno domini* 1488, to the praise of God and his glorious and most holy mother, his bride, the church, undivided and unstained, Amen."[144] Placed in relation to the Marian dedication page of the *Opus responsivum* (figure 5.5), the *Reformatio*'s colophon constructs a Marian enclosure for the two texts, the same kind of Marian coloring that we have seen across the fifteenth-century Low Countries. The dedication page shows de Rivo kneeling before the Virgin and Child while a banderole curls from his mouth into the interior of the chapel-like scene, with the text "be present at my beginning, holy Mary." It forms the first in a set of striking woodcuts at the opening of de Rivo's text that, like the parchment clock faces, unite devotional vision with attention to time.[145]

The woodcuts that follow shift the focus of devotion from the book's author to its reader. In a series of colored woodcuts that make the relationship between calendar reform and devotion startlingly clear, the substance of de Rivo's chronology of Christ's life is given visual form, acting as a window through which to view his work on the calendar (figure 5.6, plate 4, and figure 5.7).

The second of these images is a strongly affective example of the Crucifixion. The crucified Christ's blood drips from his wounds and flecks his

Fig. 5.5. *Virgin and Child with Peter de Rivo*, colored woodcut from Peter de Rivo, *Opus responsivum* (Leuven: Lodewijk Ravescot, 1488). CUL Inc.3.F.2.9 [3294], 1r. Reproduced by kind permission of the Syndics of Cambridge University Library.

Fig. 5.6. *Last Supper*, colored woodcut from Peter de Rivo, *Opus responsivum* (Leuven: Lodewijk Ravescot, 1488). CUL Inc.3.F.2.9 [3294], 1v. Reproduced by kind permission of the Syndics of Cambridge University Library.

Fig. 5.7. *Resurrection*, colored woodcut from Peter de Rivo, *Opus responsivum* (Leuven: Lodewijk Ravescot, 1488). CUL Inc.3.F.2.9 [3294], 2r. Reproduced by kind permission of the Syndics of Cambridge University Library.

body. As one fifteenth-century collection of sermons owned by the Bethleem Priory put it, the bloodiness of Christ's Passion is a sign of Christ's burning love for humanity, which breaks forth from his skin like sweat.[146] This is the kind of crucifix which, placed at the heart of the missal, became a devotional figure for the whole sacrifice of the mass. According to a fifteenth-century Cambrai missal, before commencing mass, the priest was to "open the book at the place where the image of the crucifix was to be found and to regard it with devotion, saying, 'we adore you, O Christ, and we bless you, because by your holy cross you have redeemed the world,' and he should kiss the feet of the crucifix."[147] At the secret, again, the image inside the missal was kissed.[148] This repeated kissing of the cross so damaged this particular Cambrai missal that an additional vellum sheet was pasted behind the image to stop the vellum from breaking.[149] The importance of devotion to Crucifixion images is further signaled by a controversy between the Leuven professor Giles Bailluwel and the Parisian theologian Antonio Gratia Dei over whether it was proper to walk over images of the cross on gravestones inside churches.[150]

What exactly is this kind of image doing at the start of a lengthy technical discourse on dates, lunations, and differences in Metonic cycles? An answer is provided by the unusual caption: "Christ, in the year of his age given above [that is, his 34th year], on the 8th day before the kalends of April, on the 15th moon, on the 6th day of the week, at the 6th hour, was crucified by the Jews." The other images in the opening sequence are just as precise: "Christ, in his 34th year, on the kalends of April, the 5th day of the week, on the 14th moon, at vespers, ate the Passover lamb with his disciples, according to the law, then, having washed their feet, he ate, sitting with them"; "Christ, in his 34th year, on the 6th [sic] kalends of April, the 17th moon, on a Sunday, rose from the dead at daybreak."[151] Each image, then, spells out in painstaking detail the measurement of time for biblical events: Christ's age, the calendar date, the age of the moon, the hour of the day, the time of day. Time becomes the devotional frame for the sacred image.

In a wonderful recent study, David S. Areford argues that many fifteenth-century woodcuts "are best understood not as self-sufficient artworks framed behind glass or stored in archival boxes, but as highly accessible objects designed to heighten devotional experience."[152] A crucial part in heightening devotional experience was played by the "indexical connection" made between the "spatial and physical dimensions" of "a sacred original" and its printed image through precise physical measurements and visual accuracy.[153] But what of the temporal dimensions of indexing devotional woodcuts to sacred

originals? The affective piety promoted by sacred copies must be resituated in the networks of time that the images and copies imply.[154] This is clearly seen in an example from Areford's argument that throws light on the broader European use of time in forming affective relationships between viewers, images, and sacred originals. For Areford, a 1479 woodcut of the alleged Jewish ritual murder victim Simon of Trent is modeled on the actual relic of Simon's body displayed in the church of St. Peter in Trent.[155] In the image, the murdered child is placed on an altar, with instruments of his "passion" arranged beside him, with a large banderole with the text *beatus Simon martir* (blessed Simon the martyr), and ex voto offerings hanging in the background.

Areford cites a portion of the image's caption—"it is holy and performs miracles of many kinds . . . Christians young and old have seen it"—to support his thesis that the image re-embodies the young martyr, transferring the miraculous effects of seeing Simon to viewers of the woodcut. But Areford's translation of the caption omits its opening: "in the year as men reckon 1475, the Jews in Trent killed a three-and-a-half-year-old child." The first interpretive frame for the image is thus the specific time of the historical event and the child's age. Both measures of time are involved in making the image more "real" in relation to its model, the actual body of the three-year-old child.[156]

In the woodcuts of the *Opus responsivum*, we can trace a similar indexation of woodcuts to sacred originals in two senses: to sacred images and to the historical person of Christ. Each of the woodcuts appears to derive from a panel painting. The woodcut of the Last Supper is a simplified version of Dieric Bouts's Leuven altarpiece of the Holy Sacrament (figure 5.6 and plate 1). The woodcut of the Crucifixion seems to be related to a Crucifixion now in Bruges, on the basis of the postures of Mary and John, and the distinctive bones at the foot of the Cross (plate 4 and figure 5.8).[157] The Resurrection scene may be related to the Lyversberg Passion, now in the Wallraf-Richartz-Museum, Cologne.[158]

The *Opus responsivum* captions imply a reading of these woodcuts that places indexation to the precise time of Christ's life above the indexation to sacred images. Yet the "original" paintings seem also to contribute to the authority of de Rivo's measurements of time: the triangular relationship between Christ, sacred image, and devotional woodcut can be seen as mutually supportive. The captions could be interpreted as undercutting the sacred original's power—a temporal regime associated with an iconic stasis broken in the emergence of a historicizing modern paradigm.[159] But this kind of reading fails to account for fifteenth-century understandings of the time of

Fig. 5.8. Master of the Strauss Madonna, *Crucifixion*, oil on canvas and panel, after 1445. Bruges, Groeninge Museum. Reproduced by permission of Musea Brugge, copyright www.lukasweb.be, Art in Flanders Vzw. Photo: Hugo Maertens.

Christ's life as iconic, part of a narrative icon that mediates time and eternity. The idea of the sacred image as timeless can suggest notions of the sacred that are anathema to much fifteenth-century temporal piety.

CONCLUSION

In examining the Bethleem dossier on time, from the *Monotesseron* to the calendrical texts, and finally to the *Opus responsivum*'s woodcuts, we have repeatedly found a devotional attention to time centered on the time of Christ's life. The *Monotesseron*'s task was to discover the precise chronology of each of the Gospels, to iron out kinks between the artificial time of narrative and the natural flow of chronology. This harmonizing allowed the reader to measure and comprehend the whole shape of Christ's life in history.[160] The task of the calendrical works was to ensure that the ritual practice of the church remained true to the chronology of Christ's life, to the authoritative rulings of the early church on time, and to the movements of the heavenly bodies in time. The woodcuts provided a devotional frame for reading the calendar, for contemplating the exact time of Christ's life.

De Rivo's major source for undertaking his chronological work was Augustine's *De consensu evangelistarum*, copies of which were bound with the revised version of de Rivo's *Monotesseron* in Paris and held in the library of the Bethleem Priory.[161] It is here that we find a programmatic statement for the devotional understanding of time that I have been tracing in this chapter:

> "As eternity is to that which has a beginning, so truth is to faith" [Plato, *Timaeus*, 29c]. Those two belong to the things above—namely, eternity and truth; these two belong to the things below—namely, that which has a beginning and faith. In order, therefore, that we may be called from the lowest objects, and led up again to the highest, and in order that what has a beginning may attain to the eternal, we must come through faith to truth, because all contraries are reduced to unity by some middle factor, and because temporal iniquity alienated us from the righteousness of eternity. There was, therefore, need of some mediating righteousness of a temporal nature; which mediation might be temporal on the side of those lowest objects and righteous on the side of these highest. Accordingly Christ was named the mediator between God and men, who stood between the immortal God and mortal man [1 Tim 2:5], himself both God and man, reconciling man to God, remaining that which he was,

made that which he was not. He is for us the faith in things which have a beginning, who is the truth in things eternal.[162]

For Augustine and his fifteenth-century readers, humans need temporal mediation to reach eternity. Time becomes, for Peter de Rivo and the readers of the Bethleem Priory, the essential arena of salvation; understanding it, as paradoxically both iniquitous and the field of redemption, a practice of devotion.

CHAPTER SIX

Time for the *Fasciculus temporum*: Time, Text, and Vision in Early Print Culture

The earliest works printed in Leuven included, as we have seen, texts devoted to time: to history, to prognostication, and to the calendar. Among these was one of the most popular and influential printed texts of the fifteenth century, the *Fasciculus temporum omnes antiquorum cronicas complectens* (A Bundle of Times Embracing All the Chronicles of the Ancients). This innovative genealogical history lays claim to being the first ever horizontal timeline. Extending the previous chapter's interest in temporality in the context of the new medium of print, this chapter investigates precisely how the *Fasciculus* ordered time. I begin by interpreting the languages of time in the work's prologue, then show how the *Fasciculus*'s representations of time changed between the first two editions printed in Cologne in 1474 and the edition produced in Leuven by Johannes Veldener in 1475. To conclude, I focus on a single folio at the very center of the *Fasciculus* containing a woodcut of Christ framed by biblical and liturgical texts. By concluding with the *Fasciculus*, an enormously popular text printed and read across Europe well into the sixteenth century, I hope to signal how a history of time in the fifteenth-century Low Countries can open out onto wider European horizons.

INTRODUCING THE *FASCICULUS*

The *Fasciculus* is a compendium of historical information, dates, famous men, and, less frequently, women.[1] Its major sources are chronologies and chronicles, including those compiled by Orosius (c. 385–420), Bede (c. 672/3–735), Vincent of Beauvais (c. 1190–1264), and Martin of Troppau (Martinus Polonus, d. 1278). Its earliest editions commence with an index, followed by

a short prologue of around three folios that sets out the reasons for compiling the *Fasciculus*, outlines its sources, and provides directions for the reader. After the prologue, the *Fasciculus* proper begins with a horizontal timeline that runs from the creation of the world through the six ages of man, surrounded by paragraphs on events, persons, and places of historical importance. Up to the events of Easter, the line appears on every page, charting the genealogy of Christ from Adam. At this point, the line is broken with a double page opening where Christ appears, holding an orb, surrounded by prayers, biblical citations, and liturgical texts. Following this opening, the line recommences, charting the course of Christ's vicars on earth—the popes—and concluding in the late fifteenth century.

The *Fasciculus* is usually attributed to Werner Rolewinck (1425–1502), a Carthusian from the monastery of St. Barbara in Cologne, an author of exegetical, historical, legal, theological, and devotional works.[2] Alongside the *Fasciculus*, Rolewinck's interest in the measurement of time manifested itself in a commentary on the calendar, the *De calendario*, and in a table and explanatory text for calculating the date of Septuagesima printed in 1472.[3] But on the basis of the earliest manuscript copies of the text, Andrea Worm has recently suggested that the work was perhaps authored in a monastery in the vicinity of Utrecht.[4] Whether produced around Utrecht or Cologne, the work emerged from the kind of devout reading community that we have encountered in the Windesheim houses in and around Leuven.[5] Rolewinck was, however, certainly associated with the earliest print editions of the text that first appeared in two distinct editions published by Nicolaus Götz and Arnold Ther Hoernen in Cologne in 1474.[6] The following year, on December 29, Johannes Veldener produced his Leuven edition, based on the 1474 Cologne Ther Hoernen edition.[7] The text was to prove remarkably popular: at least thirty-five editions in Latin, German, French, and Dutch appeared before 1500; editions were printed across Northern Europe, and in Italy and Spain.[8] My initial survey of surviving copies suggests that most of the *Fasciculus*'s earliest owners were members of religious houses, though there is evidence of readers from among the secular clergy, members of urban elites, and members of the Burgundian court.[9] The Cologne and Leuven editions enjoyed a wide circulation across the fifteenth-century Low Countries.

The *Fasciculus*'s prologue begins with a quotation from Psalm 145:4: "Generation to generation will praise your works and declare your power."[10] Immediately the text emphasizes that all history must be read under the sign of the future (*laudabit*). This future is rendered present as each reader praises God's work in history by reading the *Fasciculus*, and is projected

into generations beyond the present. The psalm citation is, then, a kind of *fasciculus*, a bundling together of times in a simple sentence: the past of the psalmist, the present of the reader, and the praise of future generations. The invocation of a liturgical text, the psalm, thus inaugurates a liturgical temporality: the recurring interplay and merging of past, present, and future.

More obviously, however, the psalm citation is about generations, about the genealogies that the *Fasciculus* details. If the generations who will praise are yet to come, there are also generations who have praised, and who, from any point in the past, could be read as praising God in the future. In its genealogical focus, the text of the *Fasciculus* is showing how the language of history leads to a fullness of temporal vision, which ascends to comprehend the relationship between past, present, and future. This comprehension of time was the explicit aim of the *Fasciculus*. According to the prologue, "it is delightful to see above the moment."[11] Flying through (*pervolans*) the lessons of history,

> human zeal on certain wings of internal contemplation measures not only the past and the present, but also the future, as it passes from likenesses to likenesses. If this zeal is joined to a good will, it rises from a certain weariness of its dwelling place into God, to praising and giving thanks and contemplation, desiring to be released and to be with Christ in eternity.[12]

This is not about being able to measure "how much time the world has left."[13] There is no mention in the prologue about dating the eschaton; God alone has knowledge of when the world will end.[14] It is, rather, the language of contemplative ascent which appears in numerous contemporary devotional treatises, such as the popular *De spiritualibus ascensionibus* of Gerard Zerbolt van Zutphen (1367–1398).[15] Earlier texts on contemplative ascent, like the treatise on the steps of contemplation by the thirteenth-century Victorine, Thomas Gallus (d. 1246), also continued to be influential.[16] Such texts were repeatedly printed in the fifteenth-century Low Countries. Johannes Nider's *Alphabetum divini amoris* (Alphabet of Divine Love), for example, was published in two different editions in Leuven in the 1480s.[17] In the *Alphabetum*, devotions are systematized into mnemonic alphabetical schemata to show consistent patterns of ascent in devotion, moving from the things of the world to heavenly unity with God.

A particularly strong link between contemplative ascent and devotional reading is made in a previously unnoticed and unusual illuminated opening

initial of the *Fasciculus*'s prologue, found in a copy of the Veldener edition now in Cambridge (plate 5).[18] In this image, the time of liturgy is brought into the intimate space of devotional reading, connecting the monastic reader with an eternal vision of time.

The initial *G* is partially damaged, but clearly shows a seated cleric, probably a regular canon, reading at a low lectern. Before him is an altar with a golden retable showing Christ, as at the center of the *Fasciculus*, standing holding an orb. Outside the arch of the *G*, two figures, most likely Mary and John, seem to approach a third figure, likely Christ, though possibly God the Father or a representation of the Trinity. He turns toward them, making a gesture of blessing with his right hand, and, like the golden image on the altar, holding an orb marked with a *T-O* pattern. The area outside the initial has a vibrant blue background, with golden stars creating a strong visual analogy between the heavenly scene and the altar vestments. These visual parallels center around liturgical space, which was, as we have seen, a key site for linking human perception of time with intimations of divine eternal vision. The liturgical resonances of this contemplative vision are perhaps further accentuated by the golden text that hems the upper edge of the image.[19] By reading the *Fasciculus*, then, the devout reader might hope to be translated beyond the framing text into a vision of eternity with Christ and his saints.

The *Fasciculus* marries this contemplative view of time with an exemplary understanding of history. According to the prologue, the holy fathers counted the course of time with great diligence, considering their work useful for those who steer the ship of the church:[20]

> For it is fitting that virtuous men often recall to memory the deeds of those who have gone before, that they might learn from good examples to pursue worthy deeds and from bad examples succeed in avoiding the cliff of perdition. Truly, unless the precious is separated from the worthless, foolish desire, not having the power to influence itself, in its headlong course is engulfed in the chasm of shadows.[21]

But a problem arises. History must be recorded in order to understand scripture and govern the church. Yet simply heaping up mounds of historical material was not useful. To deal with this problem, the doctors of the church removed repetitious catalogues of evildoers, fabulous superstitions, and interminable genealogies that were not strictly relevant to whatever the matter was at hand. In so doing, they opened history to view, with its "delicious meadow of diverse flowers" and "various examples of virtue."[22]

Plate 1. Dieric Bouts, *Altarpiece of the Holy Sacrament*, c. 1464–1466, oil on wood. Treasury of St. Peter's, Leuven. Reproduced by permission of M-Museum Leuven, copyright www.lukasweb.be, Art in Flanders Vzw. Photo: Dominique Provost.

Plate 2. *Transfiguration*, from Jean Gerson, *Monotessaron*, Ghent, early sixteenth century. GUB ms 11, 232v. Reproduced courtesy of the Ghent University Library.

Plate 3. *Baptism of Jesus*, from Peter de Rivo, *Monotesseron*. KBR ms 129–30, 22v. Reproduced by permission of the KBR, Brussels.

Plate 4. *Crucifixion*, colored woodcut from Peter de Rivo, *Opus responsivum* (Leuven: Lodewijk Ravescot, 1488). CUL Inc.3.F.2.9 [3294], 2r. Reproduced by kind permission of the Syndics of Cambridge University Library.

Plate 5. *Detail (Initial G)*, from Werner Rolewinck, *Fasciculus temporum* (Leuven: Johann Veldener, 1475). CUL Inc.3.F.2.1 (3159), 1r. Reproduced by kind permission of the Syndics of Cambridge University Library.

This is most definitely not antiquarian history for history's sake. Instead, history is wedded to a particular view of time and temporal existence in relation to God and eternity.[23] According to the prologue, to see our first parents, and the course of their descendants, how they progressed and regressed in virtue and power, holiness and longevity, is to marvel at God. God is to be admired in his creatures, in his unceasing direction of the creation, in his forbearance and mercy, and in the inscrutable abyss of his judgment.[24] It is this process of seeing beyond the historical moment, learning virtue, and moving toward Christ in eternity that Rolewinck sees as delightful: "for to see above the moment is delightful." The virtuous reader moves from contemplating the world of time, toward a greater and greater desire for the creator: "this contemplation began in joyful contemplation of the creatures and ends in a happier weariness of the same and in desire for the creator."[25]

Time in the prologue is therefore about the movement of desire. The repeated uses of *decursus*, the *decursus temporum*, the *decursus historiarum*, and the *decursus* of human generations, draw attention to the continual discursive movement inherent in human experiences of time. Time's discursive movement is imagined in liquid metaphors.[26] The 3,174 years from the creation of the world to the birth of Abraham flowed (*fluxerit*). The danger of being drowned in the flow of time (*precipiti cursu mergertur*) means that humans need helmsmen (*gubernatores*), in God and the church, to hold the till (*regimen*) and steer through time. Time, in this model, seems a potentially overwhelming and dangerous flow, but also the discursive field where God is revealed; time is the realm of the fallen creation and God's mysterious guiding judgment. This is the motivating tension for the depiction of time's flow in the *Fasciculus*. By measuring and detailing the flow of time in precise detail, the soul can ascend to a comprehensive vision of time that approximates intellective vision, vision that "measures" past, present, and future as it "rises" in longing to be with Christ in eternity.

Alongside metaphors of flow, vision, and ascent, the prologue instantiates two further temporal structures that sit within long traditions of the relationship of time to eternity, and of human souls to God. The first is a language of measurement, which is programmatic for the whole *Fasciculus*: human zeal measures not only the past and present, but also the future.[27] Through measurement, time loosens its hold over the soul. There is a deep metaphorical structure present here that we have encountered in the woodcuts that opened Peter de Rivo's *Opus responsivum*: numerical representation somehow grants a special access to the essential reality of the "thing"

measured.[28] Measuring time might give insight into time's totality, diminishing its power over the human mind. This language of measurement appears in classic formulations of Christian ascent in Augustine's *Confessions* and *De musica*.[29] In these texts, numbers, ratio, meter, and music provide ways into contemplating divine cognition of creation. As the soul ascends into the divine numbers, it comprehends more thoroughly worldly numbers, while realizing their transitory nature. This structure is mirrored in Rolewinck's text, where measure, ratio, and number are given a crucial mediating role between time and eternity.

The second temporal structure is the complicated and mutually supporting relationship between textual interpretation and the interpretation of time. Explicitly citing Augustine, the *Fasciculus* notes that scripture, like the course of time itself, commemorates many things that signify nothing.[30] Yet these insignificant things are necessary on account of significant events and people, which rely on their existence. Thus, superficially barren sections of scripture are comprehensible in relation to the end to which they are ordained. Just as the events of the world may seem cluttered and disordered, yet are part of the divine plan when interpreted according to their relationship to God, sections of scripture with less obvious relevance become filled with significance. The goal of this devotion to the particular is once more to raise the mind to God.

CHARTING THE COURSE OF TIME

How, then, does the *Fasciculus* propose to navigate the current of human time, while also showing the end for which it is ordained? A complex system of representation is described in the final paragraphs of the prologue, which makes sense only alongside the distinctive layout of the *Fasciculus*.

The *Fasciculus* opens with the creation of the world (figure 6.1). The first five days of creation are aligned in a descending vertical line of roundels from the upper left-hand corner of the page. They descend to the middle of the page, where they meet a horizontal band that runs across the opened volume from left to right, depicting the course of time. The very first text within this band is for the sixth day of the world, the day "on which God made beasts and man."[31] The horizontal and discursive flow of time is inaugurated with the advent of humans. On each side of the ribbon are thinner framing bands containing dates. The upper band notes the *anno mundi*, the year of the world from its creation, ascending from year 1. The lower band measures the age of the world before the coming of Christ, the time *ante Christi*, and notated from right to left and upside down; its first entry,

Fig. 6.1. *Creation of the World*, from Werner Rolewinck, *Fasciculus temporum* (Leuven: Johann Veldener, 1475). CUL Inc.3.F.2.1 [3159], 2v–3r. Reproduced by kind permission of the Syndics of Cambridge University Library.

synchronized with *anno mundi* 1, is the year 5199. It gradually descends to the year of Christ's birth.

In describing this schema, I have used language familiar to modern ears: the years of the world "ascend," while the years before Christ "descend." The prologue, however, speaks differently:

> And below and above [I have depicted] two lines, the upper of which descends with its number from Adam to Christ ... The second line, that is the lower, ascends backwards from the nativity of Christ up to the creation of the world ... After Christ both together descend to our time growing little by little.[32]

Descent and ascent in the time of the *Fasciculus* are to be viewed genealogically and directly in relation to creation and Christ. The years descend from Adam to Christ, just as the *linea Christi*, the lineage of Christ, descends from Adam at the beginning of time. Rather than showing a "neatly designed, powerfully horizontal line of time plunging forward from the creation to the present," the *Fasciculus* shows a variety of directions of reading time, framed around the language of lineage and referring explicitly forward and backward to Christ and the creation of the world.[33]

But there is something important in the observation that the *Fasciculus*'s timeline is "powerfully horizontal." The language of ascent and descent is a language of vertical relations, which points to a potential ambiguity between the *Fasciculus*'s visual representation of time and its textual description. Earlier texts that provided models for the *Fasciculus*, like the *Compendium historiae in genealogia Christi* (Compendium of History Relating to the Genealogy of Christ, c. 1180s) by the Parisian theologian Peter of Poitiers (c. 1130–1205), were arranged vertically.[34] In its earliest copies, the *Compendium* depicts Christ's forebears, commencing with Adam, descending down a scroll of parchment. The language of descent from Adam to Christ and ascent from Christ to Adam matches the form of the visual layout. In later copies of the compendium in codex form, the vertical arrangement was preserved.[35] Vertical arrangements were also important for one of the *Fasciculus*'s major sources, Martin of Troppau's *Chronicon pontificum et imperatorum* (Chronicle of Popes and Emperors), a widely disseminated text that pioneered a method of parallel histories by year for popes and emperors.[36] By the fifteenth century, copies of Martin's *Chronicon* often failed to preserve the vertical and parallel layout of the original schema, perhaps signaling a wider move away from the vertical to the horizontal.[37] With the

Fasciculus, then, we see some kind of transition, where the generic conventions of vertical genealogical ascent and descent intersect with a discursive path of time depicted as a horizontal movement.[38] Is it possible to see a connection between the form and availability of the book itself and a transition from vertical genealogy to horizontal history? The dominant Western mode of reading moves from left to right, as does the turning of the pages of a book, and in the last decades of the fifteenth century, book production increased dramatically with the rise of printing. Perhaps in the *Fasciculus*'s horizontal hybrid genealogy-history, we are seeing how powerful left-right reading conventions interact with, and participate in the change of, other systems of representation.

A reading of this kind is not, however, supported by a vertical genealogy of Christ in a manuscript from Leuven's Carthusian house dating from the early sixteenth century (figure 6.2).[39] This vertical genealogy might be interpreted as the survival of an earlier way of imagining time within the older medium of the manuscript codex. But it could equally be glossed within the continued operation of the vertical arrangement in works that are more strictly genealogical. This genealogy ends with the foundation of the church, making the timeline less an organization of all time in history (as in the *Fasciculus*) than a strictly personal genealogy of Christ. The time of the person, then, might be seen to continue in a vertical mode, while historical time, with its origin at creation and end at the apocalypse, is seen as a horizontal *cursus*. Whichever conclusion is adopted, it is necessary to stress that no uncomplicated narrative of change from the vertical to the horizontal works for the fifteenth-century Low Countries, where multiple imaginations of time exist side by side.

Unsettled interplays between horizontal and vertical time can be observed in the first two editions of the *Fasciculus*, the 1474 Cologne Götz and Ther Hoernen editions. While the Götz edition does have a horizontal timeline throughout the book, there are also folios where the immediate visual effect at least initially resembles vertical genealogy.[40] By contrast, horizontal left-right arrangement dominates Ther Hoernen's edition, freeing the vertical axis to represent synchronic events (figure 6.3).

In this first opening, the days of creation are aligned vertically and in a sense synchronically—they can be read as all equally present in one "moment."[41] They inaugurate time, yet do not participate in its discursive flow. This arrangement approximates divine cognition of this time before time; comprehending these multiple events in one vertical moment, human vision approaches divine intellection. The Ther Hoernen edition, then, and

Fig. 6.2. *Genealogy of Christ from Adam*, from *Speculum biblie demonstrativum genealogie domini nostri Iesu Christi*. KBR ms 15003–48, 4r. Reproduced by permission of the KBR, Brussels.

Fig. 6.3. *Creation of the World*, from Werner Rolewinck, *Fasciculus temporum* (Cologne: Arnold Ther Hoernen, 1474). CUL Inc.3.A.4.2 [352], 2v. Reproduced by kind permission of the Syndics of Cambridge University Library.

later editions like Veldener's, which reuse its format, read very much like music in score notation, where the diachronic and synchronic are performed through time, and the gaze of the reader is drawn between parts and whole, comprehending individual chains of melody or genealogy while also reading vertically to hear synchronic and harmonic relations.[42] Returning to the prologue, we can see how Ther Hoernen's arrangement of the book performs the kind of contemplative vision that Rolewinck saw as the aim of chronology and history. Sitting over the book, the reader sees not only the past and "present"—the roundel that is the current object of the reader's gaze—but also the "future," all laid out over the space of a page. Moving beyond the moment, from part to whole, the reader can ascend to a contemplative vision of time.

After the first five days of creation, time's course meets a large rectangular box. The text around its frame reads "here begins the first age of the world, and it has two thousand, two hundred and forty-two years, lasting up to the flood."[43] Within the frame, two roundels with the names of Adam and Eve contain the text "the first man lived nine hundred and thirty years and begat thirty-two sons and as many daughters."[44] In the interior, the role of human lives and genealogies in shaping the flow of time is emphasized. In the frame, the ages of the world mark the situation of time within biblical narratives of salvation. First developed by Augustine, the system of the six ages of the world reflects the cosmic order of the six days of creation. Both creation and the ages of the world culminate in the eternal Sabbath of God. For each of the six days of creation, there is an age of the world. The first age lasts from the creation to the flood; the second, from the flood to the birth of Abraham; the third, from Abraham to the beginning of the reign of King David; the fourth, from David to the Babylonian exile; and the fifth from the exile to the nativity of Christ. The sixth age is established with the advent of Christ and will culminate in the eschaton. On its third folio, the *Fasciculus* turns to this event, stating that the date of the world's end is unknown, and that the sixth age can be identified in one of two ways, either "old age [*senectus*] or the most new hour [*hora novissima*]."[45] The first categorization draws on an analogy between the ages of the world and the ages of man. In the second, the sixth age heralds the apocalyptic *novissima dies*.[46] The *novissima hora* is a way of describing youth, the hour most recently brought to birth.[47] These two ways of viewing the sixth age again imply a reading of time in both directions. From the beginning, time stretches out into old age and death. From the unforeseen yet approaching end, the present is the youth of the world. With both measurements, the sixth age, the fifteenth-century present, approaches the apocalypse.

VIEWS FROM THE CENTER

Strictly forward-looking linear readings of the world's time are further undercut by the central folios of the *Fasciculus*, where eschatological time breaks into the orderly procession of the years (figure 6.4).[48]

The sixth age, the *novissima dies*, commences with Christ's birth, and includes the momentous and datable events of his teaching in the temple, baptism, and Crucifixion.[49] An entry on folio 25r, just before the central opening, details Christ's thirty-fourth year:

> In Christ's thirty-fourth year there were many miraculous events. For on the day of his Passion the earth trembled, rocks were split, and the sun was darkened just as it says in the Gospel. On Easter day the Lord rose together with many others etc. Then, after 40 days, he gloriously ascended into heaven with great spoil etc. And all these things are sacred signs of our eternal salvation in which the devout discover daily [*cotidianam*] restoration of mind. Blessed is he who concerns himself with these things; how much will he reap everlasting fruit.[50]

This short entry sums up the whole time of Easter, Ascension, Pentecost, and the foundation of the church. Turn the page and the timeline abruptly stops. What has happened? The reader enters a different kind of time, a time seemingly free from the past, present, and future logic of the historical timeline, time presided over by the vision of the risen and ascended Christ.

This new time is devotional, as the prayer that runs over both folios indicates. The prayer compares the church to the heavenly Jerusalem composed wholly of the elect, defended by the divine majesty and illuminated by divine radiance.[51] "The head of this city is Jesus Christ, true God and true man." The church is guarded by angels who watch over its walls day and night. It is founded on the rock of Peter, and the gates of hell will not prevail against it.[52] This church is Sion, the spotless bride, announced by the patriarchs, predicted by prophets, and recognized by the whole Old Testament as its mistress. The enemies of the church will deny this (*negabunt*), and the church will trample their necks (*calcabis*). The prayer ends by asking God to hear the voice of his church and to turn his gaze from heaven to the vineyard that he planted and to perfect it, to extend his hand over his people. It concludes with a standard liturgical formula—through "our Lord, Jesus Christ, who lives and reigns [*vivit et regnat*] with you in the unity of the Holy Spirit, blessed God in all ages, Amen."

One simple part of this formula reveals the ways liturgical language

Fig. 6.4. *Central Opening*, from Werner Rolewinck, *Fasciculus temporum* (Cologne: Arnold Ther Hoernen, 1474). CUL Inc.3.A.4.2 [352], 25v–26r. Reproduced by kind permission of the Syndics of Cambridge University Library.

breaks standard divisions of time into past, present, and future. *Benedictus in omnia secula* (blessed in all ages) combines an adjectival perfect passive participle with *in*, a preposition that can take either the ablative or the accusative. In this case (!), it is followed by the accusative, denoting motion toward an object, rather than static location. That is, this prayer reaches out from the present of the spoken utterance into all ages, extending into time in all directions. This language situates the church, as pray-er, at the center of time.

Reading the whole double-page opening as an extended prayer for and through the church, a prayer that encompasses all of past time, from the prophets and patriarchs to the future (note the future tense of *negabunt, calcabis*), addressed to the continual presence of God (note the present tense of *vivit et regnat*), helps interpret the opening's left-hand folio. In five columns, the twelve apostles are partnered with the twelve articles of the Apostles' Creed, and in turn aligned with Old Testament figures and quotations that predict and support the Creed.[53] The final column contains an additional collection of supporting scriptural quotations. As Andrea Worm has shown, this arrangement of texts is clearly derived from earlier manuscript copies of the *Fasciculus*, and is linked to the belief that at the first Pentecost each of the twelve apostles spoke a line of the Creed.[54] The image is thus linked to a particular moment in historical time and the inauguration of the repeated performative time of the church's liturgy. Time here is bridged and aligned to show how texts and persons across time have essential coherence in the church's doctrine. The liturgical text of the Creed provides a present foundation for this unification of time across the Old and New Testaments. It is as though the diachronic flow of time has been subjected to a synchronic glance, where the implicit temporal logic of articles of the Creed encompassing past, present, and future is fulfilled in a systematic ordering of scriptural quotation and biblical characters.

This synchronic glance is embodied on the right-hand folio as Christ turns toward the opposing folio, his hand raised in blessing. Time and the church are subjected to Christ's eternal gaze, which synchronizes Creed, apostles, prophets, Old and New Testaments. In the copy from Cambridge University Library shown above, once owned by the Windesheim canons in Tongeren, Christ's blessing is given a further eschatological reference through the insertion of the text "I am the Alpha and Omega" in the banderole that curls around the top of the image (figure 6.4). This image, the most arresting feature of the opening, has a complicated print history that provides a way of distinguishing the temporal inflections of the different editions of the *Fasciculus*.[55] Commencing with early manuscript copies

and the Cologne editions, the image was continually transformed, signaling difficulties with the representation of the folio's subject and its mediation in print.[56] To understand these transformations, the image needs to be placed in the context of the preceding text and representations of "ordinary" time across editions.

As we have seen, the 1474 Götz edition does not quite manage a consistent timeline. Lines do not always connect across pages, and sometimes the same period of time is repeated across consecutive openings to include all the required text. At other times, the flow of the line is interrupted by special historical events, for example a full-page representation of Noah's ark.[57] The movement from Christ's birth to his death and the inauguration of the church is broken by just such discontinuities. Christ's birth, teaching in the temple, baptism, and Crucifixion appear on a single line. But before the central opening, the text includes four folios on Roman emperors and Cleopatra. In contrast to the Ther Hoernen and Veldener versions, there is little sense that what follows breaks the flow of time. The central image likewise differs markedly from the other print editions (figure 6.5).[58] Instead of Christ, we find a large schematic diagram with three concentric circles: the outer circle has roundels with the apostles' names, aligned with prophets on the border of the interior circle; the first inner circle contains the four evangelists and information on where and in what language each Gospel was written.[59] Surrounding the border of the innermost circle is a biblical citation commencing "all power is given to me."[60] In the innermost circle is the text "this figure clearly represents the holy catholic and universal church."[61] The Götz edition thus emphasizes the time of Pentecost, the founding of the church, which does not seem to mark such a clear break with the *Fasciculus*'s timeline.

By contrast, Ther Hoernen's central opening, as we have seen, is more clearly differentiated.[62] Christ stands in an empty plane with the horizon marked by a simple horizontal line. His right hand is raised in blessing and his partially cruciform halo intersects with a blank scroll. He holds an orb surmounted by a cross.[63] One feature does, however, connect this opening with the rest of the *Fasciculus*'s timeline. Christ is surrounded by a rectangular frame analogous to those marking the various ages of the world and the marriage of Mary and Joseph. Text is added to the image's frame, recalling the temporal referents that are included within the frames for these earlier events (compare figure 6.3). In the central opening, the rectangular frame contains a fusion of biblical texts pointing toward Christ's power over time, the future of the church, and the end of time: "all power is given to

Fig. 6.5. *The Church*, from Werner Rolewinck, *Fasciculus temporum* (Cologne: Nicolaus Götz, c. 1474). CUL Inc.3.A.4.9 [511], p. 113. Reproduced by kind permission of the Syndics of Cambridge University Library.

me in heaven and on earth. Go into the whole world and preach the gospel to all creation. And behold I am with you even to the end of the age" (Matthew 28:18; Mark 16:15; Matthew 28:20).[64] These texts tie the image to the particular time of Christ's ascension, while also pointing forward to the institution of the church at Pentecost and the end of time. This process of synchronizing different Gospels recalls the method of the *Monotessaron* tradition, and mirrors the temporal unification of Old Testament, Creed, apostles, and New Testament on the opposite page.

The image of Christ, then, provides a possible hermeneutic for the temporal markers throughout the *Fasciculus*. Like the iconic form of Christ, the events of world history become emblematic and exemplary moments for contemplation within time's flow, framed so that the viewer can understand their full temporal significance beyond their historical moment. Such a logic of emblematic visualization is realized at the point of the Crucifixion in some copies of the Ther Hoernen edition, and in later editions, where the Crucifixion roundel was accompanied by an image of the cross standing on the flow of time, resting on the date *anno mundi* 5232 (figure 6.6).[65] Indeed, images were included in roundels in early manuscript copies, in similar manuscript chronicles, and in later print editions of the *Fasciculus*.[66]

Through the practice of devout visualization and contemplation, one can taste the fruit of eternity in the sacramental transformation of time. This sacramental language emerges in the text beneath the roundel for the Crucifixion that I discussed earlier: "and all these things are sacred signs [*sacramenta*] of our eternal salvation in which the devout discover daily restoration of mind. Blessed is he who concerns himself with these things; how much will he reap everlasting fruit."[67] A copy of the *Fasciculus* printed by Conrad Winters in 1476, one of the many editions across Europe derived from Ther Hoernen's, provides an example of how this mode of seeing sacramentally may have been linked to the sacrament of the Eucharist. In this copy, the wounds of Christ have been touched with red ink, drawing attention to the flow of sacramental blood. Much like images of the Mass of St. Gregory that show the sacrifice of Christ on the Cross as physically present on the altar of the mass, this image shows the physical reality of Christ's Crucifixion in the viewer's present.[68] The historical time of the *Fasciculus* could here become analogous to the liturgical, sacramental time of the mass. Indeed, there could be a further analogy between the format of the *Fasciculus* and the form of the medieval missal itself, where a full-page image is introduced into the flow of the liturgy at its "center," the canon of the mass.[69]

Such devotional, sacramental vision was not severed from time—according to the *Fasciculus*, it happened in daily practice (*cotidianam*). And

Fig. 6.6. *Crucifixion*, from Werner Rolewinck, *Fasciculus temporum* (Cologne: Conrad Winters de Homborch, 1476). BSB, 2 Inc.c.a.527, 24v. Reproduced by permission of the Bayerische Staatsbibliothek.

the very events that trigger such vision are quite literally full of time. Take, for example, the text within the timeline accompanying the Crucifixion: "Jesus Christ, Lord of all, thirty-three years and three months old, died for his servants."[70] Just as we would expect from the *Opus responsivum* images, the movement to understanding the full significance of Christ's death comes from precision in understanding and measuring time. The more that is known about the time of Christ's death, the fuller the vision that can ascend above it—again, literally, in the image of the Crucifixion.

Further temporal complexity emerges in the image of Christ in the central opening of the 1475 Leuven edition (figure 6.7). Gone is the simple schematic horizon; Christ instead stands within a hilly garden. The folds of his robes no longer fall in static elegance, but balloon out to his right like the famous loincloth of the crucified Christ in Rogier van der Weyden's Columba altarpiece (c. 1455).[71] Christ's hands are no longer covered in cloth, and he holds a book, perhaps Revelation's book of life. Christ's gesture is both a blessing and an indication toward the scroll, which no longer passes behind his head but hovers above in the sky. Beneath his feet lies a globe of the world, marked by the classic *T-O* division of continents, an action that recalls both the surrounding text invoking Christ's aid for the church and its power over its enemies. The stumps of two trees are visible to the right of the image. Christ's halo incorporates a crucifix of fleurs-de-lis, similar to the tracery halos in iconic images of Christ's face like the much-copied *Vera Icon* of Jan van Eyck.[72] What are we to make of these differences?

In some ways, the 1474 Ther Hoernen woodcut seems more removed from time. It is still; the robes do not move; the texture is flatter; the gesture of blessing more static. But its frame, as we have seen, suggests its participation in the course of history. In the 1475 Leuven edition, the rectangular frames of the Cologne editions are replaced with larger concentric roundels (figure 6.1). With this change, the frame of the image of Christ no longer recalls the ages of the world. This differentiation is further marked by Christ's triumphant ascendancy over the world, which he has put in subjection beneath his feet. In the 1474 Ther Hoernen edition, Christ's halo intersects with the banderole, much like the circular emblems that sit within the band of time running throughout the *Fasciculus*. By contrast, the 1475 Leuven woodcut has no such intersection: Christ points to the flow of time, but there is no hint of intersection between time and eternity.

Yet the 1475 woodcut is full of time's movement. The stumps of the trees mark this garden as affected by the process of time. They perhaps represent the trees of the garden of Eden that, according to a variety of medieval sources, provided the wood for Christ's cross.[73] The trees show Christ's

Fig. 6.7. *Christ as Salvator Mundi*, from Werner Rolewinck, *Fasciculus temporum* (Leuven: Johann Veldener, 1475). CUL Inc.3.F.2.1 [3159], 26r. Reproduced by kind permission of the Syndics of Cambridge University Library.

appearance in history, giving the backstory to the triumphant Christ. The detail of the robe shows that a wind blows through this garden, just as the spirit moved over the face of the deep in the creation.[74] What seems to be offered here is not some timeless view of God, but a time-full view of eternity. We might say that the 1475 Leuven print is simultaneously more removed from the course of time and "filled out" with the textures of this very real paradise, with its motion and history. The Leuven print, then, resonates with the temporal language of artists like Jan van Eyck, Rogier van der Weyden, and Leuven's own master, Dieric Bouts, where eternity is filled with temporal reference. We might recall the constant movement of the processions and angel singers in the Ghent altarpiece. Or we might turn to Dieric Bouts's devotional panel *Ecce Agnus Dei* (figure 6.8).[75]

Here, Christ appears beside the Jordan River, which separates him from a kneeling donor and John the Baptist. The panel alludes to the baptism of Christ, that precisely datable moment that Peter de Rivo had drawn on for his chronology of Christ's life in the *Opus responsivum*.[76] Yet the figure of Christ also suggests the iconographic form of the Resurrection, the *noli me tangere* (do not touch me), that moment where eternity breaks into the present. Christ's presence is manifest, too, in the fifteenth-century present of the donor, continually present both in the persistence of the image in and through time, and in the procession of presents for each subsequent viewer. How is the viewer to cross the river that separates him from Christ's eternal presence? Is the river itself a symbol for the cursus of time, the cursus imagined through liquid metaphors in the *Fasciculus*'s prologue? Crossing this river is possible here through the devout gaze, which comprehends both past (Christ's baptism), present (the present of the fifteenth-century donor), and the future of the coming Christ who walks toward the present viewer. And there is another kind of future embedded here: the tree in the center of the image, behind Christ on the river's bank, reaches up toward the clouds of the heavens, figuratively crossing the river. Like the cross in Rolewinck's *Fasciculus*, which provided both a marker of the historical event of the Crucifixion and a trigger for a sacramental eternal vision, this tree spans heaven and earth, time and eternity. See how John's finger points both across the river to Christ, but also directly to the tree. Explorations of illusionistic depth of field—so characteristic of fifteenth-century Netherlandish painters—and the flat surface of the image here paradoxically intersect.[77] The spatial play is also a play of time. For it is through this tree, full of time, that John the Baptist's finger points across to Christ: *Ecce Agnus Dei*, behold the sacrificial lamb of the cross, of each mass, of the apocalypse.[78] By

Fig. 6.8. Dieric Bouts, *Ecce Agnus Dei*, c. 1462–1464, oil on wood. Alte Pinakothek, Munich. Copyright bpk, Berlin/Bayerische Staatsgemäldesammlungen.

contemplating this fullness of time, the devout viewer might cross the river to walk with the eternal Christ.

A COLOPHON ON THE COLOPHON

The colophon to the 1475 Veldener edition of the *Fasciculus* returns us to the dating practices of fifteenth-century Leuven. The colophon is dated "in the year from the nativity of the Lord 1476, on the fourth day before the kalends of January according to the style of the Roman curia" (*Sub anno a nativitate domini M.CCCC.LXXVI, quarto kalendas ianuarias secundum stilum romane curie*). This recalls the method of reckoning used in the contract between Dieric Bouts and the Confraternity of the Holy Sacrament for the St. Peter's altarpiece, where time was measured according to the custom of the bishop's court in Liège. In both cases the date in question is ambiguous. In the Veldener colophon, the fourth day before the kalends of January falls between two potential starting dates of the year, Christmas Day and January 1. The dating of the colophon measures time according to Christ's genealogy. After the birth of Christ, the time ribbon below the central band of time moves to measure time in the year of Christ (*anno Christi*). And it places the time of the *Fasciculus* within the church's authoritative reckoning of time at the papal curia. This matches the change in tracing the "line of Christ" (*linea Christi*), before Christ's birth, to "the line of popes" (*linea papae*) after. The colophon is not, then, an empty reckoning of numbers. It carries with it a fullness of time that we have seen running through the course of the *Fasciculus temporum*, and which, even as it looks toward the rest of Europe, is characteristic of the temporalities of the fifteenth-century Low Countries.

Conclusion

This book has attempted to convey something of the fullness of time in one region of fifteenth-century Europe. This was a region distinguished from the rest of Europe by the density of its urban networks, the power of the Dukes of Burgundy, and its remarkably vibrant cultural production, devotional life, and religious houses. Many of the temporalities I have traced were experienced in different forms across Europe both before and after the fifteenth century: the old and the new, liturgical frames for action and affect, complex interfoldings of time and eternity. But this book has shown some of the ways they were deployed in these particular times by particular people in particular places—to evoke the hermeneutic of *diversitas temporum, locorum et personarum*. In the process, I hope to have shed some light on how taking time to think about time can help us understand more about the past.

Throughout the book we have seen how the region sparked new configurations of time in the fifteenth century. The university in Leuven, founded in 1425 but more famous for its roles in the transformations of sixteenth-century Europe, became a conduit for new thinking and cultural production about time—through philosophical debates over future contingency, the role of its theology professors, the novel iconography of Dieric Bouts's altarpiece for St. Peter's, and the production of sophisticated interpretations of Gospel chronology like Peter de Rivo's.[1] The surrounding religious houses, like the priory of Bethleem at Herent, became producers and readers of texts like de Rivo's *Monotesseron*, or the *Horologium sapientiae* of Heinrich de Suso. These houses were also avid readers of the first horizontal timeline, the *Fasciculus temporum*, testifying to an interest in time that I have argued was framed by the intricate temporal architectures of the liturgy. The culturally generative power of this religious milieu and the Congregation of

Windesheim led to new ways of making time devotional beyond cultures of the book. One of the first securely attributed clocks to play mechanical music on bells was installed on a stairway at the house at Windesheim in 1405: it played the Pentecost sequence *Sancti spiritus assit nobis gratia* as an alarm to wake the sleeping brothers.[2] It was a small step from clocks like this to the clock installed in the tower at Park in 1478, or to similar clocks in towns and churches across the region that sounded out liturgical chants to surrounding rural and urban communities.[3] Conflicts between towns and the ambitious Dukes of Burgundy were mediated, too, through the languages of the liturgy in ritual and historiography, offering a repertoire of narrative transformations of time and emotion that could be deployed to navigate political tensions.

Even as the region can be analyzed as a cultural unit, its intersections with the remainder of Europe remain critical to understanding its new forms of cultural production and its practices of time: Paul of Middelburg, whose travels to Italy made him emblematic of the mobile intellectuals of the fifteenth century, developed new solutions to old chronological problems using astronomy in ways that challenged defenders of more traditional dating like Peter de Rivo. The Marian coloring of liturgical time in Cambrai would not have been possible without the gift of the icon of the Notre-Dame de Grâce, most likely made in Crete, which passed through Rome to find a home in the town's Cathedral. The chant composed for the new liturgy of the feasts of the Virgin, which traveled from Cambrai to play a role in the layering of Marian time in Leuven, was written by Guillaume Du Fay, a composer who had traveled widely outside the region.

The diversity of times encountered in the book means that the temporalities I have traced cannot be reduced to a singular fullness of time. Instead, time's fullness remains beyond reach, just as it did for those fifteenth-century subjects who sought to rise to an approximation of God's vision of time from eternity. I cannot fully sense how time might drag or race for the apprentice weaver working at a loom in fifteenth-century Leuven; I cannot see all the ways that the layers of liturgical time might fold into the temporalities of reading or writing, or the print workshop of the *Fasciculus temporum*. The elusive temporalities of singing and hearing at Cambrai can be imagined but never fully comprehended; we can never grasp in their entirety how other temporalities of communal life or life narratives could structure the reception of these events and objects in time for historical actors and groups. But I hope this book will be taken as a prompt to ask these kinds of questions about the past in more detail, because I believe that how we come to be who we are in time is one of the most important questions we can ask.

One of the ways that we have come to be who we are in modern Western societies is precisely through the positioning of the human subject as devoutly attentive to time, a subjectivity formed through centuries of engagement with questions of time, and given particular form in the fifteenth century through liturgical practices. In the fifteenth century, partly through the powerful influences of religious reform movements like the *devotio moderna*, new varieties of liturgical time came to be personal for increasingly literate laypeople through new technologies of time like books of hours, and could be disseminated broadly through new print technologies. In the birth of new cultures of learning in the republic of letters of the sixteenth and seventeenth centuries, the kinds of time given expression in texts like the *Fasciculus temporum* would be harnessed in the project of universalist encyclopedic visions of time, where boundaries between human and divine knowledge could become thin. The construction of this kind of vision owes a debt to the fifteenth-century Low Countries. But what role, if any, was played by this period in constructing the synchronic gaze now associated with the development of a scientific imagination? Is it right to associate a synchronic gaze with an atemporal gaze (as in some accounts of Newtonian science)? If I am right to see a fullness rather than an effacement of time in the devout fifteenth-century viewer's attempts to approximate divine vision, then how exactly should we articulate historical movements between time-bound, time-full, and apparently timeless observers? Further work will clarify the possible debts of later periods to the fifteenth-century Low Countries, and how the temporalities of the period were mediated into, and changed by, later practices like humanism and early modern science.

Genealogies of these analytic extratemporal standpoints can run the risk of demonizing a problematic "religious" past, which is caricatured as a "timeless" social and intellectual order grounded in a belief in an atemporal eternity. Many of the eternities of the fifteenth-century Low Countries were not quite that kind of eternity. For the cardinal and theologian Nicolas of Cusa (1401–1464), who visited the priory at Bethleem outside Leuven in 1452, for example, God could read in an instant everything in every book in the world, but also read each book with each reader who read it in temporal succession.[4] Time and timelessness blend into each other here in a paradoxical coincidence of contraries. History *sub specie aeternitatis* in this vision is not a history without movement, variety, and difference.[5]

One of the ways in which difference was positioned in the fifteenth-century Low Countries was through ancient narratives of the old and new. Dynamics of the old and new remain critical, too, to the ways that modern cultures position themselves in time. The reactivation of Pauline theology

in biblical commentaries and visual and processional culture at the University of Leuven in the fifteenth century is one of the complex threads in the genealogy of a dynamic modernity predicated on constantly making all things new—our common modern temporal regimes where each new present is taken to be determinative of what might be considered good and truthful. But in the fifteenth century, this kind of dynamic was accompanied by the constant reactivation of a long past in a deeper present, one where the (generally male and European) voices of history provided the material out of which new practices and beliefs were made, and against which they might be evaluated. How might we think about deepening our presents in our quite different social worlds?

History has a role to play here, but as we have seen in scholars like de Rivo, the roots of "modern" historical methods in the fifteenth century are not to be distinguished from a social world where the past is able to be activated in ritual, liturgy, and narrative. Some modern historians would like to keep these two worlds apart, worried about the polluting powers of liturgy and memory in forming subjects who do not match up with the ideals of secular academia.[6] But if we take up the challenge of the past and do not seek to make it such a foreign country, we will have to think further about ways that historical understandings and narratives must be lived beyond the monograph and peer-reviewed journal article in order for them to have any transformative social purposes. It is a sense of the transformative political and pastoral purposes of historical reflection and devout attention that I have argued sits at the heart of fifteenth-century engagements with historical time.

One of the chief burdens of *The Fullness of Time* has been to practice historical reflection in relation to a wider range of materials than generally admitted into modern histories of time. My introduction attempted to demonstrate why an appreciation of temporality must be transdisciplinary. To respond to traces of the past like the clock at the Abbey of Park, histories of time need to take account of objects, music, visual sources, texts, and rituals. The history of time must consider not only how these traces might witness to a history of time, but how they themselves might be said to make time in relation to their human users and interpreters. How does a liturgical chant form the temporal horizons of its performers and listeners? How do processes of seeing and devout reading shape the perception of time? Histories of time written in this key will allow older dichotomies of merchant and church time, mythic and historical time, medieval and modern time, to be supplemented by richer vocabularies that allow sacred sources and countercurrents to sound within, against, and alongside currents of secularization.

CONCLUSION 201

In my first chapter, I examined the temporalities of a single town in the Low Countries, Leuven, to give some sense of the abundance of times in the fifteenth century. The chapter showed that the analysis of time must go everywhere to see how the unfolding of time shaped, and was shaped by, human experience, measurement, and action. Central to Leuven's civic time was the appropriation of temporal structures of the old and new, which gave form to Leuven's social life over the course of the century. I see at least three areas where this sketch of the time of a fifteenth-century city might be filled out: from an economic perspective, analyzing in more detail the work time of the city, its markets, its rhythms of employment and production, and their intersections with the times of particular social groups and individuals; from a diachronic perspective, charting change in the measurement and perception of time between the fourteenth and sixteenth centuries (how, to take one obvious example, did the emerging forms of humanism shape the town's time from the later fifteenth century?); and from a comparative perspective, asking how different communities within and beyond Western Europe made time.

In the second chapter, I balanced Chapter One's survey of the times of the town with a more detailed examination of the networks of time surrounding Dieric Bouts's altarpiece of the Holy Sacrament. My intention was to think further about how objects shape and are shaped by their particular settings. I am advocating creative and speculative approaches here, which I think can open up new horizons for the history of representation and reception, mediated through a history of temporality. How could the shifting rhythms of the church's liturgical temporalities cast light on the reception of liturgical objects, and how might the changes to these objects in and through time alter their reception by viewers? Considering these questions while analyzing a wide range of material, from work contracts, theological commentaries, and philosophical disputations, to architecture, liturgical texts, gestures, and chant, allows creative historicized rereadings of objects like the altarpiece that do not freeze them in timeless vitrines.

Continuing this approach, I turned in my third chapter to music and emotions. If time is the great devourer, then something it particularly savors is the affective dimension of human life: we have often found it harder to think about the emotions of the past than to trace supposedly unaffective ideas, discourses, and structures. Similarly fleeting and difficult for historians to investigate has been the ephemeral phenomenon of music. We retain musical notation, images, verbal texts, physical spaces, and even some instruments—but what about music as heard—its sounds, its listeners? By approaching the musical life of Cambrai as a site for the investigation of

time, I hoped to show how adopting a flexible hermeneutic of time, grounded in an established and extremely useful trope of *diversitas temporum*, might open up some possible fifteenth-century emotional responses to music. My second aim was to highlight the ways in which liturgical temporalities were shaped by narrative time. Liturgical narratives might shape and discipline the emotions of participants in worship, give horizons of expectation and memory colored by affective relationships between the soul and God, and anchor these relationships in the liturgy's re-instantiation of the narrative patterns of biblical history. But again, the chapter is only a start, and this method needs to be refined and supplemented by examining further musical sources, and records of their reception. More broadly, historians and musicologists need to collaborate to think about how transformations in music, its notations, rhythms, harmonic languages, its performance and reception, might be better integrated into broader histories of time. The history of time has most often been cast as a history of measurement, yet the musical art of time measurement has too often remained silent and absent.

Absence and presence sat at the heart of the analysis of Philip the Good's 1458 Ghent entry, as the Duke's advent in the city was negotiated through complex uses of time. This chapter traversed the contested fields of ritual studies, Burgundian political and historical cultures, and urban conflict. Approaching these fields from the perspective of a history of temporality allows new readings to emerge that pay attention to liturgical time and the role of historical narrative in mediating the eventful time of the entry. I have emphasized how liturgical times were central to the symbolic action of this particular entry, and how, explicitly and implicitly, the representation of time lay at the heart of the representations of Ghent and the Duke of Burgundy. Central to the Duke's characterization was his position surveying time from a quasi-eternal synchronic perspective. Future histories of temporality will continue to uncover the diverse ways that power is positioned through such arrangements of time, and the ways that power can be undermined through destabilizing temporal structures.

Thinking about temporal subjectivities runs through the final two chapters, which interrogated authors, texts, readers, and images within the reforming monastic milieu associated with the *devotio moderna*. Reading in this context, I suggested, helped form "liturgical subjects," expert measurers and masters of time. Chapter Five draws to the surface questions of textual time and processes of reading and seeing, in the construction of the Gospel narratives and their arrangement within Peter de Rivo's *Monotesseron*. The implications of this method stretch beyond the works on calendars

and chronology studied in this chapter. All texts arrange time, and are written and read by historical agents embedded in multiple temporalities. Teasing out these complex arrangements of time can provide new readings of texts, cultures, historical agents, and their temporalities. It is probably in the genealogical timeline, the *Fasciculus temporum*, that the question of a comprehensive vision of time arises most clearly. Here, as time becomes a meadow of examples for virtuous emulation, and the measurement of history a trigger for a contemplative ascent to survey past, present, and future, the near-fullness of time in a devout vision is revealed as an always incomplete attempt to understand time from a divine and eternal perspective.

The kinds of focused studies that are the heart of *The Fullness of Time* need also to be balanced by asking large questions of form, continuity, and change: how do the different media engaged with across the book develop their own distinctive forms of temporalization in different historical periods and regions? How might we think about the legacy of the fifteenth century's fullnesses of time in the age of reformations? How were experiences of time transformed by increasingly intense engagements between Europe and the rest of the world in the later fifteenth and sixteenth centuries?

Beyond raising these kinds of questions, my hope is that *The Fullness of Time* can help us think further about the purposes of historical investigation, knowledge, and practice, and how they should be related to time. I hope that both the subjects of this work and its method can offer something to history (conceived of as a discipline, a habit of thought, and the future situation of this book as a historical document), particularly in the present moment, within Western cultures saturated with social processes of acceleration.[7] Time need not always consume and devour, fly, be spent or lost. Peter de Rivo's attention to the individual words of the Gospels is a kind of attention that takes time. Attention to the manifold temporalities of an altarpiece means spending time looking—returning to the image over time to see what has changed, taking time with other images, and with no images at all. Attention to time, in other words, needs time—critical rereading, re-seeing, and re-hearing. Lest this become a lugubrious wallowing in time, a hermeneutic of *diversitas temporum* reminds us that this kind of attention to time will also mean interrogating and practicing different temporalities of analysis: the swift glance, the sound caught for a moment, alongside slow rumination and contemplation. Only with these kinds of attention to time might it be possible to move beyond the thinness of historical time, and the logics of constant occupation, incessant activity, and temporal surveillance that dominate our presents.[8] This is not to advocate an escape—like

many of those who lived the temporalities of the fifteenth-century Low Countries, I do not think I can avoid time—it is rather a question of shifting horizons to reflect on the rich possibilities and intrications of pasts, presents, and futures, devoting our attention to interpreting and inhabiting a fullness of time.

ACKNOWLEDGMENTS

This book developed from my thinking about time at the University of Melbourne in the early 2000s, was brought to life at Queen Mary University of London and St. Catharine's College, Cambridge, and was finished at Birkbeck, University of London. Along the way, I have learned from others who have hosted me in Europe, the United States, and Australia.

I am indebted to many scholars and friends for their advice, kindness, and criticism over the course of the project. Chief among these is Miri Rubin, for whose extraordinary energy and constant support I cannot express sufficient gratitude. Emma Dillon and Graeme Small read an earlier version of the book with great care and precision, and have provided continuing support and encouragement. I also want to thank Charles Zika, who first helped me think about time, and Joanne Anderson, Adrian Armstrong, John Arnold, Barbara Baert, Nora Berend, Jennifer Bishop, Jim Bolton, Federico Botana, Patrick Boucheron, Abigail Brundin, Chris Clark, Esther Cohen, Liesbeth Corens, Dave Crispin, Julia Crispin, Johanna Dale, Peter Denley, Thomas Dixon, Theo Dunkelgrün, Jan Dumolyn, Sietske Fransen, John Gallagher, Robert Gribben, Miranda Griffin, Barbara Haagh-Huglo, Tom Hamilton, Stefan Hanß, David Harrap, Rhodri Hayward, Felicity Harley-McGowan, Kati Ihnat, Antonín Kalous, Tess Knighton, Beat Kumin, Sachiko Kusukawa, Mary Laven, Élodie Lecuppre-Desjardin, Dorothy Lee, Hester Lees-Jeffries, Kate Lowe, James Marrow, Serena Masolini, Iona McCleery, Grantley McDonald, Andrew McKenzie-McHarg, Christiaan Mostert, David Neaum, Philipp Nothaft, Conor O'Brien, Richard Oosterhoff, Anthony Ossa-Richardson, Christopher Page, Milan Pajic, Joanne Paul, Helen Pfeifer, Eyal Poleg, Kathryn Reinhart, Tim Rogan, Luc Rombouts, Ulinka Rublack, Christine Sas, Jenny Spinks, Gareth Stedman Jones, Jenny Stratford, Paul Strohm, Birgit Studt, Ineke van 't Spijker, Emily Thelen, Stephanie Trigg, Alex Walsham, and Edward Wickham.

My thanks too for those other friends who have helped in this endeavor: the Tuesday Group, Bruce and Leonie Barber, Paul Bentley, Catherine Cargill, Jennifer Cook, Leoma Dyke, Rosemary Fulljames and George and Simon Williams (who provided invaluable support with French translations), Peter and Mich Gador-Whyte, Kirsty McDougall and Neil Greenham, Hilary Howes and Conny Schüritz, John and Rosalie Hudson, Louisa Hunter-Bradley, Pam Hutcheson, David and Gonni Runia, Emma Skillington and Osman Osturk, Carola Schüritz, Martin Wright, and Žofia, Lenka, and Milan Žonca.

While working on the book, I have received kind assistance from the staff of a number of libraries and archives, including Annie Fournier and Fabien Laforge of the Mediathèque d'agglomération de Cambrai; Michiel Verweij at the KBR, Brussels; Laura Nuvoloni of Cambridge University Library; Eddy Put at the Rijksarchief in Leuven; Jill Gage and Paul Saenger at the Newberry Library; Stefan van Lani and Leo Janssen of the Abbey of Park; Herman Janssens and Theo Meulemans at the Abbey of Averbode; Henny Vijden of the Rijksarchief in Limburg; and the staff of the Baillieu Library, the British Library, the Dalton McCaughey Library, the Stadsarchief Ghent, the Universiteitsbibliotheek Ghent, and the Warburg Institute.

Marta Tonegutti and Evan White at the University of Chicago Press have been clear-sighted, kind, and practical editors, and Marianne Tatom read and corrected the typescript with great care. Their comments, together with those of Bonnie Blackburn and the reviewer who remained anonymous, have helped clarify my arguments and remove numerous errors—those that remain are mine alone.

I have been fortunate to receive funding from a number of bodies over the course of this project. My thanks to the Isobel Thornley Trust, the Scouloudi Foundation in association with the Institute of Historical Research, and the Medieval Academy of America for providing funds to support the publication and images. My thanks too for generous funding and fellowships from the Westfield Trust and the Stretton Fund at Queen Mary, the Australian and New Zealand Association for Medieval and Early Modern Studies, the Australian Research Council Centre for Excellence in the History of the Emotions, the British Society for the History of Science, the Mellon Foundation, the Newberry Library, the Centre for the Study of the Renaissance at the University of Warwick, the Warburg Institute, Queen's College, University of Melbourne, and St. Catharine's College, Cambridge. St. Catharine's has been one in a line of colleges, churches, and chapels that have showed me that careful attention to how we live in time can transform lives for the better.

Finally, to my family, Rachel and Sam, Juliette and Carl, Benita, Callum, and Ambrose, Sarah, Michael, Samuel, and Hugh, and my parents Gaye and Neil, who have surrounded me with love, beautiful books, music, art, and vigorous conversation—I am full of love and gratitude. I wish Philippa Maddern were still here to read this book, which has been shaped in more ways than I can express by her friendship. Miriam's wonderful arrival has filled the last months of the project with joy. And to Miranda, whose love and editing rock my world—we made it!

NOTES

INTRODUCTION

1. Huizinga, *Autumn of the Middle Ages*; Burckhardt, *Civilization of the Renaissance in Italy*. See further Belozerskaya, *Rethinking the Renaissance*, 32–44.
2. On Huizinga's reception, see Krul, "In the Mirror of Van Eyck"; Peters and Simons, "The New Huizinga and the Old Middle Ages."
3. On Huizinga and art history, see Haskell, *History and Its Images*, 431–95, 515–19. For a musicologist's reception of Huizinga, see Strohm, *Music in Late Medieval Bruges*, vi, 1–9, 151. On Strohm and Huizinga, see Page, *Discarding Images*, 155–57.
4. Arnade, *Realms of Ritual*, 3.
5. Belozerskaya, *Rethinking the Renaissance*; Nuttall, *From Flanders to Florence*.
6. Belozerskaya, *Rethinking the Renaissance*, 5–6.
7. Van Engen, "Multiple Options." Also Rubin, "Europe Remade."
8. For general histories in English, see Blockmans and Prevenier, *Promised Lands*; and Prevenier and Blockmans, *Burgundian Netherlands*. For an introduction to economy and urban life, see Stabel, *Dwarfs among Giants*.
9. This definition is adopted from van Engen's discussion in *Sisters and Brothers of the Common Life*, 48–55.
10. See van Engen, *Sisters and Brothers of the Common Life*. For a classic study, see Post, *Modern Devotion*.
11. On Burgundy and Portugal, see Paviot, *Portugal et Bourgogne au XVe siècle*.
12. Derwich and Staub, eds., "Neue Frömmigkeit," 131–264.
13. Augustine, *Confessions*, ed. James J. O'Donnell, XI.14.17, hereafter *Confessions*. Translation from Augustine, *Confessions*, trans. Henry Chadwick, 230–31.
14. Ricoeur, *Time and Narrative*, particularly 3:104–9.
15. *Confessions*, 9:12.32, 11:27.34–41; Augustine, *De musica*, passim. For *De musica*'s reception, see Jeserich, *Musica naturalis*, 149–58.
16. For further reflections on Augustine, text, and time, see Ricoeur, *Time and Narrative*; "Narrative Time"; "Introduction."

17. Important studies include Landes, *Revolution in Time*; Kern, *Culture of Time and Space*; Whitrow, *Time in History*; Hunt, *Measuring Time, Making History*; Glennie and Thrift, *Shaping the Day*. Works on medieval time include Smythe, *Imaginings of Time*; Jaritz and Moreno-Riano, eds., *Time and Eternity*; Humphrey and Ormrod, eds., *Time in the Medieval World*; Strohm, *Social Chaucer*, Chapter 5; Lock, *Aspects of Time in Medieval Literature*. Journal editions on time include *Disputatio* (1997), *Jewish History* (2000), and *Studies in the Age of Chaucer* (2007).

18. On rhythm, see Jean-Claude Schmitt's new study *Les rhythmes au Moyen Âge*.

19. The following draws on Burke, "Reflections on the Cultural History of Time," and Munn, "Cultural Anthropology of Time."

20. For example, Durkheim, *Elementary Forms of Religious Life*, 9–10, 441–42.

21. Burke, "Reflections on the Cultural History of Time," 619.

22. Michelet, *Histoire de France*, 7:ii.

23. Quinones, *Renaissance Discovery*, 3–27.

24. Bilfinger, Die mittelalterlichen Horen particularly 142–43.

25. Koselleck, *Futures Past*, 11. Also Burke, *Renaissance Sense of the Past*.

26. Compare Constable, "Past and Present in the Eleventh and Twelfth Centuries."

27. For example, Cullmann, *Christ and Time*, and Eliade, *Myth of the Eternal Return*.

28. Fabian, *Time and the Other*. For further critique, see Higgins, "Medieval Notions of the Structure of Time"; Rosen, ed., *Time and Temporality in the Ancient World*.

29. Auerbach, "Figura."

30. Ibid., 29.

31. Ibid., 43. See also Nagel and Wood, *Anachronic Renaissance*, 32–33.

32. Mitchell, "Spatial Form in Literature," 288–93. Ingold, *Lines*, 167–69, discusses fragmentation. On timelines, see Rosenberg and Grafton, *Cartographies of Time*.

33. Burke, "Reflections on the Cultural History of Time," 623–25, citing Gurvitch's *La vocation actuelle de la sociologie*, 2:325.

34. "Merchant's Time and Church's Time in the Middle Ages" (original publication 1960) and "Labor Time in the 'Crisis' of the Fourteenth Century: From Medieval to Modern Time" (original publication 1963), in Le Goff, *Time, Work and Culture*, 29–42, 43–52.

35. Le Goff, "Merchant's Time," 38.

36. Burke, "Reflections on the Cultural History of Time," 626. See also Glennie and Thrift, *Shaping the Day*, especially 66–68.

37. Burke, "Reflections on the Cultural History of Time," 626.

38. Le Goff, *Un autre Moyen Âge*, 403.

39. Bergson, *Matter and Memory*, 205–12.

40. Augustine, *Confessions*, 11:20–23. Bergson's theory is drawn more closely from Plotinus. See Flasch, *Was ist Zeit?*, 30.

41. Burke, "Reflections on the Cultural History of Time," 626.

42. Ibid. Also Burke, "Performing History."

43. Burke, "Performing History," 44–45.

44. Ibid., 45.

45. On structure in relation to culture, see Sewell, *Logics of History*, particularly 6–12, 124–96, 205–13.

46. Bruner, *Actual Minds, Possible Worlds*.

47. Ibid., 32.

48. Time's relationship to the visual has often been framed through Gotthold Ephraim Lessing's *Laocoön: An Essay on the Limits of Painting and Poetry*. Lessing's attempts to police the borders of poetry as an art of time and painting as an art of space ultimately fail. See Mitchell, *Iconology*, 101.

49. Acres, "Compositions of Time in the Art of Rogier van der Weyden"; "The Columba Altarpiece and the Time of the World"; "Rogier van der Weyden's Painted Texts."

50. Williamson, "Altarpieces, Liturgy and Devotion."

51. Williamson, "Sensory Experience in Medieval Devotion," especially 23, 42.

52. See also Nagel and Wood, "Toward a New Model of Renaissance Anachronism" and responses in the *Art Bulletin* (2005), and Wood's *Forgery, Replica, Fiction*.

53. Nagel and Wood, *Anachronic Renaissance*, 17–18.

54. Ibid., 10.

55. See, for example, Hartog, *Regimes of Historicity*; Hoy, *Time of Our Lives*; Engammare, *On Time, Punctuality, and Discipline*; Darby, *Bede and the End of Time*; Perovic, *Calendar in Revolutionary France*; Blake, *Time in Early Modern Islam*; Ogle, *Global Transformation of Time*.

56. Fassler, *Virgin of Chartres*.

57. Le Goff, *In Search of Sacred Time*, 182.

58. For payments, see AAP R VIII 13, 173v–174v; AAP R X 220, 35v. The most complete description appears in the *Cathalogus fratrum Parchensium ordine professionis*, AAP, R VIII 2, 46v. See also Frumentius, AAP R VII 21, 139; de Pape, Delfleche, Le Scellier, vander Maelen, *Summaria cronologia insignis ecclesiae Parchensis*, 295; and Sanderus, *Chorographia sacra Brabantiae*, 1:232. The clock tower appears in pre-Revolutionary illustrations of the Abbey. See Baisier and van Lani, *Met zicht op de abdij*. See further Rombouts, *Zingend Brons*, 85–86; Rombouts, "Beiaarden te Leuven," 12–18. On Thierry van Thulden, see D'Haenens, "Abbaye de Parc, à Heverlee," 805–7.

59. The text here is from KBR ms II 2347, 204v, a 1527 Park Missal. The notated chant is taken from the closest Premonstratensian house to Park at Averbode.

60. See above, 6–7.

61. For Josquin's five-part setting, see Elders, ed., *Motets on Non-Biblical Texts*, 21–30. See also Elders, "Perfect Fifths and the Blessed Virgin's Immaculate Conception"; Nelson, "Parody on Josquin's *Inviolata*."

62. The twelve-part division is strikingly shown in initials from liturgical manuscripts from Cambrai Cathedral: CMM ms 72, 111v–112r, and CMM ms 76, 91r–92v. On Josquin's motet, see Elders, *Motets on Non-Biblical Texts*, XIV:31–42; Elders, *Symbolic Scores*, 176, 245–48.

63. Izbicki, "Immaculate Conception and Ecclesiastical Politics," 154–55.

64. Other *Inviolata* textings—for example, "O benigna, O regina, O Maria"—make the *Salve* resonances more explicit. On these lines, see Macey, "Josquin and Musical Rhetoric," 525–27.

65. On liturgical fusing of time and eternity, see Hammerstein, *Die Musik der Engel*, 30–52; Kirkman, *Cultural Life*, 192.

66. Wright, *Music and Ceremony*, 107, 111.
67. Ibid., 107, 151, 181, 184–85.
68. Haggh, "Archives of the Order of the Golden Fleece," 26.
69. Bruges's churches hosted the Order's meetings in 1468 and 1478. De Gruben, *Les Chapitres de la Toison d'Or*, 322–28.
70. Haggh, "Virgin Mary and the Order of the Golden Fleece." For *Inviolata* at a meeting of the Order, see Haggh, "Archives," 11.
71. For *Inviolata* in Bruges, see Strohm, *Music in Late Medieval Bruges*, 5–6, 52–53.
72. Haggh, "Foundations or Institutions?," 111–12; Strohm, *Rise of European Music*, 438.
73. Forney, "Music, Ritual and Patronage at the Church of Our Lady, Antwerp," 28.
74. Haggh, "Music, Liturgy and Ceremony in Brussels," 426–27, 433.
75. See Nosow, *Ritual Meanings*, 184–85; Haggh, "Introduction," xiii, xviii.
76. Haggh, "Guillaume Du Fay and the Evolution of the Liturgy," 557; Nosow, *Ritual Meanings*, 172, 246.
77. CMM ms 1019, p. 65, cited in Wright, "Performance Practices at the Cathedral of Cambrai," 304.
78. See also the testament of Gilles Nettelet from 1506. Houdoy, *Histoire artistique*, 273, 288.
79. See, for example, Lehr, Truyen, and Huybens, *Art of the Carillon*, 86; Sauvageot, "Étude sur les Cloches," 219–34.
80. Durieux, "La dernière cloche de l'ancienne église métropolitaine de Cambrai."
81. See below, 99–100.
82. Le Glay, *Recherches sur l'église métropolitaine de Cambrai*, 41.
83. Curtis, *Cambrai Cathedral Choirbook*, 7–9; Curtis, "Music Manuscripts and Their Production."
84. See Haggh, "First Printed Antiphoner of Cambrai Cathedral."
85. See below, 99–101. CMM ms 739, 35v, in Wright, "Performance Practices," 118.
86. See, for example, Peter de Rivo, *Opus responsivum ad epistolam apologeticam M. Pauli de Middelburgo* (Leuven: Ludovicus Ravescot, 1488), t.1 c.3 p.2.
87. CMM ms 1064, 127v, cited in Wright, "Performance Practices," 304. On the *Salve*, see CMM ms 739 35v, 118r; CMM ms 69, 2r. See also Houdoy, *Histoire artistique*, 219. On mural chant, see Wright, "Performance Practices," 305.
88. Ibid., 304–5. On the clock, see Le Glay, *Recherches*, 42–43; Bouly, ed., *Dictionnaire historique de la ville de Cambrai*, 237–38.
89. CMM ms 1019, 275, cited in Wright, "Performance Practices," 305.
90. Suso, *Wisdom's Watch*; Künzle, *Heinrich Seuses Horologium Sapientiae*.
91. Künzle, *Heinrich Seuses Horologium Sapientiae*, 215–16, 220–25. For manuscript copies from Cambrai's St. Sepulchre's Abbey, see CMM mss 173, 209, 332.
92. Künzle, *Heinrich Seuses Horologium Sapientiae*, 250–76.
93. See below, 118–19.
94. Künzle, *Heinrich Seuses Horologium Sapientiae*, 262, 279–81, 284–85. On the *devotio moderna* circulation, see Hoffmann, "Die volkssprachliche Rezeption des 'Horologium sapientiae,'" 202–54; van Engen, *Sisters and Brothers of the Common Life*, 16–17, 141, 277–78, 382.

95. "Unde et praesens opusculum in visione quadam sub cuiusdam horologii pulcherrimi rosis speciosissimis decorati et cymbalorum bene sonantium et suavem ac caelestem sonum reddentium cunctorumque corda sursum moventium varietate perornati figura dignata est ostendere clementia salvatoris." See Künzle, *Heinrich Seuses Horologium Sapientiae*, 364–65 (translation from Suso, *Wisdom's Watch*, 54).

96. Quotations from the Marian chants *Ave rosa sine spinis* and *Ave virgo sanctissima*.

97. See Monks, *Brussels Horloge*.

98. On these instruments, see ibid., 53–58.

99. Dufay, *Opera omnia*, 5:XI–XII, 8–10. For probable composition dates, see Fallows, *Dufay*, 146–49.

100. See below, 48–50.

101. Haggh, "Celebration of the '*Recollectio Festorum Beatae Mariae Virginis.*'"

102. See below, 50.

CHAPTER ONE

1. On Leuven, see Bergmans, ed., *Leuven in de late Middeleeuwen*; Bessemans et al., eds., *Leven te Leuven*; van Uytven, *Het dagelijks leven*; van Uytven, *Stadsfinanciën*. Given Leuven's destruction in both world wars, Eduard van Even's documentary work remains essential: van Even, *Louvain dans le passé et dans le présent*; van Even, *Louvain monumental*.

2. Munro, *Textiles, Towns and Trade*, XI:235–50.

3. Van Uytven, *Stadsfinanciën*, 428–45; van Uytven, "Landtransport durch Brabant."

4. Munro, "Monetary Contraction and Industrial Change," 110–22; Munro, "Industrial Protectionism in Medieval Flanders," 250–63.

5. See van Mingroot, *Sapientie Immarcessibilis*; de Jongh, *L'ancienne faculté de théologie de Louvain*, 30–103; Lamberts and Roegiers, eds., *Leuven University*, 21–153. Originally not mandated to teach theology, in 1432 Pope Eugenius IV (1383–1447) expanded the university's privileges to include the teaching of all disciplines. See Reusens, ed., *Documents*, 1:111–13; Claes, "Changes in the Educational Context."

6. Van Uytven, "Leven te Leuven," 20.

7. See van Uytven, *Dagelijks leven*, 111–39.

8. For the foundation, see Miræus, *Opera diplomatica et historica*, 1:388–89.

9. Horsten, "Ter ere van God en van de stad," 41. On temporal positioning and architectural history in fifteenth-century visual culture, see Wood, *Forgery, Replica, Fiction*, 193–201; Nagel and Wood, *Anachronic Renaissance*, 152–58.

10. Mondelaers, "Rondom de Sint-Pieterskerk," 27.

11. Smeyers, "Abbaye de Sainte-Gertrude," 910.

12. Van Uytven, "Leven te Leuven," 10–13.

13. Mondelaers, "Rondom de Sint-Pieterskerk," 26.

14. On Leuven's Carthusians, see Champion, "Emotions and the Social Order of Time."

15. Smeyers and van Dooren, eds., *Het Leuvense stadhuis*; Terlinden, "Le cinquième centenaire de l'Hôtel de Ville de Louvain."

16. Van Uytven, "Leven te Leuven," 10–11.
17. De Jongh, *L'ancienne faculté*, 34.
18. Twycross, "Worthy Women of the Old Testament," 230.
19. See Blümle, *Der Zeuge im Bild*.
20. Twycross, "Worthy Women," 230.
21. KBR ms 2395–410, 156r–170r.
22. Ibid., 168v. "In nova vero lege ille leges universales iuris naturalis manserunt sed determinaciones sunt relicte prelatis et principibus pro diversitate locorum et temporum instituende prout expedierit." See also Schreiner, "'*Diversitas temporum*,'" especially 401–4.
23. For example, Varenacker's commentary on the Psalm *Beati Immaculati*, KBR ms 5172–74, especially 5r–v. For commentaries on the New Testament epistles in Leuven, see Burie, "Proeve tot inventarisatie," 239, 243–48.
24. De Jongh, *L'ancienne faculté*, 43–44.
25. For the following, see ARAL 601/1, 1296, 27r–30r. Also Miræus, *Opera*, 2.896–97; D'Hoop, *Inventaire général des Archives ecclesiastiques*, 1:172–74.
26. Similar arrangements were made for the translation of the chapter of St. Peter's, Eeyncourt, to St. James's, Leuven. See Miræus, *Opera*, 1:263–64, 2:900–902, 2:189–90.
27. On Leuven's guilds, see Verhavert, *Het Ambachtswezen*.
28. Van Uytven, "Leven te Leuven," 14.
29. Verhavert, *Het Ambachtswezen*, 67–75, 80–83, 107; Verheyen, "Onderwijs en opleiding," 121–23.
30. Verhavert, *Het Ambachtswezen*, 45–51; van Uytven, "Leven te Leuven," 13–14.
31. SAL 4655, 34r–35v; SAL 11670 5r–v.
32. See below, 49.
33. For the blacksmiths' guild, see van Uytven, *Stadsfinanciën*, 422.
34. Thompson, "Time, Work-Discipline, and Industrial Capitalism," 70–71.
35. On fire, see Verhavert, *Het Ambachtswezen*, 69–70; van Uytven, *Dagelijks leven*, 97–98.
36. Des Marez, *L'organisation du travail à Bruxelles*, 243–45; Verhavert, *Het Ambachtswezen*, 69–70.
37. For a detailed examination of Leuven's cloth industry, see van Uytven, *Stadsfinanciën*, 337–95.
38. Munro, *Textiles, Towns and Trade*, I:1–27; Endrei, "Manufacturing a Piece of Woolen Cloth."
39. Verhavert, *Het Ambachtswezen*, 70; van Uytven, *Stadsfinanciën*, 393.
40. Stabel, "Labour Time, Guild Time?," 38, 40–41, 45.
41. Ibid., 48–50. On wages and time more generally, see Arnoux, "Relation salariale et temps du travail."
42. Stabel, "Labour Time," 36, 41–42, 46, 49, 51.
43. Munro, *Textiles, Towns and Trade*, V:33, citing SAL 722, 46r–59r, 127r–129v, and SAL 718, 21v–38v.
44. Ibid., I:19.
45. Ibid., I:21.
46. On piece-rate wages, see Reith, "Making of Wages," especially 282–87.
47. Stabel, "Labour Time," 42–45, 52.

48. See Simons, *Cities of Ladies*, 85–87; Hutton, *Women and Economic Activities*, 11, 32, 151–52.
49. For such crises and Leuven's economy, see van Uytven, *Stadsfinanciën*, 48, 474–77, 580–85.
50. A classic study is Noonan, *Scholastic Analysis of Usury*; also Le Goff, "Merchant's Time," 29–30.
51. Van Uytven, *Stadsfinanciën*, 53–54, 166, 184–86, 231.
52. For the following, see ibid., 196–231, 446–50.
53. Ibid., 182, 231.
54. Ibid., 382–89, 397, 412.
55. SAL 4659.
56. Ibid., 2r.
57. On meat and fish, see van Uytven, *Stadsfinanciën*, 280–89.
58. SAL 4659, 6v.
59. Ibid., 2r.
60. Ibid., 6r.
61. Ibid., 9r. For vernacular months, see Leendertz, "De namen der maanden," 326–37.
62. Vandendriessche, "The Children of the Planets."
63. See Smeyers and Smeyers, "De kalenderwijzerplaat in het Leuvense Stedelijk Museum." More generally, Hourihane, ed., *Time in the Medieval World*; Henisch, *Medieval Calendar Year*.
64. On leisure, see de Vroede, "Volkse ontspanning, speelholen en sportspektakel."
65. Vanden Broecke, *Limits of Influence*, 30–31.
66. Johannes de Westfalia, 1484; Aegidius van der Heerstraten, 1485–1486; Johannes Veldener, 1486.
67. Vandendriessche, "Children of the Planets," 63, 73–74.
68. Joannes Spierinck, *Almanack pro anno 1484*, Printer of the Heilichdomme. RLM, RA 416 (08354–5), sheet 12v. Also vanden Broecke, *Limits of Influence*, 31.
69. *Opus responsivum*, t.1 c.3 p.3.
70. Ibid.
71. Van Uytven, "Leven te Leuven," 13. On seasonal variation, see further van Uytven, *Stadsfinanciën*, 564–65, 574–76.
72. For the following, see ibid., 480; van Uytven, *Dagelijks leven*, 23–25. More generally, see Marx, *The Development of Charity*, 49–59.
73. Miræus, *Opera*, 2:901.
74. KBR mss 3096, 4655, 11784, and 11788 are surviving breviaries from St. Peter's, Leuven.
75. See Bede's influential discussion in his *De temporum ratione*, 64, CCSL 123B: 456–59.
76. For an excellent recent survey, see Arnold and Goodson, "Resounding Community."
77. Bearda, Sergeys, and Teugels, eds., *Campanae Lovaniensis*, 13, 86; van Even, *Louvain monumental*, 192.
78. See above, 8.
79. See, for example, payments for repairs in SAL 5103 (1476), 17r–v.
80. Maesschalck and Viaene, *Het Stadhuis van Brussel*.

81. Terlinden, "Le cinquième centenaire," 10–11.
82. Horsten, "Ter ere van God," 41.
83. On soundscapes and for further bibliography, see recently Dillon, *Sense of Sound*, particularly 51–91.
84. St. Gertrude's and St. James's also had storm bells. See Bearda, Sergeys, and Teugels, *Campanae*, 12, 117; van Even, *Louvain monumental*, 220.
85. Bearda, Sergeys, and Teugels, *Campanae*, 86; van Even, *Louvain monumental*, 192.
86. Bearda, Sergeys, and Teugels, *Campanae*, 11.
87. For a bell consecration in fifteenth-century Leuven, see Reusens, ed., "Chronique de la Chartreuse de Louvain," 248, hereafter Carthusian Chronicle.
88 . Dohrn-van Rossum, *History of the Hour*, 204.
89. Bearda, Sergeys, and Teugels, *Campanae*, 13.
90. Van Even, *Louvain monumental*, 220; Dohrn-van Rossum, *History of the Hour*, 204.
91. Bearda, Sergeys, and Teugels, *Campanae*, 13, 93.
92. For example, SAL 5103 (1476), 4v, 6v, 45r, 45v, 63v.
93. Ibid., 45r.
94. On night, see Koslofsky, *Evening's Empire*.
95. See, for example, SAL 5103 (1476), 46r. Also Greilsammer, "Midwife, Priest, Physician," 292.
96. See, for example, SAL 5103 (1476), 27v.
97. Ibid., 20r.
98. Lamberts and Roegiers, *Leuven University*, 132.
99. Bearda, Sergeys, and Teugels, *Campanae*, 14.
100. Ibid., 47.
101. Ibid., 47–48.
102. Ibid., 93, 120, 130–32.
103. AA, I, reg. 53, 160v–161r; AA, I, reg. 4, 144r–145r. Also Lefèvre, "Textes concernant l'histoire artistique."
104. Van Even, *Louvain monumental*, 194. For the following, see Bearda, Sergeys, and Teugels, *Campanae*, 86–87. Also Cardon, "Aspecten van de tijd," 23.
105. Van Even, *Louvain monumental*, 194; Bearda, Sergeys, and Teugels, *Campanae*, 12.
106. Bearda, Sergeys, and Teugels, *Campanae*, 86.
107. Leopold, *Almanus Manuscript*, 108–23.
108. Bearda, Sergeys, and Teugels, *Campanae*, 93.
109. Van Even, *Louvain monumental*, 220.
110. Miræus, *Opera*, 2:901.
111. *Opus responsivum*, t.1 c.3 p.2. "Primus etenim ordo temporum apud hebreos in quo lux tenebras precessit: casum hominis a luce gratie in tenebras peccati designavit."
112. Ibid. "Ordo vero temporum quem servaverunt in suis festis postquam egiptum egressi sunt: designavit nos in tempore gratie a peccatorum tenebris ad claritatem regni celestis transferendos."
113. *Expositio hymnorum cum commento* (Delft: Christiaan Snellaert, 1496), 9r–v, hereafter *Expositio*. The terms are *sero, hesperus, conticinium, gallicinium, crepusculum*,

and *mane*. For the *Expositio* at the Bethleem Priory near Leuven, see Persoons, "De incunabels," 162.

114. See Ostorero, *Le diable au sabbat*.
115. Van Balberghe, ed., *Jean Tinctor*; Jacquier, *Flagellum hæreticorum fascinariorum*.
116. KBR mss 11441-42 and 733-41.
117. Van Balberghe, *Les manuscrits médiévaux*, 133.
118. *Flagellum*, 4. See also *Expositio*, 9r. For versions from Park, see KBR ms 11556, 147r-v.
119. Van Balberghe, *Jean Tinctor*, 65-70; *Flagellum*, 44.
120. See above, 30, 32-33.
121. Lefèvre, *Les Ordinaires*, 2, 18.
122. On liturgy and the senses, see recently Palazzo, *L'invention chrétienne des cinq sens*.
123. For the following, see Innocent III, *Liber de sacramento ecclesie*, KBR ms 657-66, 216r-217r.
124. Kirkman, *Cultural Life*, 193-95.
125. Lefèvre, *Les Ordinaires*, 78.
126. See de Roos, "Carnival Traditions in the Low Countries"; Stalpaert, *Van Vastenavond tot Pasen*. For Midsummer festivals, see Billington, *Midsummer*.
127. Lefèvre, *Les Ordinaires*, 74.
128. Antonius de Butrio, *Speculum de confessione* (Leuven: Johannes de Westfalia, c. 1481-1483), hereafter *Speculum de confessione*.
129. Ibid., 2r.
130. Ibid., 2v.
131. Jean Gerson, *Contra superstitiosam dierum observantiam* and *De observatione dierum quantum ad opera*, in JGOC 10.116-21, 128-30. On Egyptian days, see Steele, "Dies Aegyptiaci."
132. *Speculum de confessione*, 3r. "Si tunc male disposuit tempus suum circa ludos circa spectacula vel tabernas."
133. Ibid., 5v-6r.
134. Ibid., 4r.
135. Ibid., 5v, 6r, 8r-v.
136. On Ember Days, see Pàttaro, "Christian Conception of Time," 188-89; Sears, *Ages of Man*, 116.
137. *Speculum de confessione*, 8v.
138. Ibid. "Causa quare homines non debeant in festis laborare est ut possint audire divina officia et orationibus vacare."
139. Ibid.
140. ARAL 630-703.
141. See Charles Caspers and Peter Sijnke, "Middelburg, Heilig Sacrament," in the *Databank Bedevaart en Bedevaartplaatsen in Nederland*, accessed September 7, 2016, http://www.meertens.knaw.nl/bedevaart/bol/plaats/501.
142. ARAL 630-702.
143. See above, 22.

144. KBR ms 11788, 182v–183r. See also Rudy, "Dirty Books."

145. For the following, see Twycross, "Worthy Women"; van Even, *L'Omgang de Louvain*. On processions, see Kirkland-Ives, *In the Footsteps of Christ*.

146. The manuscripts are the *Liber Boonen* (1593–1594) (Museum Leuven) and KBR ms II 306.

147. KBR ms II 306, 2v.

148. KBR ms II 306, 3r. See further Champion, "Presence of an Absence."

149. Barbara Haggh, "Officium of the *Recollectio Festorum Beate Virginis*."

150. KBR ms 11788, 245r–245v. "Istud festum solempnitatum omnium festorum beate marie virginis fuit primitus celebratum in ecclesia sancti petri lovaniensis prima dominica septembris anno septuagesimo septimo que tunc fuit septima dies mensis septembris. Et deinceps semper celebrabitur prima dominica septembris quia tunc est processio lovaniensis."

151. Sutch and van Bruaene, "Seven Sorrows of the Virgin Mary"; Schuler, "Seven Sorrows of the Virgin."

152. On Leuven's rosary confraternity, see van Uytven, *Dagelijks leven*, 67.

153. On seven, see Angenendt et al., "Counting Piety," 17, 25; Lentes, "Counting Piety," 78.

154. KBR ms 11788, 168r. "Quia semper prima dominica septembris celebratur processio beate marie virginis, et tunc tenetur festum recollectionis omnium festorum beate marie virginis, et quia illud festum non habet fixum et determinatum diem, sic require in fine huius libri."

155. Reusens, *Documents*, 1:5–17.

156. See Bartocci, Masolini, and Friedman, "Reading Aristotle (I)," 140–43; Claes, "Changes in the Educational Context," 146.

157. Vanden Broecke, *Limits of Influence*, 40–41; Reusens, *Documents*, 2:1, 235. Payment for afternoon classes appears in SAL 5103, 5v.

158. Wils, "Les dépenses," 492, 497.

159. For the university cursus, see Lamberts and Roegiers, *Leuven University*, 69–70.

160. Wils, "Les dépenses," 494.

161. De Jongh, *L'ancienne faculté*, 63–65.

162. Reusens, *Documents*, 1:691–705.

163. Ibid., 1:692.

164. For other regulations of Leuven's nightlife, see de Jongh, *L'ancienne faculté*, 34; Lamberts and Roegiers, *Leuven University*, 36, 127.

165. Reusens, *Documents*, 693.

166. AUL ms 109–10; Ker, "'For All That I May Clamp.'"

167. Compare KBR ms 801. VDG 1.144.

168. For similar colophons from university notes at Leuven, see Guedens and Masolini, "Teaching Aristotle."

169. AUL mss 195–97.

170. National Gallery, London (NG943). On the following, see Campbell, *Fifteenth Century Netherlandish Schools*, 46–51.

171. KBR ms 15043; Carthusian Chronicle.

172. Johannes de Westfalia, Leuven, c. 1482–1483; Johannes Veldener, Leuven, c. 1484 and c. 1486.
173. See below, 144.
174. Van Aelst, "Het gebruik van beelden," 89–91.
175. Carthusian Chronicle, 236.
176. See Carruthers, *Book of Memory*.
177. Carthusian Chronicle, 242.
178. Ibid., 242.
179. Caspers, "Indulgences in the Low Countries," 73–75. On baptism and jubilee, see Strøm-Olsen, "Dynastic Ritual and Politics," 45.
180. Caspers, "Indulgences," 96–97.
181. Rudy, "Dirty Books."
182. Ibid.
183. KBR Inc.B.1463. "Ad campanam dum pulsatur/ Si ter ave maria dicatur/ Dies dantur quadraginta/ Et ad gloriam psalmore/ liij qui sequuntur chore/ Sint devote inclinantes/ Quadraginta sunt habentes/ Et quando Jhesus nominatur/ Si devote inclinatur/ Dies dantur to[ti]dem."
184. See also Landes, *Revolution*, 90–91; Whitrow, *Time in History*, 110–11.
185. See above, 21.
186. See, for example, Kock, *Die Buchkultur der Devotio moderna*, 134.
187. JGOC 2:35. Translation from McGuire, *Jean Gerson*, 28.
188. On Gerson and humanism, see Ouy, "Discovering Gerson the Humanist."
189. Valerius, *Fasti academici studii generalis Lovaniensis*, 58.
190. Compare Ovid, *Metamorphoses*, 15:234. On humanism, see IJsewijn, "The Coming of Humanism," 193–301.
191. Carthusian Chronicle, 243.
192. Ibid.
193. Ibid.
194. Compare White, "Value of Narrativity," 4–5. For further discussion, see Champion, "Emotions and the Social Order of Time," 102–7.
195. KBR ms 15003-48, 43v–48r.
196. Carthusian Chronicle, 250.
197. Ibid., 251.
198. Ibid., 257.
199. Ibid., 261.
200. Ibid., 269.
201. See van Uytven, *Dagelijks leven*, 159–70.
202. Reusens, *Documents*, 4:446, 451, 455.
203. Van der Essen, "Testament de Maître Guillaume de Varenacker," 13–14.
204. GUB ms 476. On provenance, see Jansen-Sieben and van Winter, eds., *De Keuken*, 9, 40–41, 72, 100.
205. Ibid., 23–25.
206. GUB ms 476, 37r; Jansen-Sieben and van Winter, *De Keuken*, 25, 113.
207. GUB ms 476, 54v. Jansen-Sieben and van Winter, *De Keuken*, 25, 140.

208. See, for example, Thompson, "Time, Work-Discipline, and Industrial Capitalism," 58.

209. See Mannaerts and Knoops, *Divine Sounds*, 31.

210. For gender and time, see Yandell, *Carpe Corpus*. On women's time, see Kristeva, *New Maladies of the Soul*.

211. Howell, *Marriage Exchange*; Hutton, *Women and Economic Activities*.

212. On Leuven's legal and political structures, see van Uytven, *Dagelijks leven*, 35–56. On law, see Brand, "Lawyer's Time."

213. Simons, *Cities of Ladies*, 310–11.

214. SAL 4659, 4r, 9r–v.

215. See, for example, ARAL 601/2 9456 (1437), 6v.

216. Figures from *Speculum de confessione*, 6v, where their imprecision is acknowledged.

217. See above, 46.

218. Sears, *Ages of Man*.

219. Rieder, *On the Purification of Women*.

220. On religious women and the *devotio moderna*, see Scheepsma, *Medieval Religious Women*.

221. Reinburg, *French Books of Hours*; Pearson, *Envisioning Gender*; Wieck, *Book of Hours*.

222. Rudy, "Dirty Books," suggests that compline's lower use relates to evening prayer's difficulty within households.

223. On this manuscript, see de Kesel, "Cambridge University Library Ms Add. 4100." Gabriel's hands perhaps evoke the hands of a clock.

CHAPTER TWO

1. Important work on the altar includes Schlie, *Bilder des Corpus Christi*, 76–83; Welzel, "Ausstattung für Sakramentsliturgie und Totengedanken"; Bergmans, *Leuven in de late Middeleeuwen*; McNamee, *Vested Angels*, 19–32; Smeyers, ed., *Dirk Bouts (ca. 1410–1475)*; Comblen-Sonkes, *Collegiate Church*, 2:1–84; Butzkamm, *Bild und Frömmigkeit*; Dale, "'Latens Deitas'"; Lane, *Altar and the Altarpiece*, 112–17.

2. SAL 4143 contains a plan of the altars.

3. Welzel, "Ausstattung für Sakramentsliturgie und Totengedanken," 183 n. 130. Butzkamm, *Bild und Frömmigkeit*, 142–45, argues for a wider set of opening dates.

4. Van Even, "Le contrat"; Comblen-Sonkes, *Collegiate Church*, 73–74.

5. Campbell, "Art Market," 192.

6. Translations from the contract are modified from Stechow, *Northern Renaissance Art*, 10–11.

7. Koselleck, *Futures Past*. Compare Welzer, "Albert Speer's Memories."

8. See Strubbe and Voet, *De Chronologie*.

9. For political years, see Billington, *Midsummer*, 119. Compare Cambrai's midsummer elections, CMM ms 1058–60. For financial years, see van Uytven, *Stadsfinanciën*, 46–47. See also for accounts implying different administrative years, SAL 5103, 33r (Christ-

mas or January); 56r (Easter); 63v (All Saints); also SAL 4659, 9v (Easter); ARAL 601/2 9456, 1419, 1434, 1437–1439, 1449 (Feast of St. Thomas); 1463–1464 (All Saints).

10. Strubbe and Voet, *De Chronologie*, 494.

11. It was used in Cambrai's ecclesiastical accounts (e.g., CMM mss 1058–60), and by civic authorities in Ghent (e.g., SAG 330/28).

12. Strubbe and Voet, *De Chronologie*, 53.

13. See below, 84–85.

14. Compare Matthew 12:1–8.

15. On this process elsewhere, see Philip, *Ghent Altarpiece*, 31–32.

16. Mark 15:38; Matthew 27:51; Luke 23:45.

17. Van Even, "Le contrat"; Cardon and Dekeyzer, "Dirk Bouts in de universiteitsstad." For Varenacker's orthodox interpretation of the sacraments, see his *Sacramentale*, KBR ms 2395–410, 170v–177r; KBR ms 4414–24, 50r–57r.

18. The Latin sources are collected in Baudry, ed., *La querelle des futures contingents*, translated by Guerlac as *The Quarrel over Future Contingents*. This collection has been supplemented in Schabel, "Peter de Rivo (Part 1)" and "Peter de Rivo (Part 2)." Recently discovered texts relating to the debate found in Leuven, KUL Centrale Bibliotheek, ms 1635, are being edited by Schabel and Serena Masolini. See Bartocci, Masolini, and Friedman, "Reading Aristotle (I)," 133. For further analysis, see Evans, "Peter de Rivo"; Schabel, *Theology at Paris*, 315–36; Streveler and Tachau, eds., *Seeing the Future*; Craig, *Problem of Divine Foreknowledge*; Gabriel, "Intellectual Relations," 119–27.

19. For the debate's chronology, see Baudry, *Quarrel*, 14–30.

20. Ibid., 33–35; Baudry, *La querelle*, 67–69.

21. Baudry, *Quarrel*, 33–34; *La querelle*, 67–68.

22. For de Rivo's biography and an (incomplete) list of works, see Macken, *Medieval Philosophers*, 1:437–47; Bartocci, Masolini, and Friedman, "Reading Aristotle (I)," 133–40. On de Rivo's Aristotelianism more generally, see Bartocci and Masolini, "Reading Aristotle (II)."

23. Schabel, "Peter de Rivo (Part 1)," 374–75.

24. Baudry, *Quarrel*, 20, 24, 53–55, 222–23, 364–65, 418–19.

25. Ibid., 55; Baudry, *La querelle*, 87.

26. Baudry, *Quarrel*, 198; *La querelle*, 241.

27. Baudry, *Quarrel*, 63; *La querelle*, 95.

28. Aquinas, *Summa contra gentiles*, 1.66; Craig, *Problem of Divine Foreknowledge*, 106.

29. ST Ia, q.1 a. 10 resp.; Ia, q. 10. a. 2 resp. 4; Ia, q. 14 a. 13 resp. Aquinas, *Compendium theologiae*, 1.133. See also Augustine, *Confessions* XII, 42; Craig, *Problem of Divine Foreknowledge*, 116–18.

30. Aquinas, *Compendium theologiae*, 1.133. Also Aquinas, *De veritate*, 2.12; Aquinas, *In libros perihermeneias expositio*, 14.19; ST Ia.14.13 *ad* 3. Craig, *Problem of Divine Foreknowledge*, 106, 254.

31. Ibid., 106.

32. Aquinas, *De veritate* 2.12.

33. ST Ia, q. 79 a. 9 resp.; Ia, q. 58 a. 3 resp: "est enim actus rationis quasi quidam motus de uno in aliud perveniens." On this and the following, see Cook, *Milton, Spenser and the Epic Tradition*, 164–66; Schmidt, *Domain of Logic*, 202–9, 242.

34. ST Ia, q. 58 a. 4 resp.

35. ST IIIa, q. 76 a. 7 resp.

36. Baudry, *Quarrel*, 40; *La querelle*, 73. On Auriol, see Schabel, *Theology at Paris*. See also Evans, "Peter de Rivo," 48–49.

37. Baudry, *Quarrel*, 40; *La querelle*, 73–74.

38. Baudry, *Quarrel*, 266; *La querelle*, 307–8. On this argument's debt to Auriol, see Schabel, "Peter de Rivo (Part 1)," 376–79.

39. For the following, see Baudry, *Quarrel*, 40; *La querelle*, 74.

40. On this aspect of de Rivo's argument, see Evans, "Peter de Rivo," 47–52.

41. Baudry, *Quarrel*, 43; *La querelle*, 76.

42. Baudry, *Quarrel*, 43; *La querelle*, 77.

43. For this and the following, see Baudry, *Quarrel*, 43–44; *La querelle*, 77.

44. Baudry, *Quarrel*, 27.

45. For the following, see Baudry, *Quarrel*, 199–201; *La querelle*, 243–45.

46. Baudry, *Quarrel*, 12–13. In 1472, Bailluwel denied that he had ever taught on future contingents.

47. Baudry, *Quarrel*, 213–80; *La querelle*, 259–321.

48. Baudry, *Quarrel*, 214; *La querelle*, 260.

49. Baudry, *Quarrel*, 274–75; *La querelle*, 315–16.

50. See Welzel, "Ausstattung für Sakramentsliturgie und Totengedanken," 183.

51. Genesis 14:18–20.

52. This interpretation is proposed by Smeyers, but not endorsed by Welzel. See Cardon and Dekeyzer, "Dirk Bouts," 205.

53. Genesis 12:1–32.

54. Exodus 16:9–21.

55. 1 Kings 19:4–8.

56. Welzel, *Abendmahlsaltäre*, 87, reads this as a sign of the passing away of the old law.

57. A marginal note in a fourteenth-century ordinal records the feast's institution. See Lefèvre, *Les Ordinaires*, xi, 128, 281. ARA 601/1, 1377/1–8, record regular payments for Corpus Christi decorations. On Eucharistic piety, see further Caspers, *De eucharistische vroomheid*.

58. For example, KBR ms 4665, 6v, 75r–76r.

59. Baudry, *Quarrel*, 40; *La querelle*, 74. On God as mirror, see Grabes, *Mutable Glass*, 75–76.

60. Van Even, *Louvain monumental*, 199; Timmerman, *Real Presence*, 92–94; Welzel, "Ausstattung für Sakramentsliturgie und Totengedanken," 179–80.

61. Lefèvre, *Les Ordinaires*, 2, 18, 74, 78.

62. See above, 1–2, 7.

63. On the problematic language of "frozen" images, see Mitchell, "Spatial Form," 274. For an example of frozen time in images, see Strohm, *Music in Late Medieval Bruges*, 1.

64. For the following, see Caspers, "Wandering between Transubstantiation and Transfiguration," 341–54.
65. KBR ms 11788, 100v–108r.
66. Caspers, "Wandering between Transubstantiation and Transfiguration," 346.
67. McNamee, *Vested Angels*, 26.
68. Mark 9:2–13; Matthew 17:1–13; Luke 9:28–36.
69. SBB ms Magdeb. 7, 27v–28r.
70. Deuteronomy 34:1–8.
71. For other treatments of the problem, see *Biblia latina cum glossa ordinaria*, 4:175, and Thomas Aquinas's *Scriptum super libros Sententiarum*, III, d. 16, q. 2, a. 1, and ST III, q. 45, a. 3. Also Canty, *Light and Glory*.
72. For a similar fifteenth-century reading, see Caspers, "Wandering between Transubstantiation and Transfiguration," 345.
73. See below, 169–71.
74. See Caspers, "Wandering between Transubstantiation and Transfiguration," 345.
75. KBR ms 11788, 100v. "Salvatorem expectamus dominum nostrum jhesum christum qui reformavit corpus humilitatis nostre configuratum corpori claritatis sue."
76. 2 Corinthians 3:18. KBR ms 11788, 101r.
77. Ibid., 103v. Bede, *Homiliarum euangelii*, 1.24, CCSL 122:172. "Quod autem post dies sex ex quo promisit discipulis claritatem sue visionis ostendit significat sanctos in die iudicii regnum percepturos quod eis promisit qui non mentitur deus ante tempora secularia, [tempora quippe secularia] sex etatibus constant. Quibus completis audient ipso dicente: venite benedicti patris mei possidete regnum vobis paratum a constitutione mundi." The square brackets mark an omission (noted in the St. Peter's breviary margins).
78. Bede, *Homiliarum euangelii*, 1.24, CCSL 122:174.
79. Leo I, *Sermones*, 51, PL 54: 308–13.
80. Col 3:9. KBR ms 11788, 107r–v.
81. SAL 5063, 100r (new foliation). See also van Uytven, *Stadsfinanciën*, 632; Stengers, *Les Juifs dans le Pays-Bas*, 148.
82. On the episode and for bibliography, see Cluse, *Studien zur Geschichte der Juden*, 284–95.
83. Welzel, "Ausstattung für Sakramentsliturgie und Totengedanken," 184.
84. On gold, see Baert, "Between Technique and Symbolism," especially 8–10.
85. On the manuscript, see Derolez, "L'editio Mercatelliana."
86. Smeyers, "Living Bread." Varenacker's commentary can be found in SBB ms Magdeb. 7, 334r–389r. Bailluwel also authored an almost illegible commentary on Hebrews: KBR ms 11731.
87. Hebrews 5–7; 9:2.
88. Comblen-Sonkes, *Collegiate Church*, 85–117.
89. See, for example, Blum, *Early Netherlandish Triptychs*, 72.
90. Cardon, "Na allen synen besten vermoegenen," 76–78.
91. Ibid., 76.
92. SBB ms Germ. Oct. 6, 145r–146v. Translation adapted from Rudy, "Dirty Books."
93. On temporal space, see Ohly, "Die Kathedrale als Zeitenraum."

94. SBB ms Germ. Oct. 6, 146r–v. "Oec beveel ic di heilige maertelaer Sinte herasme mijn siel ende mijn lichaem ende alle mijnre vrienden ende haer werken op dath leven in voerspoet in vreden ende in bliscappen ewilic end ymmermeer."

95. Ibid., 145r. "O heilighe ende gloriose maertelaert xpi, sinte herasme, die opten sonnendach ter doot gheoffert wordes[.]"

CHAPTER THREE

1. Citations are from the modern edition of the *Tractatus* in Cullington and Strohm, "That Liberal and Virtuous Art," 31–57, hereafter *Tractatus*, paragraph reference (page number).

2. Classic studies include Dixon, *From Passions to Emotions*, and Rosenwein, *Emotional Communities*. On emotions in the Burgundian territories, see Lecuppre-Desjardin and van Bruaene, eds., *Emotions in the Heart of the City*; Brown, "Devotion and Emotion."

3. Kaster, *Emotion, Restraint, and Community*, 8–9.

4. Hartmut Rosa has, for example, linked modern acceleration to social and personal feelings of alienation. See Rosa, *Alienation and Acceleration*.

5. For an example of devotional and affective life structured by week, see CMM ms B 143, 1v–15v.

6. See, for example, issues of *Early Music* (1997, no. 4, "Listening Practice") and *Musical Quarterly* (1998, no. 3–4, "Music as Heard"). Also Pesce, ed., *Hearing the Motet*; Judd, *Reading Renaissance Music Theory*, 5–16; Wegman, "'Musical Understanding'" and "Johannes Tinctoris and the Art of Listening."

7. An exception is Shai Burstyn, "In Quest of the Period Ear," 695.

8. Dillon, *Sense of Sound*, 13.

9. For the following, see Cullington and Strohm, "*That Liberal and Virtuous Art*," 7–9; Kaluza, "Matériaux et remarques."

10. Houdoy, *Histoire artistique*, 361.

11. Ibid., 365.

12. See above, 22, 49–50.

13. See above, 17–21. On Cambrai's liturgy, see also Haggh, "Late-Medieval Liturgical Books of Cambrai." For a fifteenth-century Cambrai *Recollectio*, see CMM ms 91, 136r. For additional fifteenth-century Marian devotion at Cambrai, see CMM mss 6 and 11, which open and close with Marian chant, and where *cantus coronatus* marks the Virgin's name (e.g., CMM ms 6, 6v–7r, 21v–22r). A Marian coda is added to the Creed in CMM ms 6, 9v–10r. See also Pierre d'Ailly's commentaries on *Ave Maria* in CMM mss 55 and 577, and the dedication image in CMM ms 29, 227r. For Marian piety in Cambrai's books of hours, see CMM ms 108 and CMM Inc. 110. Fifteenth-century foundations for masses of the Virgin, as well as special provisions for lights and bell-ringing on her feasts, can be charted in Cambrai's obituary, CMM ms 170, 3r, 6v, 8v, 15v, 17r, 18r. Mary's role as guarantor of communal unity is emphasized in a fifteenth-century dispute, recorded in CMM ms 1038, over jurisdiction between the Dean and Chapter and the town's échevinage, where the restitution of rights was to be made in front of an image of the Virgin in the Cathedral.

14. Cullington and Strohm, "*That Liberal and Virtuous Art*," 15–16. Also Derolez, *Library of Raphael de Marcatellis*, 233.

15. On Tinctoris, see Page, "Reading and Reminiscence"; Wegman, "Johannes Tinctoris." For Tinctoris extracts at Cambrai, see CMM ms 416.

16. *Tractatus*, 1.1 (p. 48).

17. Cullington and Strohm, "*That Liberal and Virtuous Art*," 13–14. Noting the meanings of *iubilatio armonica* outlined by Strohm, and following Ulrike Hascher-Burger, Carlier may be referring to a range of musical practices from elaborate monophonic melismas to simple note-against-note counterpoint and more complex polyphony. See Hascher-Burger, *Gesungene Innigkeit*, 185–205; Wegman, *Crisis of Music*, 49–51.

18. On Cambrai's musical life, in addition to works already cited, see Atlas, ed., *Dufay Quincentenary Conference*; Wright and Ford, "French Polyphonic Hymnal"; Wright, "Dufay at Cambrai." Barbara Haggh has expanded understandings of Cambrai in a series of studies including "Itinerancy to Residency"; "Guillaume Du Fay's Birthplace"; and "Nonconformity in the Use of Cambrai." A further prolific scholar of Cambrai is Alejandro Enrique Planchart. See, for example, "Choirboys in Cambrai"; "Guillaume Du Fay's Benefices"; "Guillaume Dufay's Masses."

19. Fallows, *Josquin*, 23–39.

20. Sadly, a collated list of foundations at Cambrai once available on Barbara Haggh's 2004 webpage, http://www.music.umd.edu/Faculty/haggh-huglo/barbnine.html, is no longer easily accessible (hereafter Haggh, *Foundations*). Wright, "Performance Practices," 305. The endowment should probably be understood as including adult singers. See Planchart, "Choirboys in Cambrai," 142.

21. Haggh, *Foundations*.

22. Cullington and Strohm, "*That Liberal and Virtuous Art*," 11, 14. On musical conflict more generally, see Wegman, *Crisis of Music*.

23. Von der Hardt, ed., *Magnum oecumenicum Constantiense Concilium*, 1.8.423; Haggh, "Introduction," xii.

24. Fallows, *Dufay*, 16.

25. CMM ms 38. See Haggh, "Introduction," xii.

26. Planchart, "Choirboys in Cambrai," 141–42.

27. Fallows, *Dufay*, 16–21.

28. Cullington and Strohm, "*That Liberal and Virtuous Art*," 14.

29. Hascher-Burger, *Gesungene Innigkeit*, 185–205; Blachly, "Archaic Polyphony"; Meyer, "Devotio Moderna et pratiques musicales polyphoniques."

30. Wegman, "Musical Understanding," 55–56, 65–66; Hascher-Burger, *Gesungene Innigkeit*, 195–200.

31. "De vita canonicorum," in *Doctoris Ecstatici D. Dionysii Cartusiani opera omnia*, 37:197. For Peraldus's *Summa*, see Siegfried Wenzel's edition, accessed September 7, 2016, http://www.unc.edu/~swenzel/superbit.html.

32. Wegman, "Musical Understanding," 55, 66.

33. Johannes Busch, *Chronicon Windeshemense*, cited in Hascher-Burger, *Gesungene Innigkeit*, 195. Translation from Blachly, "Archaic Polyphony," 184.

34. See Hascher-Burger, *Gesungene Innigkeit*, 251–470. Also Blachly, "Archaic Polyphony," 207–27, and Blachly, "Mechelen *Ave verum corpus*."

35. CMM, ms 1043.

36. Ibid., 62r–66v.

37. Ibid., 64r. Translation adapted from Harrán, *In Defense of Music*, 107–8.
38. CMM, ms 1043, 64v.
39. Wright, *Music and Ceremony*, 347; Wegman, *Crisis of Music*, 19.
40. For the following, see Wright, *Music and Ceremony*, 347–49. At Lyon, polyphony was banned. See Dobbins, *Music in Renaissance Lyons*, 130–31.
41. Wright, *Music and Ceremony*, 166–69.
42. *Tractatus*, 3 (48). Compare ST, 2.2.91.2.
43. *Tractatus*, 4 (48). Compare ST, 2.2.91.2.
44. On difficulties of vocabulary, see Champion, Garrod, Haskell, and Ruys, "But Were They Talking About Emotions?"
45. *Tractatus*, 1.9 (48). "Uterque autem, cantus simplex, scilicet, et musicalis iubilatio, trahit animam ad divinam contemplationem, secundum diversitatem statuum, personarum, temporum et locorum."
46. Ibid., 1.10 (48).
47. Ibid., 1.11 (48).
48. Ibid., 1.12 (48).
49. Ibid., 1.13–14 (48).
50. Ibid., 1.18 (48–49).
51. Ibid., 1.26 (49).
52. Ibid., 1.31 (49).
53. Ibid., 1.24 (49).
54. Ibid., 1.19 (49). "Est etiam consideranda regio: si terra canit [ars] musicalis habet locum, si iniuste oppressa cantus simplex gemebundus."
55. Ibid., 1.14 (48).
56. Small, *George Chastelain*, 168–69.
57. I have consulted versions from Cambrai (CMM ms 835), the Priory of Bethleem at Herent (KBR ms 2395–410), and the Abbey of Park (GUB ms 1429).
58. KBR ms 2395–410, 197v.
59. See Ainsworth, "'À la façon grèce,'" 547, 553–54, 582–84. Also Nagel and Wood, *Anachronic Renaissance*, 109–13; Urbach, "*Imagines ad Similitudinem*," 225; Wilson, "Reflections on St. Luke's Hand"; Ainsworth, *Facsimile in Early Netherlandish Painting*; Périer-d'Ieteren, "Une copie de Notre-Dame de Grâce de Cambrai"; Rolland, "La Madone italo-byzantine de Frasnes-lez-Buissenal." Useful local documentation is collected in Faille, ed., *Le Culte de Notre-Dame de Grâce*; Thelliez, *La merveilleuse image de Notre-Dame de Grâce*; Begne, *Histoire de Notre-Dame de Grâce*; Destombes, *Notre-Dame de Grace*, 39–53.
60. See above, 17–20. Also CMM ms 38, 33 1r; CMM ms 76, 48r; Destombes, *Notre-Dame*, 47; Haggh, "Introduction," xxv. On the Trinity Chapel, see Le Glay, *Recherches*, 29, 168.
61. Houdoy, *Histoire artistique*, 194. On manuscripts, see Planchart, "Guillaume Dufay's Masses"; Curtis, "Brussels, Bibliothèque Royale MS. 5557."
62. Kirkman, *Cultural Life*, 6.
63. Ibid., 3–25, quotation at 22.
64. Ibid., 32.

65. This seems a way of rehabilitating Wilhelm Ambros's observation, cited in Kirkman, *Cultural Life*, 12, that the "end of the first Kyrie of [Du Fay's] Mass *L'homme armé*" is like "smiling through tears." On medieval examples of *varietas* and contrary emotions, see Carruthers, *Experience of Beauty*, particularly 140–41.

66. See, for example, Ginzburg, "The Letter Kills," 71–77. Also Schreiner, "'Diversitas temporum.'"

67. Augustine, *De doctrina christiana*, III.35–78 (148–67).

68. Augustine, *Confessions*, III.7.13–III.8.15; Augustine, *De musica*, VI.vii.19; Pickstock, "Music: Soul, City," 258, 275.

69. Fabre, *La Doctrine du chant du cœur*.

70. For the following, see Irwin, "Mystical Music," 194–97.

71. Jean Gerson, *Tractatus secundis de canticis*, sections 43–44: "descendit hujusmodi varietas usque ad Canticorum diversificationem in ecclesiasticis ceremoniis multiplicem." Fabre, *La Doctrine du chant du cœur*, 395–96; Irwin, "Mystical Music," 199.

72. Gerson, *Tractatus secundis*, section 23: "stabit igitur quod simile canticum sit in ore unius novum et in altero vetus; ymo sint in eodem ore, tempore et corde mutatis." Fabre, *La Doctrine du chant du cœur*, 383; Irwin, "Mystical Music," 196–97.

73. For Gerson's use of *diversitas temporum*, see Pascoe, "Gerson and the Donation of Constantine," 479–84; Mazour-Matusevich, "Gerson's Legacy," 380–81.

74. *D. Martin Luthers Tischreden*, 4:215–16 (no. 4316). Leaver, *Luther's Liturgical Music*, 103, 389. Also Østrem, "Luther, Josquin and *des fincken gesang*."

75. On *consolatio* and *Trost*, see van Engen, "Multiple Options," 282. On emotions in sixteenth-century Germany, see Karant-Nunn, *Reformation of Feeling*.

76. For this emotional shape elsewhere in Luther, see Aurelius, "*Quo verbum dei vel cantu inter populos maneat*," 24–26.

CHAPTER FOUR

1. On the Ghent war and its aftermath, see Populer, "Le conflit de 1447 à 1453," 99–123; Boone, *Gent en de Bourgondische hertogen*, 226–35; Vaughan, *Philip the Good*, 303–33.

2. Boone, *Geld en macht*, 60–67, 146–52, 207–17.

3. Dhanens, "Het Boek der Privilegiën," 95–98.

4. See, for example, Blockmans, "Le dialogue imaginaire." For orientations in the copious scholarship, see Small, "When Indiciaires Meet Rederijkers"; Brown, "Ritual and State-Building," 2–13.

5. Arnade, *Realms of Ritual*, 29–31.

6. Ibid., 30.

7. Ibid., 29.

8. Ibid.

9. Fassler, *Virgin of Chartres*, 67. Compare the marginalization of liturgy in Soly, "Plechtige intochten," 342. Studies far more alert to liturgy are Boureau, "Les cérémonies royales françaises"; Brown, *Civic Ceremony and Religion*; and Brown, "Liturgical Memory and Civic Conflict," 130–31.

10. Dhanens, "De Blijde Inkomst"; Hurlbut, "Ceremonial Entries in Burgundy," 222–57; Chipps Smith, "Venit nobis pacificus Dominus"; Kipling, *Enter the King*.

11. Kantorowicz, "The 'King's Advent.'"

12. Ibid., 207–21.

13. Ibid., 229.

14. Lecuppre-Desjardin, *La ville des cérémonies*; Lecuppre-Desjardin and van Bruaene, *Emotions in the Heart of the City*.

15. Chipps Smith, "Venit nobis pacificus Dominus"; Geertz, *Interpretation of Cultures*, 93–94.

16. These manuscripts are the basis for the generally reliable edition cited here for ease of consultation: Blommaert and Serrure, eds., *Kronyk van Vlaenderen van 580 tot 1467*, hereafter *Chronyck*.

17. Kervyn de Lettenhove, ed., *Oeuvres de Georges Chastellain*, hereafter *Oeuvres*. On Chastelain and his chronicle, see Small, *George Chastelain*; Delclos, *Le témoignage de Georges Chastelain*. On Chastelain's reception, see Small, *George Chastelain*, 197–227; Small, "Qui a lu la chronique de George Chastelain." Further accounts of the entry are found in Fris, ed., *Dagboek van Gent*, 2:184–85, hereafter *Dagboek*; Maetschappy der Vlaemsche Bibliophilen, ed., *Memorieboek der Stad Ghent*, 1:249–50, hereafter *Memorieboek*; de Reiffenberg, ed., *Mémoires du J. du Clercq*, 3:278–81; and de Viriville, ed., *Chronique de Charles VII*, 3:80–89.

18. Small, *George Chastelain*, 107–8, 114–15, 127, 134–35.

19. On the prologue, see ibid., 167–69; for Chastelain's familiarity with scripture and patristic theology, partly as a result of his Leuven training, see 111–12, 134–36. On providential history, see Delclos, *Le témoignage de Georges Chastelain*, 291–97.

20. *Oeuvres* 1:2.

21. Ibid., 1:4. "Sy ne souffiroit de donner exemple, ni un, ni plusieurs, quand bien, par l'espace de deux mille ans, Dieu a ainsi traité les Juifs entre chaud et froid, puis chus, puis relevés, puis oubliés, puis rappelés, tousjours en haut et singulier mistère, outre povoir de nature et toute faculté d'humain engin."

22. Ibid., 1:8–10.

23. For the following, see ibid., 3:396.

24. Ibid., 3:399. "O que plust à Dieu que sa miséricorde se pust ouvrir envers nous et que sa hautesse vousist cognoistre la ferme et bonne amour de quoy nous l'aimons!"

25. Ibid., 3:398.

26. See recently Paul, "Use of *Kairos*."

27. *Oeuvres*, 3:406.

28. Ibid., 3:406: "car de tout temps du monde avoit aimé Gantois sur tous autres et encore les aimoit non obstant quelque guerre qu'il eust eue contre eux."

29. John 13:1.

30. *Oeuvres*, 3:407.

31. Kipling, *Enter the King*, 31. Compare Brown, "Liturgical Memory," 140–45, who similarly locates the 1486 entry of Frederick III and Maximilian into Bruges within a liturgical season other than Advent.

32. *Chronyck*, 2:128–29.

33. *Oeuvres*, 3:407.
34. Ibid. On Bertoul, see also 4:216; Stecher, ed., *Oeuvres de Jean Lemaire de Belges*, 4:500–501; Delclos, *Le témoignage de Georges Chastellain*, 325–26.
35. Matthew 27:51–52.
36. See below, 148.
37. See above, 57–58.
38. For example, *Oeuvres*, 3:359–62.
39. Ibid., 3:408.
40. Ibid., 3:401.
41. Ibid.
42. Ibid., 3:408, 411. *Chronyck*, 2:212.
43. See above, 39–40, 52.
44. Contamine, "Les Chaînes dans les bonnes villes de France," 293–314.
45. Devillers, "Les Séjours des ducs de Bourgogne en Hainaut," 344–48, 408–10 (quotation on 409). For the translation, see Brown and Small, eds., *Court and Civic Society*, 157. On a similar case at Besançon in 1451, see Vaughan, *Philip the Good*, 303–4.
46. This discussion draws on Lecuppre-Desjardin, "Les lumières de la ville." Town and guild accounts include records of significant expense on lighting (e.g., SAG 400/19 and 165/1, 64r–v).
47. *Chronyck*, 2:248. See also *Memorieboek*, 249–50; de Reiffenberg, *Mémoires*, 281.
48. This reading is offered alongside Lecuppre-Desjardin's, which emphasizes potential destabilizations of ducal power. See Lecuppre-Desjardin, *La ville des cérémonies*, 7, 318–19.
49. *Oeuvres*, 3.415–416. Translation adapted from Brown and Small, *Court and Civic Society*, 175–76.
50. Revelation 21:25; 22:5.
51. Arnade, "Secular Charisma, Sacred Power," 80; Dhanens, "De Blijde Inkomst," 59; Lecuppre-Desjardin, *La ville des cérémonies*, 298; On St. George, see Morgan, "Cult of St. George c. 1500."
52. Moulin-Coppens, *De geschiedenis van het oude Sint-Jorisgilde*, 83–106; De Potter, *Jaarboeken der Sint-Jorisgild*, 61–98, 103–4.
53. Morgan, "Cult of St. George," 152, 160; Dhanens, "Vorstelijke glasramen van circa 1458," 124–25.
54. De Potter, *Gent*, 506–15.
55. ONB ms 2583, 349v. Clark, *Made in Flanders*, 13, 348. For a later use of the dragon in Ghent's ritual life, see Strøm-Olsen, "Dynastic Ritual," 50.
56. Compare the possible alignment of Maximilian and Saint Michael on Bruges's belfry in Brown, "Liturgical Memory," 136, 142.
57. De Potter, *Gent*, 523.
58. Compare the useful formulation in Small, *George Chastelain*, 217: "mastery of *terra* and *tempus* was a natural aim of lordship." We could, however, read this as one of the ambiguous moments in the ritual communication between court and town that have been persuasively identified by Lecuppre-Desjardin in *La ville des cérémonies*: while Philip ostensibly trampled on the sin of the city, the dragon of Ghent remained flying proudly above the city.

59. *Chronyck*, 2:212. Compare *Memorieboek*, 249. On *murmuratio*, see Dumolyn and Haemers, "'A Bad Chicken Was Brooding,'" 56.
60. Revelation 21:25.
61. Dhanens, "De Blijde Inkomst," 63–64; De Potter, *Gent*, 497–98; De Busscher, *Recherches sur les peintres gantois*, 57. A new driver for the clock was also made in 1458. See Fris, *Dagboek*, 185.
62. *Chronyck*, 2:213.
63. Ibid.
64. Ibid., 2:211–12.
65. On the Prince as the source of history, see Small, *George Chastelain*, 126, 163.
66. *Chronyck*, 2:213.
67. KBR ms 4665, 3r. "Jesu, nostra redemptio,/ amor et desiderium,/ Deus creator omnium,/ homo in fine temporum."
68. Bousmanne and van Hoorebeeck, eds., *La librairie des ducs de Bourgogne*, 1:260–63. See above, 21.
69. Judith 3:6.
70. Judith 3:9–10. The quotation creates the potential for an unsettling identification of Philip with Holofernes, once more showing possible instability in the entry's symbolic structures. Yet the Duke may also be protected against a direct symbolic identification by the context in Judith. Holofernes and the pagan peoples who offer him an entry celebration are one step removed from the direct model of a truly "peaceful Lord" and a responsive Jewish or Christian community.
71. *Chronyck*, 2:210–11.
72. Ibid., 2:216.
73. Ibid., 2:216–17.
74. Kipling, *Enter the King*, 269; Chipps Smith, "Venit nobis pacificus Dominus," 265.
75. Song of Solomon 3:4. See further Hurlbut, "Ceremonial Entries in Burgundy," 234–35. On tableaux generally, see Bussels and van Oostveldt, "De traditie van de tableaux vivants"; Eichberger, "*Tableau Vivant*."
76. On the maid of Ghent, see Chipps Smith, "Venit nobis pacificus Dominus," 261; Arnade, "Secular Charisma," 85.
77. *Chronyck*, 2:218. Luke 15:21.
78. Luke 15:24.
79. Proverbs 31:26.
80. See Brown and Small, *Court and Civic Society*, 180.
81. *Chronyck*, 2:214.
82. Dhanens, "De Blijde Inkomst," 78.
83. *Chronyck*, 2:219.
84. Kipling, *Enter the King*, 272.
85. *Chronyck*, 2:219.
86. Haggai 2:8.
87. *Chronyck*, 2:219–20.
88. Ibid., 2:221.
89. Kipling, *Enter the King*, 273; Chipps Smith, "Venit nobis pacificus Dominus," 262, 270.

90. See Cumming, *Motet in the Age of Du Fay*, 199–200.

91. Masser and Siller, eds., *Das Evangelium Nicodemi*, 280, 294–95; Hoffmann, "Gospel of Nicodemus in High German," 318–19, 326–30.

92. 1 Corinthians 15:52. On sound in civic entries, see Clouzot, "Le son et le pouvoir."

93. *Chronyck*, 2:221.

94. Ibid., 2:222.

95. The following discussion of the Ghent altar draws on, and modifies, the readings offered by Dequeker, *Het Mysterie van het Lam Gods*; McNamee, *Vested Angels*; Philip, *Ghent Altarpiece*; Schlie, *Bilder des Corpus Christi*; Purtle, *Marian Paintings*; Harbison, *Jan van Eyck*; Ward, "Disguised Symbolism."

96. Strohm, *Music in Late Medieval Bruges*, 1.

97. *Chronyck*, 2:223.

98. Ibid., 2:224.

99. Isaiah 28:12; Psalm 131:14. Kipling, *Enter the King*, 277.

CHAPTER FIVE

1. *Epistola apologetica ad doctores Louvanienses* (Leuven: Johannes de Westfalia, 1488).

2. On Peter de Rivo, see above, 70–73.

3. For example, Kaltenbrunner, "Die Vorgeschichte der Gregorianischen Kalenderreform"; Marzi, *La questione della riforma del calendario*; Struik, "Paulus van Middelburg"; North, "The Western Calendar." For an early description of de Rivo, see Valerius, *Fasti*, 61.

4. For Paul of Middelburg's biography, see Struik, "Paulus van Middelburg," 85–87. Also Molhuysen and Blok, eds., *Nieuw Nederlandsch Biografisch Woordenboek*, 860–61.

5. See, for example, Grafton, *Joseph Scaliger*; Carlebach, *Palaces of Time*.

6. I use the spelling *Monotesseron* preserved in the manuscripts of de Rivo's work to distinguish de Rivo's text from Gerson's *Monotessaron*. In practice, both spellings circulated for Gerson's work in the fifteenth century.

7. "In hoc libro continetur/ Augustinus super genesim ad litteram—confrater noster ricardus hermanni scripsit/ Monotesseron evangelicum venerabilis magistri petri de rivo—diversi fratres scripserunt/ Opera eiusdem contra magistrum paulum de middelburgho—data sunt tempori nostro ab eodem magistro petro/ Idem de reformatione kalendarij. frater petrus maes scripsit."

8. De Schepper, Kelders, and Pauwels, *Les seigneurs du livre*, 46–56. I am grateful to Michiel Verweij for advice on the manuscript.

9. VDG 1:164. See also Burie, "Proeve tot inventarisatie," 257; Persoons, "De incunabels"; Kohl, Persoons, and Weiler, eds., *Monasticon Windeshemense*, 1:22–24.

10. The contents are described in Oates, *Catalogue of the Fifteenth-Century Printed Books*, 633 (3825). Oates's entry is restated in Derolez et al., *Corpus Catalogorum Belgii*, 7:309.

11. KBR ms II 1185, vol. 3 (*Sciences et Artes*), entry 183b.

12. It is possible that the works had already been separated, and rebound, while the volume was still in Bethleem's library. A seventeenth-century booklist from the Priory

records the printed works of Peter de Rivo on the calendar as bound with a copy of Lorenzo Valla's *Elegantiae*. See KBR ms 14673, 35v. This may have been a second copy of de Rivo's works, or they may have been separated and rebound again sometime before or during van de Velde's ownership.

13. At some stage, CUL Inc.3.F.2.9 was cut down to 27 x 19.5 cm.

14. Kohl, Persoons, and Weiler, *Monasticon Windeshemense*, 1:24. VDG 3:99; Ker, *Medieval Manuscripts*, 3:466.

15. Maes finished an incomplete text of Gregory's *Moralia in Job* in Rylands ms 476. He appears to have adapted his hand to match the script of the earlier copyist.

16. For the following, see ONB ms ser. nov. 12816; Persoons, "Het intellectuele leven in het klooster Bethlehem," 47–84; Persoons, "Prieuré de Bethleem," 1005–18.

17. ONB ms ser. nov. 12816, 76v; Persoons, "Intellectuele leven," 47–48; de Jongh, *L'ancienne faculté*, 49.

18. ONB ms ser. nov. 12816, especially 34v–39r. On the chronicle more generally, see van Engen, "Brabantine Perspective."

19. ONB ms ser. nov. 12816, prologue and book 1, especially 20r on liturgical order.

20. Prims, "De Kloosterslot-beweging." On the wider phenomenon, see van Engen, *Sisters and Brothers of the Common Life*, 158–61; van Engen, "Brabantine Perspective," 14–15.

21. KBR ms 11752–64. VDG 2:167–69.

22. On Carlier, see above, 91.

23. Prims, "De Kloosterslot-beweging," 32.

24. Ibid., 28. On the Carthusians, see Lindquist, *Agency, Visuality and Society*. On Dominicans, see de Meyer, *La Congrégation de Hollande*, xxiv–xxvii.

25. Van Waefelghem, "Une élection abbatiale"; D'Haenens, "Abbaye de Parc," 805–7; Persoons, "Intellectuele leven," 62. De Rivo's calendrical works were also known at Park's sister Premonstratensian house at Averbode. See AA, I, reg. 43, 70v.

26. Persoons, "Prieuré de Bethleem," 1016.

27. Ibid., 1017.

28. Persoons, "Intellectuele leven," 52.

29. ONB ms ser. nov. 12816, 314v. Also Persoons, "Intellectuele leven," 63; van der Essen, "Testament."

30. For Eymeric in the Bethleem chronicle, see ONB ms ser. nov. 12816, 82r, 216v, 224v. Also Persoons, "Intellectuele leven," 58–59, 62.

31. Persoons, "Intellectuele leven," 67–80. On the book culture of *devotio moderna* houses, see Kock, *Buchkultur*, especially 286–87, for references to Bethleem's library.

32. Thomas à Kempis, *Doctrinale sive manuale iuvenum*, cited in ibid., 80.

33. See, for example, ONB ms ser. nov. 12816, 57r–v, 58v, 66r–v, 118v, 119v, 125v–126r, 148r, 182r.

34. Persoons, "Intellectuele leven," 57. On the book list, see Kock, *Buchkultur*, 126–40.

35. See above, 21.

36. ONB ms ser. nov. 12816. For copies of the *Horologium*, see 114v, 116v, 128v (a copy in the first library of the priory), and 209r. KBR ms 2846 is a surviving copy.

37. Van Engen, "Brabantine Perspective," 11–13.

38. New York, Columbia Rare Book and Manuscript Library, Western ms 31, 313–87, with summary 389–97, and related historical calendars 403–20, 422–29. For the *Dialogus* at St. Martin's, see Lourdaux and Haverals, *Bibliotheca Vallis Sancti Martini*, 2:425. Serena Masolini, Philipp Nothaft, and I are preparing a more detailed study of the *Dialogus*.

39. Burie, "Proeve tot inventarisatie," 257–58.

40. Michiel Verweij has suggested to me that the volumes may come from an institutional library. Their earliest traceable owner was Augustinus Hunnaeus, a theologian and biblical scholar associated with various Leuven University colleges, St. Gertrude's and St. Peter's. See Reusens, "Hunnaeus (Augustin)," 711–19.

41. KBR ms 129–30, 11r–18r.

42. At least two further related manuscripts exist: BMP ms 300 includes a revised version of de Rivo's text made at the Augustinian Roodklooster outside Brussels; ONB ms ser. nov. 12890 contains another Roodklooster copy of this *Monotesseron*. I am grateful to Serena Masolini for drawing my attention to this manuscript. For further discussion, see Champion, "*Videre supra modum est dilectabile*."

43. KBR ms 11750–51, 86r. Also KBR ms 129–30, 19r: "Presens volumen quod in unum quatuor evangelia complectitur non inepte dici prout Monotesseron a monos quid est unum et tesseron quatuor."

44. KBR ms 11750–51, 86r: "quarum prima terminatur in morte Johannis baptiste; secunda in resuscitacione lazari; et tercia in gloriosa domini ascensione."

45. Ibid., 86r.

46. On the longer history of Gospel harmonies, see Burger, den Hollander, and Schmid, eds., *Evangelienharmonien des Mittelalters*.

47. On Gerson's *Monotesseron*, see Vial, "Zur Funktion des *Monotessaron*"; de Lang, "Jean Gerson's Harmony of the Gospels."

48. Jean Gerson, *Monotessaron, sive concordantiae IV evangelistarum* (Cologne: Arnold Ther Hoernen, c. 1474) and (Cologne: Ludwig von Renchen?, ante 1478). For manuscript copies, see GUB mss 11 and 17.

49. Varenacker's harmony is mentioned in de Rivo's *Monotesseron* prologue, KBR ms 129–30, 11r, and in his brother's will. See van der Essen, "Testament," 7, 19. Valerius, *Fasti*, 88, states that Varenacker's text was derived from Gerson's. On Dutch Gospel harmonies, see den Hollander, "Mittelniederländische Evangelienharmonien." For a Latin Gospel Harmony from the house of Groenendaal, see Chicago, Newberry Library ms 161.

50. Jean Gerson, *Monotessaron, sive concordantiae IV evangelistarum* (Cologne: Arnold Ther Hoernen, c. 1474), 7v.

51. KBR ms 129–30, 6r–9r. Such tables appear in other harmonies. See BMP ms 300; ONB ms ser. nov. 12890, 1r–2r, 332r–333v; den Hollander, "Mittelniederländische Evangelienharmonien," 99–107.

52. KBR ms 129–30, 6r.

53. Ibid., 18v.

54. Ibid., 6v.

55. Ibid., 24v.

56. Ibid., 26r.

57. For explorations of liturgical subjectivity in other periods, see Krueger, *Liturgical Subjects*; Leachman, ed., *Liturgical Subject*.

58. See above, 21, 136.

59. See above, 226 n. 57, 136. Examples of Bethleem's surviving liturgical books include KBR ms 2395–2410; KBR ms 11789. For liturgical commentaries, see KBR ms II 2332; KBR ms 2395–410.

60. On Gerson's system, see Hobbins, *Authorship and Publicity*, 170–72. For an introduction to memory techniques and the Bible, see Doležalová, "*Summarium biblicum.*"

61. For examples from the *devotio moderna*, see Post, *Modern Devout*, 378–79, 542–49. More generally, Carruthers, *Craft of Thought;* Busse Berger, *Medieval Music and the Art of Memory.*

62. Anianus, *Compotus cum commento.* Paris: Pierre Levet, c. 1490, 7v. On Anianus, see Smith, *Le comput manuel de Magister Anianus;* Kusukawa, "Manual Computer," 31. For a similar example, see KBR ms 1392–98, 112v–114r, originally from St. Martin's, Leuven, and containing liturgical commentaries alongside computus.

63. Jan Mombaer, Rosetum *exercitiorum spiritualium et sacrarum meditationum* ([Zwolle: Peter van Os], 1494). See also Fuller, Brotherhood of the *Common Life*, 167–72.

64. See above, 5.

65. KBR ms 129–30, 11v.

66. See above, 54. Smeyers, *Dirk Bouts*, 485–88; Rudy, *Virtual Pilgrimages*, 162–70.

67. For subtle accounts of this tradition of image, see Kirkland-Ives, *In the Footsteps*, particularly 1–30; and Rudy, *Virtual Pilgrimages*, particularly 150–70, though I place more emphasis on these images as paradoxically locating viewers in time and intimating the possibility of " 'taking in' the image in a single glance" (ibid., 159).

68. KBR ms 129–30, 11r–12r.

69. Ezekiel 1:1–28.

70. KBR ms 129–30, 11r. "[q]uia . . . pluribus forsan gratis erit si totam viderint evangelicam historiam in unico volumine singulaque sub ordine eo quo probabiliter et dicta sunt et gesta horum votis inservire cupiens ex quatuor evangeliis unum conflare conatus sum."

71. Ibid., 11r.

72. KBR ms 5570, 2r.

73. Ibid., 2r–v.

74. Ibid., 80v.

75. Ibid., 175v.

76. Luke 23:44; KBR ms 5570, 175r–v.

77. For a fifteenth-century edition, see Augustine, *De consensu evangelistarum* (Leuven: Johannes de Westfalia, c. 1477). For a translation, see Schaff, ed., *Saint Augustin*, 73–236.

78. KBR ms 129–30, 13r.

79. Acts 1:1. KBR ms 129–30, 13r: "(velut historiographum decet) [lucas] res eo narrat ordine quo geste sunt."

80. Ibid., 14r: "lucas in ordine rerum quos narrat frequenter ab aliis evangelistis discrepat."

81. Ibid., 13v: "Frequenter enim apud historiographicos eciam ordinanti scribentes res que postea geste sunt narrantur prius anticipando. Et que prius geste sunt narrantur postea rememorando."

82. Ibid., 13v: "Unde distingui solet triplex ordo narrationis: unus rerum gestarum; alter anticipationis; et tercius rememorationis."

83. See Lausberg, *Handbuch der literarischen Rhetorik*, 245–47.

84. Ibid., 13v: "Ordine naturali communiter utuntur historiographi."

85. Ibid., 13v: "Sed a te doceri cupio quin ratio subesse solet ut ordo naturalis immutetur."

86. Ibid., 13v–14r.

87. Matthew 26; Mark 14.

88. John 12.

89. KBR ms 129–30, 13v. "Alium audi contingit in eadem historia conscribi partes diversorum generum quas ethenogenas appellant verbi gratia contineat historia iam doctrinas morales, iam miracula quibus eidem doctrine confirmatur. Et eandem scribens historiam seorsum narret doctrinas et seorsum miracula velut quidam opinantur de matheo quo sermonem illum velut continuum a capitulo quinto protrahit usque ad octavum licet ut aiunt in eo recollegerit pures doctrinas que postea diversis vicibus a domino predicate sunt."

90. Matthew 5–7.

91. See above, 57–58, 112–13.

92. KBR ms 129–30, 14v.

93. Matthew 27:50–51; Luke 23:45–46.

94. Augustine, *De consensu evangelistarum*, 3.19.

95. Matthew 11:20; KBR ms 129–30, 16r.

96. KBR ms 129–30, 16r. "His assentirem facile si michi persuaseris quod per hoc adverbum tunc denotari possit tam amplum tempus quo verisimilie est omnia gesta esse que a luca narrata sunt a capitulo viio usque ximum que certum est tempus non modicum exegisse."

97. Ibid., 16r. "Id tibi breviter persuasum efficiam: si cristostomo credideris . . . istud tunc est hoc ergo in loco tunc dicit non statim post antecedentia tempus designans." John Chrysostom, *Homiliae in Matthaeum*, 10, PG 57:183.

98. The literature on calendars is extensive. In addition to works already cited, for the following, see Mosshammer, *Easter Computus*; Poole, *Time's Alteration*; and Borst, *Ordering of Time*.

99. For the problematic ascription of the rule to Nicaea, see Mosshammer, *Easter Computus*, 50–52.

100. Further complications involving the synodic month's non-integral length were dealt with in part by "hollow" and "full" months of 29 and 30 days, respectively, each year. But remainders multiplied over 19 years to a full day's "wandering moon," requiring a correction known as the "leap of the moon" (*saltus lunae*).

101. See above, 58.

102. D'Ailly's program relied on Roger Bacon. On Bacon, see Nothaft, *Dating the Passion*, 155–201.

103. Pierre d'Ailly, *Tractatus de imagine mundi et varia ejusdem auctoris* (Leuven: Johannes de Westfalia, c. 1483).

104. See Stegemann and Bischoff, eds., *Nikolas von Cues*.

105. See *Opus responsivum*, 3r.

106. Ibid.

107. Ibid.
108. Ibid., 3v.
109. Readers were reminded of Augustine's revisions through insertions of his *Retractiones* at the beginning of his works. For a Bethleem example, see KBR ms 657-66.
110. *Opus responsivum*, 3v.
111. Ibid.
112. Ibid., c.1 p.1. References are to *Tractatus* 1, using the system of *capitula* and *particula*.
113. Ibid.
114. John Chrysostom, *Homiliae in Matthaeum*, 10, PG 57:183-86. See above, 149.
115. See above, 149.
116. De Rivo's source is Maximus of Turin, *Homiliae*, 23, PL 57:271-76.
117. *Opus responsivum*, c.1 p.4.
118. Ibid.
119. Ibid.; Bede, *De temporum ratione*, 47 CCSL 123B:431.
120. *Opus responsivum*, c.2. p.2. "Decretum ergo patrum de pascha celebrando luna xiiij primi mensis intelligendum est non de luna vere xiiij sed de luna xiiij legali."
121. Ibid.
122. See above, 27-30, 42, 68-69, 76-77, 105, 120, 123-25.
123. For the following, see *Opus responsivum*, c.2 p.3. De Rivo's source is once more Roger Bacon. See Bridges, ed., "*Opus Majus*," 3:197-99.
124. *Opus responsivum*, c.2 p.3: "non secundum precisionem sed secundum propinquam existimationem, nec in perpetuum, sed ad tempus."
125. For the following, see ibid., c.2 p.4.
126. Ibid. I am grateful to Philipp Nothaft for pointing out a citation from an early medieval forgery, the *Epistola Cyrilli*, in this passage.
127. See, for example, Bossy, "The Mass as a Social Institution"; Rubin, *Corpus Christi*.
128. "Reformacio kalendarii Romani Eiusque reductio ad statum pristinum In quo fut temporibus patrum qui decreta et ordinaciones ediderunt ut paschalis festivitas a fidelibus non nisi die domenico celebretur."
129. On these traditions in the twelfth century (and influential for the fifteenth century), see Constable, "Renewal and Reform."
130. For the following, see *Reformatio*, 1r, c.1.
131. Bede, *De temporum ratione*, 66, l.1180, CCSL 123B:502.
132. For the following, see *Reformatio*, 1r, c.2.
133. There is symmetry here with de Rivo's earlier argument regarding legal and observable moons in the Hebrew cycle. Such distinctions between legal ("ecclesiastical") and observable ("true") moons appear elsewhere in astronomical tables of the period, for example CMM ms 55, 14v.
134. Citing Bede, *De temporum ratione*, 51, CCSL 123B:437-41.
135. Ibid., sections 412-18.
136. *Reformatio*, 1v, c.3.
137. For the following, see *Reformatio*, 1v-2r, c.4.

138. *Reformatio*, 2r, c.5.
139. *Reformatio*, 2r, c.6. My thanks to Philipp Nothaft for his advice on this passage.
140. *Reformatio*, 2v, c.6.
141. *Reformatio*, 3r, c.7.
142. Compare Koselleck, *Futures Past*, 15.
143. See Rudy, *Postcards on Parchment*, 141–55.
144. *Reformatio*, 3r, c.7.
145. On Ravescot and these woodcuts, see Kok, *Woodcuts in Incunabula*, 1:463–66, 4:829–33.
146. Johannes Herolt, *Sermones discipuli de tempore* (Deventer: Richardus Pafraet, c. 1480–1481), Sermon 79. CUL Inc.2.E.4.1 [4269].
147. CMM ms 146, 133r.
148. Ibid., 135r.
149. Ibid., 149r–v. For wider practices of kissing and touching holy objects, see Rudy, "Kissing Images," especially 21–30.
150. Antonius Gratia Dei and Egidius Bailluel, *Conclusio de signo crucis lapidibus subiectis impresso levando* . . . (Leuven: Johannes de Westfalia, c. 1477–1483).
151. The vi is corrected by hand in many copies.
152. Areford, "Multiplying the Sacred," 147. Areford's argument sits in the tradition of scholarship that emphasizes devotional uses of woodcuts, rejecting Walter Benjamin's theory that the sacred and iconic dimensions of images were dealt a death blow by mechanical reproduction. See Areford, *Viewer and the Printed Image*, 9–16.
153. Areford, "Multiplying the Sacred," 147.
154. For another attempt to consider the temporalities of woodcuts, see Nagel and Wood, *Anachronic Renaissance*, 26.
155. Areford, "Multiplying the Sacred," 131. See also Areford, *Viewer and the Printed Image*, 164–227. On Simon of Trent, see Po-Chia Hsia, *Trent 1475*.
156. The relationship between original and copy is mediated through time elsewhere in Areford's examples. See Areford, "Multiplying the Sacred," 136–37.
157. Milan Žonca kindly alerted me to this parallel.
158. See Conway, *Woodcutters of the Netherlands*, 136.
159. Compare the approach to captions in Nagel and Wood, *Anachronic Renaissance*, 20–28.
160. A desire to fill out narratives of Christ's life is an important aspect of late-medieval piety. See Lentes, "Counting Piety," 75; Marrow, *Passion Iconography*.
161. BMP ms 300; KBR ms 657–66, 2r–85v.
162. Augustine, *De consensu evangelistarum*, Book 1.35. Translation modified from Schaff, *Saint Augustin*, 100.

CHAPTER SIX

1. For recent work on the *Fasciculus* and further bibliography, see Worm, "Das Zentrum der Heilsgeschichte," and Worm, "'*Ista est Jerusalem*.'" Worm's *Habilitation, Geschichte und Weltordnung. Bildliche Modelle von Zeit und Raum vor 1500* (Berlin: Deutscher Verlag für Kunstwissenschaft) is forthcoming. Also Ward, "Werner Rolevinck and

the *Fasciculus temporum*"; Ward, "A Carthusian View"; Ward, "Authors and Authority"; Rosenberg and Grafton, *Cartographies*, 28–54; Classen, "Werner Rolevinck's *Fasciculus temporum*"; Biddick, "Becoming Collection," 224–25.

2. See Worm, "Rolevinck, Werner," 1292–93; Colberg, "Rolevinck, Werner," 153–58; Bücker, *Werner Rolevinck*.

3. SBB ms theol. lat. oct. 171; Werner Rolewinck, *Legenda de Sancto Servatio* (Cologne: Arnold Ther Hoernen, 1472).

4. This suggestion was made at the 2015 Renaissance Society of America meeting in Berlin. For additional scholarship on manuscript copies, see Martens, "Dating of the *Fasciculus Temporum*"; Overgaauw, "Observations on the Manuscripts"; Melville, "Geschichte in graphischer Gestalt," 79; Bühler, "*Fasciculus Temporum*."

5. For links between the Cologne Carthusians and the modern devout, see Ward, "Authors and Authority," particularly 178–79. More generally, see Schäfke, ed., *Die Kölner Kartauser*.

6. I use Rolewinck as a shorthand for the possible composite authorship. On the relationship between Rolewinck and Ther Hoernen, see Janssen, "Author and Printer," 16–22; Marks, "Significance of Fifteenth-Century Hand Corrections." Rolewinck refers to Ther Hoernen in his *Sermo ad populum predicabilis* (Cologne: Arnold Ther Hoernen, 1470), 1v.

7. On this edition, see Baer, *Die illustrierten Historienbücher*, 64–66.

8. Josephson, "Fifteenth-Century Editions," 61–65, gives at least thirty-seven editions. On the print history of the *Fasciculus*, see also Murray, "Edition of the '*Fasciculus Temporum*'"; Werner, *Etude sur le* "*Fasciculus Temporum*"; Martens, "*Fasciculus Temporum* of 1474."

9. Beyond ownership marks, a number of further copies can be traced in Derolez et al., *Corpus Catalogorum Belgii*, 1:142, 144; 2:208; 3:124, 127–28; 4:26, 52, 90, 126, 136–37, 144; 7:116, 138, 154, 177, 192, 203, 240, 244, 304, 310, 321, 325.

10. Werner Rolewinck, *Fasciculus temporum* (Leuven: Johannes Veldener, 1475), 1r, hereafter *Fasciculus*. Unless otherwise noted, all citations are taken from this edition.

11. *Fasciculus*, 1r: "videre enim supra modum est delectabile."

12. Ibid., 1r: "humana industria pennis quibusdam interne contemplationis non solum preterita et presencia, sed etiam futura metitur, dum ex similibus ad similia progreditur, cui si bona voluntas adiuncta fuerit, tedio quodam incolatus huius in deum surgit ad laudandum et regraciandum et contemplandum cupiens dissolvi et esse cum christo in eternum."

13. Rosenberg and Grafton, *Cartographies*, 54.

14. *Fasciculus*, 3r: "finem mundi . . . solus deus novit." Compare Mark 13:32.

15. For an English translation, see van Engen, *Devotio Moderna*, 243–315. On the work's dissemination and theology of intellective vision, see Gerrits, *Inter timorem et spem*, 27–37, 239–40. For devotional uses with meditation timetables, see Hascher-Burger, *Singen für die Seligkeit*, 83–106. For copies at St. Barbara's, see Marks, *Medieval Manuscript Library*, 2:256, 284, 330.

16. For a fifteenth-century copy from the Bethleem Priory, see CUL ms add. 6453.

17. See above, 53–54. For copies at St. Barbara's, see Marks, *Medieval Manuscript Library*, 2:302, 304, 384.

18. CUL Inc.3.F.2.1 [3159]. Oates, *Catalogue*, 613 (3688). The exact provenance of the copy is uncertain. Once owned by Gerrit van Holt and a brother Johannis Stephanus, additions to the copy's index may suggest an early institutional owner in the diocese of Liège.

19. The text is damaged. What remains seems to read "intellectus [lacuna] veritatis voluntatis divine bonitatis memoria paternitatis."

20. *Fasciculus*, 3r.

21. Ibid., 1r. "Decet namque viros virtuosos precedentium facta sepe ad memoriam revocare, ut bonis exemplis discant dignis operibus insistere, et in malis valeant perditionis scopulum declinare. Verum nisi preciosum a vili separetur, stulta concupiscentia se temptare non valens, in tenebrarum voraginem precipiti cursu mergeretur."

22. Ibid.

23. It is probably for this reason that the *Fasciculus* was included in the *Libri necessarii alla salute humana corporale, temporale, spirituale, et eterna* by Marco dal Monte Santa Maria (Florence: Antonio Miscomini, 1494). For a problematic reading of Marco's list, see Bühler, "Fifteenth-Century List," 49–53.

24. *Fasciculus*, 1r.

25. Ibid. "Incipit hec contemplatio in iocunda speculacione creaturarum et finit in feliciori tedio earundem et appetitu creatoris." Here, as elsewhere, the influence of the Victorine school can be felt. See, for example, Staubach, "L'influence victorine."

26. See further Melville, "Geschichte in graphischer Gestalt," 60.

27. See above, 175.

28. See above, 168, fig. 5.6, plate 4, and fig. 5.7. Measurement's power to re-embody objects can be traced in a variety of fifteenth-century sources. On measurement and pilgrimage from the Low Countries to Jerusalem, see Kirkland-Ives, *In the Footsteps*, 62, 68–70. On the wider phenomenon, see Areford, *Viewer and the Printed Image*, 229–67; Barbier de Montault, *Œuvres complètes*, 7:313–493.

29. See above, 5.

30. For the following, see *Fasciculus*, 1r–v.

31. Ibid., 2v.

32. Ibid., 2r.

33. Rosenberg and Grafton, *Cartographies*, 31.

34. See Worm, "Visualizing the Order of History."

35. For example, Chicago, Newberry Library, Case ms 29.

36. Ikas, "Martinus Polonus' Chronicle," 329.

37. For example, GUB ms 3862, a fifteenth-century copy connected to Leuven University.

38. This is not to propose that examples of horizontal temporal progression were not available within other genres and media.

39. KBR ms 15003–48, 4r–9v. See further Champion, "Emotions and the Social Order of Time," 91–92.

40. See, for example, Werner Rolewinck, *Fasciculus temporum* (Cologne: Nicolaus Götz, c. 1474), 35.

41. On this layout and medieval bibles, see Ward, "Werner Rolevinck," 221.

42. Score notations are rare in fifteenth-century music. Score-like notation appears in the Low Countries in GUB ms 14, and in the English Old Hall manuscript. But Bonnie

Blackburn argues that in the course of the fifteenth century compositional processes shifted from note-against-note composition to all parts being composed together. Vertical and horizontal elements of composition came into being together, in a process that resembles the construction of the *Fasciculus*. See Blackburn, "On Compositional Process." On scores and synoptic vision, see Judd, *Reading Renaissance Music Theory*, 8, 15.

43. *Fasciculus*, 2v.
44. Ibid.
45. Ibid., 3r.
46. Compare Gerard de Vliederhoven's popular *Cordiale de quattuor novissima* (Deventer: Jacobus de Breda, c. 1490s).
47. Mark 13:8; Matthew 24:8; Romans 8:22.
48. On the central opening's longer history, see Worm, "Das Zentrum der Heilsgeschichte."
49. *Fasciculus*, 24v–25r.
50. Ibid., 25r.
51. For the following, see ibid., 25v–26r. See also Worm, "Das Zentrum der Heilsgeschichte," 293, 302–4.
52. Matthew 16:18.
53. Ibid., 296–302. Also Bühler, "Apostles and the Creed," 335–39.
54. Worm, "Das Zentrum der Heilsgeschichte," 296–98.
55. On its earlier manuscript history, see ibid., 288–307.
56. Ibid., 307–10.
57. *Fasciculus*, Götz, 11.
58. On the Götz image and the manuscript tradition, see Worm, "Das Zentrum der Heilsgeschichte," 308.
59. *Fasciculus*, Götz, unnumbered page following 113.
60. Matthew 28:18.
61. *Fasciculus*, Götz, unnumbered page following 113.
62. Worm, "Das Zentrum der Heilsgeschichte," 308–10.
63. Curiously, Christ does not directly touch the orb. This detail (which might suggest Christ veiling his hands to his own power, in a problematic analogy to an earthly priest) was removed in some later editions based on Ther Hoernen, including Conrad Winters de Homborch (Cologne, 1476), Götz (1478), and Heinrich Quentell (1479, 1480, 1481). Peter Drach (Speyer, 1477), Georgius Walch (Venice, 1479), and Ehrhard Ratdolt (Venice, 1480, 1481) follow Ther Hoernen.
64. *Fasciculus*, Ther Hoernen, 26r.
65. On the crucifix's print history, see Baer, *Die illustrierten Historienbücher*, 61; Murray, "Edition of the '*Fasciculus Temporum*,'" 61.
66. See Worm, "Das Zentrum der Heilsgeschichte," figures 104, 112–14. The 1495 Geneva edition introduced printed devotional images used in books of hours. See Baer, *Die illustrierten Historienbücher*, 76–78.
67. *Fasciculus*, 24v. On the sacrament, see Werner Rolewinck, *De venerabili sacramento et valore missarum* (Paris: Mercator, 1499).
68. Bynum, "Seeing and Seeing Beyond," 208–40.

69. At least one fifteenth-century missal has the standard Crucifixion image accompanied by a *salvator mundi* with evangelists that resembles the *Fasciculus* (BMR ms Y103, 122v–123r, from St. Catherine-du-Mont, Rouen). As in some missals, the central folio of the *Fasciculus* in figure 6.7 has smudging on Christ's face, a sign of possible devotional use. See above, 168.

70. *Fasciculus*, 25r.

71. Acres, "Compositions of Time," 42–57, 69–70; Acres, "Columba Altarpiece," 424–25.

72. See, for example, the *vera icon* after Jan van Eyck, probably c. 1500 in the Alte Pinakothek, Munich, inv. no. WAF 251. On the *vera icon*, see Smeyers, "An Eyckian Vera Icon," 195–224.

73. Kuretsky, "Rembrandt's Tree Stump," 573.

74. Genesis 1:2.

75. See Périer-d'Ieteren, *Dieric Bouts*, 290–95; Smeyers, *Dirk Bouts*, 437–39.

76. See above, 154–55.

77. For further exploration of the innovative use of spatial depth and narrative time by fifteenth-century Netherlandish artists, see Kemp, *Die Räume der Maler*.

78. John's finger pointing to the tree that bridges the river recalls the gesture of Christ in Jan van Eyck's Rolin Madonna, Paris, Musée du Louvre, inv. 1271. See Ward, "Disguised Symbolism," 13–14, 47.

CONCLUSION

1. For a classic example of Leuven's importance in the sixteenth century, see Jardine, *Erasmus*.

2. Grube, ed., *Des Augustinerpropstes Ioannes Busch Chronicon*, 165.

3. I am currently working on a study of these musical clocks and their transformations from the fourteenth to the sixteenth centuries.

4. Riemann, ed. *Nicolai de Cusa: De visione dei*, 29–30 (8[29]). On Cusa's visit to Bethleem, see ONB ms ser. nov. 12816, 175v–176r. Persoons, "Nikolaas van Cusa te Leuven"; Meuten and Hallauer, eds., *Acta Cusana*, 1446–47.

5. Compare Koselleck, *Futures Past*, 21.

6. Compare Spiegel, "Memory and History."

7. On acceleration, modernity, and historical practice, see Hunt, *Measuring Time*, 75–86. On acceleration, see Koselleck, *Futures Past*; Rosa, *Alienation and Acceleration*. On the politics of temporalities, see Scheuerman, *Liberal Democracy*.

8. On these themes, see Hartog, *Regimes of Historicity*; Mountz et al., "For Slow Scholarship."

BIBLIOGRAPHY

MANUSCRIPTS AND ARCHIVAL MATERIAL

Averbode, Archief van de Abdij van Averbode

I, reg. 4
I, reg. 43
I, reg. 53
Ms IV 413

Berlin, Staatsbibliothek

Ms Magdeb. 7
Ms Germ. Oct. 6

Brussels, Bibliothèque Royale

Ms 129–30
Ms 576–80
Ms 657–66
Ms 733–41
Ms 801
Ms 1382–91
Ms 1392–98
Ms 2030
Ms 2064–65
Ms 2395–2410
Ms 2846
Ms 3096
Ms 4414–24
Ms 4655

Ms 5172–74
Ms 5570
Ms 10981
Ms 11441–42
Ms 11556
Ms 11731
Ms 11750–51
Ms 11752–64
Ms 11784
Ms 11788
Ms 11789
Ms 14673
Ms 15003–48
Ms 21371
Ms II 306
Ms II 1148
Ms II 1185
Ms II 2332
Ms IV 111

Cambrai, Mediathèque municipale

Ms 6
Ms 11
Ms 29
Ms 38
Ms 55
Ms 69
Ms 72
Ms 76
Ms 91
Ms 108
Ms 143
Ms 146
Ms 170
Ms 173
Ms 209
Ms 332
Ms 416
Ms 577
Ms 739
Ms 835
Ms 1038
Ms 1043
Ms 1058 (K)

Ms 1059 (L)
Ms 1060 (M)

Cambridge, University Library

Inc.3.F.2.9 [3294]
Ms Add. 4100
Ms Add. 6453

Chicago, Newberry Library

Case ms 29
Ms 161

Ghent, Stadsarchief

165/1
400/18-19

Ghent, Universiteitsbibliotheek

Ms 11
Ms 15
Ms 17
Ms 433
Ms 476
Ms 590
Ms 1429
Ms 3862

Heverlee, Archief van de Abdij van Park

VII 21
VIII 2
VIII 13
X 220

Leuven, Rijksarchief

601/1 1296
601/1 1377/1-8
601/2 9456/1-3
630 702
630 703

Leuven, Stadsarchief

4143
4655
4659
4863
5063
5103
11670

Maastricht, Rijksarchief Limburg

RA 416 (08354-5)

Manchester : John Rynalds Library

Ms Latin 476

New York, Columbia University Library

Western ms 31

Paris, Bibliothèque Mazarine

Ms 300

Rouen, Bibliothèque municipale

Ms Y103

Vienna, Österreichische Nationalbibliothek

Ms ser. nov. 12816
Ms ser. nov. 12890

PRINT WORKS PRE-1600

Antiphoner for the Use of Cambrai. Paris: Simon Vostre, c. 1508-1518.
Expositio hymnorum cum commento. Delft: Christiaan Snellaert, 1496.
Anianus. *Computus cum commento*. Paris: Pierre Levet, c. 1490.
Antonius de Butrio, *Speculum de confessione*. Leuven: Johannes de Westfalia, c. 1481-1483.
Augustine. *De consensu evangelistarum*. Leuven: Johannes de Westfalia, c. 1477.
Carlier, Gilles, *Sportula fragmentorum*. Brussels: [Brothers of the Common Life], 1479.

D'Ailly, Pierre. *Tractatus de imagine mundi et varia ejusdem auctoris et Joannis Gersonis opuscula*. Leuven: Johann de Westphalia, c. 1483.

Dal Monte Santa Maria, Marco, *Libri necessarii alla salute humana corporale, temporale, spirituale, et eterna*. Florence: Antonio Miscomini, 1494.

Gerardus de Vliederhoven. *Cordiale de quattuor novissima*. Deventer: Jacobus de Breda, c. 1490s.

Gerson, Jean. *Monotessaron, sive concordantiae IV evangelistarum*. Cologne: Arnold Ther Hoernen, c. 1474.

———. *Monotessaron, sive concordantiae IV evangelistarum*. Cologne: Ludwig von Renchen?, ante 1478.

Gratia Dei, Antonius, and Egidius Bailluel. *Conclusio de signo crucis lapidibus subiectis impresso levando. Epistola super materia conclusionis praedictae*. Leuven: Johannes de Westfalia, c. 1477–1483.

Heinrich de Suso. *Horologium aeternae sapientiae*. Alost: Thierry Martens, c. 1486–1492.

Herolt, Johannes. *Sermones discipuli de tempore*. Deventer: Richardus Pafraet, c. 1480–1481.

Jacquier, Nicolas. *Flagellum hæreticorum fascinariorum*. Frankfurt, 1581.

Mombaer, Jan. *Rosetum exercitiorum spiritualium et sacrarum meditationum*. [Zwolle: Peter van Os], 1494.

Nider, Johannes. *Alphabetum divini amoris*. Leuven: Johannes de Westfalia, c. 1482–1483.

———. *Alphabetum divini amoris*. Leuven: Johann Veldener, c. 1484.

———. *Alphabetum divini amoris*. Leuven: Johann Veldener, c. 1486.

Paul of Middelburg. *Epistola apologetica ad doctores Lovanienses*. Leuven: Johannes de Westfalia, not before February 27, 1488.

———. *Paulina de recta Paschae celebratione: et de die passionis domini nostri Iesu Christi*. Fossombrone: Ottaviano Petrucci, 1513.

Peter de Rivo. *Opus responsivum ad epistolam apologeticam*. Leuven: Ludovicus Ravescot, 1488.

———. *Tercius tractatus de anno, die et feria passionis*. Leuven: Johannes de Westfalia, 1492.

Rolewinck, Werner. *De venerabili sacramento et valore missarum*. Paris: Mercator, 1499.

———. *Fasciculus temporum*. Cologne: Arnold Ther Hoernen, 1474.

———. *Fasciculus temporum*. Cologne: Nicolaus Götz, c. 1474.

———. *Fasciculus temporum*. Leuven: Johann Veldener, 1475.

———. *Fasciculus temporum*. Cologne: Conrad Winters de Homborch, 1476.

———. *Fasciculus temporum*. Speyer: Peter Drach, 1477.

———. *Fasciculus temporum*. Cologne: Nicolaus Götz, 1478.

———. *Fasciculus temporum*. Cologne: Heinrich Quentell, 1479.

———. *Fasciculus temporum*. Venice: Georgius Walch, 1479.

———. *Fasciculus temporum*. Cologne: Heinrich Quentell, 1480.

———. *Fasciculus temporum*. Venice: Ehrhard Ratdolt, 1480.

———. *Fasciculus temporum*. Utrecht: Johann Veldener, 1480.

———. *Fasciculus temporum*. Cologne: Heinrich Quentell, 1481.

———. *Fasciculus temporum*. Venice: Ehrhard Ratdolt, 1481.

———. *Les fleures et manieres des temps passes (Le fardelet hystorial)*. Geneva: Printer unknown, 1495.

———. *Legenda de Sancto Servatio*. Cologne: Arnold Ther Hoernen, 1472.

Spierinck, Joannes. *Almanack pro anno 1484*, Location unknown: Printer of the Heilichdomme, c. 1484.

Modern Editions and Translations

Biblia latina cum glossa ordinaria. *Facsimile Reprint of the Editio Princeps Adolph Rusch of Strassburg 1480/81*. 4 vols. Turnhout: Brepols, 1992.

Aquinas, Thomas. *Opera omnia*. Corpus Thomisticum: http://www.corpusthomisticum.org. Fundación Tomás de Aquino: 2016. [Citations from all Aquinas's works other than the *Summa* are taken from this edition.]

———. *Summa theologiae*. Edited by Fathers of the English Dominican Province. 61 vols. London: Blackfriars, 1964–1981.

Augustine. *Confessions*. Translated by Henry Chadwick. Oxford: Oxford University Press, 1992.

———. *Confessions*. Edited by James J. O'Donnell. 3 vols. Oxford: Oxford University Press, 1992.

———. *De doctrina christiana*. Edited by R. P. H. Green. Oxford: Clarendon Press, 1995.

———. *De musica liber VI: A Critical Edition with a Translation and an Introduction by Martin Jacobsson*. Stockholm: Almqvist and Wiksell International, 2002.

Bede. *Homiliarum euangelii*. Edited by D. Hurst. CCSL 122. Turnhout: Brepols, 1955.

———. *De temporum ratione*. Edited by C. W. Jones. CCSL 123B. Turnhout: Brepols, 1977.

Baudry, Léon, ed. *La querelle des futures contingents (Louvain 1465–1475)*. Paris: J. Vrin, 1950.

———. *The Quarrel over Future Contingents*. Translated by Rita Guerlac. Dordrecht: Kluwer Academic Publishers, 1989.

Blommaert, P., and C. P. Serrure, eds. *Kronyk van Vlaenderen van 580 tot 1467*. 2 vols. Ghent: Maetschappy der Vlaemsche Bibliophilen, 1839–1840.

Bridges, John Henry, ed. *The "Opus Majus" of Roger Bacon*. Vol. 3. Oxford: Clarendon Press, 1900.

Chrysostom, John. *Homiliae in Matthaeum*. PG 57. Paris: Migne, 1862.

Cullington, J. Donald, and Reinhard Strohm. *"That Liberal and Virtuous Art": Three Humanist Treatises on Music*. Newtownabbey: University of Ulster Press, 2001.

De Reiffenberg, Frederic, ed. *Mémoires du J. du Clercq*. 4 vols. Brussels: Arnold Lacrosse, 1823.

De Viriville, Vallet, ed. *Chronique de Charles VII, roi de France, par Jean Chartier*. 3 vols. Paris: P. Jannet, 1858.

Dionysius the Carthusian, *Doctoris Ecstatici D. Dionysii Cartusiani opera omnia*. 42 vols. Tournai, 1896–1935.

Dufay, Guillaume. *Opera omnia*. Edited by Heinrich Besseler. Corpus mensurabilis musicae. Rome: American Institute of Musicology, 1951.

Elders, Willem, ed. *Motets on Non-Biblical Texts 4: De beata Maria virgine 2*. Vol. 24, New Josquin Edition. Utrecht: Koninklijke Vereniging voor Nederlandse Muziekgeschiedenis, 2007.

Fabre, Isabelle. *La Doctrine du chant du cœur de Jean Gerson: édition critique, traduction et commentaire du "Tractatus de canticis" et du "Canticordum au pélerin."* Geneva: Droz, 2005.

Fris, V., ed. *Dagboek van Gent van 1447 tot 1470 met een vervolg van 1477 tot 1515.* 2 vols. Ghent: C. Arnoot-Braeckman, 1901–1904.

Gerson, Jean. *Jean Gerson: Early Works.* Translated by Brian Patrick McGuire. New York: Paulist Press, 1998.

Glorieux, Palemon, ed. *Jean Gerson: Oeuvres complètes.* 10 vols. Paris: Desclée, 1960–1973.

Grube, Karl, ed. *Des Augustinerpropstes Iohannes Busch Chronicon Windeshemense und Liber de reformatione monasteriorum.* Geschichtsquellen der Provinz Sachsen, 19. Halle: Otto Hendel, 1886.

Houdoy, Jules. *Histoire artistique de la Cathédrale de Cambrai, ancienne église métropolitaine Notre-Dame.* Paris: Damascène Morgand et Charles Fatout, 1880.

Jansen-Sieben, Ria, and Johanna Maria van Winter, eds. *De Keuken van de late Middeleeuwen. Een kookboek uit de Lage Landen.* 2nd ed. Amsterdam: Bert Bakker, 1998.

Kervyn De Lettenhove, J. C., ed. *Oeuvres de Georges Chastellain.* 8 vols. Brussels: F. Heussner, 1863–1866.

Künzle, Pius. *Heinrich Seuses Horologium Sapientiae.* Freiburg, CH: Universitätsverlag Freiburg-Schweiz, 1977.

Lefèvre, Placide. *Les Ordinaires des collégiales Saint-Pierre à Louvain et Saints-Pierre-et-Paul à Anderlecht d'après des manuscripts du XIVe siècle.* Leuven: Publications Universitaires de Louvain, 1960.

Leo I. *Sermones.* PL 54. Paris: Migne, 1846.

Leopold, J. H. *The Almanus Manuscript: Staats- und Stadtbibliothek Augsburg Codex in 2 no. 209, Rome circa 1475–circa 1485.* London: Hutchinson, 1971.

Luther, Martin. *D. Martin Luthers Werke. Kritische Gesamtausgabe (Weimarer Ausgabe). Tischreden.* Vol. 4. Weimar: Hermann Böhlhaus Nachfolger, 1916.

Maetschappy der Vlaemsche Bibliophilen, ed. *Memorieboek der Stad Ghent van 't j. 1301 tot 1737.* Vol. 1. Ghent: C. Arnoot-Braeckman, 1852.

Maximus of Turin. *Homiliae.* PL 57. Paris: Migne, 1847.

Miræus, Aubertus. *Opera diplomatica et historica . . .* 4 vols. Brussels: Petrus Foppens, 1723–1748.

Reusens, Edmond, ed. "Chronique de la Chartreuse de Louvain depuis sa fondation, en 1498, jusqu'à l'année 1525." *Annalectes pour servir à l'histoire ecclésiastique de la Belgique* 14 (1877): 228–99.

———, ed. *Documents relatifs à l'histoire de l'université de Louvain (1425–1797).* 5 vols. Leuven: E. Reusens, 1881–1903.

Riemann, Adelaida Dorothea, ed. *Nicolai de Cusa: De visione dei.* Nicolai de Cusa Opera Omnia. Vol. 6. Hamburg: Felix Meiner, 2000.

Schaff, Philip, ed. *Saint Augustin: Sermon on the Mount. Harmony of the Gospels. Homilies on the Gospels.* New York: Christian Literature Company, 1888.

Stecher, J., ed. *Oeuvres de Jean Lemaire de Belges.* Vol. 4. Leuven: Lefever frères et soeur, 1891.

Stechow, Wolfgang. *Northern Renaissance Art, 1400–1600: Source Documents.* Englewood Cliffs, NJ: Prentice-Hall, 1966.

Stegemann, Viktor, and Bernhard Bischoff, eds. *Nikolas von Cues: Die Kalenderverbesserung (De correctione kalendarii).* Heidelberg: F. H. Kerle, 1955.

Suso, H. *Wisdom's Watch upon the Hours*. Translated by Edmund Colledge. Washington, DC: Catholic University of America Press, 1994.
Tarrant, R. J., ed. *P. Ovidi Nasonis Metamorphoses*. Oxford Classical Texts. Oxford: Oxford University Press, 2004.
Van Balberghe, Émile, ed. *Jean Tinctor, Invectives contre la Secte de Vauderie*. Tournai: Archives du Chapitre Cathédral, 1999.
Van Engen, John. *Devotio Moderna: Basic Writings*. New York: Paulist Press, 1988.
Von der Hardt, Hermann, ed. *Magnum oecumenicum Constantiense concilium de universali ecclesiae reformatione, unione, et fide*. Vol. 1/8. Helmstedt: Salomon Schnorr, 1696–1700.

SECONDARY WORKS

Acres, Alfred. "The Columba Altarpiece and the Time of the World." *Art Bulletin* 80 (1998): 422–51.
———. "Compositions of Time in the Art of Rogier van der Weyden." PhD diss., University of Pennsylvania, 1992.
———. "Rogier van der Weyden's Painted Texts." *Artibus et Historiae* 41 (2000): 75–109.
Ainsworth, Maryan W. "'À la façon grèce': The Encounter of Northern Renaissance Artists with Byzantine Icons." In *Byzantium: Faith and Power (1261–1557)*, edited by Helen C. Evans, 545–93. New Haven, CT: Yale University Press, 2004.
———. *Facsimile in Early Netherlandish Painting: Dieric Bouts's Virgin and Child*. New York: Metropolitan Museum of Art, 1993.
Angenendt, Arnold, Thomas Braucks, Rolf Busch, and Hubertus Lutterbach. "Counting Piety in the Early and High Middle Ages." In *Ordering Medieval Society: Perpectives on Intellectual and Practical Modes of Shaping Social Relations*, edited by Bernhard Jussen, 15–54. Philadelphia: University of Pennsylvania Press, 2001.
Areford, David S. "Multiplying the Sacred: The Fifteenth-Century Woodcut as Reproduction, Surrogate, Simulation." In *The Woodcut in Fifteenth-Century Europe*, edited by Peter Parshall, 118–53. Washington, DC: National Gallery of Art, 2009.
———. *The Viewer and the Printed Image in Late Medieval Europe*. Farnham: Ashgate, 2010.
Arnade, Peter J. *Realms of Ritual: Burgundian Ceremony and Civic Life in Late Medieval Ghent*. Ithaca, NY: Cornell University Press, 1996.
———. "Secular Charisma, Sacred Power: Rites of Rebellion in the Ghent Entry of 1467." *Handelingen der Maatschappij voor Geschiedenis en Oudheidkunde te Gent* 45 (1991): 69–94.
Arnold, John H., and Caroline Goodson. "Resounding Community: The History and Meaning of Medieval Church Bells." *Viator* 43 (2012): 99–130.
Arnoux, Mathieu. "Relation salariale et temps du travail dans l'industrie médiévale." *Le Moyen Âge* 115 (2009): 557–81.
Atlas, Allan W., ed. *Dufay Quincentenary Conference*. Brooklyn: Department of Music, Brooklyn College of the City University of New York, 1976.
Auerbach, Eric. "Figura." In *Scenes from the Drama of European Literature*, 11–76. Manchester: Manchester University Press, 1984 [1938].
Aurelius, Carl Axel. "*Quo verbum dei vel cantu inter populos maneat*: The Hymns of Martin Luther." In *The Arts and the Cultural Heritage of Martin Luther*, edited by

Eyolf Østrem, Jens Fleischer, and Nils Holger Petersen, 19–34. Copenhagen: Museum Tusculanum Press, 2002.

Baer, Leo. *Die illustrierten Historienbücher des 15. Jahrhunderts. Ein Beitrag zur Geschichte des Formschnittes.* Strasbourg: Heitz und Mündel, 1903.

Baert, Barbara. "Between Technique and Symbolism: Notes on the Meaning of the Use of Gold in Pre-Eyckian Panel Painting." In *Pre-Eyckian Panel Painting in the Low Countries,* edited by Cyriel Stroo, 7–22. Brussels: Brepols, 2009.

Baisier, C., and S. van Lani. *Met zicht op de abdij: de iconographie van de abdij van Park.* Leuven: Centrum voor Religieuze Kunst en Cultuur, 2003.

Barbier de Montault, Xavier. *Œuvres complètes de Mgr X. Barbier de Montault.* Vol. 7. Paris: Librairie Vivès, 1893.

Bartocci, Barbara, and Serena Masolini. "Reading Aristotle at the University of Louvain in the Fifteenth Century: A First Survey of Petrus de Rivo's Commentaries on Aristotle (II)." *Bulletin de philosophie médiévale* 56 (2014): 281–383.

Bartocci, Barbara, Serena Masolini, and Russell L. Friedman. "Reading Aristotle at the University of Louvain in the Fifteenth Century: A First Survey of Petrus de Rivo's Commentaries on Aristotle (I)." *Bulletin de philosophie médiévale* 55 (2013): 133–76.

Bearda, Twan, Jacques Sergeys, and Jef Teugels, eds. *Campanae Lovaniensis: Het klokkenpatrimonium van Groot-Leuven.* Leuven: Peeters, 2008.

Begne, Abbé. *Histoire de Notre-Dame de Grâce.* Cambrai: Oscar Masson, 1910.

Belozerskaya, Marina. *Rethinking the Renaissance: Burgundian Arts across Europe.* Cambridge: Cambridge University Press, 2002.

Bergmans, Anna, ed. *Leuven in de late Middeleeuwen: Dirk Bouts, Het Laatste Avondmaal.* Brussels: Tielt, 1998.

Bergson, Henri. *Matter and Memory.* Translated by N. M. Paul and W. S. Palmer. New York: Zone Books, 1988 [1896].

Bessemans, Lutgarde, Inès Honoré, Maurits Smeyers, Veronique Vandekerchove, and Raymond van Uytven, eds. *Leven te Leuven in de late Middeleeuwen.* Leuven: Peeters, 1998.

Biddick, Kathleen. "Becoming Collection: The Spatial Afterlife of Medieval Universal Histories." In *Medieval Practices of Space,* edited by Barbara A. Hanawalt and Michal Kobialka, 223–41. Minneapolis: University of Minnesota Press, 2000.

Bilfinger, Gustav. *Die mittelalterlichen Horen und die modernen Stunden. Ein Beitrag zur Kulturgeschichte.* Stuttgart: W. Kohlhammer, 1892.

Billington, Sandra. *Midsummer: A Cultural Sub-Text from Chrétien de Troyes to Jean Michel.* Turnhout: Brepols, 2000.

Blachly, Alexander. "Archaic Polyphony in Dutch Sources of the Renaissance." *Tijdschrift van de Koninklijke Vereniging voor Nederlandse Muziekgeschiedenis* 53 (2003): 183–227.

———. "The Mechelen *Ave verum corpus*: Simplex Polyphony for the *Devotio Moderna.*" In *Beghinae in cantu instructae: Musical Patrimony from Flemish Beguinages (Middle Ages–Late 18th C.),* edited by Pieter Mannaerts, 99–107. Turnhout: Brepols, 2009.

Blackburn, Bonnie J. "On Compositional Process in the Fifteenth Century." *Journal of the American Musicological Society* 40 (1987): 210–84.

Blake, Stephen P. *Time in Early Modern Islam: Calendar, Ceremony, and Chronology in the Safavid, Mughal, and Ottoman Empires.* Cambridge: Cambridge University Press, 2013.

Blockmans, Wim. "Le dialogue imaginaire entre princes et sujets: les Joyeuses Entrées en Brabant en 1494 et 1496." In *A la cour de Bourgogne. Le Duc, son entourage, son train*, edited by Jean-Marie Cauchies, 155–70. Turnhout: Brepols, 1998.

Blockmans, Wim, and Walter Prevenier. *The Promised Lands: The Low Countries under Burgundian Rule, 1369–1530*. Translated by Elizabeth Fackelman and Edward Peters. Philadelphia: University of Pennsylvania Press, 1999.

Blum, Shirley Neilsen. *Early Netherlandish Triptychs*. Berkeley: University of California Press, 1969.

Blümle, Claudia. *Der Zeuge im Bild*. Munich: Wilhelm Fink, 2011.

Boone, Marc. *Gent en de Bourgondische hertogen ca. 1384–ca. 1453: een sociaal-politieke studie van een staatsvormingsproces*. Brussels: AWLSK, 1990.

———. *Geld en macht: de Gentse stadsfinanciën en de Bourgondische staatsvorming (1384–1453)*. Ghent: Maatschappij voor Geschiedenis en Oudheidkunde te Gent, 1990.

Borst, Arno. *The Ordering of Time: From the Ancient Computus to the Modern Computer*. Chicago: University of Chicago Press, 1993.

Bossy, John. "The Mass as a Social Institution, 1200–1700." *Past and Present* 100 (1983): 29–61.

Bouly, Eugène, ed. *Dictionnaire historique de la ville de Cambrai*. Brussels: Editions culture et civilisation, 1979 [1854].

Boureau, Alain. "Les cérémonies royales françaises entre performance juridique et compétence liturgique." *Annales ESC* 46 (1991): 1253–64.

Bousmanne, Bernard, and Céline van Hoorebeeck, eds. *La librairie des ducs de Bourgogne. Manuscrits conservés à la Bibliothèque royale de Belgique*. Vol. 1. Turnhout: Brepols, 2000.

Brand, Paul. "Lawyer's Time in England in the Later Middle Ages." In *Time in the Medieval World*, edited by Chris Humphrey and W. M. Ormrod, 73–104. York: York Medieval Press, 2001.

Brown, Andrew. *Civic Ceremony and Religion in Medieval Bruges c. 1300–1520*. Cambridge: Cambridge University Press, 2011.

———. "Devotion and Emotion: Creating the Devout Body in Late Medieval Bruges." *Digital Philology* 1 (2012): 210–34.

———. "Liturgical Memory and Civic Conflict: The Entry of Emperor Frederick III and Maximilian, King of the Romans, into Bruges on 1 August 1486." In *Mémoires conflictuelles et mythes concurrents dans les pays bourguignons (c. 1380–1580)*, edited by Jean-Marie Cauchies, 129–48. Turnhout: Brepols, 2012.

———. "Ritual and State-Building: Ceremonies in Late Medieval Bruges." In *Symbolic Communication in Late Medieval Towns*, edited by Jacoba van Leeuwen, 1–28. Leuven: Leuven University Press, 2006.

Brown, Andrew, and Graeme Small, eds. *Court and Civic Society in the Burgundian Low Countries c. 1420–1530*. Manchester: Manchester University Press, 2007.

Bruner, Jerome S. *Actual Minds, Possible Worlds*. Cambridge, MA: Harvard University Press, 1986.

Bücker, Hermann. *Werner Rolevinck. Leben und Persönlichkeit im Spiegel des Westfalenbuches*. Münster: Regensbergsche Verlagsbuchhandlung, 1953.

Bühler, Curt F. "The Apostles and the Creed." *Speculum* 28 (1953): 335–39.
———. "The *Fasciculus Temporum* and Morgan Manuscript 801." *Speculum* 27 (1952): 178–83.
———. "A Fifteenth-Century List of Recommended Books." *New Colophon* 3 (1950): 49–53.
Burckhardt, Jacob. *The Civilization of the Renaissance in Italy*. Oxford: Phaidon, 1995 [1860].
Burger, Christoph, August den Hollander, and Ulrich Schmid, eds. *Evangelienharmonien des Mittelalters*. Assen: Royal Van Gorcum, 2004.
Burie, Luc. "Proeve tot inventarisatie van de in handschrift of in druk bewaarde werken van de Leuvense theologieprofessoren uit de XVe eeuw." In *Facultas S. Theologiae Lovaniensis, 1432–1797: bijdragen tot haar geschiedenis*, edited by Edmond J. M. van Eijl and A. J. Black, 215–72. Leuven: Leuven University Press, 1977.
Burke, Peter. "Performing History: The Importance of Occasions." *Rethinking History* 9 (2005): 35–52.
———. "Reflections on the Cultural History of Time." *Viator* 35 (2004): 617–26.
———. *The Renaissance Sense of the Past*. London: Edward Arnold, 1969.
Burstyn, Shai. "In Quest of the Period Ear." *Early Music* 25 (1997): 693–701.
Busse Berger, Anna Maria. *Medieval Music and the Art of Memory*. Berkeley: University of California Press, 2005.
Bussels, Stijn, and Bram van Oostveldt. "De traditie van de tableaux vivants bij de plechtige intochten in de Zuidelijke Nederlanden (1496–1653)." *Tijdschrift voor Geschiedenis* 115 (2002): 166–80.
Butzkamm, Aloys. *Bild und Frömmigkeit im 15. Jahrhundert: Der Sakramentsaltar von Dieric Bouts in der St.-Peters-Kirche zu Löwen*. Paderborn: Bonifatius, 1990.
Bynum, Caroline Walker. "Seeing and Seeing Beyond: The Mass of St. Gregory in the Fifteenth Century." In *The Mind's Eye: Art and Theological Argument in the Middle Ages*, edited by Jeffrey F. Hamburger and Anne-Marie Bouché, 208–40. Princeton, NJ: Princeton University Press, 2006.
Campbell, Lorne. "The Art Market in the Southern Netherlands in the Fifteenth Century." *Burlington Magazine* 118 (1976): 188–98.
———. *The Fifteenth Century Netherlandish Schools*. London: National Gallery Publications, 1998.
Canty, Aaron M. *Light and Glory: The Transfiguration of Christ in Early Franciscan and Dominican Theology*. Washington, DC: Catholic University of America Press, 2011.
Cardon, Bert. "Aspecten van de tijd in de 15de-eeuwse stad." In *Leven te Leuven in de late Middeleeuwen*, edited by Lutgarde Bessemans, Inès Honoré, Maurits Smeyers, Veronique Vandekerchove, and Raymond van Uytven, 23–29. Leuven: Peeters, 1998.
———. "Na allen synen besten vermoegenen. Dirk Bouts en zijn opdrachtgevers." In *Leuven in de late Middeleeuwen: Dirk Bouts, Het Laatste Avondmaal*, edited by Anna Bergmans, 73–85. Brussels: Tielt, 1998.
Cardon, Bert, and B. Dekeyzer. "Dirk Bouts in de universiteitsstad: intellectuele netwerken." In *Geen povere schoonheid: laat-middeleeuwse kunst in verband met de moderne devotie*, edited by Kees Veelenturf, 195–221. Nijmegen: Valkhof, 2000.

Carlebach, Elisheva. *Palaces of Time: Jewish Calendar and Culture in Early Modern Europe*. Cambridge, MA: Harvard University Press, 2011.
Carruthers, Mary J. *The Book of Memory: A Study of Memory in Medieval Culture*. Cambridge: Cambridge University Press, 1990.
———. *The Craft of Thought: Meditation, Rhetoric, and the Making of Images, 400–1200*. Cambridge: Cambridge University Press, 1998.
———. *The Experience of Beauty in the Middle Ages*. Oxford: Oxford University Press, 2013.
Caspers, Charles M. A. *De eucharistische vroomheid en het feest van Sacramentsdag in de Nederlanden tijdens de Late Middeleeuwen*. Leuven: Peeters, 1992.
———. "Indulgences in the Low Countries, c. 1300–c. 1520." In *Promissory Notes on the Treasury of Merits: Indulgences in Late Medieval Europe*, edited by R. N. Swanson, 65–99. Leiden: Brill, 2006.
———. "Wandering between Transubstantiation and Transfiguration: Images of Elijah in Western Christianity, 1200–1500 CE." In *Saints and Role Models in Judaism and Christianity*, edited by Marcel Poorthuis and Joshua Schwartz, 335–54. Leiden: Brill, 2004.
Champion, Matthew S. "Emotions and the Social Order of Time: Constructing History at Louvain's Carthusian House, 1486–1525." In *Gender and Emotions in Medieval and Early Modern Europe: Destroying Order, Structuring Disorder*, edited by Susan Broomhall, 89–108. Farnham: Ashgate, 2015.
———. "The Presence of an Absence: Jews in Late-Medieval Louvain." In *A World Enchanted: Magic and the Margins. Essays Presented in Honour of Charles Zika*, edited by Julie Davies and Michael Pickering, 37–67. Melbourne: MHJ Research Series, 2014.
———. "*Videre supra modum est dilectabile*: Reading Chronology in the Medieval Low Countries." In *Medieval and Early Modern Chronology*, edited by M. Choptiany. Forthcoming.
Champion, Michael, Raphaële Garrod, Yasmin Haskell, and Juanita Feros Ruys. "But Were They Talking About Emotions? *Affectus, Affectio* and the History of Emotions." *Rivista Storica Italiana* 128 (2016): 521–43.
Chipps Smith, Jeffrey. "Venit nobis pacificus Dominus: Philip the Good's Triumphal Entry into Ghent in 1458." In *All the World's a Stage . . . Art and Pageantry in the Renaissance and Baroque*, edited by B. Wisch and S. Munshower, 258–90. Pennsylvania: Pennsylvania State University Press, 1990.
Claes, Dirk. "Changes in the Educational Context of the Leuven Faculty of Theology in the Fifteenth and Sixteenth Centuries: Canon Law and Humanism." In *Schooling and Society: The Ordering and Reordering of Knowledge in the Western Middle Ages*, edited by Alasdair A. MacDonald and Michael W. Twomey, 139–55. Leuven: Peeters, 2004.
Clark, Gregory T. *Made in Flanders: The Master of the Ghent Privileges and Manuscript Painting in the Southern Netherlands in the Time of Philip the Good*. Turnhout: Brepols, 2000.
Classen, Albrecht. "Werner Rolevinck's *Fasciculus Temporum*: The History of a Late-Medieval Bestseller, or: The First Hypertext." *Gutenberg-Jahrbuch* (2006): 225–30.
Clouzot, Martine. "Le son et le pouvoir en Bourgogne au XVe siècle." *Revue Historique* 302 (2000): 615–28.

Cluse, Christoph. *Studien zur Geschichte der Juden in den mittelalterlichen Niederlanden.* Hanover: Hahn, 2000.
Colberg, Katharina. "Rolevinck, Werner." In *Die deutsche Literatur des Mittelalters: Verfasserlexikon,* edited by Wolfgang Stammler and Karl Langosch, 153–58. 14 vols. Vol. 8.1. Berlin: de Gruyter, 1977–2008.
Comblen-Sonkes, Micheline (secretary). *The Collegiate Church of Saint Peter Louvain.* Translated by John Cairns. Vol. 2, Corpus of Fifteenth-Century Painting in the Southern Netherlands and the Principality of Liége no. 18. Brussels: Internationaal Studiecentrum voor de Middeleeuwse Schilderkunst in het Schelde- en het Maasbekken, 1996.
Constable, Giles. "Past and Present in the Eleventh and Twelfth Centuries: Perceptions of Time and Change." In *L'Europa dei secoli XI e XII fra novità e traditione: sviluppi di una cultura. Atti della decima Settimana internazionale di studio, Mendola, 25–29 agosto 1986,* 135–70. Milan: Vita e pensiero, 1989.
———. "Renewal and Reform in Religious Life: Concepts and Realities." In *Renaissance and Renewal in the Twelfth Century,* edited by Robert L. Benson and Giles Constable, 37–67. Cambridge, MA: Harvard University Press, 1982.
Contamine, Philippe. "Les Chaînes dans les bonnes villes de France (spécialement Paris), XIVe–XVe siècle." In *Guerre et société en France, en Angleterre et en Bourgogne, XIVe–XVe siècle,* edited by Philippe Contamine, Charles Giry-Deloison, and Maurice H. Keen, 293–314. Villeneuve d'Ascq: Centre d'histoire de la région du Nord et de l'Europe du Nord-Ouest: Université Charles de Gaulle Lille III, 1991.
Conway, William Martin. *The Woodcutters of the Netherlands in the Fifteenth Century.* Cambridge: Cambridge University Press, 1884.
Cook, Patrick J. *Milton, Spenser and the Epic Tradition.* Aldershot: Scolar Press, 1996.
Coyne, G. V., M. A. Hoskin, and O. Pedersen, eds. *Gregorian Reform of the Calendar: Proceedings of the Vatican Conference to Commemorate its 400th Anniversary, 1582–1982.* Vatican: Pontificia Academia Scientiarum, 1983.
Craig, William Lane. *The Problem of Divine Foreknowledge and Future Contingents from Aristotle to Suarez.* Leiden: Brill, 1988.
Cullmann, Oscar. *Christ and Time: The Primitive Christian Conception of Time and History.* Translated by Floyd V. Filson. London: SCM Press, 1951.
Cumming, Julie E. *The Motet in the Age of Du Fay.* Cambridge: Cambridge University Press, 1999.
Curtis, Gareth R. K. "Brussels, Bibliothèque Royale MS. 5557, and the Texting of Dufay's 'Ecce ancilla Domini' and 'Ave regina celorum' Masses." *Acta Musicologica* 51 (1979): 73–86.
Curtis, Liane. *Cambrai Cathedral Choirbook: Mid-15th C. Cambrai, Bibliothèque municipale MS 11.* Alamire: Peer, 1992.
———. "Music Manuscripts and Their Production in Fifteenth-Century Cambrai." PhD diss., University of North Carolina at Chapel Hill, 1991.
D'Haenens, Albert. "Abbaye de Parc, à Heverlee." In *Monasticon Belge: Province de Brabant,* edited by Dom U. Berlière, Vol. 4.3, 773–827. Liège: Centre national de recherches d'histoire religieuse, 1969.
D'Hoop, Alfred. *Inventaire général des Archives ecclesiastiques du Brabant.* Vol. 1. Brussels: E. Guyot, 1905.

Dale, William S. "'Latens Deitas': The Holy Sacrament Altarpiece of Dieric Bouts." *Revue d'art canadienne/Canadian Art Review* 11 (1984): 110–16.

Darby, Peter. *Bede and the End of Time*. Farnham: Ashgate, 2012.

Davis, Natalie Zemon. "The Sacred and the Body Social in Sixteenth-Century Lyon." *Past and Present* 90 (1981): 40–70.

De Busscher, Edmond. *Recherches sur les peintres gantois des XIVe et XVe siècles*. Ghent: L. Hebbelynck, 1859.

De Gruben, Françoise. *Les Chapitres de la Toison d'Or à l'époque bourguignonne (1430–1477)*. Leuven: Leuven University Press, 1997.

De Hen, Ferd. J. "Folk Instruments of Belgium: Part I." *Galpin Society Journal* 25 (1972): 87–132.

De Jongh, H. *L'ancienne faculté de théologie de Louvain au premier siècle de son existence (1432–1540)*. Leuven: Bureaux de la revue d'histoire ecclésiastique, 1911.

De Kesel, Lieve. "Cambridge University Library Ms Add. 4100: A Book of Hours Illuminated by the Master of the Prayer Books of circa 1500?" *Transactions of the Cambridge Bibliographical Society* 10 (1992): 182–202.

De Lang, Marijke H. "Jean Gerson's Harmony of the Gospels (1420)." *Nederlands Archief voor Kerkgeschiedenis* 71 (1991): 37–49.

De Pape, Libertus, Prosper Delfleche, Augustinus Le Scellier, Josephus vander Maelen. *Summaria cronologia insignis ecclesiae Parchensis*. Leuven: Petrus Sassenus, 1662.

De Potter, Frans. *Gent, van den vroegsten tijd tot heden*, Geschiedenis van de gemeenten der provincie Oost-Vlaanderen. Ghent: C. Annoot-Braeckman, 1882.

———. *Jaarboeken der Sint-Jorisgild van Gent*. Ghent: F. Hage, 1866.

De Roos, Marjoke. "Carnival Traditions in the Low Countries." In *Custom, Culture and Community in the Later Middle Ages*, edited by Thomas Pettitt and Leif Søndergaard, 17–36. Odense: Odense University Press, 1994.

De Schepper, Marcus, Ann Kelders, and Jan Pauwels. *Les seigneurs du livre: Les grands collectionneurs du XIXème siècle à la Bibliothèque royale de Belgique*. Brussels: Bibliothèque royale de Belgique, 2008.

De Vroede, Eric. "Volkse ontspanning, speelholen en sportspektakel te Leuven in de 15de eeuw." In *Leven te Leuven in de late Middeleeuwen*, edited by Lutgarde Bessemans, Inès Honoré, Maurits Smeyers, Veronique Vandekerchove, and Raymond van Uytven, 95–108. Leuven: Peeters, 1998.

Den Hollander, August. "Mittelniederländische Evangelienharmonien—Form und Funktion: Eine erste Orientierung." In *Evangelienharmonien des Mittelalters*, edited by Christoph Burger, August den Hollander, and Ulrich Schmid, 89–108. Assen: Royal Van Gorcum, 2004.

Des Marez, Guillaume. *L'organisation du travail à Bruxelles au XVe siècle*. Brussels: H. Lamertin, 1904.

Dean, Jeffrey. "Listening to Sacred Polyphony." *Early Music* 25 (1997): 611–36.

Delclos, Jean-Claude. *Le témoignage de Georges Chastellain. Historiographe de Philippe le Bon et de Charles le Téméraire*. Geneva: Droz, 1980.

Dequeker, Luc. *Het Mysterie van het Lam Gods. Filips de Goede en de Rechtvaardige Rechters van Van Eyck*. Leuven: Peeters, 2011.

Derolez, Albert. "L'editio Mercatelliana du Monotessaron de Gerson." In *Hommages à André Boutemy*, 43–54. Brussels: Latomus, 1976.

———. *The Library of Raphael de Marcatellis, Abbot of St. Bavon's, Ghent*. Ghent: E. Story-Scientia, 1979.

Derolez, Albert, Benjamin Victor, Lucien Reynhout, Wouter Bracke, Michel Oosterbosch, and Jan Willem Klein. *Corpus Catalogorum Belgii: The Medieval Booklists of the Southern Low Countries*. 7 vols. Brussels: WLSK, 1994.

Derwich, Marek, and Martial Staub, eds. *Die "Neue Frömmigkeit" in Europa im Spätmittelalter*. Göttingen: Vandenhoeck and Ruprecht, 2004.

Destombes, C.-J. *Notre-Dame de Grace et le culte de la sainte Vierge. Cambrai dans le Cambresis*. Cambrai, D'Halluin-Carion 1871.

Devillers, Léopold. "Les Séjours des ducs de Bourgogne en Hainaut: 1427–1482." *Bulletin de la commission royale d'histoire* 6 (1879): 323–468.

Dhanens, Elisabeth. "De Blijde Inkomst van Filips de Goede in 1458 en de plastische kunsten te Gent." *Mededelingen van de Koninklijke Academie voor Wetenschappen, Letteren en Schone Kunsten van Belgie: Klasse der Schone Kunsten* 48 (1987): 53–89.

———. "Het Boek der Privilegiën van Gent." *Mededelingen van de Koninklijke Academie voor Wetenschappen, Letteren en Schone Kunsten van Belgie: Klasse der Schone Kunsten* 48 (1987): 91–112.

———. "Vorstelijke glasramen van circa 1458 te Gent." In *Relations artistiques entre les Pays-Bas et l'Italie à la renaissance*, 123–126. Brussels: Études d'histoire de l'art, 1980.

Dillon, Emma. *The Sense of Sound: Musical Meaning in France 1260–1330*. Oxford: Oxford University Press, 2012.

Dixon, Thomas. *From Passions to Emotions: The Creation of a Secular and Psychological Category*. Cambridge: Cambridge University Press, 2003.

Dobbins, Frank. *Music in Renaissance Lyons*. Oxford: Clarendon Press, 1992.

Dohrn-van Rossum, Gerhard. *History of the Hour: Clocks and Modern Temporal Orders*. Translated by Thomas Dunlap. Chicago: Chicago University Press, 1996.

Doležalová, Lucie. "The *Summarium biblicum*: A Biblical Tool Both Popular and Obscure." In *Form and Function in the Late Medieval Bible*, edited by Laura Light and Eyal Poleg, 163–84. Leiden: Brill, 2013.

Dumolyn, Jan, and Jelle Haemers. "'A Bad Chicken Was Brooding': Subversive Speech in Late Medieval Flanders." *Past and Present* 214 (2012): 45–86.

Durieux, A. "La dernière cloche de l'ancienne église métropolitaine de Cambrai." *Mémoires de la société d'émulation de Cambrai* 29 (1867): 145–58.

Durkheim, Émile. *The Elementary Forms of Religious Life*. Translated by Karen Fields. New York: Free Press, 1995 [1912].

Eichberger, Dagmar. "The *Tableau Vivant*: An Ephemeral Art Form in Burgundian Civic Festivities." *Parergon* 6 (1988): 37–64.

Elders, Willem. "Perfect Fifths and the Blessed Virgin's Immaculate Conception: On Ficta in Josquin's Five-Part Inviolata." In *Uno Gentile et Subtile Ingenio: Studies in Renaissance Music in Honour of Bonnie J. Blackburn*, 403–11. Turnhout: Brepols, 2009.

———. *Symbolic Scores: Studies in the Music of the Renaissance*. Leiden: Brill, 1994.

Eliade, Mircea. *The Myth of the Eternal Return.* London: Routledge and Kegan Paul, 1955.

Endrei, Walter. "Manufacturing a Piece of Woolen Cloth in Medieval Flanders: How Many Work Hours?" In *Textiles of the Low Countries in European Economic History,* edited by Erik Aerts and John H. Munro, 14–23. Leuven: Leuven University Press, 1990.

Engammare, Max. *On Time, Punctuality, and Discipline in Early Modern Calvinism.* Translated by Karin Maag. Cambridge: Cambridge University Press, 2010.

Evans, Jonathan. "Peter de Rivo and the Problem of Future Contingents." *Carmina Philosophiae* 10 (2001): 39–55.

Fabian, Johannes. *Time and the Other: How Anthropology Makes Its Object.* New York: Columbia University Press, 1983.

Faille, René, ed. *Le Culte de Notre-Dame de Grâce à travers l'histoire.* Cambrai: Musée d'Art Religieux, 1971.

Fallows, David. *Dufay.* London: Dent, 1982.

———. *Josquin.* Turnhout: Brepols, 2009.

Fassler, Margot E. *The Virgin of Chartres: Making History through Liturgy and the Arts.* New Haven, CT: Yale University Press, 2010.

Flasch, Kurt. *Was ist Zeit? Augustinus von Hippo, das XI. Buch der Confessiones.* Frankfurt: Klostermann, 1993.

Forney, Kristine K. "Music, Ritual and Patronage at the Church of Our Lady, Antwerp." *Early Music History* 7 (1987): 1–57.

Fuller, Ross. *The Brotherhood of the Common Life and Its Influence.* New York: SUNY Press, 1995.

Gabriel, A. L. "Intellectual Relations between the University of Louvain and the University of Paris in the 15th Century." In *The Universities in the Late Middle Ages,* edited by J. IJsewijn and J. Paquet, 82–132. Leuven: Leuven University Press, 1978.

Geertz, Clifford. *The Interpretation of Cultures: Selected Essays.* New York: Basic Books, 1973.

Gerrits, G. H. *Inter timorem et spem: A Study of the Theological Thought of Gerard Zerbolt of Zutphen, 1367–1398.* Leiden: Brill, 1986.

Ginzburg, Carlo. "The Letter Kills: On Some of the Implications of 2 Corinthians 3:6." *History and Theory* 49 (2010): 71–89.

Glennie, Paul, and Nigel Thrift. *Shaping the Day: A History of Timekeeping in England and Wales 1300–1800.* Oxford: Oxford University Press, 2009.

Grabes, Herbert. *The Mutable Glass: Mirror Imagery in Titles and Texts of the Middle Ages and English Renaissance.* Cambridge: Cambridge University Press, 1982.

Grafton, Anthony. *Joseph Scaliger: A Study in the History of Classical Scholarship.* Vol. 2. *Historical Chronology.* Oxford: Clarendon Press, 1993.

Greilsammer, Myriam. "Midwife, Priest, Physician: The Subjugation of Midwives in the Low Countries at the End of the Middle Ages." *Journal of Medieval and Renaissance Studies* 21 (1991): 285–329.

Guedens, Christophe, and Serena Masolini. "Teaching Aristotle at the Louvain Faculty of Arts, 1425–1500." *Rivista di Filosofia Neoscolastica,* forthcoming.

Gurvitch, Georges. *La vocation actuelle de la sociologie.* 2 vols. Paris: Presses universitaires de France, 1963.

Haggh, Barbara. "The Archives of the Order of the Golden Fleece and Music." *Journal of the Royal Musical Association* 120 (1995): 1–43.

———. "The Celebration of the '*Recollectio Festorum Beatae Mariae Virginis*,' 1457–1987." *Studia Musicologica Academiae Scientiarum Hungaricae* 30 (1988): 361–73.

———. "The First Printed Antiphoner of Cambrai Cathedral." In *Gestalt und Entstehung musikalischer Quellen im 15. und 16. Jahrhundert*, edited by Martin Staehelin, 75–110. Wiesbaden: Harrassowitz, 1998.

———. "Foundations or Institutions? On Bringing the Middle Ages into the History of Medieval Music." *Acta Musicologica* 68 (1996): 87–128.

———. "Guillaume Du Fay and the Evolution of the Liturgy of Cambrai Cathedral in the Fifteenth Century." In *International Musicological Society Study Group Cantus Planus: Papers Read at the Fourth Meeting, Pécs, Hungary, 3–8 September 1990*, edited by L. Dobzay, A. Papp, and F. Sebó, 549–69. Budapest: Hungarian Academy of Sciences, 1992.

———. "Guillaume Du Fay's Birthplace: Some Notes on a Hypothesis." *Revue belge de Musicologie/Belgisch Tijdschrift voor Muziekwetenschap* 51 (1997): 17–21.

———. "Introduction." In *Two Cambrai Antiphoners: Cambrai, Médiathèque Municipale, 38 and Impr. XVI C 4*, edited by Barbara Haggh, Charles Downey, Keith Glaeske, and Lilla Collamore, vii–xliv. Ottowa: Institute of Medieval Music, 1995.

———. "Itinerancy to Residency: Professional Careers and Performance Practices in 15th-Century Sacred Music." *Early Music* 17 (1989): 359–366.

———. "The Late-Medieval Liturgical Books of Cambrai Cathedral: A Brief Survey of Evidence." In *Laborare fratres in unum, Festschrift Lászlów Dobszay zum 60. Geburtstag*, edited by D. Hiley and J. Szendrei, 79–85. Hildesheim: Spolia Berolinensia, 1995.

———. "Music, Liturgy and Ceremony in Brussels, 1350–1500." PhD diss., University of Illinois at Urbana-Champaign, 1988.

———. "Nonconformity in the Use of Cambrai Cathedral: Guillaume Du Fay's Foundations." In *The Divine Office in the Latin Middle Ages: Methodology and Source Studies, Regional Developments, Hagiography*, edited by Margot E. Fassler and Rebecca A. Baltzer, 372–97. Oxford: Oxford University Press, 2000.

———. "The Officium of the *Recollectio Festorum Beate Virginis* by Gilles Carlier and Guillaume Du Fay: Its Celebration and Reform in Leuven." In *Recevez ce mien petit labeur: Studies in Renaissance Music in Honour of Ignace Bossuyt*, edited by Mark Delaere and Pieter Bergé, 93–105. Leuven: Leuven University Press, 2008.

———. "The Virgin Mary and the Order of the Golden Fleece." In *Le Banquet du Faisan. 1454: l'Occident face au défi de l'Empire ottoman*, edited by Marie-Thérèse Caron and Denis Clauzel, 273–87. Arras: Artois Presses Université, 1997.

Hammerstein, Reinhold. *Die Musik der Engel. Untersuchungen zur Musikanschauung des Mittelalters*. Munich: A. Francke, 1962.

Harbison, Craig. *Jan van Eyck: The Play of Realism*. London: Reaktion Books, 1991.

Harrán, Don. *In Defense of Music: The Case for Music as Argued by a Singer and Scholar of the Late Fifteenth Century*. Lincoln: University of Nebraska Press, 1989.

Hartog, François. *Regimes of Historicity: Presentism and Experiences of Time*. Translated by Saskia Brown. New York: Columbia University Press, 2015 [2003].

Hascher-Burger, Ulrike. *Gesungene Innigkeit. Studien zu einer Musikhandschrift der Devotio moderna (Utrecht, Universiteitsbibliotheek, Ms. 16 H 34, olim B 113)*. Leiden: Brill, 2002.

———. *Singen für die Seligkeit. Studien zu einer Liedersammlung der Devotio moderna*. Leiden: Brill, 2007.

Haskell, Francis. *History and Its Images: Art and the Interpretation of the Past*. New Haven, CT: Yale University Press, 1993.

Henisch, Ann Bridget. *The Medieval Calendar Year*. University Park: Pennsylvania State University Press, 1999.

Higgins, Anne. "Medieval Notions of the Structure of Time." *Journal of Medieval and Renaissance Studies* 19 (1989): 227–50.

Hobbins, Daniel. *Authorship and Publicity Before Print: Jean Gerson and the Transformation of Late Medieval Learning*. Philadelphia: University of Pennsylvania Press, 2009.

Hoffmann, Werner J. "Die volkssprachliche Rezeption des 'Horologium sapientiae' in der Devotio moderna." In *Heinrich Seuses Philosophia spiritualis: Quellen, Konzept, Formen, Rezeption*, edited by Rüdiger Blumrich and Philipp Kaiser, 202–54. Wiesbaden: Ludwig Reichert, 1994.

———. "The Gospel of Nicodemus in Dutch and German Literatures of the Middle Ages." In *The Medieval Gospel of Nicodemus: Texts, Intertexts, and Contexts in Western Europe*, edited by Zbigniew S. Izydorczyk, 337–60. Tempe, AZ: Medieval and Renaissance Texts and Studies, 1997.

———. "The Gospel of Nicodemus in High German Literature of the Middle Ages." In *The Medieval Gospel of Nicodemus: Texts, Intertexts, and Contexts in Western Europe*, edited by Zbigniew S. Izydorczyk, 287–336. Tempe, AZ: Medieval and Renaissance Texts and Studies, 1997.

Horsten, Martin. "Ter ere van God en van de stad: de bouw van de nieuwe Sint-Pieterskerk." In *Leuven in de late Middeleeuwen: Dirk Bouts, Het Laatste Avondmaal*, edited by Anna Bergmans, 38–51. Brussels: Tielt, 1998.

Hourihane, Colum, ed. *Time in the Medieval World: Occupations of the Months and Signs of the Zodiac in the Index of Christian Art*. University Park, PA: Index of Christian Art, 2007.

Howell, Martha C. *The Marriage Exchange: Property, Social Place, and Gender in Cities of the Low Countries, 1300–1550*. Chicago: University of Chicago Press, 1998.

Hoy, David Couzens. *The Time of Our Lives: A Critical History of Temporality*. Cambridge, MA: MIT Press, 2009.

Huizinga, Johan. *The Autumn of the Middle Ages*. Translated by Rodney J. Payton and Ulrich Mammitzsch. Chicago: Chicago University Press, 1996 [1919].

Humphrey, Chris, and W. M. Ormrod, eds. *Time in the Medieval World*. York: York Medieval Press, 2001.

Hunt, Lynne. *Measuring Time, Making History*. Budapest: Central European University Press, 2008.

Hurlbut, Jesse D. "Ceremonial Entries in Burgundy: Philip the Good and Charles the Bold, 1419–1477." PhD diss., Indiana State University, 1990.

———. "Immobilier et cérémonie urbaine: les joyeuses entrées françaises à la fin du Moyen Âge." In *Civic Ritual and Drama*, edited by Wim Hüsken and Alexandra F. Johnston, 125–42. Amsterdam: Rodopi, 1997.

Hutton, Shennan. *Women and Economic Activities in Late Medieval Ghent*. Basingstoke: Palgrave Macmillan, 2011.

IJsewijn, J. "The Coming of Humanism to the Low Countries." In *Itinerarium Italicum: The Profile of the Italian Renaissance in the Mirror of its European Transformations*, edited by H. A. Oberman and T. A. Brady, 193–310. Leiden: Brill, 1975.

Ikas, Wolfgang-Valentin. "Martinus Polonus' Chronicle of the Popes and Emperors: A Medieval Best-Seller and Its Neglected Influence on Medieval English Chroniclers." *English Historical Review* 116 (2001): 327–41.

Ingold, Tim. *Lines: A Brief History*. London: Routledge, 2007.

Irwin, Joyce L. "The Mystical Music of Jean Gerson." *Early Music History* 1 (1981): 187–201.

Izbicki, Thomas M. "The Immaculate Conception and Ecclesiastical Politics from the Council of Basel to the Council of Trent: The Dominicans and Their Foes." *Archiv für Reformationsgeschichte* 96 (2005): 145–70.

Janssen, Frans A. "Author and Printer in the History of Typographical Design." *Quaerendo* 21 (1991): 11–37.

Jardine, Lisa. *Erasmus, Man of Letters: The Construction of Charisma in Print*. Princeton, NJ: Princeton University Press, 1993.

Jaritz, Gerhard, and Gerson Moreno-Riano, eds. *Time and Eternity: The Medieval Discourse*. Turnhout: Brepols, 2003.

Jeserich, Philipp. *Musica naturalis: Tradition und Kontinuität spekulativ-metaphysischer Musiktheorie in der Poetik des französischen Spätmittelalters*. Stuttgart: Franz Steiner, 2008.

Josephson, Aksel G. S. "Fifteenth-Century Editions of *Fasciculus temporum* in American Libraries." In *The Papers of the Bibliographical Society of America*, edited by Aksel G. S. Josephson, 61–65. Chicago: University of Chicago Press, 1917.

Judd, Cristle Collins. *Reading Renaissance Music Theory: Hearing with the Eyes*. Cambridge: Cambridge University Press, 2000.

Kaltenbrunner, Ferdinand. "Die Vorgeschichte der Gregorianischen Kalenderreform." *Sitzungsberichte der Philosophisch-Historischen Klasse der Kaiserlichen Akademie der Wissenschaften, Wien* 82 (1876): 289–414.

Kaluza, Zenon. "Matériaux et remarques sur le catalogue des œuvres de Gilles Charlier." *Archives d'histoire doctrinale et littéraire du Moyen Âge* 36 (1969): 169–87.

Kantorowicz, Ernst H. "The 'King's Advent' and the Enigmatic Panels in the Doors of Santa Sabina." *Art Bulletin* 26 (1944): 207–31.

Karant-Nunn, Susan C. *The Reformation of Feeling*. Oxford: Oxford University Press, 2010.

Kaster, Robert A. *Emotion, Restraint, and Community in Ancient Rome*. Oxford: Oxford University Press, 2005.

Kemp, Wolfgang. *Die Räume der Maler: Zur Bilderzählung seit Giotto*. Munich: C. H. Beck, 1996.

Ker, Neil Ripley " 'For All That I May Clamp': Louvain Students and Lecture-Rooms in the Fifteenth Century." *Medium Ævum* 39 (1970): 32–33.

———. *Medieval Manuscripts in British Libraries*. Vol. 3. Oxford: Clarendon Press, 1983.

Kern, Stephen. *The Culture of Time and Space, 1880–1918*. London: Weidenfeld and Nicolson, 1983.

Kipling, Gordon. *Enter the King: Theatre, Liturgy and Ritual in the Medieval Civic Triumph*. Oxford: Clarendon Press, 1998.

Kirkland-Ives, Mitzi. *In the Footsteps of Christ: Hans Memling's Passion Narratives and the Devotional Imagination in the Early Modern Netherlands*. Turnhout: Brepols, 2013.

Kirkman, Andrew. *The Cultural Life of the Early Polyphonic Mass*. Cambridge: Cambridge University Press, 2010.

Kock, Thomas. *Die Buchkultur der Devotio moderna. Handschriftproduktion, Literaturversorgung und Bibliotheksaufbau im Zeitalter der Medienwechsels*. Frankfurt: Peter Lang, 1999.

Kohl, Wilhelm, Ernest Persoons, and Anton G. Weiler, eds. *Monasticon Windeshemense*. Vol. 1. Brussels: Archives et Bibliothèques de Belgique, 1976.

Kok, Ina. *Woodcuts in Incunabula in the Low Countries*. 4 vols. Houten: Hes and De Graaf Publishers, 2013.

Koselleck, Reinhart. *Futures Past: On the Semantics of Historical Time*. Translated by Keith Tribe. New York: Columbia University Press, 2004 [1979].

Koslofsky, Craig. *Evening's Empire: A History of the Night in Early Modern Europe*. Cambridge: Cambridge University Press, 2011.

Kristeva, Julia. *New Maladies of the Soul*. Translated by Ross Guberman. New York: Columbia University Press, 1995.

Krueger, Derek. *Liturgical Subjects: Christian Ritual, Biblical Narrative, and the Formation of the Self in Byzantium*. Philadelphia: University of Pennsylvania Press, 2014.

Krul, Wessel. "In the Mirror of Van Eyck: Johan Huizinga's *Autumn of the Middle Ages*." *Journal of Medieval and Early Modern Studies* 27 (1997): 353–84.

Kuretsky, Susan Donahue. "Rembrandt's Tree Stump: An Iconographic Attribute of St. Jerome." *Art Bulletin* 56 (1974): 571–80.

Kusukawa, Sachiko. "Catalogue 42A and 42B." In *Writing on Hands: Memory and Knowledge in Early Modern Europe*, edited by Claire Richter Sherman, 166–67. Carlisle, PA/Washington, DC: Trout Gallery, Dickenson College/Folger Shakespeare Library, 2000.

———. "A Manual Computer for Reckoning Time." In *Writing on Hands: Memory and Knowledge in Early Modern Europe*, edited by Claire Richter Sherman, 28–34. Carlisle, PA/Washington, DC: Trout Gallery, Dickenson College/Folger Shakespeare Library, 2000.

Lamberts, Emiel, and Jan Roegiers, eds. *Leuven University, 1425–1985*. Leuven: Leuven University Press, 1990.

Landes, David S. *Revolution in Time: Clocks and the Making of the Modern World*. Cambridge, MA: Harvard University Press, 1983.

Lane, Barbara G. *The Altar and the Altarpiece: Sacramental Themes in Early Netherlandish Painting*. New York: Harper and Row, 1984.

Lausberg, Heinrich. *Handbuch der literarischen Rhetorik. Eine Grundlegung der Literaturwissenschaft.* Munich: Max Hueber, 1960.

Le Glay, A. *Recherches sur l'église métropolitaine de Cambrai.* Paris: F. Didot, 1825.

Le Goff, Jacques. *In Search of Sacred Time: Jacobus de Voragine and the Golden Legend.* Translated by Lydia G. Cochrane. Princeton, NJ: Princeton University Press, 2014.

———. "Labor Time in the 'Crisis' of the Fourteenth Century: From Medieval to Modern Time." In *Time, Work and Culture in the Middle Ages,* 43–52, translated by Arthur Goldhammer. Chicago: University of Chicago Press, 1980.

———. *The Medieval Imagination.* Translated by Arthur Goldhammer. Chicago: University of Chicago Press, 1988.

———. "Merchant's Time and Church's Time in the Middle Ages." In *Time, Work and Culture in the Middle Ages,* 29–42, translated by Arthur Goldhammer. Chicago: University of Chicago Press, 1980.

———. *Un autre Moyen Âge.* Paris: Gallimard, 1999.

Leachman, James G., ed. *The Liturgical Subject: Subject, Subjectivity and the Human Person in Contemporary Liturgical Discussion and Critique.* London: SCM Press, 2008.

Leaver, Robin A. *Luther's Liturgical Music: Principles and Implications.* Grand Rapids, MI: Eerdmans, 2007.

Leclercq, Jean. "The Experience of Time and Its Interpretation in the Late Middle Ages." *Studies in Medieval Culture* 8–9 (1976): 137–50.

Lecuppre-Desjardin, Élodie. *La ville des cérémonies: Essai sur la communication politique dans les anciens Pays-Bas bourguignons.* Turnhout: Brepols, 2004.

———. "Les lumières de la ville: recherche sur l'utilisation de la lumière dans les cérémonies bourguignonnes (XIVe–XVe siècles)." *Revue Historique* 301 (1999): 23–43.

Lecuppre-Desjardin, Élodie, and Anne-Laure van Bruaene, eds. *Emotions in the Heart of the City (14th–16th Century).* Turnhout: Brepols, 2005.

Leendertz, P. "De namen der maanden." *Noord en Zuid* 22 (1899): 321–37.

Lefèvre, Placide. "Textes concernant l'histoire artistique de l'abbaye d'Averbode." *Revue Belge d'archéologie et d'histoire de l'art* 4/5 (1934/1935): 247–64, 45–58.

Lehr, André, Wim Truyen, and Gilbert Huybens. *The Art of the Carillon in the Low Countries.* Tielt: Lannoo, 1991.

Lentes, Thomas. "Counting Piety in the Late Middle Ages." In *Ordering Medieval Society: Perspectives on Intellectual and Practical Modes of Shaping Social Relations,* edited by Bernhard Jussen, 55–91. Philadelphia: University of Pennsylvania Press, 2001.

Lessing, Gotthold Ephraim. *Laocoön: An Essay on the Limits of Painting and Poetry.* Translated by Edward Allen McCormick. Baltimore: Johns Hopkins University Press, 1984 [1766].

Lindquist, Sherry C. M. *Agency, Visuality and Society at the Chartreuse de Champmol.* Aldershot: Ashgate, 2008.

Lock, Richard. *Aspects of Time in Medieval Literature.* New York: Garland, 1985.

Lourdaux, Willem, and Marcel Haverals. *Bibliotheca Vallis Sancti Martini in Lovanio: Bijdrage tot de studie van het geesteleven in de Nederlanden (15de–18de eeuw).* 2 vols. Leuven: Universitaire Pers, 1978–1982.

Macey, Patrick. "Josquin and Musical Rhetoric: *Miserere mei, Deus* and Other Motets." In *The Josquin Companion*, edited by Richard Sherr, 485–530. Oxford: Oxford University Press, 2000.

Macken, Raymond. *Medieval Philosophers of the Former Low Countries*. 2 vols. Leuven: Editions Medieval Philosophers of the Former Low Countries, 1997.

Maesschalck, A., and J. Viaene. *Het Stadhuis van Brussel. Mensen en bouwkunst in Boergondisch Brabant*. Bruges-Sint-Andries: vanden Broele, 1960.

Mannaerts, Pieter, and Rudi Knoops. *Divine Sounds: Seven Centuries of Gregorian Chant Manuscripts in Flanders*. Leuven: Museum Leuven, 2011.

Marks, Richard Bruce. *The Medieval Manuscript Library of the Charterhouse of St. Barbara in Cologne*. Analecta Cartusiana 21, 22. 2 vols. Salzburg: Institut für Englische Sprache und Literatur, 1974.

———. "The Significance of Fifteenth-Century Hand Corrections in the Düsseldorf Exemplas of Some of Therhoernen's Editions of the Works of Werner Rolevinck." *Gutenberg-Jahrbuch* (1977): 49–56.

Marrow, James H. *Passion Iconography in Northern European Art of the Late Middle Ages and Early Renaissance*. Kortrijk: van Ghemmert, 1979.

Martens, Johan C. "The Dating of the *Fasciculus Temporum* Manuscript in the Arnhem Public Library." *Quaerendo* 21 (1991): 3–10.

———. "The *Fasciculus Temporum* of 1474: On Form and Content of the Incunable." *Quaerendo* 22 (1992): 197–204.

Marx, Walter John. "The Development of Charity in Medieval Louvain." PhD diss., University of Columbia, 1936.

Marzi, Demetrio. *La questione della riforma del calendario nel quinto concilio lateranense (1512–1517)*. Florence: G. Carnesecchi e figli, 1896.

Masser, Achim, and Max Siller, eds. *Das Evangelium Nicodemi in spätmittelalterlicher deutscher Prosa*. Heidelberg: Carl Winter, 1987.

Mazour-Matusevich, Yelena. "Gerson's Legacy." In *A Companion to Jean Gerson*, edited by Brian Patrick McGuire, 357–99. Leiden: Brill, 2006.

McGuire, Brian Patrick. *Jean Gerson and the Last Medieval Reformation*. University Park: Pennsylvania State University Press, 2005.

McNamee, Maurice B. *Vested Angels: Eucharistic Allusions in Early Netherlandish Paintings*. Peeters: Leuven, 1998.

Meconi, Honey. "Listening to Sacred Polyphony." *Early Music* 26 (1998): 375–79.

Melville, Gert. "Geschichte in graphischer Gestalt. Beobachtungen zu einer spätmittelalterlichen Darstellungsweise." In *Geschichtsschreibung und Geschichtsbewusstsein im späten Mittelalter*, edited by Hans Patze, 57–154. Sigmaringen: Jan Thorbecke, 1987.

Meuten, Erich, and Hermann Hallauer, eds. *Acta Cusana. Quellen zur Lebensgeschichte des Nikolaus von Kues*. Vol. 1.3b. Hamburg: Felix Meiner, 1996.

de Meyer, A. *La Congrégation de Hollande ou la réform dominicaine en territoire bourguignon*. Liège: Imprimerie Soledi, 1946.

Meyer, Christian. "Devotio Moderna et pratiques musicales polyphoniques." In *Rencontres de Colmar-Strasbourg (29 septembre au 2 octobre 1988): La dévotion moderne dans les pays bourguignons rhénans des origines à la fin du XVIe siècle*, edited by

Jean-Marie Cauchies, 159–70. Neuchâtel: Centre européen d'études bourguignonnes (XIVe–XVIe s.), 1989.
Michelet, Jules. *Histoire de France*. 17 vols. Vol 7. Paris: Chamerot, 1855.
Mitchell, W. J. T. *Iconology: Image, Text, Ideology*. Chicago: Chicago University Press, 1986.
———. "Spatial Form in Literature: Toward a General Theory." In *The Language of Images*, edited by W. J. T. Mitchell. Chicago: University of Chicago Press, 1980.
Molhuysen, P. C., and P. J. Blok, eds. *Nieuw Nederlandsch Biografisch Woordenboek*. Leiden: A. W. Sijthoff, 1914.
Mondelaers, Lydie. "Rondom de Sint-Pieterskerk: het stedelijk landschap in vogelvlucht." In *Leuven in de late Middeleeuwen: Dirk Bouts, Het Laatste Avondmaal*, edited by Anna Bergmans, 23–37. Brussels: Tielt, 1998.
Monks, Peter Rolfe. *The Brussels Horloge de Sapience: Iconography and Text of Brussels, Bibliothèque Royale, MS. IV 111*. Leiden: E. J. Brill, 1990.
Morgan, David A. L. "The Cult of St. George c. 1500: National and International Connotations." *Publication du centre européen d'études bourguignonnes (XIVe–XVIe s.)* 35 (1995): 151–62.
Mosshammer, Alden A. *The Easter Computus and the Origins of the Christian Era*. Oxford: Oxford University Press, 2008.
Moulin-Coppens, Josée. *De geschiedenis van het oude Sint-Jorisgilde te Gent vanaf de vroegste tijden tot 1887*. Gent: Hoste Staelens, 1982.
Mountz, Alison, Anne Bonds, Becky Mansfield, Jenna Loyd, Jennifer Hyndman, Margaret Walton-Roberts, Ranu Basu, et al. "For Slow Scholarship: A Feminist Politics of Resistance through Collective Action in the Neoliberal University." *ACME* 14 (2015): 1235–59.
Munn, Nancy D. "The Cultural Anthropology of Time: A Critical Essay." *Annual Review of Anthropology* 21 (1992): 93–123.
Munro, John H. "Industrial Protectionism in Medieval Flanders: Urban or National?" In *The Medieval City*, edited by Harry A. Miskimin, David Herlihy, and A. L. Udovitch, 229–67. New Haven, CT: Yale University Press, 1977.
———. "Monetary Contraction and Industrial Change in the Late Medieval Low Countries, 1335–1500." In *Coinage in the Low Countries (800–1500)*, edited by N. J. Mayhew, 95–161. Oxford: B. A. R., 1979.
———. *Textiles, Towns and Trade: Essays in the Economic History of Late-Medieval England and the Low Countries*. Aldershot: Variorum/Ashgate, 1994.
Murray, A. G. W. "The Edition of the '*Fasciculus Temporum*' Printed by Arnold Ther Hoernen in 1474." *Library* 4, Third Series (1913): 57–71.
Nagel, Alexander, and Christopher S. Wood. *Anachronic Renaissance*. New York: Zone Books, 2010.
———. "Toward a New Theory of Renaissance Anachronism." *Art Bulletin* 87 (2005): 403–15.
Nelson, Bernadette. "A Parody on Josquin's *Inviolata* in Barcelona 1967: An Unknown Mass by Philippe Verdelot." *Journal of the Royal Musical Association* 127 (2002): 153–90.
Nobis, Heribert M. "Zeitmaß und Kosmos im Mittelalter." In *Mensura: Mass, Zahl, Zahlensymbolik im Mittelalter*, edited by Albert Zimmermann, 261–76. Berlin: Walter de Gruyter, 1983–1984.

Noonan, John T. *The Scholastic Analysis of Usury*. Cambridge, MA: Harvard University Press, 1957.

North, J. D. "The Western Calendar—'Intolerabilis, Horribilis, et Derisibilis'; Four Centuries of Discontent." In *Gregorian Reform*, edited by G. V. Coyne, M. A. Hoskin, and O. Pedersen, 75–113. Vatican: Pontificia Academia Scientiarum, 1983.

Nosow, Robert. *Ritual Meanings in the Fifteenth-Century Motet*. Cambridge: Cambridge University Press, 2012.

Nothaft, C. Philipp E. *Dating the Passion: The Life of Jesus and the Emergence of Scientific Chronology (200–1600)*. Leiden: Brill, 2012.

Nuttall, Paula. *From Flanders to Florence: The Impact of Netherlandish Painting, 1400–1500*. New Haven, CT: Yale University Press, 2004.

Oates, J. T. C. *A Catalogue of the Fifteenth-Century Printed Books in the University Library Cambridge*. 2 vols. Cambridge: Cambridge University Press, 1954.

Ogle, Vanessa. *The Global Transformation of Time: 1870–1950*. Cambridge, MA: Harvard University Press, 2015.

Ohly, Friedrich. "Die Kathedrale als Zeitenraum. Zum Dom von Siena." In *Schriften zur mittelalterlichen Bedeutungsforschung*, 171–273. Darmstadt: Wissenschaftliche Buchgesellschaft, 1977.

Ostorero, Martine. *Le diable au sabbat. Littérature démonologique et sorcellerie (1440–1460)*. Florence: Sismel, editioni del galluzo, 2011.

Østrem, Eyolf. "Luther, Josquin and *des fincken gesang*." In *The Arts and the Cultural Heritage of Martin Luther*, edited by Eyolf Østrem, Jens Fleischer, and Nils Holger Petersen, 51–79. Copenhagen: Museum Tusculanum Press, 2002.

Ouy, Gilbert. "Discovering Gerson the Humanist." In *A Companion to Jean Gerson*, edited by Brian Patrick McGuire, 79–132. Leiden: Brill, 2006.

Overgaauw, E. A. "Observations on the Manuscripts of Werner Rolewinck's *Fasciculus Temporum*." *Quaerendo* 22 (1992): 292–300.

Page, Christopher. *Discarding Images: Reflections on Music and Culture in Medieval France*. Oxford: Clarendon Press, 1993.

———. "Reading and Reminiscence: Tinctoris on the Beauty of Music." *Journal of the American Musicological Society* 49 (1996): 1–31.

Palazzo, Eric. *L'invention chrétienne des cinq sens dans la liturgie et l'art au Moyen Âge*. Paris: Éditions du Cerf, 2014.

Parshall, Peter, ed. *The Woodcut in Fifteenth-Century Europe*. Washington, DC: National Gallery of Art, 2009.

Pascoe, Louis B. "Gerson and the Donation of Constantine: Growth and Development within the Church." *Viator* 5 (1974): 469–85.

Pàttaro, Germano. "The Christian Conception of Time." In *Cultures and Time*, edited by Paul Ricoeur, 169–95. Paris: Unesco Press, 1976.

Paul, Joanne. "The Use of *Kairos* in Renaissance Political Philosophy." *Renaissance Quarterly* 67 (2014): 43–78.

Paviot, Jacques. *Portugal et Bourgogne au XVe siècle (1384–1482)*. Lisbonne: Centre Culturel Calouste Gulbenkian, 1995.

Pearson, Andrea G. *Envisioning Gender in Burgundian Devotional Art, 1350–1530*. Aldershot: Ashgate, 2005.

Périer-d'Ieteren, Catheline. *Dieric Bouts: The Complete Works*. Brussels: Mercatorfonds, 2006.

———. "Une copie de Notre-Dame de Grâce de Cambrai aux Musées royaux des Beaux-Arts de Belgique à Bruxelles." *Bulletin des Musées royaux des beaux-arts de Belgique* 3–4 (1968): 111–14.

Perovic, Sanja. *The Calendar in Revolutionary France: Perceptions of Time in Literature, Culture, Politics*. Cambridge: Cambridge University Press, 2012.

Persoons, Ernest. "De incunabels van de priory Bethleem te Herent." *Mededeelingen van de Geschied- en Oudheidkundige Kring voor Leuven en Omgeving* 1 (1961): 55–60, 151–69.

———. "Het intellectuele leven in het klooster Bethlehem in de 15de eeuw." *Archives et bibliothèques de Belgique/Archief- en bibliotheekwezen in België* 43 (1972): 47–84.

———. "Nikolaas van Cusa te Leuven en te Bethleem in 1452." *Mededelingen van de Geschied- en Oudheidkundige Kring voor Leuven en Omgeving* 4 (1964): 63–69.

———. "Prieuré de Bethleem, à Herent." In *Monasticon Belge: Province de Brabant*, edited by Dom U. Berlière, Vol. 4.4, 1005–24. Liège: Centre national de recherches d'histoire religieuse, 1970.

Pesce, Dolores, ed. *Hearing the Motet: Essays on the Motet of the Middle Ages and Renaissance*. Oxford: Oxford University Press, 1998.

Peters, Edward, and Walter P. Simons. "The New Huizinga and the Old Middle Ages." *Speculum* 74 (1999): 587–620.

Philip, Lotte Brand. *The Ghent Altarpiece and the Art of Jan van Eyck*. Princeton, NJ: Princeton University Press, 1971.

Pickstock, Catherine. "Music: Soul, City and Cosmos after Augustine." In *Radical Orthodoxy: A New Theology*, edited by Graham Ward, John Milbank, and Catherine Pickstock, 243–77. London: Routledge, 1999.

Planchart, Alejandro Enrique. "Choirboys in Cambrai in the Fifteenth Century." In *Young Choristers, 650–1700*, edited by Susan Boynton and Eric Rice, 123–45. Cambridge: Boydell Press, 2008.

———. "Guillaume Du Fay's Benefices and His Relationship to the Court of Burgundy." *Early Music History* 8 (1988): 117–71.

———. "Guillaume Dufay's Masses: A View of the Manuscript Traditions." In *Dufay Quincentenary Conference*, edited by A. W. Atlas, 26–60. Brooklyn, NY: Brooklyn College, 1976.

Po-Chia Hsia, Ronnie. *Trent 1475: Stories of a Ritual Murder Trial*. New Haven, CT: Yale University Press, 1992.

Poole, Robert. *Time's Alteration: Calendar Reform in Early Modern England*. London: UCL Press, 1998.

Populer, Michèle. "Le conflit de 1447 à 1453 entre Gand et Philippe le Bon. Propagande et historiographie." *Handelingen der Maatschappij voor Geschiedenis en Oudheidkunde te Gent* 44 (1990): 99–123.

Post, R. R. *The Modern Devotion: Confrontation with Reformation and Humanism*. Leiden: Brill, 1968.

Prevenier, Walter, and Wim Blockmans. *The Burgundian Netherlands*. Translated by Peter King and Yvette Mead. Cambridge: Cambridge University Press, 1986.

Prims, Fl. "De Kloosterslot-beweging in Brabant in de XVde eeuw." *Mededeelingen van de Koninklijke Academie voor Wetenschappen, Letteren en Schoone Kunsten, van België* 6 (1944): 1–34.

Purtle, Carol J. *The Marian Paintings of Jan van Eyck.* Princeton, NJ: Princeton University Press, 1982.

Quinones, Ricardo J. *The Renaissance Discovery of Time.* Cambridge, MA: Harvard University Press, 1972.

Reinburg, Virginia. *French Books of Hours: Making an Archive of Prayer, c. 1400–1600.* Cambridge: Cambridge University Press, 2014.

Reith, Reinhold. "The Making of Wages and Attitudes towards Labour and the Crafts in Early Modern Central Europe." In *The Idea of Work in Europe from Antiquity to Modern Times,* edited by Josef Ehmer and Catharina Lis, 277–306. Farnham: Ashgate, 2009.

Reusens, Edmond. "Hunnaeus (Augustin)." In *Biographie Nationale,* Vol. 9, 711–19. Brussels: Émile Bruylant, 1886–1887.

Ricoeur, Paul. "Introduction." In *Cultures and Time,* edited by Paul Ricoeur, 13–33. Paris: Unesco Press, 1976.

———. "Narrative Time." In *On Narrative,* edited by W. J. T. Mitchell, 165–86. Chicago: University of Chicago Press, 1981.

———. *Time and Narrative.* Translated by Kathleen McLaughlin and David Pelauer. 3 vols. Chicago: University of Chicago Press, 1984–1988.

Rieder, Paula. *On the Purification of Women: Churching in Northern France, 1100–1500.* New York: Palgrave, 2006.

Rolland, P. "La Madone italo-byzantine de Frasnes-lez-Buissenal." *Revue belge d'archéologie et d'histoire de l'art/Belgisch Tijdschrift voor Oudheidkunde en Kunstgeschiedenis* 17 (1947/1948): 97–106.

Rombouts, Luc. "Beiaarden te Leuven. De Abdij van 't Park: de wieg van de beiaard." In *Stad met Klank,* edited by Gilbert Huybens et al., 12–18. Leuven: Centrale Bibliotheek, KU Leuven, 1990.

———. *Zingend Brons. 500 jaar beiaardmuziek in de Lage Landen en de Nieuwe Wereld.* Leuven: Davidsfonds, 2010.

Rosa, Hartmut. *Alienation and Acceleration: Towards a Critical Theory of Late-Modern Temporality.* Malmö: NSU Press, 2010.

Rosen, Ralph M., ed. *Time and Temporality in the Ancient World.* Philadelphia: University of Pennsylvania Museum of Archaeology and Anthropology, 2004.

Rosenberg, Daniel, and Anthony Grafton. *Cartographies of Time: A History of the Timeline.* New York: Princeton Architectural Press, 2010.

Rosenwein, Barbara H. *Emotional Communities in the Early Middle Ages.* Ithaca, NY: Cornell University Press, 2006.

Rubin, Miri. *Corpus Christi: The Eucharist in Late Medieval Culture.* Cambridge: Cambridge University Press, 1991.

———. "Europe Remade: Purity and Danger in Late Medieval Europe." *Transactions of the Royal Historical Society* 11 (2001): 101–24.

Rudy, Kathryn M. "Dirty Books: Quantifying Patterns of Use in Medieval Manuscripts Using a Densitometer." *Journal of Historians of Netherlandish Art* 2 (2010).

———. "Kissing Images, Unfurling Rolls, Measuring Wounds, Sewing Badges and Carry-

ing Talismans: Considering Some Harley Manuscripts through the Physical Rituals They Reveal." *Electronic British Library Journal* (2011): 1–56.

———. *Postcards on Parchment: The Social Lives of Medieval Books.* New Haven, CT: Yale University Press, 2015.

———. *Virtual Pilgrimages in the Convent: Imagining Jerusalem in the Late Middle Ages.* Turnhout: Brepols, 2011.

Sanderus, Antonius. *Chorographia sacra Brabantiae.* 3 vols. Vol. 1. The Hague: Christianus van Lom, 1726–1727.

Sauvageot, Claude. "Étude sur les Cloches." *Annales Archéologiques* 22 (1862): 212–44.

Schabel, Christopher. "Peter de Rivo and the Quarrel over Future Contingents at Louvain: New Evidence and New Perpectives (Part 1)." *Documenti e studi sulla tradizione filosofica medievale* 6 (1995): 363–473.

———. "Peter de Rivo and the Quarrel over Future Contingents at Louvain: New Evidence and New Perpectives (Part 2)." *Documenti e studi sulla tradizione filosofica medievale* 7 (1996): 369–435.

———. *Theology at Paris, 1316–1345: Peter Auriol and the Problem of Divine Foreknowledge and Future Contingents.* Aldershot: Ashgate, 2000.

Schäfke, Werner, ed. *Die Kölner Kartauser um 1500.* Cologne: Kölnisches Stadtmuseum, 1991.

Scheepsma, Wybren. *Medieval Religious Women in the Low Countries: The "Modern Devotion," the Canonesses of Windesheim and Their Writings.* Translated by David F. Johnson. Woodbridge: Boydell Press, 2004.

Scheuerman, William E. *Liberal Democracy and the Social Acceleration of Time.* Baltimore: Johns Hopkins University Press, 2004.

Schlie, Heike. *Bilder des Corpus Christi. Sakramentaler Realismus von Jan van Eyck bis Hieronymus Bosch.* Berlin: Gbr. Mann, 2002.

Schmidt, Robert W. *The Domain of Logic According to Thomas Aquinas.* The Hague: Martinus Nijhoff, 1966.

Schmitt, Jean-Claude. *Les rhythmes au Moyen Âge.* Paris: Gallimard, 2016.

Schreiner, Klaus. "'Diversitas temporum'—Zeiterfahrung und Epochengliederung im späten Mittelalter." In *Epochenschwelle und Epochenbewusstsein,* edited by Reinhart Herzog and Reinhart Koselleck, 381–428. Munich: Wilhelm Fink, 1987.

Schuler, Carol M. "The Seven Sorrows of the Virgin: Popular Culture and Cultic Imagery in Pre-Reformation Europe." *Simiolus* 21 (1992): 5–28.

Sears, Elizabeth. *The Ages of Man: Medieval Interpretations of the Life Cycle.* Princeton, NJ: Princeton University Press, 1986.

Sewell, William H. *Logics of History: Social Theory and Social Transformation.* Chicago: University of Chicago Press, 2005.

Simons, Walter. *Cities of Ladies: Beguine Communities in the Medieval Low Countries, 1200–1565.* Philadelphia: University of Pennsylvania Press, 2001.

Small, Graeme. *George Chastelain and the Shaping of Valois Burgundy: Political and Historical Culture at Court in the Fifteenth Century.* Woodbridge: Royal Historical Society: Boydell Press, 1997.

———. "Qui a lu la chronique de George Chastelain." In *A la cour de Bourgogne. Le Duc, son entourage, son train,* edited by Jean-Marie Cauchies, 115–25. Turnhout: Brepols, 1998.

———. "When Indiciaires Meet Rederijkers: A Contribution to the History of the Burgundian 'Theatre State.'" In *Stad van koopmanschap en vrede. Literatuur in Brugge tussen Middeleeuwen en Rederijkerstijd*, edited by Johan Oosterman, 133–61. Leuven: Peeters, 2005.

Smeyers, Katharina, and Maurits Smeyers. "De kalenderwijzerplaat in het Leuvense Stedelijk Museum en de kalendericonografie in laat-middeleeuwse getijdboeken." *Arca Lovaniensis* 22 (1993): 85–124.

Smeyers, Maurits. "Abbaye de Sainte-Gertrude, à Louvain." In *Monasticon Belge: Province de Brabant*, edited by Dom U. Berlière, Vol. 4.4, 865–961. Liège: Centre national de recherches d'histoire religieuse, 1970.

———. "An Eyckian Vera Icon in a Bruges Book of Hours, ca. 1450 (New York, Pierpont Morgan Library, Ms. 421)." In *Serta Devota in memoriam Guillelmi Lourdaux. Pars Posterior: Cultura Mediaevalis*, edited by Werner Verbeke, Marcel Haverals, Rafaël De Keyser, and Jean Goossens, 196–224. Leuven: Leuven University Press, 1995.

———, ed. *Dirk Bouts (ca. 1410–1475): een Vlaams primitief te Leuven*. Leuven: Peeters, 1998.

———. "The Living Bread. Dirk Bouts and the Last Supper." In *Dirk Bouts (1410–1475), een Vlaams primitief te Leuven*, edited by Maurits Smeyers, 35–58. Leuven: Peeters, 1998.

Smeyers, Maurits, and Rita van Dooren, eds. *Het Leuvense stadhuis: pronkjuweel van de Brabantse gotiek. Tentoonstellingscatalogus, Stadhuis Leuven (19 september–6 december 1998)*. Leuven: Peeters, 1998.

Smith, David Eugene. *Le comput manuel de Magister Anianus*. Paris: Droz, 1928.

Smythe, Karen Elaine. *Imaginings of Time in Lydgate and Hoccleve's Verse*. Farnham: Ashgate, 2011.

Soly, H. "Plechtige intochten in de steden van de Zuidelijke Nederlanden tijdens de overgang van Middeleeuwen naar Nieuwe Tijd: communicatie, propaganda, spektakel." *Tijdschrift voor Geschiedenis* 97 (1984): 341–61.

Spiegel, Gabrielle M. "Memory and History: Liturgical Time and Historical Time." *History and Theory* 41 (2002): 149–62.

Stabel, Peter. *Dwarfs among Giants: The Flemish Urban Network of the Late Middle Ages*. Leuven: Garant, 1997.

———. "Labour Time, Guild Time? Working Hours in the Cloth Industry of Medieval Flanders and Artois (Thirteenth-Fourteenth Centuries)." *Tijdschrift voor Sociale en Economische Geschiedenis* 11 (2014): 27–53.

Stalpaert, Herve. *Van Vastenavond tot Pasen: Oudvlaamse volksgebruiken*. Heule: Uitgeverij voor Gemeenteadministratie, 1960.

Staubach, Nikolaus. "L'influence victorine sur la dévotion moderne." In *L'école de Saint-Victor de Paris. Influence et rayonnement du Moyen Âge à l'époque moderne*, edited by Dominique Poirel, 583–99. Turnhout: Brepols, 2010.

Steele, Robert. "Dies Aegyptiaci." *Proceedings of the Royal Society of Medicine, Section of the History of Medicine* 12 (1919): 108–21.

Stengers, Jean. *Les Juifs dans le Pays-Bas au Moyen Âge*. Brussels: Académie Royale de Belgique, 1950.

Streveler, Paul A., and Katherine H. Tachau, eds. *Seeing the Future Clearly: Questions on Future Contingents by Robert Holcot.* Toronto: Pontifical Institute of Medieval Studies, 1995.

Strohm, Paul. *Social Chaucer.* Cambridge, MA: Harvard University Press, 1989.

Strohm, Reinhard. *Music in Late Medieval Bruges.* Oxford: Clarendon Press, 1985.

———. *The Rise of European Music, 1380–1500.* Cambridge: Cambridge University Press, 1993.

Strøm-Olsen, Rolf. "Dynastic Ritual and Politics in Early Modern Burgundy: The Baptism of Charles V." *Past and Present* 175 (2002): 33–64.

Strubbe, Egied I., and Leon Voet. *De Chronologie van de Middeleeuwen en de Moderne Tijden in de Nederlanden.* Antwerp: Standaard-Boekhandel, 1960.

Struik, D. J. "Paulus van Middelburg (1445–1533)." *Mededeelingen van het Nederlandsch Historisch Instituut te Rome* 5 (1925): 79–118.

Sutch, Susie Speakman, and Anne-Laure van Bruaene. "The Seven Sorrows of the Virgin Mary: Devotional Communication and Politics in the Burgundian Habsburg Low Countries, c. 1490–1520." *Journal of Ecclesiastical History* 61 (2010): 252–78.

Terlinden, Charles. "Le cinquième centenaire de l'Hôtel de Ville de Louvain." *Revue belge d'archéologie et d'histoire de l'art/Belgisch Tijdschrift voor Oudheidkunde en Kunstgeschiedenis* 17 (1947/1948): 3–14.

Thelliez, C. *La merveilleuse image de Notre-Dame de Grâce de Cambrai.* Cambrai: H. Mallez, 1951.

Thompson, E. P. "Time, Work-Discipline, and Industrial Capitalism." *Past and Present* 38 (1967): 56–97.

Timmerman, Achim. *Real Presence: Sacrament Houses and the Body of Christ, c. 1270–1600.* Turnhout: Brepols, 2009.

Twycross, Meg. "Worthy Women of the Old Testament: The Ambachtsvrouwen of the Leuven Ommegang." In *Urban Theatre in the Low Countries, 1400–1625,* edited by Elsa Strietman and Peter Happé, 221–50. Turnhout: Brepols, 2006.

Urbach, Susan. "*Imagines ad Similitudinem.* Copies after Miraculous Images (Gnadenkopien). The Abbenbroek Painting: A Case Study." In *La peinture ancienne et ses procédés: copies, répliques, pastiches,* edited by Roger Schoute and Anne Dubois, 224–33. Leuven: Peeters, 2006.

Valerius, Andreas. *Fasti academici studii generalis Lovaniensis . . .* Leuven: Ioannis Oliverius, 1635.

Van Aelst, José. "Het gebruik van beelden bij Suso's lijdensmeditatie." In *Geen povere schoonheid: laat-middeleeuwse kunst in verband met de moderne devotie,* edited by Kees Veelenturf, 86–110. Nijmegen: Valkhof, 2000.

Van Balberghe, Émile. *Les manuscrits médiévaux de l'Abbaye de Parc.* Brussels: Ferraton, 1992.

Van Der Essen, Léon. "Testament de Maître Guillaume de Varenacker (1478). Un document pour l'histoire sociale du XVe siècle." *Bulletin de la commission royale d'histoire* 93 (1929): 1–31.

Van Engen, John. "A Brabantine Perspective on the Origins of the Modern Devotion: The First Book of Petrus Impens's *Compendium Decursus Temporum Monasterii*

Christifere Bethleemitice Puerpere." In *Serta Devota in memoriam Guillelmi Lourdaux. Pars Prior: Devotio Windeshemensis,* edited by Werner Verbeke, Marcel Haverals, Rafaël De Keyser, and Jean Goossens, 3–78. Leuven: Leuven University Press, 1992.

———. "Multiple Options: The World of the Fifteenth-Century Church." *Church History* 77 (2008): 257–284.

———. *Sisters and Brothers of the Common Life: The Devotio Moderna and the World of the Later Middle Ages.* Philadelphia: University of Pennsylvania Press, 2008.

Van Even, Eduard. "Le contrat pour l'exécution du triptyque de Thierry Bouts de la collégiale Saint-Pierre à Louvain." *Bulletins de l'Académie royale des Sciences, des Lettres et des Beaux-Arts de Belgique* 35 (1898): 469–79.

———. *L'Omgang de Louvain, dissertation historique et archéologique sur ce célèbre cortége communal.* Leuven: C.-J. Fonteyn, 1863.

———. *Louvain dans le passé et dans le présent.* Leuven: Auguste Fonteyn, 1895.

———. *Louvain monumental ou description historique et artistique de tous les édifices civils et religieux de la dite Ville.* Leuven: C.-J. Fonteyn, 1860.

Van Mingroot, Erik. *Sapientie Immarcessibilis: A Diplomatic and Comparative Study of the Bull of Foundation of the University of Louvain (December 9, 1425).* Translated by Angela Fritsen. Leuven: Leuven University Press, 1994.

Van Uytven, Raymond. *Het dagelijks leven in een middeleeuwse stad: Leuven anno 1448.* Leuven: Davidsfonds, 1998.

———. "Landtransport durch Brabant im Mittelalter und im 16. Jahrhundert." In *Auf den Römerstraßen ins Mittelalter,* edited by Freidhelm Burgard and Alfred Haverkamp, 471–99. Mainz: Philipp von Zabern, 1997.

———. "Leven te Leuven ten tijde van Dirk Bouts." In *Leuven in de late Middeleeuwen: Dirk Bouts, Het Laatste Avondmaal,* edited by Anna Bergmans, 9–21. Brussels: Tielt, 1998.

———. *Stadsfinanciën en stadsekonomie te Leuven (van de XIIe tot het einde der XVIe eeuw).* Brussels: WLSK, 1961.

Van Waefelghem, R. "Une élection abbatiale au XVe siècle. Thierry de Thulden, abbé du Parc (1462)." In *Mélanges d'histoire offerts à Charles Moeller,* edited by F. Bethune et al., 671–82. Leuven: van Linthout, 1914.

Vanden Broecke, Steven. *The Limits of Influence: Pico, Louvain, and the Crisis of Renaissance Astrology.* Leiden: Brill, 2003.

Vandendriessche, Gaston. "The Children of the Planets in the Late-Medieval Calendar-Clock in the City Museum of Leuven." *Arca Lovaniensis* 22 (1993): 45–80.

Vaughan, Richard. *Philip the Good: The Apogee of Burgundy.* London: Longmans, 1970.

———. *Valois Burgundy.* London: Allen Lane, 1975.

Verhavert, J. *Het Ambachtswezen te Leuven.* Leuven: Universiteit te Leuven Publicaties, 1940.

Verheyen, Ann. "Onderwijs en opleiding in de 15de eeuw te Leuven." In *Leven te Leuven in de late Middeleeuwen,* edited by Lutgarde Bessemans, Inès Honoré, Maurits Smeyers, Veronique Vandekerchove, and Raymond van Uytven, 113–25. Leuven: Peeters, 1998.

Vial, Marc. "Zur Funktion des *Monotessaron* des Johannes Gerson." In *Evangelienharmonien des Mittelalters*, edited by Christoph Burger, August den Hollander, and Ulrich Schmid, 40–72. Assen: Royal Van Gorcum, 2004.
Ward, John L. "Disguised Symbolism as Enactive Symbolism in Van Eyck's Paintings." *Artibus et Historiae* 15 (1994): 9–53.
Ward, Laviece C. "Authors and Authority: The Influence of Jean Gerson and the 'Devotio Moderna' on the *Fasciculus temporum* of Werner Rolevinck." In *Die Kartäuser und ihre Welt—Kontake und gegenseitige Einflüsse*, edited by James Hogg. Analecta Cartusiana 62, 171–88. Salzburg: Institut für Anglistik und Amerikanistik, 1993.
———. "A Carthusian View of the Holy Roman Empire: Werner Rolevinck's *Fasciculus temporum*." In *Die Kartäuser und das Heilige Römische Reich*, edited by James Hogg, Alain Girard, and Daniel Le Blévec, 23–44. Salzburg: Institut für Anglistik und Amerikanistik, 1999.
———. "Werner Rolevinck and the *Fasciculus temporum*: Carthusian Historiography in the Late Middle Ages." In *Normative Zentrierung. Normative Centering*, edited by R. Suntrump and J. R. Veenstra, 209–30. Frankfurt: Peter Lang, 2002.
Weber, Max. *The Protestant Ethic and the Spirit of Capitalism with Other Writings on the Rise of the West*. Translated by Stephen Kalberg. 4th ed. New York: Oxford University Press, 2009 [1905].
Wegman, Rob C. *The Crisis of Music in Early Modern Europe, 1470–1530*. New York: Routledge, 2005.
———. "Johannes Tinctoris and the Art of Listening." In *Recevez ce mien petit labeur: Studies in Renaissance Music in Honour of Ignace Bossuyt*, edited by Mark Delaere and Pieter Bergé, 279–96. Leuven: Leuven University Press, 2008.
———. "Music as Heard: Listeners and Listening in Late-Medieval and Early Modern Europe (1300–1600): A Symposium at Princeton University, 27–28 September 1997." *Musical Quarterly* 82 (1998): 432–33.
———. "'Musical Understanding' in the Fifteenth Century." *Early Music* 30 (2002): 46–66.
Welzel, Barbara. *Abendmahlsaltäre vor der Reformation*. Berlin: Gebr. Mann, 1991.
———. "Ausstattung für Sakramentsliturgie und Totengedanken: Die Sakramentsbruderschaft in der St. Pieterskerk zu Löwen." In *Kunst und Liturgie im Mittelalter*, edited by N. Bock, 177–89. Munich: Hirmer, 2000.
Welzer, Harald. "Albert Speer's Memories of the Future: On the Historical Consciousness of a Leading Figure in the Third Reich." In *Narration, Identity, and Historical Consciousness*, edited by Jürgen Straub, 245–55. New York: Berghan Books, 2005.
Werner, Robert. *Etude sur le "Fasciculus Temporum," édition de Henri Wirczburg moine au prieuré de Rougemont (1481)*. Chateau-d'Oex: Musée du Vieux-Pays d'Enhaut, 1937.
White, Hayden. "The Value of Narrativity in the Representation of Reality." In *On Narrative*, edited by W. J. T. Mitchell, 1–23. Chicago: University of Chicago Press, 1981.
Whitrow, G. J. *Time in History*. Oxford: Oxford University Press, 1988.
Wieck, Roger S. *The Book of Hours in Medieval Art and Life*. London: Sotheby's Publications, 1988.
Williamson, Beth. "Altarpieces, Liturgy and Devotion." *Speculum* 79 (2004): 341–406.
———. "Sensory Experience in Medieval Devotion: Sound and Vision, Invisibility and Silence." *Speculum* 88 (2013): 1–43.

Wils, Joseph. "Les dépenses d'un étudiant à l'université de Louvain (1448–1453)." *Annalectes pour servir à l'histore ecclésiastique de la Belgique*, 3rd Series, II, 32 (1906): 489–507.

Wilson, Jean C. "Reflections on St. Luke's Hand: Icons and the Nature of Aura in the Burgundian Low Countries during the Fifteenth Century." In *The Sacred Image East and West*, edited by Robert G. Ousterhout and Leslie Brubaker, 132–146. Urbana: University of Illinois Press, 1995.

Wood, Christopher S. *Forgery, Replica, Fiction: Temporalities of German Renaissance Art.* Chicago: University of Chicago Press, 2008.

Worm, Andrea. "Das Zentrum der Heilsgeschichte als Diagramm: Die Gründung der Kirche, das Apostolische Glaubensbekenntnis und das Himmlische Jerusalem im *Fasciculus Temporum*." In *Diagramm und Text. Diagrammatische Strukturen und die Dynamisierung von Wissen und Erfahrung*, edited by Eckhart Conrad Lutz, Vera Jerjen, and Christine Putzo, 287–317 (Abb. 103–18). Wiesbaden: Reichert Verlag, 2014.

———. "'Ista est Jerusalem.' Intertextuality and Visual Exegesis in Peter of Poitiers." In *Imagining Jerusalem in the Medieval West*, edited by Lucy Donkin and Hanna Vorholt, 123–61. Oxford: British Academy, 2012.

———. "Rolevinck, Werner." In *Encyclopedia of the Medieval Chronicle*, edited by R. Graeme Dunphy, 1292–93. Leiden: Brill, 2010.

———. "Visualizing the Order of History: Hugh of Saint Victor's *Chronicon* and Peter of Poitiers' *Compendium Historiae*." In *Romanesque and the Past: Retrospection in the Art and Architecture of Romanesque Europe*, edited by John McNeill and Richard Plant, 243–63. Leeds: Maney Publishing for the British Archeological Association, 2013.

Wright, Craig M. "Dufay at Cambrai: Discoveries and Revisions." *Journal of the American Musicological Society* 28 (1975): 163–229.

———. *Music and Ceremony at Notre Dame of Paris, 500–1500.* Cambridge: Cambridge University Press, 1989.

———. "Performance Practices at the Cathedral of Cambrai 1475–1550." *Musical Quarterly* 64 (1978): 295–328.

Wright, Craig M., and Robert Ford. "A French Polyphonic Hymnal of the 16th Century: Cambrai Bibliothèque municipale, MS 17." In *Essays on Music for Charles Warren Fox*, edited by Jerald C. Graue, 145–63. Rochester, NY: Eastman School of Music Press, 1979.

Yandell, Cathy M. *Carpe Corpus: Time and Gender in Early Modern France.* Newark: University of Delaware Press, 2000.

INDEX

Abbey of Averbode, 13, 40, 206, 211n59, 232n25
Abbey of Park (Heverlee), 44, 56, 136, 206; clocks, 12, 14–17, 21, 24, 41, 198, 200
Aberdeen University, 52
Abraham, 49, 75, 97, 157, 177, 184
Acres, Alfred, 10
Adam, 158, 174, 180, 182; and Eve, 110, 127, 184
Advent, 17, 33, 45, 47–48, 65–66, 112, 117–18, 120–21, 123, 126–27, 129, 130, 228n31
Adventus, 108, 112, 117
Aeneid, 148
age, 30, 48, 51, 55, 57, 61, 169, 178; Christ's, 152–57, 168; of the world, 60, 83, 184–85. See also *saeculum*
Agnus Dei (mass), 15, 102, 104
Alexander the Great, 2, 7
almanacs, 34, 36
Alma redemptoris mater, 21
alphabet, 53–54, 142–44, 175. See also numbers
Alphabetum divini amoris (Nider), 53–54, 175
altarpieces, 143–44, 192, 194, 203; Ghent (van Eyck), 124, 125–28; historicized rereadings of, 10–11, 201; of Holy Sacrament (Bouts), 24, 28–29, 64–89, 169, 196, 197, 201, plate 1; and music, 79
Altdorfer, Albrecht, 7
Anianus, 142–43
Annunciation, 17, 18, 45, 50, 62, 66, 126, 127, 153, 158, 164
Anselm, 70–71
anthropology/anthropologists, 2, 6, 7, 210n19
anticipation, 147

antiphoners, 13, 17–18, 19, 20, 100–101, 120–21, 129–31, 130, 141
antiphons, 44, 99–102, 121, 123, 141
antiquarianism, 2–3, 177
antiquity, 1
Antonius de Butrio, 46, 47–48, 56, 246
Antonius Gratia Dei. See Gratia Dei, Antonius
Antwerp, 3, 4, 16, 33
Apocalypse, 44, 108, 116, 120–21, 125, 126, 129, 131, 161, 181, 184, 194
Apostles' Creed, 187
Aquinas, Saint Thomas, 70–72, 76–77, 96, 154
architecture, 5, 24, 27–29, 41–50, 201
archival material and manuscripts, 243–46
Areford, David S., 168–69, 237n152, 237n156
Aristotle, 24, 64, 69–74, 96, 221n22
Ark of the Covenant, 68
Arnade, Peter J., 2, 108
Arnold Ther Hoernen. See Ther Hoernen, Arnold
Arnolfini, Giovanni, 4
art, 3, 5, 107; historians/history, 2, 10–11, 65; as timeless, 11, 79, 125
Ascension, 45, 138, 185
astrolabe, 22
astrology, 34–36, 132–33, 152
astronomy, 34, 36, 42, 132–33, 152–61, 198, 236n133
atemporal gaze, 199
Auerbach, Eric, 7–8
Augustine of Hippo, Saint, 4–5, 9–10, 70–71, 96, 105, 134, 137, 143, 147–48, 153–54, 158, 171–72, 178, 184, 209n16

275

Augustinians, 12, 133–37, 141, 143, 233n42
Auriol, Peter, 72
Autumn of the Middle Ages, The (Huizinga), 2
Ave Maria, 56, 59, 224n13
Averbode, Abbey of. *See* Abbey of Averbode

Babylonian exile, 97–99, 101, 110, 184
Bacon, Roger, 235n102, 236n123
Bailluwel, Giles, 69, 74–75, 89, 168, 222n46, 223n86
baptism, 39, 55, 84, 156; of Jesus, 139, 142, 143, 154–55, 185, 188, 194, plate 3
Bede, 83–84, 155, 159–60, 173, 248
bells/bell towers, 8, 12, 14–15, 17, *18*, 21–22, 24, 27, 31–32, 46, 52–53, 56, 59–60, 95, 112, 115–16, 118, 198, 216n84, 216n87, 224n13; sounding time in Leuven, 38–41. *See also* clocks/clock towers
Belozerskaya, Marina, 2–3, 209n1, 209n5, 209n6
Benedicamus Domino, 45, 94
Bergson, Henri, 9, 210n40
Beringhen, Michael de. *See* de Beringhen, Michael
Bertoul, Saint, 112–13, 229n34
Berwouts, Willem, 135
Bethleem Priory (Herent), 25, 56, 133, 134–38, 141–42, 168, 171–72, 197, 199, 216–17n113, 226n57, 231–32n12, 234n59, 236n109, 238n16, 241n4
Beyaert, Joes, 40
biblical history, 202
Bibliothèque Royale (Brussels). *See* KBR
Bilfinger, Gustav, 6–7, 8
Binchois, Gilles, 3
Boethius, 70–71, 96
books, and memories, 131. *See also* early print culture
books of hours, 21, 34, 56, 61, 62, *81*, 86, *163*, 199, 224n13, 240n66
Boucheroul, Egidius, 135
Bouts, Dieric, 3–4, 7, 24, 28–29, 53, 64–70, 74–89, 169, 194–96, 197, 201, plate 1
Brabant, 26, 27, 31, 33, 54, 55, 84, 135, 143–45
Brethren/Brothers of the Common Life, 21, 91
breviaries, 48–50, 93
Brown, Andrew, 228n31, 229n56
Bruges, 3, 4, 16, 169, 212n69, 228n31, 229n56
Bruille, Fursy de. *See* de Bruille, Fursy
Bruner, Jerome S., 10

Brussels, 3, 16, 17, 26, 31, 38, 84, 91, 135
Bundle of Times, The. *See Fasciculus temporum* (The Bundle of Times)
Burckhardt, Jacob, 1, 2
Burgundian court, 3, 69, 109, 113–15, 174
burial practices, 24, 27, 56
Burke, Peter, 9–10, 210n19
Butrio, Antonius de. *See* Antonius de Butrio

Caesar, 2, 122
calendar dial, 34–36
calendars, 12, 30–36, *35*, *36*, 44–48, 51, 66, 173, 174, 231–32n12, 233n38, 235n98; and chronology, 25, 132–72, 202–3; reform of, 25, 132–33, 137, 146, 149–50, 156, 158–64; and temporal devotion, 164–71. *See also* liturgical calendar
Calendar Table and Rotae (de Rivo), *162*, 164
Calixtus III (pope), 39, 79–80
Cambrai Cathedral, 3, *18*, 24–25, 56, 100, 168; emotional narratives and musical life of, 24, 90–106, 107, 201–2; Marian time in, 17–22, 198, 224n13; singing and hearing at, 198
Cambridge University Library, 18, 43, 62, 133, 134, 135, 162, 165, 166, 167, 179, 183, 186, 187, 189, 193, 206, plate 4, plate 5
Campbell, Lorne, 53
cantus firmus, 78–79, 88, 102–3, 110
Carlier, Gilles, 90–91, 93–99, 104–5, 135
Carthusian Chronicle (Leuven), 57–59, 148, 216n87
Carthusians, 27, 53–54, 58–59, 94, 113, 135, 174, 181, 238n5
Caspers, Charles M., 79
catholic church, 188
catholic faith, 70, 73–74
Cele, Johan, 94–95
chants, 5, 12–22, 54, 59, 78–79, 88, 92, 96–106, 123, 129, 198, 200, 201
charity, 37, 59
Charles V, 55
Charles VII, 110
Charles the Bold, 3–4, 52
Chastellain, Georges, 3, 107, 109–17, 120, 148, 228n17, 228n19, 229n58
Children of Mercury (Calendar Dial), 36
Chips-Smith, Jeffrey, 108–9
Christmas, 17, 44–46, 48, 51, 66, 94–95, 196
chronicles, 3, 53–55, 57–59, 107–25, 127–29, 135–36, 148, 173, 180, 190, 241n2. *See*

also *Fasciculus temporum* (The Bundle of Times)
chronology, 1, 38, 45, 53, 113, 173, 194, 197–98; and calendars, 25, 132–72, 202–3; Gospel, 197; and history, 184. *See also* timelines
Chrysostom, John, 149, 154–55
church time, 8, 38, 41–59
Cicero, 122
Cisiojanus, 45
Cistercians, 52, 56
civic time, 22; polyphony of, 24, 26–63, 201; ringing of bells for, 38–41
Cleopatra, 188
clocks/clock towers, 12, 14–18, 21–22, 24, 34–36, 38–41, 60–61, 115–16, 118, *119*, *163*, 164, 198, 200, 211n58, 212n88, 220n223, 230n61, 241n3; in kitchens, 59. *See also* bells/bell towers
Cokeroel, Quentin, 41
Cologne, 3, 6, 69, 70, 135, 138, *169*, 173–74, 181, 187–88, 192, 238n5
color, 34, 45–46
Columba altarpiece (van der Weyden), 192
commemoration, 53, 80, 120
Conditor alme siderum, 17, *19*
confession, 46–48, 56, 61
confraternities, 3, 22, 28, 48, 64–65, 75, 76, 78, 82, 85–89, 196, 218n152
Constance, 54
cooking time, 59
Copernicus, 132–33
Corpus Christi, 45, 64–65, 69, 76, 88, 91, 93, 158
Council of Basel, 91, 94–95, 152
Council of Constance, 70, 93, 152
Council of Nicaea, 151, 156, 159–60, 235n99
court time, 55, 107–8, 113–14
Creation, 110, 161, 174, 177–84, *183*, 194
Creeds. *See* Apostles' Creed; Nicene Creed
Crucifixion, 42, 45, 104, 146–47, 150, 152, 155, 157–58, 164, 168–70, 185, 188, 190–92, 194, plate 4
cultural history, 6, 133, 210n19
cultural production, 1, 24, 27, 31, 197, 198
Cum rex gloriae (*Canticum triumphale*), 123
Cyril of Alexandria, 158

D'Ailly, Pierre, 93, 95, 98, 152, 156, 160, 224n13, 235n102
dal Monte Santa Maria, Marco, 239n23

days, 5, 14–15, 26, 33, 34, 37, 39, 57, 83, 90, 114–16, 147, 168, 185; calendars and, 150–64, 196; of creation, 178, 179, 181, 183, 184; liturgical, 10, 18, 41–42, 141; superstitions about, 47; work, 30–32. *See also* Egyptian days; Ember days; feasts; festivals; holidays
de Beringhen, Michael, 17
de Bruille, Fursy, 17–18, 99
de Butrio, Antonius, 46–48, 56
de Homborch, Conrad Winters. *See* Winters de Homborch, Conrad
de la Marche, Olivier, 3
demon worshipping, 44
Denys Rijkel. *See* Dionysius the Carthusian
de Putte, Joris van. *See* van de Putte, Joris
der Heyden, Henri van. *See* van der Heyden, Henri
de Rivo, Peter. *See* Peter de Rivo
desire, 15, 82–85, 98–99, 101, 110, 116–18, 121–23, 125–29, 177
des Prez, Josquin. *See* Josquin des Prez
de Suso, Heinrich. *See* Heinrich de Suso
determinate truth, 70, 72
de Velde, Jan Frans van. *See* van de Velde, Jan Frans
de Vliederhoven, Gerardus. *See* Gerardus de Vliederhoven
devotio moderna, 3–4, 21, 54, 93–94, 98, 136–37, 199, 202, 212n94, 220n220, 232n31, 234n61, 238n15
devotion, temporal. *See* temporal devotion
devotional: life, 26, 64, 95, 137, 197; practice(s), 3, 11–12, 61, 86, 133, 172; reading, 137, 141–42, 175–76; time, 25, 54, 59, 61, 88, 197–98
de Zomeron, Henri, 44, 70, 72, 74–75, 77
Dhanens, Elisabeth, 108
diachronics, 67, 71, 139, 144, 147, 184, 187, 201
Dialogus de temporibus Christi (de Rivo), 136
Dieric Bouts. *See* Bouts, Dieric
Dies naturalis (de Rivo), 43
difference, 149, 199
Dillon, Emma, 91, 205
Dionysius Exiguus, 151
Dionysius the Carthusian, 94
discantus, 94–95
discursive time, 24, 71, 76, 79, 104, 128–29, 177–78, 181
distentio animi, 5
diversitas temporum, 105, 197, 201–2, 203

divine foreknowledge. *See* foreknowledge, divine
divine law. *See* law
divine office. *See* Office
Dohrn-van Rossum, Gehard, 7
dominical letters, 152–53, 156, 160–61, 164
Dominicans, 11, 21, 44, 98, 135
Drach, Peter, 240n63
ducal ideology/power, 16, 107–29, 135, 229n5
Du Fay, Guillaume, 3, 22, 92–93, 98–99, 102–4, 198, 227n65
Duke of Urbino, 35
Dukes of Burgundy, 2, 3, 16, 17, 24, 26, 107–18, 120–23, 125, 128–29, 135, 197–98, 202

early print culture, 91, 132; antiphoner, 17–18; technologies, 199; time, text, and vision in, 25, 173–96, 203; works, 246–50
Easter, 37–38, 44–46, 51, 66–67, 69, 86, 111–13, 117, 121–23, 125, 132, 142–43, 146, 151–54, 156, 159–61, 164, 174, 185
eating patterns, and time, 59
Ecce Agnus Dei (Dieric Bouts), 194–96, *195*
ecclesiastical time, 236n133; architectures of in Leuven, 41–59; ringing of bells for, 38–41
Egyptian days, 47
Eleutherius (pope), 159
Elfynston, William, 52–53
Elijah, 68, 75–76, 80, 83–84
Ember days, 47–48
emotion(s), 6, 46, 108–9, 117–18, 120, 198; and music, 24, 90–106, 107, 201–2; of past, 201–2
emotional narratives, 110–12, 120; at Cambrai Cathedral, 24, 90–106, 201–2; of liturgy, 91, 117–18. *See also* liturgical narratives
empiricism, 11
Engen, John van. *See* van Engen, John
Epiphaniam Domino, 22
Epiphany, 22, 31, 41, 45, 139, 155
Erasmus, Desiderius, 4, 241n1
Erasmus, Saint, 86–88
Erasmus Altar (Dieric Bouts), 86–88, *87*
eschatology/eschaton, 1, 11, 108, 116–17, 122, 126, 128–29, 175, 184, 185, 187
eternal Truth, 72
eternity, 15–16, 29, 70–75, 109, 118, 120, 155, 170–72, 175–78, 190, 203; atemporal, 199; God's vision from, 8, 24, 71, 75, 102–3, 198; liturgical fusing of time and, 15,

211n65; of soul, 57, 61; temporalization of, 2, 116, 144, 194; and time, 1, 8, 15, 22, 24, 63, 71, 79, 82–85, 89, 104, 128, 171–72, 178, 192, 194, 197, 211n65
Eucharist, 45, 46, 68–69, 71, 76–84, 86, 88–89, 102, 125–27, 190, 222n57. *See also* host
Eugenius IV (pope), 29, 213n5
Eusebius, 157, 159
Exodus, 42, 97, 112. *See also* Passover
extratemporal perspective, 8, 199
Eymeric de Campo, 135, 136

Fabian, Johannes, 7
Fasciculus temporum (The Bundle of Times), 25, 56, 173–96, *179*, *183*, *186*, *189*, *191*, *193*, 197, 198, 199, 203; colophon, 196; introduction to, 173–78; prologue, 173–78, 180, 184, 194, plate 5
Fassler, Margot E., 11
fasts/fasting, 31, 33, 47–48, 61, 121, 153, 158
feasts, 16–18, 21–22, 29–30, 32, 34, 37–38, 41–42, 44–52, 54, 58–59, 61, 64–66, 75–76, 78–80, 83, 85–86, 91, 93–94, 97, 101, 115, 126–27, 158, 161, 164, 198, 224n13. *See also* festivals; holidays
festivals, 42, 46, 108, 111, 150–51, 158–59. *See also* feasts; holidays
figura, 7–8, 49, 83, 123
fish, 33, 60, 114
floods, 32, 58
food, 31, 34, 37, 47, 59
foreknowledge, divine, 72–73, 74–75, 77
fractio vocis, 94–95
Franciscans, 15, 72
Fursy de Bruille. *See* de Bruille, Fursy
future, 1, 4–5, 28, 32–33, 46, 56, 57, 64, 65, 69–75, 76, 78, 84, 88–89, 113, 117, 118, 120, 121, 126–27, 130–31, 135, 159, 161, 174–75, 177, 184, 185, 187, 188, 194, 203, 204. *See also* past; present

Gallus, Thomas, 175
Gavere, Battle of, 107, 113, 116, 120, 122
Geertz, Clifford, 108–9
gender, 6, 39, 59, 60–61
genealogies, 6–7, 9, 10, 109, 173–76, 180–81, *182*, 184, 196, 199, 203; of modernity, 6–7, 200
Genealogy of Christ from Adam, *182*
George, Saint, 115–16, 121
Gerardus de Vliederhoven, 240n46

INDEX

Gerson, Jean, 47, 56–57, 85, 95, 105, 138–39, 142, 231n6, 233n49, 234n60
Gertrude, Saint, 161. *See also* St. Gertrude's Abbey (Leuven)
Ghein, Peter vanden. *See* vanden Ghein, Peter
Ghent, 16, 40, 54, 55, 59, 85; history and liturgy in, 24–25, 107–31, 198, 202; as rebellious mercantile city, 3, 24; as trading center, 4
Ghent war, 107, 111, 118, 120, 227n1
Ghert van Smet, 86
Gloria (mass), 45, 56, 99, 102
Gloria, laus, et honor, 46
gluttony, 47
Godthebsdeel, Joannes, 57
Gospel harmony: *De consensu evangelistarum* (Augustine), 147, 148, 171–72, 234n77; *Ex quatuor unum* (Varenacker), 138, 233n49. *See also Monotessaron* (Gerson); *Monotesseron* (Peter de Rivo)
Gospels, attention to words of, 149, 155, 203
Gothic style, 27, 64
Götz, Nicolaus, 174, 181, 188, *189*, 240n63
Gratia Dei, Antonio, 168
Gregory of Nazianzus, 154
Groenendaal monastery, 135, 233n49
Grosbeck, John, 52–53
Guennes, Guillaume, 136
guilds, 3, 30–38, 48, 49, 60, 107, 114–15, 122, 229n46

Haggai, 123, 127–28
Haggh, Barbara, 225n18, 225n20
hands, 9, 77, 105, 118, 134–35, 136, 142–43, 176, 185, 187, 188, 192, 220n223, 232n15, 240n63, 241n78
Hapsburg Empire, 4
Harmony of the Gospels. *See* Gospel harmony; *Monotessaron* (Gerson); *Monotesseron* (Peter de Rivo)
Heinrich de Suso, 21–23, 54, 56, 118–19, 136, 141–42, 197
hermeneutics, 8, 29, 92, 104–6, 117, 138, 143, 148, 152, 154, 190, 197, 201–2, 203
Heyden, Henri van der. *See* van der Heyden, Henri
Hilarius (pope), 160
historical narrative, 147, 202
historical time, 28, 39, 53, 55, 108, 112, 131, 143–44, 149, 153, 181, 185, 187, 190, 200, 203

historiography, 109, 198, 234n79, 234n81
history: biblical and salvation, 15, 24, 110–16, 141, 154, 171, 176, 202; and chronology, 133, 184; cultural, 6, 133, 210n19; of emotions, 24, 90; exemplary, 176–77, 190; and liturgy, 24–25, 90, 107–31, 198, 202; of temporalities, 12, 24–25, 54, 63, 64, 116, 149, 199–204
holidays, 44, 51–52. *See also* feasts; festivals; *and specific holiday(s)*
Holofernes, 118, 120, 230n70
Holy Week, 46, 112, 117, 131, 146
Homborch, Conrad Winters de. *See* Winters de Homborch, Conrad
Horologium sapientiae (Heinrich de Suso), 21–23, 56, 118–19, 136, 141–42, 197, 212n91, 212n94, 232n36
host, 48, 56, 76, 78, 80, 82, 84, 126, 158. *See also* Eucharist
hourglasses, in kitchens, 59
Hugh of Saint Cher, 98–99, 101, 126
Huizinga, Johan, 1, 2, 209n1, 209n2, 209n3
human bodies, and passage of time, 47, 60–61
humanism/humanists, 2–3, 57, 132–33, 199, 201, 219n188, 219n190
human law. *See* law
Hunnaeus, Augustinus, 233n40
Hurlbut, Jesse D., 108

iconography, 3, 29, 68, 76, 80, 129, 194, 197
Immaculate Conception, 15
indulgences, 55–56, 86, 88
institutional time, in Leuven, 27, 48–59
interdisciplinary, 2, 11. *See also* transdisciplinarity
intuition, 24, 71, 83, 109, 144
Inviolata, 12–17, 21
Isidore of Seville, 159
Italy, 2–4, 132–33, 174, 198

Jacquier, Nicolas, 44
Jean VI Le Robert, 51
Jerome, Saint, 86, 96, 158
Jewish religion/Jews, 42, 75–76, 84, 99, 110–11, 118, 120, 123, 136, 147, 150–51, 154–55, 157, 168–69, 230n70
Johannes de Westfalia, 46, 152, 215n66, 217n128, 219n172, 231n1, 234n77, 235n103, 237n150
John, Saint (evangelist), 80, 111, 143, 144, 147, 148, 150, 169, 176

John IV (Duke of Brabant), 26
John of Burgundy, 17
John Rylands University Library (Manchester), 135, 232n15
John the Baptist, Saint, 27, 45, 46, 138–39, 141, 149, 194
John the Fearless, Duke, 17
Josquin des Prez, 14–15, 93, 105
Joyce, James, 10
Jubilee, 55, 160

kairos, 111
Kantorowicz, Ernst H., 108
KBR, 23, 49, 50, 119, 134–35, 137–38, 140, 163, 182, 206, plate 3
Kersmaker, Nicolas, 41
Kipling, Gordon, 108, 112, 117, 122
Kirkman, Andrew, 102, 227n65
kitchens, clocks or hourglasses in, 59
knowledge, temporal, 72
Koselleck, Reinhart, 7, 65, 237n142, 241n5
Kyrie, 46, 102–3, 227n65

Lambertus, Johannes, 17
Landes, David S., 7, 210n17
Last Supper, 28, 68, 75, 76, 80, 146, 166, 169
Lateran Council (IV, 1215), 46
Lateran Council (V, 1512–1517), 132
law, 55, 105–6, 122, 220n212; divine, 29; human, 29; natural, 29; old and new, 28–29, 42, 49, 68–69, 75–80, *81*, 84–85, 154–55, 156, 159, 168, 222n56
Lecuppre-Desjardin, Élodie, 108–9, 205, 224n2, 229n48, 229n58, 263
Le Goff, Jacques, 8–9, 11, 38
Lent, 33, 45–48, 58, 65, 69, 83, 99, 101, 112, 117–18, 121, 126
Leo I (pope), 84
Leuven, 3, 4, 14, 22, 24–25; bells in, 38–41; ecclesiastical time in, 38–50; institutional time in, 27, 48–59; labor and economy in, 30–38; old and new in, 27–30, 68; polyphony of civic time in, 24, 26–63, 201. *See also* St Peter's (Leuven); University of Leuven
Lichton, George, 52
Liège, 56, 65–66, 135, 139, 196
liturgical calendar, 22, 27, 44, 46–48, 68, 155. *See also* liturgical year; *sanctorale*; *temporale*

liturgical hours, 6–7, 11–12, 16, 18, 29, 32, 41, 44, 59, 61, 80, 83, 84, 93, 100, 117, 121, 220n222
liturgical narratives, 96–106, 116, 202. *See also* emotional narratives
liturgical ritual, 16, 27, 39, 46, 54, 55, 61, 107–8, 123, 126, 141, 154. *See also* mass; Office
liturgical selves/subjectivity, 25, 141–42, 202, 233n57
liturgical temporalities/time, 2, 14–17, 24–25, 30, 32–33, 42, 45, 48–50, 56, 60–61, 64, 68, 79, 86–89, 90–92, 95, 108, 112, 118, 120, 126, 139, 141–42, 149, 155, 175, 197–99, 201–2; affective narratives and, 98–106; and social life, 25
liturgical year, 16, 41, 44–45, 47, 50–51, 66, 68, 98–99, 118, 120–21, 139, 153, 158, 161. *See also* liturgical calendar; seasons
liturgy: and history, 24–25, 107–31, 198, 202; language of, 117–18; as political, 16
Lokeren, Jan van. *See* van Lokeren, Jan
lotteries, 33
Low Countries, map, xi
Luke, Saint (evangelist), 99, 121, 143, 144, 147–49, 155
Luther, Martin, 105

Maes, Peter, 134–35, 232n15
Magret, Simon, 41
manuscripts and archival material, 243–46
map, Low Countries, xi
Marcatellis, Raphael, 85
Marcellus, Marcus Claudius, 122
Marche, Olivier de la. *See* de la Marche, Olivier
Marian liturgy, 12–24, 99–100. *See also* Virgin Mary
Marian temporalities, 24. *See also* Virgin Mary
Marian time, 12–24, 49–51, 164, 198. *See also* Virgin Mary
Mark, Saint (evangelist), 143, 144, 147, 148, 190
markets, 30–33, 60, 114, 201
Martin V (pope), 26, 51
Martini, Jean, 17
Martin of Troppau (Martinus Polonus), 173, 180
Mary, Virgin. *See* Virgin Mary

mass, 15, 16, 24, 29, 30, 32, 39, 41, 45, 46, 55, 56, 59, 78–79, 85–86, 88, 93, 98–99, 102–4, 120, 125–29, 139, 141, 158, 168, 190, 194, 224n13, 227n65
Mathijs de Grootheere, 116–17
Matthew, Saint (evangelist), 54, 83, 112, 139, 141, 143, 144, 147–49, 190
Maximus of Turin, 236n11
measurement(s) of time, 6–7, 17, 21–22, 25, 26, 33, 36–38, 40–42, 44, 52, 55, 58–59, 60–61, 66–67, 133–34, 145, 149–59, 168–69, 174–75, 177–78, 192, 196, 202
Mechelen, 40, 59
Melchizedek, 68, 75, 85–86
memory, 5, 6, 15, 16, 30, 41, 45, 53, 54, 55, 58, 59, 77, 85, 88, 102, 115–16, 131, 142–43, 155–56, 176, 200, 202, 234n60, 234n61
metaphors, 8, 72, 84, 177, 194
Middle Ages, 1, 2, 8
mirror, 77–78, 120, 222n59
Miserere, 59
Missa ecce ancilla (Du Fay), 99, 102–4
modernity, 25, 241n7; genealogy of, 6–7, 200
Mombaer, Jan, 143
Monotessaron (Gerson), 85, 138–39, 142, plate 2
Monotesseron (Peter de Rivo), 133, 134, 137–49, 152, 155, 157, 171, 197, 202, plate 3
Monte Santa Maria, Marco dal. *See* dal Monte Santa Maria, Marco
Moses, 80, 83–84, 97
Munro, John H., 32
music, 2–5, 10–22, 88, 125–29, 142–43, 178, 184, 198, 200, 207, 209n3, 225n17, 225n18, 225n22, 239–40n42, 241n3; affective qualities, 96, 98–106; and altarpieces, 79; control of *discantus*, 95; and emotion(s), 24, 90–106, 107, 201–2; ephemeral phenomenon of, 201–2; as heard, 90–91, 201–2; jubilant, 96; liturgical, 14–22, 78–79, 90–106; plain, 96; sacred, 98; and time, 14–22, 54, 90–106, 128, 201–2

Nagel, Alexander, 11, 213n9, 237n154
Nancy, Battle of, 4
narrative, 2, 5, 7, 15, 24, 28, 42, 54, 58, 68, 83, 90–106, 107, 110–18, 120–25, 129, 137–49, 154–55, 170–71, 184, 198–200, 202, 209n16, 237n160, 241n77. *See also* emotional narratives; liturgical narratives

Nativity of the Virgin, 22, 48–51
natural law. *See* law
Nebuchadnezzar, 118, 120
new. *See* old and new
Newberry Library (Chicago), 206, 233n49, 239n35
New Testament, 29, 99, 105, 187, 190, 214n23. *See also* law: old and new; Old Testament
Newtonian science, 199
Nicene Creed, 82–83
Nicodemus, Gospel of, 123
Nicolaas de Bruyne, 49
Nicolas of Cusa, 156, 160, 199, 241n4
Nider, Johannes, 53–54, 175
night, 31, 39–40, 42–44, 47, 52, 56, 57, 61, 94, 113–16, 129, 147, 185
Noah's Ark, 188
noble succession, 55
Nothaft, Philipp, 133, 205, 236n126, 237n139
Notre-Dame (Paris), 16, 95
Notre-Dame de Flamenghe, 21
Notre-Dame de Grâce, 17–18, 92, 99, 100, 198
Notre-Dame de Sablon (Brussels), 17
numbers, 5, 49, 53, 143, 196; divine, 178; golden, 151–52, 157, 159–60, 161. *See also* alphabet
Nuttall, Paula, 2

objectivity/objectification, 8–9, 61. *See also* subjectivity
Ockeghem, Johannes, 3, 92–93
Office, 48, 82–84, 90, 92, 93, 94–95, 112
old and new, 1, 26, 27–30, 40, 42, 68, 84, 99, 102, 105, 120, 123–25, 156, 161, 187, 190, 197, 199–200, 201. *See also* law: old and new; New Testament; Old Testament
Old Testament, 28, 49, 68, 76, 79–80, 99, 105, 112, 120–21, 123, 126–28, 185, 187, 190. *See also* law: old and new; New Testament
O nata lux, 80, 82, 88
Orosius, 173
Ovid, 219n190

Palm Sunday, 46, 60, 108, 129
Pange lingua gloriosi corporis mysterium, 76–77, 78, 88
paradox, 1, 7, 79, 104, 144, 172, 194, 199, 224n67

Park, Abbey of. *See* Abbey of Park (Heverlee)
Passover, 42, 75–78, 111, 120, 146, 150–51, 155–57, 168. *See also* Exodus
past, 1–2, 4–5, 7, 11, 15, 25, 46, 54, 65, 70–73, 76, 83, 88, 108, 110, 115, 117, 118, 120, 122, 127, 131, 148, 157, 159, 175, 177, 184–87, 194, 197–204. *See also* future; present
past's future, 65
Pater noster, 56, 59
Paul, Saint (apostle), 83. *See also* pauline theology
pauline theology, 1, 28–29, 83–84, 105, 132, 156, 199–200
Paul of Middelburg, 35, 36–37, 42, 132, 134, 136, 152, 156, 158–59, 198, 231n4
Pentecost, 47–48, 51, 185, 187–88, 190, 198
Peraldus, William, 94
Peter de Rivo, 25, 36–37, 42–43, 70–78, 132–72, 177–78, 194, 197–98, 200, 202–3, 221n22, 231n6, 231–32n12, 232n25, 233n42, 236n133
Peter of Poitiers, 180
Peter van Sinte Peters, 84
Philip I (Duke of Brabant), 26
Philip the Fair, 54–55
Philip the Good, 3–4, 16, 21, 24–25, 85, 107, 109–16, 129, 202, 230n70; as liturgical lord of time, 116–25
Pius I (pope), 159
Plato, 171
polyphony, 1, 2, 16–17, 22, 78–79, 88, 93–99, 102–3, 105–6, 125, 225n17, 226n40; of civic time, 24, 26–63, 201
Pompey, 122
power, 32, 41, 107–8, 110, 114–15, 156, 188–90, 192, 202, 229n48, 240n63. *See also* ducal ideology/power
present, 1–2, 4–5, 11, 15, 46, 49, 56, 65, 67, 71–73, 76–80, 84, 85, 88, 101, 108, 110, 118, 120, 122, 126–29, 131, 155, 159, 164, 174–77, 180, 181, 184, 185, 187, 190, 194, 200, 203–4. *See also* future; past
print culture, early. *See* early print culture
providence, 110, 177
Purgatory, 55, 85, 88
Putte, Joris van de. *See* van de Putte, Joris

Quentell, Heinrich, 247
Quinones, Ricardo J., 6
quodlibet, 29, 72–74, 153

Ratdolt, Ehrhard, 240n63
ratio, 5, 143, 178. *See also* measurement(s) of time
Recollectio festorum beate Marie virginis, 22, 49–50, 91
Regina caeli, 101
remembrance, 89, 147
Renaissance, 1, 6–7, 93, 132–33, 206
rents, 33
responsory, 93, 121, 129
Resurrection, 42, 45, 46, 83, 99, 104, 112, 121, 122, 123, 125, 129, 132, 144, 146, 150, 151, 152, 156, 158, 167, 169, 194
Rether, Henry, 52
rhythms, 58–61, 79, 95, 143, 153, 201–2, 210n18; of action, 6, 12; biological, 47, 60–61; of cosmic and social orders, 150; economic, 37, 201; of holidays, 44; of life, 30–32; of liturgical time, 41, 61, 158, 201; natural, 26–27, 37; of noble succession, 55; seasonal, 31, 32, 37; social, 58, 137; and social acceleration, 6; of work, 30–31, 38, 44, 47, 48, 201
Ricoeur, Paul, 5, 7–8, 147, 209n16
Rivo, Peter de. *See* Peter de Rivo
Robert au Clau, 94
Rolewinck, Werner, 56, 174, 177–78, 179, 183, 184, 186, 189, 191, 193, 194, 238n6
Roman Empire, 150
rosary, 50, 59
Rossum, Gehard Dohrn-van. *See* Dohrn-van Rossum, Gehard
Rouen Cathedral, 93, 95
Rudy, Kathryn M., 56, 164, 220n222, 234n67, 237n149
Rumelans, Wouter, 135
Ruysbroeck, Jan van, 27
Rylands University Library (Manchester), 135, 232n15

saeculum, 14–15, 22, 82, 190. *See also* age
Saint Augustine. *See* Augustine of Hippo, Saint
salvation, 15, 73, 141, 154, 172, 184, 185, 190
Salve regina, 15, 18, 21
Sancti spiritus assit nobis gratia, 198
sanctorale, 11, 44, 45, 50, 139, 161. *See also* *temporale*
science, and time, 199
scientific imagination, 199

seasons, 5, 24, 26–27, 41, 43–48, 60, 64–65, 69, 95, 101–2, 112, 117–18, 122, 126–27, 150–51, 159, 215n71, 228n31; and labor/economy, 30–38; natural rhythms of, 32, 37. *See also* liturgical year
secularization, 12, 14, 25, 133, 200
secular time, 1–2, 6–7, 12
sequence, 17, 22, 198
Simon of Trent, 169
Sixtus IV (pope), 15
Smeyers, Maurits, 85, 222n52
sociology, 6
Spierinck, Joannes, 36
Stabel, Peter, 31–32
St. Aubert's (Cambrai), 51
St. Augustine. *See* Augustine of Hippo, Saint
St. Barbara's (Cologne), 174, 238n15, 238n17
St. Bavo's (Ghent): Abbey, 85, 129–31; Cathedral, *124*
St. Catherine-du-Mont (Rouen), 241n69
St. Gertrude's Abbey (Leuven), 27, *28*, 136, 216n84, 233n40
St. James's (Leuven), 27, 37, 39, 41, 48, 214n26, 216n84
St. James the Greater (Madeira), 4
St. John's (Ghent), 125
St. Martin's Priory (Leuven), 44, 56, 136, 233n38, 234n62
St. Michael's (Leuven), 39, 52
St. Peter's (Leuven), 22, 27–29, 38–41, 46, 48–50, 60, 63, 112, 169, 233n40; altarpiece of Holy Sacrament in, 24, 64–89, 196, 197, 201; clocks, 41; making time in, 64–89
St. Peter's (Trent), 169
St. Peter's Abbey (Ghent), 112
Strohm, Reinhard, 125–26, 222n63, 225n17
St. Sepulchre's Abbey (Cambrai), 212n91
subjectivity, 9–10, 61, 199; liturgical, 25, 141–42, 202, 233n57; temporal, 202. *See also* objectivity/objectification
Sub tuum presidium, 18, 20, 99–101
sundials, 22
Suso, Henry. *See* Heinrich de Suso
synchronic gaze, 109, 115, 187, 199, 202
synchronic/synchronicities, 49, 67, 71, 109, 115, 181, 184, 187, 190, 199, 202

Tatian, 138
Te lucis ante terminum, 44
temporal devotion, 25, 132–72, 202–3; and calendar, 164–71

temporal distance, 7, 72, 76, 79, 101, 194–96
temporale, 11, 44–45, 58, 139. *See also sanctorale*
temporalities/temporality, 26–27, 83, 99, 118, 125, 129, 133, 196, 203–4, 237n154, 241n7; of an altarpiece, 75–89, 203; of analysis, 203; of communal life or life narratives, 198; and diversity of times, 198; history/histories of, 4–12, 6, 11, 24, 201, 202; Marian, 24; of politics, 107; of reading or writing, 198, 199, 200, 202; and science, 199; of singing and hearing, 24, 103–4, 198, 200, 201–2; textual, 137–49; as transdisciplinary, 5–6, 24, 200; of university student life, 52
temporalization, 11; of eternity, 2, 144; forms of, 203; of history, 7; and musicology, 24; paradoxical, 144
temporal mediation, 172
theology/theologians, 1, 25, 28–29, 36, 44, 51, 57, 64, 69–73, 75, 86, 91, 94, 95, 98, 105, 118, 132, 135, 153, 168, 174, 180, 197, 199, 201, 213n5, 228n19, 238n15
Theophilus of Caesarea, 153
Ther Hoernen, Arnold, 174, 181, 183, 184, 186, 188, 190, 192, 238n6
Thierry van Thulden. *See* van Thulden, Thierry
Thomas à Kempis, 136
Thomas Aquinas. *See* Aquinas, Thomas, Saint
Thulden, Thierry van. *See* Thierry van Thulden
time: bookish cultures of, 131; charting course of, 178–84; counting, 37; as devotional, 197–98; as distance, 72; as framework for life, 57; fullness of, 1, 12, 25, 79, 88, 116, 120, 125–26, 195–96, 197, 198, 203–4; God's vision of, 71, 198; as great devourer, 57, 201; history/histories of, 5–7, 9–12, 24, 63, 200, 202; how we become who we are in, 198; how we live in, 206; intellective perception of, 158; narrative negotiations of, 95–98; natural flow/order of, 147–49; as precious, 56–57; and ritual, 107–8; social order of, 33–34; structures of, 107–8, 109; textual, 137–49, 202–3; wasted, 56–57; and work, 8, 9, 30–34, 38–39, 47–48, 60, 66–67
Time and Narrative (Ricoeur), 7, 209n16
timelessness, 2, 7–8, 79, 116, 171, 194, 199, 201; of art, 11, 79

timelines, 25, 56, 173–74, 180–81, 185, 188, 192, 197, 203, 210n32; genealogical, 203. *See also* chronology
Tinctor, Jean, 44
Tinctoris, Johannes, 91, 92–93
transdisciplinarity, 5–6, 24, 200. *See also* interdisciplinary
Transfiguration, 79–80, 82–85, 88, plate 2
truth, 69–75

University of Cologne, 69, 70, 135
University of Leuven, 3, 4, 24, 25, 26, 28, 29, 44, 64, 89, 133, 136, 152, 164, 197, 199–200; future contingents at, 69–75; institutional time, 27, 48–59
University of Paris, 69, 91, 95, 135
usury, 32–33
Utrecht, 174

vanden Ghein, Peter, 40
vanden Velkener, Jan, 40
van de Putte, Joris, 40
van der Heyden, Henri, 136
van der Weyden, Rogier, 3, 10, 192, 194
van de Velde, Jan Frans, 134, 231–32n12
van Engen, John, 209n9, 227n75, 232n18, 232n20
van Eyck, Hubert, *124*
van Eyck, Jan, 3–4, 7, *124*, 125, 192, 194, 241n72, 241n78
van Lokeren, Jan, 40
van Rossum, Gehard Dohrn-. *See* Dohrn-van Rossum, Gehard
van Ruysbroeck, Jan. *See* Ruysbroeck, Jan van
van Thulden, Thierry, 12
van Winckele, Jan, 53
Varenacker, Guillaume, 59, 233n49
Varenacker, Jan, 29, 59, 69–70, 73–75, 77, 80, 83, 85, 89, 136, 138, 153, 214n23, 221n17, 223n86, 233n49
Velde, Jan Frans van de. *See* van de Velde, Jan Frans
Veldener, Johannes, 173–74, 175–76, *179*, 183–84, 188, *193*, 196, 215n66, 219n172

Velkener, Jan vanden. *See* vanden Velkener, Jan
Veni creator spiritus, 54
Vesalius, Joannes, 34
Victor I, Pope, 159
Victorius, 160
Vincent of Beauvais, 173
Virgil, 148
Virgin Mary, 12–24, 49, 50–52, 91–93, 100–101, 127, 134, 164, 169, 176, 188. *See also* Marian liturgy; Marian time
Vliederhoven, Gerardus de. *See* Gerardus de Vliederhoven

wages, 32
Walch, Georgius, 240n63
Waldensians, 44
Walter Henry de Thymon, 49, 50
wasted time, 56–57
Weber, Max, 6
Willem Berwouts. *See* Berwouts, Willem
Williamson, Beth, 10–11
Winckele, Jan van. *See* van Winckele, Jan
Windesheim Congregation, 3, 56, 133, 135–36, 174, 187, 197–98
Winters de Homborch, Conrad, 190, 191, 240n63
Wood, Christopher S., 11, 213n9, 237n154
woodcuts, 133–34, 164–94, 237n152
Worm, Andrea, 174, 187
Wouter Rumelans. *See* Rumelans, Wouter
Wyclif, John, 70

years, 22, 26, 30, 31, 33, 34, 37, 45, 47, 48, 50, 51, 52, 56, 60, 65–67, 150–52, 155, 157–61, 169, 185, 196, 220–21n9, 221n11; before Christ (*ante Christi*), 178–80; of grace (*annus gratie*), 54–55, 58; of the world (*annus mundi*), 178–80. *See also* liturgical year

Zerbolt van Zutphen, Gerard, 175
Zomeron, Henri de. *See* de Zomeron, Henri
Zwolle, 94–95